COMPLETE

MARTY BAX

Lund Humphries

MONDRIAN

First published in 2001 by
Lund Humphries
Gower House
Croft Road
Aldershot
Hampshire GU11 3HR
United Kingdom

and

131 Main Street
Burlington
VT 05401
USA

Lund Humphries is part of Ashgate Publishing

British Library Cataloguing-in-Publication Data
A catalogue record for this book is available
from the British Library

Library of Congress Control Number:
2001092685

Paperback ISBN: 0 85331 822 0
Hardback ISBN: 0 85331 803 4

Designed by Jan Johan ter Poorten
and Cees de Jong, V+K Design, Blaricum,
The Netherlands
Translated from the Dutch by Lynn George,
Amsterdam, The Netherlands
Printed by Snoeck-Ducaju & Zoon, Ghent, Belgium

Publisher's note:
All titles appear in their original language as
intended by Mondrian. Translations have been
added where appropriate.

COMPLETE MONDRIAN

CONTENTS

INTRODUCTION

Marty Bax

1872–92

Pieter (Piet) Cornelis Mondrian, originally Pieter Cornelis Mondriaan, was born on 7 March 1872 at Amersfoort, the eldest son of Pieter Cornelis Mondriaan (1839–1921) and Johanna Christina de Kok (1839–1909). His father was head teacher of a Christian national education primary school in the city and supported the Christian anti-revolutionary minister Abraham Kuyper, who later became prime minister. So Piet Mondriaan Senior was a strict, conservative Christrian, although he never actually became a member of Kuyper's Dutch Reformed Church.

Through Kuyper's personal intervention the Mondriaan family moved to the village of Winterswijk where the father was appointed head teacher of another Christian national education primary school. His children also attended. After leaving school the young Piet Mondrian began training to become a primary school art teacher and acquired his national diploma three years later in Amsterdam. It was already clear to him that he not only wanted to earn a living teaching a creative subject, but also wanted to be an artist, even though his father opposed the idea.

Mondrian exhibited his first paintings in 1890, and a year later prepared for entrance examinations to be able to attend either the Aacademy of Art in The Hague or in Amsterdam. He successfully applied to the Queen Regent Emma fund for a grant which he received in 1892. It would cover Mondrian's fees for two years. In September 1892 he also obtained his diploma to teach drawing in secondary school and on the basis of his formal qualifications was admitted to Amsterdam's State Academy of Fine Arts. The daytime courses meant Mondrian had to move to Amsterdam, where his father's friends took him under their wing and provided his initial accommodation. On 7 November 1892 he moved in with J.A. Wormser, a member of the Dutch Reformed Church, who owned a bookshop in the city's Kalverstraat. Like Piet's father he was a fervent supporter of Abraham Kuyper.

1892–1904

In 1894 Mondrian's two year's of full time study came to an end and he enrolled for an evening course, which he paid for himself. That same year he became a member of Amsterdam's artists' society Arti et Amicitiae, which gave him access to the official exhibition network. When his evening course finished in 1895 Mondrian enrolled for another in October that year, this time to study drawing with the emphasis on learning to etch.

It is likely that via his friends at the State Academy, Mondrian came into contact with the bohemian life of the city, which centred on 'the Windmill without Sails' on Tolstraat. The disused mill was on the southern edge of what were then the city limits. From here Mondrian took his first trips along the river and polders of the surrounding, still undeveloped landscape. In 1892 the windmill was situated roughly on the corner of the same street as the Dutch Theosophical Society, an organisation that was to have a profound impact on Mondrian's life.

From 1897 Mondrian was engaged in promoting himself as an artist, in the hope of creating a potential market for his work, and in finding a regular source of income when he could not live from his art. In 1897 he became a member of St Lucas, the second most important artists' association in Amsterdam, which again gave him opportunities to exhibit. A year later he sat the examinations for the State Academy's *Prix de Rome*, a grant awarded to young artists to visit Italy, but failed on account of his inability to render the human anatomy accurately. That same year he applied to the Winterswijk police for a 'reference of good character', stating that he hoped to make his living as a teacher.

From about 1898 onwards Mondrian was able to secure a number of private commissions, which brought in a certain amount of income. He gave private lessons, for instance, to relatively well-off women, usually from the same Reformed background as himself, or he painted portraits in a traditional

manner, which usually appear to have been copied from photographs. Occasionally there were the special commissions, like the design for the English Church's pulpit at the Begijnhof (Beguinage), Amsterdam, or a mural for a private client living on the Keizersgracht, one of the city's canals. He also bartered pictures with his doctors and dentists, which was the usual way for artists with insufficient funds to pay their medical bills.

In 1900 Mondrian extended his social circle to include two people he was to remain friendly with for several decades: Albert van den Briel (1881–1971),who later became a forester, and who in the 1960s wrote his not very reliable memoirs of the artist, and the painter Simon Maris (1873–1935). It was through Maris that Mondrian came into contact with Amsterdam's more sophisticated avant-garde artistic circles, including the 'joffers', a group of women artists. Various photographs exist depicting Mondrian standing between these stylishly dressed ladies in white and lace. Typically in most of these he has positioned himself modestly within the group – sometimes in fact he is barely in the picture. One of the 'joffers', Lizzy Ansingh, later recalled Mondrian's reserved nature, as even then he entertained high-minded ideals which he attempted to convey in a hesitant manner to this frivolous crowd. This mix of introspection and extroversion was to dominate his later life as an artist in Paris and New York. While Mondrian enjoyed an active social life in the international avant-garde, liked to dance and had a passion for modern music, as an artist he set himself high ideals and lived and worked detached from the world around him.

In 1901 Mondrian again took the entrance examination for the *Prix de Rome* and again failed due to his poor attempt at reproducing the human form. Perhaps it was because of this repeated criticism of his figure drawing that he decided around this time to devote himself to landscape painting – apart from still taking on commissioned portraits and producing still lifes for commercial use.

In this period the first clear indications of those signs and concepts began to appear in his work which were later to lead him later to new pictorial experiments. For the first time his work revealed the influence of a previous generation of painters, with their mix of Realism, the Amsterdam School style of painting, Art Nouveau and Symbolism. The compositions show the same 'snapshot' approach for which Isaac Israels and Hendrik Breitner were known, although the colours are more vivid and the work has a certain frontality to it. Mondrian's works on paper around this time were similar to Jan Voerman's works from the early 1890s. They show the same flatness, partly through the use of gouache (opaque watercolour) and the same intense use of colour which Voerman converted to after his meeting with the French Symbolist, Paul Sérusier. Mondrian, however, focused on rhythmic compositional elements, such as branches, trees and fences, which created an abrupt division between foreground and background and which weakened the naturalism of the subject. He also raised the horizon until it almost disappeared from the image thereby banishing the illusion of natural three-dimensionality. Sometimes he divided the space into large, geometric-type forms, as in a series of paintings of farmhouses in which triangular gables are reflected in the water. A clear indication of Mondrian's burgeoning sympathy for Symbolism is found in his depiction of flowers. These were chiefly chrysanthemums – not the small variety indigenous to Europe, but the large Eastern, globular ones. These were popular in Symbolist circles because they were highly symbolic in the Far East and, among other things, represented the Japanese emperor. It is noteworthy that Mondrian isolated the flower from any context. Thus there is little reference to a background, and the flower was never painted as part of a bouquet. He also often painted it full face. The psychological effect of this frontality is both confrontational and meditative and in contemplative and religious art this view is an essential visual element.

1904–11

Around 1903 it was rumoured that Mondrian, then about thirty, was having an identity or mid-life crisis. On the recommendation of his friend Albert van den Briel, he withdrew for most of 1904 to Uden, a small town in the Dutch province of Brabant. Like many artists of his generation and those before him, he became inspired by rural life. However, in Uden Mondrian spoke more explicitly for the first time about the principles of abstraction and his theosophical beliefs about the structures of life. According to Van den Briel, his interest in both subjects was already evident in Amsterdam, 'but for the first time in Brabant it became part of his way of thinking. During the weekday evenings he was often alone with Beppie [a dog Van den Briel gave to Mondrian to keep him company] and meditated on the abstract form of circles. Mondrian said: "You don't find this in nature, yet it is still created. It is as we think it is." In Uden the artist also read a lot from the Bible, had discussions with Van den Briel about Catholicism, in which he saw 'beauty and depth' and became particularly interested in John the Baptist. He also read Henri Borel's translation of the *Tao Te Ching* by Lao Tzu and it is likely that Mondrian also received visits from theosophists. Whatever the case, Van den Briel notes in his memoirs that after guests left there were often long discussions about Theosophy.

Contrary to Albert van den Briel's claims, however, Mondrian almost certainly did not spend a year in Uden. In June he became librarian and board member of St Lucas, as is evident in a letter from the period, and a photograph exists of him and his friend Simon Maris resting after a customary trip along the Gein river, to the south of Amsterdam.

Back from Uden, on 27 January 1905 Mondrian officially registered Amsterdam as his place of residence once more. He moved into the upper storey of a dwelling on the Albert Cuypstraat, at the heart of Amsterdam's new entertainment and red-light district, known for short as Buurt YY, the former official name of this part of the city. Apart from a period between February 1905 and June 1906, when he stayed at St Lucas on Rembrandtplein, one of Amsterdam's main squares, Mondrian lived at various addresses in the Buurt YY until he left for Paris sometime around New Year's Eve 1911–12. After returning from Uden, as well as teaching in a school and extending his circle of clients in order to earn a living, Mondrian focused on producing sets of landscapes made along the Gein river. During this period he increasingly painted evening views of windmills with their cross-shaped sails and also clumps of trees, in which the moon and water were prominent visual elements, and the sky lit up in purple and yellow. The trees dissolve into large dark blots and contours reflected in the water so that the paintings take on the appearance of Rorschach tests.

Taken as a whole, the evening landscapes show that Mondrian was acutely aware of the inherent sense of tragedy in nature, which he later attempted to eliminate in his abstract art. Through a subtle and effective use of small and large brushstrokes, delicate, bright and glowing colours and highly simplified forms, which became apparent in nature at nightfall, but which Mondrian exaggerated even more, he created sensual depictions of landscape which instinctively appealed to deeper layers of feeling in the observer. This landscape phase of Mondrian's development towards abstraction is the first expression of a subconscious awareness of the Absolute.

The year 1908 was generally one of enormous change for Mondrian as far as his philosophy and art were concerned. In the spring, for instance, he exhibited *Evening,* his first work entirely painted in the primary colours of red, yellow and blue. His pictures changed drastically in other ways as well. Under the influence of his encounter with the bohemians Jan Sluijters and Leo Gestel, he began working in a more luminous and expressive manner, and also broadened his subject matter. He painted female portraits again – something he had not done since about 1901 – and because of the pose or the painting technique they were more than just a naturalistic rendering of the sitter. The portrait *Passion Flower* certainly falls within this category. It is both a portrait of the artist's new theosophical girlfriend

10

Marie Simon (1887–1976), and a more general, symbolic depiction of someone grappling with earthly and spiritual aspirations. Theosophical symbolism was also evident in the artist's other new themes. Mondrian's choice of certain flowers, for instance, appears to be based on the fact that the petals are nearly always two overlapping triangles, the symbol of the oneness of material and spirit, or are circle-shaped, the theosophical symbol of unity. Mondrian also painted blooms in various stages of flowering and dying, giving the observer a sense of the evolution of life.

Many of these thematic changes were linked to Mondrian's growing interest in Theosophy. In March 1908 Rudolf Steiner, the then general secretary of the German Theosophical Society, gave several readings at various venues in the Netherlands, including Amsterdam. His topics concerned the existence of both a visible and invisible world and how this duality could be experienced and become part of one's life.

A compilation of these readings is one of the few books Mondrian still possessed when he died. Mondrian's new friend, Cornelis Spoor, probably had a great influence on Mondrian's increasing involvement with Theosophy. A painter of mainly traditional portraits and still lifes, Spoor became a member of the Theosophical Society in 1905. Three years later as one of the 'initiates', he began studying yoga. It was possibly at his urging that Mondrian stayed for the first time at Domburg, in Zeeland, in the summer of 1908, where he was seen seated in a Buddha position by the painter Jan Toorop's daughter, Charley. Mondrian was to revisit Domburg over the next few years with his friend Spoor. These visits led to new themes – dunes, seaviews and church towers – which however were not expressly theosophical in content and which were painted in a glowing style. The major elements in these works are the play of light, the solid versus the immaterial and the overwhelming force and splendour of nature.

In January 1909 the notorious exhibition *Spoor – Mondrian – Sluijters* was mounted. Mondrian subsequently corresponded with the journalist Is Querido, who had reviewed the show in May, about the 'development of more refined senses', about his attempts 'to gain knowledge of the occult' and about 'the steep climb towards giving up matter'. On 14 May Mondrian became a member of the Amsterdam lodge of the Dutch Theosophical Society with Spoor's one of the two signatures on his application form. On 25 May the artist was official registered in the membership annals in India.

Between 1910 and 1911 Mondrian's work developed chiefly in two directions that cannot be entirely separated from each other. On the one hand the artist created intense Symbolist pictures crowded with theosophical allusion. His triptych *Evolution* is one of the most succinct among these, although not the most successful from a visual and technical viewpoint. It depicts a woman in various stages of spiritual awakening. On the other hand, Mondrian produced paintings in which the most striking feature is the brushwork and use of colour. Over the next few years these were to become freer and more expressive, so that the image appears to disintegrate into areas of colour. This is seen particularly in his Domburg works, where his search for a new language of form – emanating from his painting technique and his study of the compositional possibilities of painting – comes to the fore.

The latter, chiefly pictorial, research opened up fresh avenues for Mondrian between 1910 and 1911. Along with Spoor, Jan Toorop and the Paris-based artist Conrad Kickert, in the autumn of 1910 Mondrian made plans to set up the Modern Art Circle for progressive Dutch artists and on 28 November this became a reality. In spring 1911 Mondrian showed his first painting at the Sociétés des Artistes Indépendants in Paris. In June he paid a brief visit to the capital, where he came into contact with Cubism, then a new movement which attempted to express the multi-dimensional aspects of visible reality on canvas by using freer planes and lines to amalgamate several viewpoints at the same time. Mondrian must have viewed the resulting 'dematerialisation'

11

as another alternative route for his pictorial studies using his Domburg themes.

In October 1911 the Modern Art Circle mounted its first exhibition in Amsterdam in which works by French and Dutch artists working in an Expressionist and pre-Cubist style was shown. It was about this time that Mondrian must have decided to stay for a while – possibly even permanently – in Paris. He gathered his things together, broke off his short engagement to Greta Heijbroek, did not bother to have his name officially deleted from Amsterdam's registry office, and headed for the French capital.

1912–14

After a short stay at the French headquarters of the Theosophical Society, then in the atelier of Peter Alma at 33 Rue du Maine, in May 1912 Mondrian moved officially to 26 Rue du Départ, where Kickert and Leo Schelfhout also lived. At the same time he changed his name from Mondriaan to Mondrian, wishing to begin a new life as a man of the world liberated from his background in provincial Holland.

Parisian friends introduced Mondrian to many artists from various countries, including Henri le Fauconnier, Fernand Léger and Gino Severini, who had all adopted a kind of Expressionist-cum-Cubist style. Mondrian did not forge any profound friendships with these artists, neither was he able to gain access to the 'top echelons' of artists to which Picasso and Braque belonged – artists whom he continued to admire all his life. He did attend openings and suchlike, obviously in search of new avenues for selling his work, and was jokingly referred to as 'Piet-zie-je-me-niet' (You-can't-see-me-Piet). During these early Paris years, Mondrian's style was primarily influenced by the way the Cubists resolved visible reality into planes and lines. This reality, no matter how abstractly it was rendered by Mondrian, was always his source of inspiration. He painted nudes, still lifes, landscapes and sometimes compositions based on architectural forms, inspired by his view over the Paris rooftops. He also took earlier themes – flowers, trees, the Domburg dunes and seascapes – and translated these into more abstract depictions. However, Mondrian, unlike other Cubists, linked the fragmentation of visible reality with his theosophical beliefs in a telling manner. This is revealed from certain sketchbooks made between 1912 and 1915, in which his renditions are accompanied by pure theosophical statements. These include: 'Two ways towards spirituality: the way of the pupil directly practising (meditation etc.) and the slow sure way of evolution. This reveals itself in art. One sees in art the slow development towards the spiritual, while the makers are completely unaware of this. The conscious way of learning leads mainly in art to corruption of same. When these two paths converge together, i.e., the maker is on the stairway of evolution where it is possible for a conscious spirit to be directly achievable, then you have ideal art.'

Between 1913 and 1914 Mondrian made a concrete attempt to set down on paper a new theosophical theory of art. He submitted an article on 'Art and Theosophy' to the editor of the Dutch journal *Theosophia*, but this was rejected as being 'too revolutionary'. Around the same time, Mondrian wrote an illuminating letter to a new and important advocate of his, the art critic and teacher H.P. Bremmer, who taught art classes and advised collectors such as Helene Kröller-Müller, around whose collection the Kröller-Müller Museum in Otterlo was founded.

In the letter Mondrian wrote, 'I construct lines and combinations of colour on a flat picture plane with the aim of deliberately depicting a *general sense of beauty* as far as is possible. Nature (or what I see) inspires me, gives me, as it does virtually every painter, the emotion from which the urge derives to create something. But I want to approach truth as closely as is possible, and thus I abstract everything until I come to the essence (always the external essence!) of things. [...] I believe this can be achieved through horizontal and vertical lines, constructed in a *conscious* but *non-calculated* way and guided by a large degree of intuition, and reduced to rhythm and harmony. I believe that with these basic forms of beauty – if need be supplemented by other vector lines or

12

curved lines, you achieve an art work that is as powerful as it is truthful. To a more perceptive person, there is nothing vague about this, it is only vague to a trivial person looking at nature.'
In August 1914 Mondrian was on holiday in the Netherlands where he was forced to remain due to the outbreak of the First World War.

1915–19

During the First World War Mondrian stayed at Laren, the artist's colony at Het Gooi, still a rural area close to Amsterdam. In retrospect this enforced stay in the Netherlands was extremely inspiring. It also produced new clients, such as the art dealer Sal Slijper, whose large collection of Mondrians was bequeathed to The Hague's Gemeentemuseum on his death. In order to support himself, Mondrian took up his old custom of making copies of museum paintings and teaching at a school in Amsterdam. He also made copies of his earlier work showing farmhouses along the Gein or windmills.
Much more significantly, however, his exile in Het Gooi saw the further development of his new artistic theories. In this he was particularly inspired by the ideas of his new acquaintances, Bart van der Leck and Theo van Doesburg, whom he met in 1915 and later by Vilmos Huszár.
Mondrian admired Van Doesburg, particularly as an organiser and writer, while in Van der Leck he found an artistic sounding board. Van der Leck, more of a craftsman and monumental artist, had already arrived independently – without being influenced by the new international movements – at a large degree of abstraction, using only primary colours combined with black and white.
The exchange of ideas between the two men led on both sides, albeit in different ways, to a radicalisation of visual elements – an intensification and simplification of colour, form and line as well as an 'unsentimental' handling of paint. In 1917 Mondrian applied himself to paintings of 'dancing' and syncopated rectangular blocks of colour, some of the sides outlined, or to 'chessboard' compositions or diamond paintings with black or black and grey lines crossing each other. Finally Mondrian completely liberated himself from figuration, including all 'vector lines' other than horizontal and vertical – in contrast to Van der Leck and Theo van Doesburg who never went so far.
Meanwhile Mondrian continued to apply himself to his writings in which he attempted to draw together his new artistic theories. His contact with the books of the late theosophist Mathieu Schoenmakers was of some importance to the unchanging theosophical basis of his artistic concepts. In Schoenmakers's 1915 *Het nieuwe wereldbeeld* (The New World Vision) and 1916 *Beginselen der beeldende wiskunde* (Principles of Visual Mathematics) many parallels can be found with Mondrian's basic ideas. It is possible that the artist, who was not a natural writer, borrowed Schoenmakers's theories and used them to explain his own fundamental ideas. Whatever the case, Mondrian always maintained his innocence of this, and instead derived his ideas from a book published in 1888 *De geheime leer* (The Secret Doctrine) by Helena Blavatsky, one of the founders of modern Theosophy and the author of virtually all standard works on the subject.
Mondrian's attempts at writing led to a series of articles being published in the autumn 1917 issue of *De Stijl*, a periodical he had just founded with Theo van Doesburg. The series entitled 'New Imagery in Painting', 'A Dialogue on the New Imagery (Singer and Painter)' and the trilogy 'Naturalist and Abstract Reality' appeared in issues of the magazine until October 1920 and form the basis for Mondrian's later writings. In these he gives his art a new name, Neo-Plasticism, a term he borrowed from Blavatsky's writings. In *De geheime leer* she describes the origin of everything in the universe as the plastic essence. This is the realm of the dormant potential for personal development, the source from which 'the creative, formative and material world' arises.
A Neo-Plastic painting does not render the natural world of a landscape, still life or portrait, for instance, since this would be more of a representation of everyday reality. What Mondrian wanted to create was a personal interpretation of reality. Not an interpretation of visible reality – as the Cubists and Fauvists in

13

essence created – but a depiction of *cosmic* reality. 'One has to change natural *appearance* so that *nature* can be seen in a more pure (cosmic) manner', he wrote. While this cosmic nature is invisible to the human eye, Mondrian believed it to be the reason why objects appear as they do.

In Mondrian's essays in *De Stijl* he explained that a painting is a space where an invisible, cosmic interplay of forces takes place, made visible to the eye in the shape of colours, lines and simple forms. In other words, these were forces in themselves since they possessed the nucleus of the original cosmic force of creation. This force needed matter in order to have an effect on the world, and the *kind* of matter determines the final appearance. Thus blue has a different visual and compositional force to red or yellow, while the size of a line or, say, a rectangle partly determines the visual force these will have on the composition as a whole.

Ideally, the interplay of colour, lines and forms is supposed to create a sense of harmony in the observer. This harmony linked to the greater cosmic harmony is expressed in ordinary terms by the word 'beauty'. Thus, this beauty is evident in the oneness of opposite principles – translated by Mondrian, for instance, into horizontal and vertical axes, into lines that together form a rectangle, or into combinations of forms and lines, or into rhythm. The variety of ways in which opposites existing in nature can form a 'oneness' is endless, and is found again in the extent to which colours, lines and forms vary. According to Mondrian, however, in every new composition all the visual elements had to be weighed carefully against each other, so that each work conveyed its own 'cosmic' beauty in a different manner.

In this field of cosmic forces artists are mediators. In fact they, themselves, according to Mondrian, are a combination of Soul and Matter. For him the true artist was a magician able to manipulate these forces; the true artist for him was in fact a kind of god, able to breathe life onto a flat canvas with paint and brush. The choice of particular lines, colours or forms and the way they were arranged on the canvas partly depended on how far the artist could feel intuitively the 'cosmic force' of these visual elements and transform them into harmonious compositions.

14 Throughout his life Mondrian's theosophical artistic beliefs hardly changed, especially as regards his paintings, of which more later. His articles in *De Stijl*, in their turn, formed the basis for his book *Le Néo-Plasticisme. Principe général de l'équivalence plastique*, written in 1920 and published by the theosophical art dealer Léonce Rosenberg in 1921. In this Mondrian quoted at length from earlier published essays, but also gave his theories a more general, art historical perspective.

Subsequent essays left no doubt about the close, lifelong relationship between Mondrian's theosophical beliefs and his art. In a letter written in the early 1930s, possibly to the writer Til Brugman, he further explained the broader social relationship between his art and Theosophy. In the following quote from the letter the artist touches on the laws of the universe, the hidden meaning of reality and the importance of 'objective' observation – topics already raised in his essays for *De Stijl*. 'I've added an introduction to my book [*L'art nouveau – La vie nouvelle*, published posthumously], because people don't seem to understand how a painter can get involved with universal questions and do not understand that the laws of the universe are perhaps most clearly evident in art. In traditional art perhaps they are vague, but in the new art, especially in my work, they are plainly there. For instance I can develop things and indicate laws according to how life evolves, and in this way everything is then 'real' and there is no illusion as far as harmony and happiness in life are concerned. I construct everything on observation, but because this implies an entire culture, art is so suitable to depict this, since art is now nearing its fulfilment and we have an overview of the whole.'

1919–38

In June 1919, after the First World War had ended, Mondrian returned to his studio in Paris. In November he moved to 5 Rue des Coulmiers, but in 1921 returned to his studio on Rue du Départ.

He remained there until 1936 and then moved to 278 Boulevard Raspail. Once back in Paris he mixed in international avant-garde circles far more than before the war, especially those emanating from new movements like Dada, Surrealism and Constructivism. Mondrian's friends visited him chiefly at his studio – although he did particularly like visiting other people – where they sometimes had their pictures taken. Sometimes these visits would wind up with records being played, especially Jazz and dance music – Mondrian was a big fan of the tango and shimmy.

The artist's new friends supported him financially by sometimes buying work, and through their contacts Mondrian was increasingly interviewed and had exhibitions in various European countries as well as in America. However, he was unable to survive solely on the sale of his abstract paintings and thus agreed to requests, chiefly from the Netherlands, to make watercolours of flowers in delicate hues. For these, he reverted to the special type of flowers he had chosen to paint in the 1908–11 period.

In the early 1920s an estrangement arose between Mondrian and some of his old friends, among them Theo van Doesburg, who had been so greatly inspired by him since 1916, and who was also trying to achieve pictorial and spiritual harmony by using colour, line and geometric forms. But Mondrian rejected Van Doesburg's attempts as not being 'absolute' enough, and later distanced himself from Van Doesburg's views on the exact relationship between painting and architecture, for instance in his essay 'Neo-Plasticism. The Dwelling – The Street – The City' (1927). On his side, Van Doesburg maintained that Mondrian was 'intellectually backward because of his theosophical limitations'. Apart from their dissent over painting and architecture, their differing characters also caused friction, so that by 1925 estrangement between the two was unavoidable. I will return later to this relationship between painting and architecture.

From the second half of 1919, when he produced his first completely abstract works, until the end of his life, Mondrian made pictures based on the visual impact of colour, line and form in accordance with his theosophical beliefs as expounded in *De Stijl* and other publications. However, from 1919 it seemed as if a breach had appeared between his relatively consistent art theories and the dynamics of his work. It has often been thought, unjustifiably, that when Mondrian shifted completely to abstraction, he also distanced himself from his theosophical beliefs, as if he no longer needed them once he had arrived at a 'mature' style.

Nothing could be further from the truth, since anyone who reads his essays written after 1920 will discover that, in essence, they still pursue the same lines of argument. Mondrian's basic concepts on art actually changed very little until the end of his life. The most one could say is that his theosophical beliefs were formulated in increasingly more general – i.e., not strictly theosophical – artistic terms. The Theosophy had become incorporated into his artistic ideals, so to speak, but as an undercurrent it was still very much present and had a bearing on the content of Mondrian's work.

Thus Mondrian's ideas remained esoteric, although he evidently strived towards a less rigorously Blavatskyian theosophical interpretation. Indications of Mondrian's broader outlook on the philosophical truths expounded by Theosophy are evident in his (failed) attempts in 1932 to be admitted to the Freemasons and, in the small number of books he left behind, including literature by Jiddu Krishnamurti. This theosophical 'world teacher', abandoned the Theosophical Society in 1929 to develop his own doctrine based on pursuing complete personal self-knowledge. And if Mondrian had really distanced himself from Theosophy, this would be at odds with the fact that in 1939 he transferred his membership from Paris to London.

However after his return to Paris his writings do show certain shifts in emphasis, which are related to his encounter with new developments that had occurred during his absence, such as the emergence of classicising Realism, Surrealism and Dada. Mondrian was also increasingly concerned by social

15

developments, which were ultimately to culminate in Fascism. The latter alarmed him so much that in 1938 he fled Paris for London.

Mondrian began concentrating more in his essays on the relationship between painting and architecture, a focus that had its roots in the interdisciplinary group that comprised the De Stijl movement. At the time Mondrian wrote various essays in Dutch on the subject, including 'The Achievement of Neo-Plasticism in the Distant Future and in Contemporary Architecture (Architecture in the Sense of Our Entire [unnatural] Environment' (1922), 'Should Painting Be Inferior to Architecture?' (1923) and 'Neo-Plasticism. The Dwelling – The Street – The City' (1927).

In contrast to his artistic beliefs, a continual, even sometimes, revolutionary development can be traced in Mondrian's work from 1919 onwards. While the first few paintings created during his second phase in Paris hark back to the compositions with large colour planes of the previous year, they are now calmer with larger areas of colour and the hues less powerful and atmospheric. These paintings were followed in 1921 by works in which the variety of colours were further reduced until they simply showed pure primary colours and 'non-colours'. The number of forms rendered in the same colour were similarly reduced to perhaps one square or rectangle for each primary colour. The grey tones, which until now had linked the coloured areas with each other, were again reduced to a more limited range of nuances. Finally the appearance of the lines also changed. Whereas they had been narrow and painted in grey, now they were emphatic, broad and painted in shiny black. In fact they are as visually forceful as the blocks of colour. And where Mondrian had previously ended the lines at the edge of the painting by fading them out, they now terminated abruptly, like a final chord.

Mondrian made other changes to his compositions. Whereas before the forms and lines, despite their different sizes and colours, were spread evenly across the canvas, Mondrian now shifted them to the edge of the canvas, so that they seemed to be 'falling off' it, or they created the impression that the composition was meant to be a close-up of a larger whole. As a result of this and because of where Mondrian placed the lines, the centre of the composition was painted in various shades of white, giving the work an open, empty appearance.

Between 1924 and 1925 Mondrian made many diamond-shaped paintings, chiefly as a result of his ideological and artistic conflicts with Van Doesburg. Mondrian had already painted works like these when he was in Het Gooi, but now the composition was filled with the same dynamic interplay between colour, form and line as in his rectangular paintings. In some of these works Mondrian reduced the visual elements to the absolute minimum: two black lines on a white background with perhaps just one area in colour. The lines have a subtle, uneven thickness and seem to shoot out of the slanting canvas and colonise the surrounding space. These paintings can be seen as the ultimate retort to Van Doesburg in that Mondrian is demonstrating that his 'rigid' theosophical beliefs can, in fact, produce extremely dynamic results.

In the late 1920s Mondrian moderated his use of colour even more. In ostensibly similar compositions, he seems to be testing the force of primary colours in relation to each other. This reduction in colour is chiefly evident in his use of white and black. Apart from the odd exception, all the colour planes are painted in exactly the same shade of white.

This simplification in Mondrian's work, however, is deceptive in that it forms a counterpoint to his adoption of a complex painting technique and to his optical experiments. White, for instance, is built up from many layers of paint, with the brushstrokes going in all directions so that they remain subtly visible. This gives 'body' to the areas of colour, which is clearly evident under floodlight. In contrast, the black lines are painted extremely thinly and appear to sink into the white. Mondrian also changed the shape of his frames. The thin framing strips around the canvas were replaced by wide slats, which he attached to the back of the work, so that the entire canvas is projected forward. The lines that

end at the edge of the composition appear to continue across the broad outer edges. After 1930 Mondrian appeared to focus chiefly on lines. He even began painting these for the first time in colour and went so far as to make them so wide that they could be interpreted as forms. The result of this experiment was the painting *Composition with Yellow Lines* (1933) and for a long time this work remained an isolated example in Mondrian's oeuvre. It was only in the 1940s in New York that he picked up the idea again, though in a new manner, in his *Broadway Boogie Woogie* and *Victory Boogie Woogie*.

From 1932, however, Mondrian was absorbed with using the double line in his compositions and this was to preoccupy him until his death in 1944. Mondrian regarded this particular change as 'revolutionary' – again a sign that he still thought according to theosophical tenets. Mondrian derived the double line as a compositional element from the woman artist Marlow Moss, a dedicated disciple of his. However, she was probably guided by mathematical principles (particularly the Golden Section) when painting the lines, whereas Mondrian saw the double line as an autonomous visual aid. That he was completely absorbed by this is evident in letters he wrote to the architect Alfred Roth: 'I'm busy with a new painterly study into double lines, so I've been eliminating the black a little, since I'm liking it less and less.' And to the painter Jean Gorin, he wrote: 'In my last works the double line was widened to a form and yet it is still more of a line. But whatever the case, I think this is one of the issues that falls outside theories and which is so subtle that in the long run it falls under the mystery of 'art'. However, that is still not entirely clear to me!'

Two important points arise from this last quotation. Firstly, Mondrian was wrestling with his definition of line and form, two visual elements that he originally conceived as complementing each other, as equal parts of a harmonious whole. But now, creating a line that looked like a form, he had breached this 'harmony' and had to search for a new equilibrium of forces. Secondly, his pictorial studies took him along such novel paths that he had to test his findings according to his theory of Nieuwe Kunst (New Art). Thus his theory also had to evolve. This does not mean that Mondrian could not fit his new findings into his theory – he simply had to discover the means.

Mondrian's compositions from the 1930s show much more variation than those he had done previously. While they mainly consist of black lines – which contradicts what he wrote to Alfred Roth – the double line creates the illusion of form. The lines are also optically broken up at their intersections and a new equilibrium is reached between the 'non-colours', white and black, and the often extremely meagerly applied areas of colour. The effect achieved by breaking up the lines at their intersections was a preamble to Mondrian's later New York paintings.

A special part of Mondrian's artistic development in Paris were his studio interiors. These were already famous during his lifetime and were often photographed. They expressed Mondrian's personal views on the precise relationship between painting and architecture. Views which had their origins many years previously. A first hesitant attempt to make his studio 'modern' and 'fitting' dates from his late Amsterdam period when he painted, as an experiment, an entire wall black.

During the First World War the debate about the link between painting and architecture was stimulated by certain members of De Stijl, some of whom were from architecture-related backgrounds. Actually Mondrian kept well away from these architectural assistants who, through Van Doesburg, were involved with the magazine.

As has been seen, Mondrian's most notable sparring partner in developing his ideas on the relationship between painting and architecture was Van Doesburg himself. But the two men were not on the same wavelength as regards their ideas. Mondrian was convinced that 'true' architecture, which was equal to 'true' painting (his Neo-Plasticism) and could form an equilibrium of opposites, still had to be created. He also believed that such an architecture could only originate from an artist who pursued

the same esoteric beliefs as himself. Thus he disagreed with Van Doesburg who invariably worked in collaboration with other architects. According to Mondrian, concept and execution had to originate from one and the same spirit, or from a collaboration of like-minded people who stood for the same spiritual objectives, i.e., his Nieuwe Kunst (New Art), otherwise there could be no organic spiritual link between the two. Mondrian also contested Van Doesburg's view that architecture is connected to the actual experiencing of space whenever a person moves through a building or a space of any kind. Mondrian, what is more, had an entirely different attitude on the experiencing of space. In his Dutch essay 'The Achievement of Neo-Plasticism in the Distant Future and in Contemporary Architecture' (1922), he argued that traditional architecture works with forms and volumes (i.e., in perspective), while new architecture must be conceived in terms of *planes*. In this architecture the viewer would always stand in front of a flat image. This can be seen as a radical interpretation of a Cubist view of reality, but Mondrian enlarged on it by adding the theosophical creed on the eternal multi-dimensionality of (cosmic) space. In his essay he wrote: 'The new seeing [...] is not from one given point: it places the perspective *everywhere* and *nowhere*. It is not restricted to time and place (in keeping with the theory of relativity). In practice it puts it before the *plane* [...]. It sees architecture as a *multitude of planes*: again *flat*. Thus this multitude of planes composes itself into a (abstract) *flat image.*' So in the same way as his paintings, Mondrian believed the built environment should be 'purified' of its natural attributes. Then elements that had lain hidden within these, notably the cosmic forces, would form the basis for the new architecture. Based on the laws of the universe, architecture could then provide an impulse for people to experience space intuitively, not so much material space, but the endless cosmic space in which no consciousness of time exists.

Mondrian was realistic enough to recognise that the time was not yet ripe for such a type of architecture and that as a painter he could only make a limited contribution. So the greatest difference of opinion between him and Van Doesburg was that the latter regarded modern architecture as something concrete, dynamic and achievable in the present time, while Mondrian saw it as abstract, without dimension, timeless and an inaccessible ideal. Nevertheless Mondrian tried to achieve this future vision of architecture within the confines of his own studio. His studio became his own seedbed of experimentation in which he tried to draw his furniture, paintings and personal possessions into harmony with each other, according to his notions explained in De Stijl. 'The *entire aspect* – form and colour – of an item of furniture should be in keeping with the *entire aspect* of the room, to reach a *perfect equilibrium* not only in relationship to form, but also in relation to dimension and colour [...]. Everything must be made according to *the same concept, that of the Nieuwe Beelding* (New Vision) in order to express precisely the *absolute* harmonious relationship of the whole. Then all the different areas come together automatically.'

Mondrian's studio was more than simply an experimental arrangement of a modern *Gesamtkunstwerk*. Because the choices he made were interwoven with his views on the harmony of forces, as enshrined in his *Nieuwe Beelding*, it functioned as a personal space for meditation, in which he attempted to convey 'cosmic harmony' by constantly rearranging paintings, coloured cardboard boxes and other objects.

1938–44

In September 1938 Mondrian decided not to wait around for the impending war so he left for London, where his friend Ben Nicholson arranged accommodation for him. From the outset he saw his stay in London as a stopping-off point for New York. After the invasion of the Netherlands in May 1940 and the capture of Paris in the following month, events which distressed him so much he was unable to paint, he decided to make the crossing to America. On 3 October he arrived in New York and was received by his friend Harry Holtzman, who arranged a studio for him on the corner of 56th and 6th Avenue and paid for Mondrian's furniture. He also bought him a gramophone player and introduced him to boogie-

woogie and the Blues. In New York, Mondrian, by now a respected artist, was accepted in America's avant-garde circles, whose numbers had been swelled by other refugees from Europe.

In his New York period Mondrian's paintings as well as his beliefs entered a new phase. While his earlier work consisted of an interplay between lines and forms, as virtually autonomous elements, now the lines themselves dissolved into areas of colour. Thus his New York diamond paintings are a fresh interpretation of his *Composition with Yellow Lines* (1925).

In 1943 Mondrian wrote a candid letter to the art critic and historian James Sweeney about his discovery that a line was also in essence a shape. 'It is only now that I'm aware that my work in black, white and small blocks of colour has only been 'drawings' in oils. When drawing, lines are the chief means of expression [...]. In painting, however, the lines are absorbed by the areas of colour. The boundaries of the areas are shown as lines and still have great value.' In his compositions Mondrian now used new flexible materials which he could rearrange or correct easily. Among these was coloured adhesive tape and its characteristics, combined with paint, gave his paintings a new surge of energy. It is important to realise, however, that these works are, in fact, unfinished. Mondrian would never have been happy with them as they were, but they do give a certain insight into his later technique.

On 1 February 1944 Mondrian died of a lung infection, his *Victory Boogie Woogie* still unfinished on his easel.

1 Welsh/Joosten 1969, pages 33 and 35.

Bibliography

J. Joosten and R. Welsh, *Catalogue raisonné Piet Mondrian*, Blaricum 1998.

Mondriaan aan de Amstel 1892–1912, exh.cat. Amsterdam (Municipal archive) 1994 [English version: *Mondrian 1892–1912. The Amsterdam Years*].

C. Blotkamp, *Mondriaan:. Destructie als kunst*, Zwolle 1994 [English version: *Mondrian. The Art of Destruction*, London 1994].

L. Heyting, *Een wereld in een dorp: Schilders, schrijvers en wereldverbeteraars in Laren en Blaricum 1880–1920*, Amsterdam 1994.

M. Bax, *Het Web der Schepping: Theosofie en kunst in Nederland van Lauweriks tot Mondriaan* (forthcoming dissertation).

19

20

Photographs of P.C. Mondriaan Sr. (1867) and his wife (1868).
Photograph courtesy of the J. Homann Coll. Haags Gemeentemuseum The Hague

Southern section of the Zonnenbrink c.1870 as viewed from in front of the State Secondary School; on the left is the social society, De Eendracht (Harmony), followed by the first Winterswijk gas factory and the façade of the Dutch Reformed Church; on the right the textile factory, De Batavier, which utilised steam-driven machinery

(opposite) Photograph of the Mondriaan children. c.1890; from left to right: Carel, Pieter Cornelis, Johanna Christina, Willem Frederik and Louis
Photograph courtesy of the Haags Gemeentemuseum The Hague

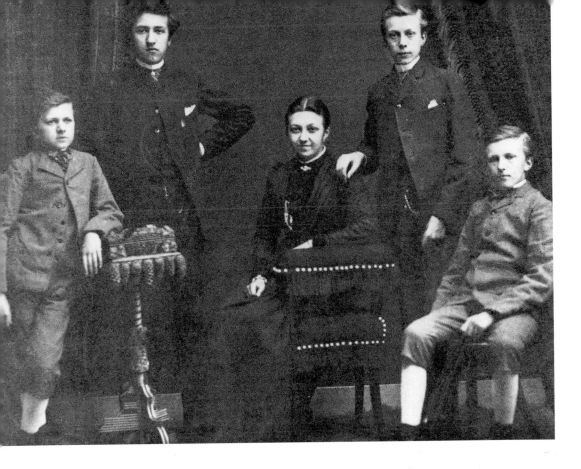

Façade of the State Secondary School (HBS –
Hoogere Burgerschool) on the Zonnebrink,
Winterswijk

Façade of the Rijksacademie van Beeldende
Kunsten, Stadhouderskade, Amsterdam
Jacob Olie, 1897
Photograph courtesy of the Gemeentearchief
Amsterdam

Stedelijk Museum under construction, in the
distance at left, the Rijksmuseum
Jacob Olie, 1894
Photograph courtesy of the Gemeentearchief
Amsterdam

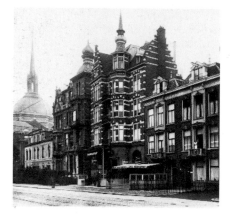

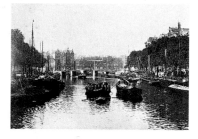

Stadhouderskade near the Overtoomsevaart,
with the Koepelkerk (basilica) on the left
Photograph courtesy of the Gemeentearchief
Amsterdam

Apartment block at 128a Ringdijk, Water-
graafsmeer, c.1940
Photograph courtesy of the Gemeentearchief
Amsterdam

A view of Waals-Eilandgracht with draw-
bridge looking in the direction of Het IJ
Photograph courtesy of the Gemeentearchief
Amsterdam

(opposite) The window of J.A. Wormser's
bookshop at 154 Kalverstraat, c.1930
Photograph courtesy of the Gemeentearchief
Amsterdam

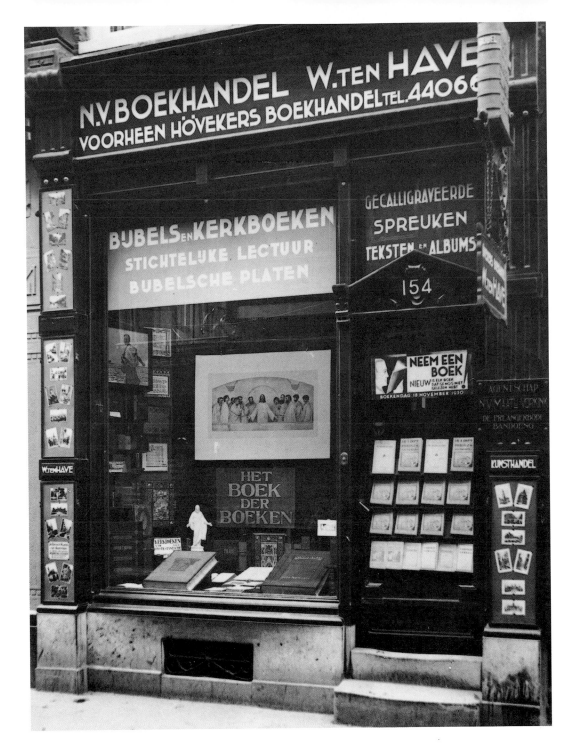

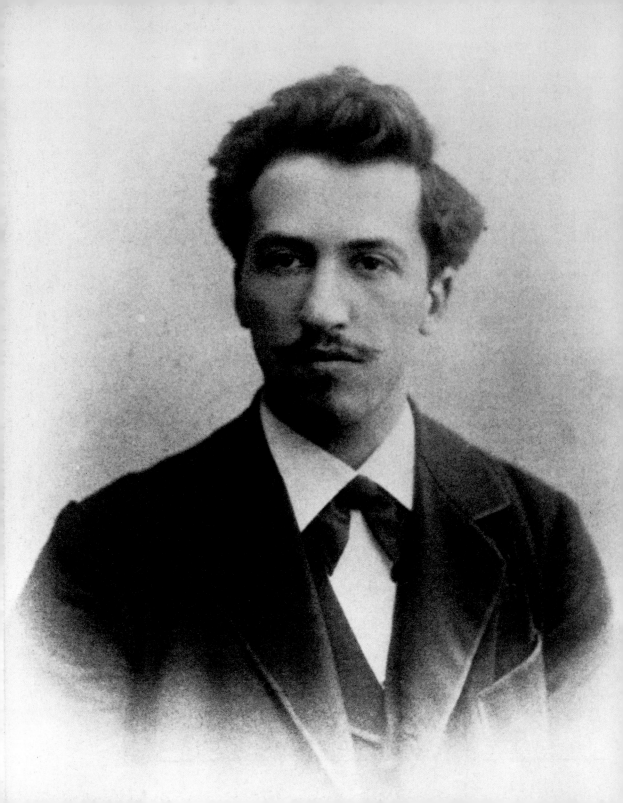

(left) Photograph of Piet Mondriaan, inscribed to his
father and mother, 1899
Photograph courtesy of the Haags Gemeentemuseum
The Hague

Winterswijk, Ratumsestraat

The farm building at Bullens in Lintelo near Aalten,
originally built between 1750 and 1800; destroyed
by fire in 1936
Photograph courtesy of the Staring Instituut
Doetinchem

Farm building near WInterswijk
Photograph courtesy of S.H.B.O. Arnhem

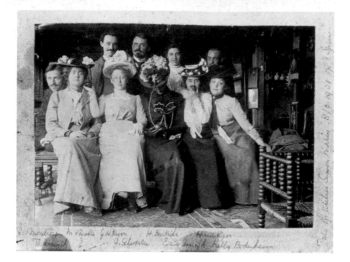

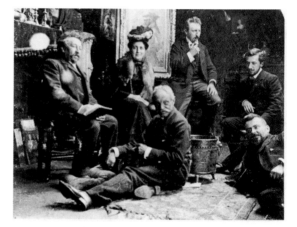

30 Group portrait, 8 June 1901. Mondrian on the left
Photograph taken at the studio of Simon Maris, Het
Spui, Amsterdam. The women present were members
of the group of painters known as the Amsterdamse
joffers (Amsterdam ladies) and included the former
Rijksacademie students, M.E.G. (Lizzy) Ansingh
(1875–1959), Georgine E. Schwartze (1854–1935)
and, far right, J.C.H. (Nelly) Bodenheim
(1874–1951)

498 Keizersgracht, Amsterdam (?), including
Mondrian (seated right), Willem Maris (seated left)
and Simon Maris (seated upper right), c.1902

(opposite) Interior of the atelier on Rembrandtplein
with Mondrian, 1905 / early 1906
Photograph courtesy of the Haags Gemeentemuseum
The Hague

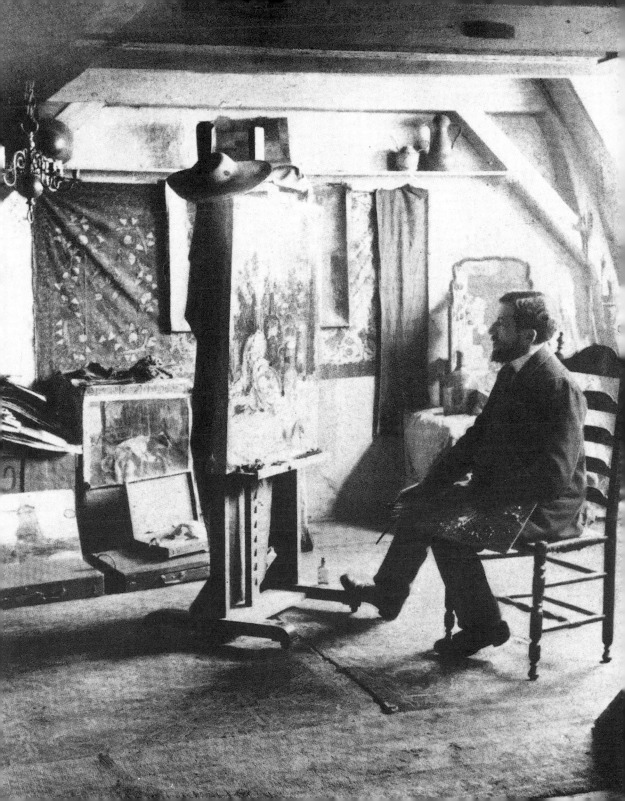

32

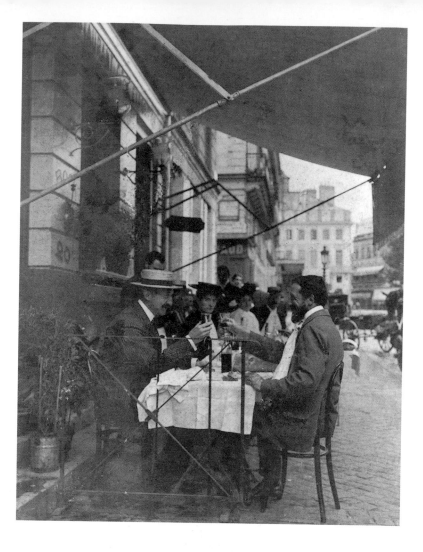

Mondrian and Simon Maris having a meal in
Bordeaux during their 1903 trip to Spain
Photograph courtesy of the Haags Gemeentemuseum
The Hague

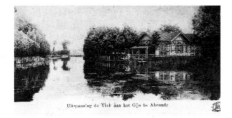

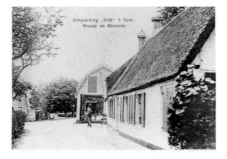

Café and Hostel De Vink along the Gein river near
Abcoude, 1890
Photograph courtesy of the Gemeentearchief
Amsterdam

Café De Vink seen from the road, c.1915
Photograph courtesy of the Rijksarchief Utrecht,
Topographical Atlas

View along the Gein river
Photograph courtesy of the Gemeentearchief Amster-
dam

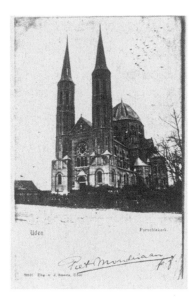

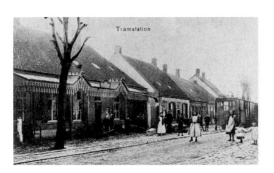

Postcard, with illustration of Saint Peter's church,
Uden, sent in April 1904 by Mondrian to the mother
of Albert van den Briel, Mrs. S.A.J. van den Briel-
Bisdom

Tram station on the Sint Jansstraat in Uden, North
Brabant, with the house in which Mondrian lived in
1904 immediately to the right, c.1900

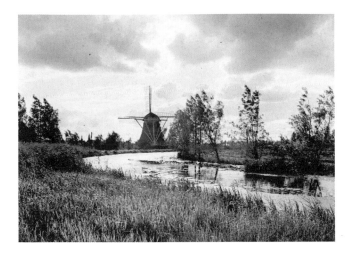

The Oostzijdse Mill on the Gein
Photograph courtesy of the Gemeentearchief
Amsterdam

Landzicht Farm (left) and Oostzijdse Mill
c.1900
Photograph courtesy of the Rijksarchief Utrecht

Landzicht Farm c.1900
Photograph courtesy of J. Olie
Coll. Gemeentearchief Amsterdam

Simon Maris
Piet Mondrian on the Gein, painting
Pencil drawing from a sketchbook, June
1906, 19 x 12 cm.
Photograph courtesy of H. de Boer, Amsterdam

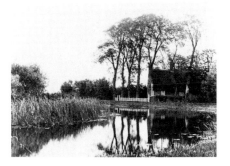

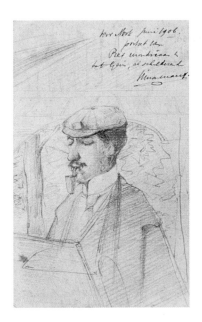

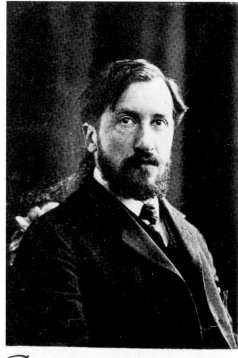

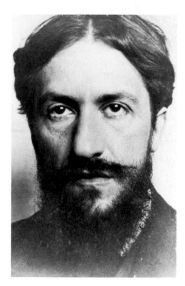

Photograph of Mondrian taken for F.M.
Lurasco, *Onze Moderne Meesters*, published
December 1907, but this example signed
Piet Mondriaan and dated 10/'08

Photograph of Mondrian, with full beard and
hair parted in the middle, *c*.1908

(opposite) Interior of the Sarphatipark No.42
residence-atelier, 1908
Photograph courtesy of the R. Drektraan
Coll. P. Huf, Amsterdam

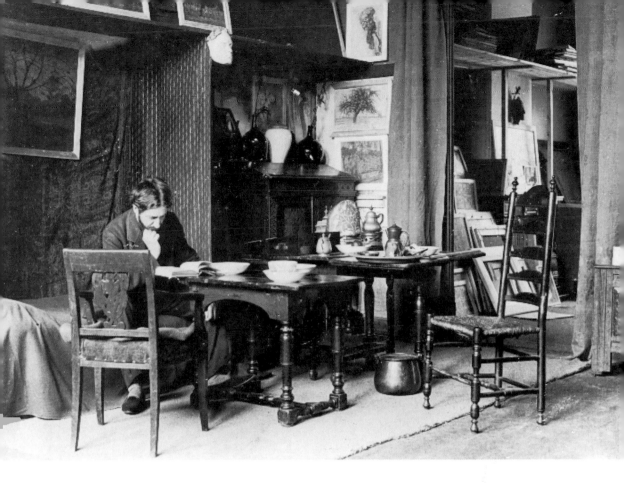

Photograph of Mondrian taken by the phrenologist
A. Waldenburg, Spring 1909

The Badhotel, Domburg, c.1890
Photograph from Coll. F. van Vloten, courtesy of W.
Warners, Domburg

The Exhibition stand of the Walcheren painters
Domburg, Summer 1911; among others: J. Toorop;
F. Hart Nibbrig; Jacoba van Heemskerck; Charley
Toorop; Marie Tak van Poortvliet; General Johan
Drabbe
Courtesy of E. Helder, Domburg

Wide-angle view of Domburg from the Hoge Hil (High
Hill), showing the beach with piers, dunes and vil-
lage, c.1900
Photograph F.B. den Boer, Middelburg,
Coll. F. van Vloten, Deventer, courtesy of W. Warners,
Domburg

39

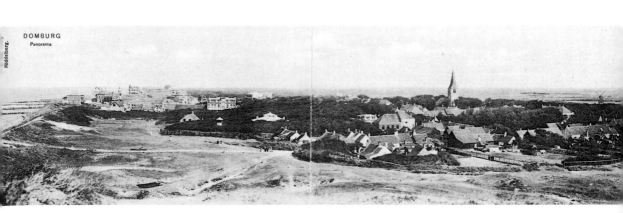

MUSÉE DU LOUVRE.

Les Gardiens laisseront travailler tous les jours
d'étude dans les galeries du Musée _____
Mr Mondriaan, 26 rue du Départ
VALABLE **1912** _____

Palais du Louvre, le **1 JUIN 1912**

Le Directeur des Musées nationaux
et de l'École du Louvre,

N° 3747

Cette autorisation n'est valable que revêtue de
la photographie du titulaire. Elle doit être pré-
sentée à toute réquisition des agents du Musée.

40 Piet Mondrian and Greta Heijbroek,
c. September 1911
Photographer unknown

Mondrian's copying pass for the Musée du
Louvre, dated 1 June 1912

The rue du Départ facing the boulevard du
Montparnasse with 26, rue du Départ on the
left
Photograph by J. Seeberger

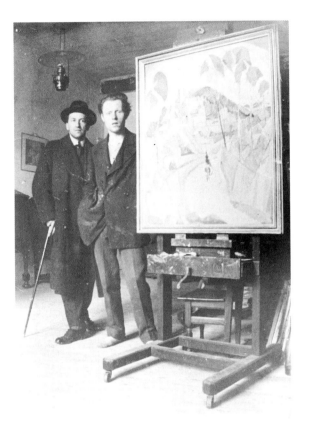

Mondrian and Schelfhout at 26, rue du
Départ, 1912. On the easel, *View of
Villeneuve-les-Avignon* (1912) by Schelfhout

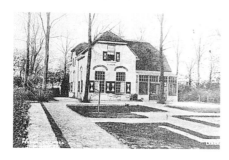

42

To Hannaert's guest house, De Linden, Laren
Photograph of an old picture postcard
C. Folmer, Amsterdam

Farmhouse on the Pijlsteeg (now 17 Groene
Gerritsweg), Laren, where Jaap and Maaike van
Domselaer and Mondrian lived, 1915–16
Photograph C. Folmer, Amsterdam

'De Groote Basselt' on the Melkweg (now 1 Pastoor
de Sayerweg), Blaricum, where Mondrian had his
studio in 1916
Photograph Historische Kring, Blaricum

Farmhouse on the Pijlsteeg (now 5 Ruiterweg), Laren,
where Mondrian and Jo Steijling lived, 1916–19
Photograph C. Folmer, Amsterdam

Mies Elout-Drabbe
Portrait of Piet Mondrian. Domburg
October 1914 (dated afterwards 1915)
Pencil on paper, 63 x 50 cm
Haags Gemeentemuseum The Hague

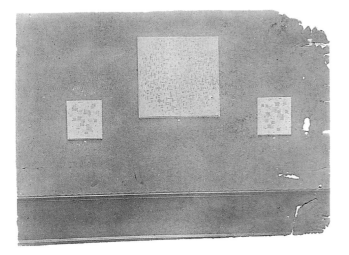

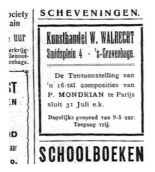

Installation view, Hollandsche Kunstenaarskring
exhibition, Amsterdam, May 1917, showing
three *Compositions* by Mondrian from 1917
Photograph by F.H. van Hengelaar, courtesy
of Van Doesburg-Van Moorsel Archives, RKD,
The Hague

Advertisement of the Mondrian exhibition
at the Walrecht Gallery in The Hague in
De Hofstad, 25 July 1914

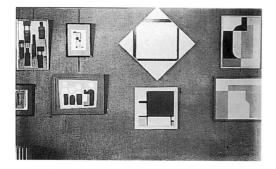

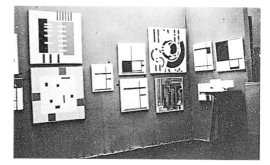

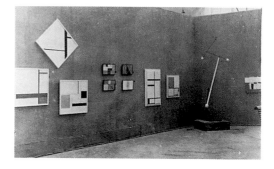

44

Installation view, Cercle et Carré exhibition,
Paris, April 1930, showing works by
N. Werkman, V. Huszar, Taeuber-Arp,
Mondrian and two works by H. Stazewski
Photograph Michel Seuphor, Paris

Installation view, L'Association '1940' exhibi-
tion, Paris, June 1931, showing works by
Van Doesburg, J. Hélion, Mondrian, F. Kupka
and J. Gorin
Photographer unknown

Installation view, L'Association '1940' exhibi-
tion, Paris, January 1932, showing works by
J. Gorin, Paul Roubillotte, Mondrian and
A. Calder
Photographer unknown

Mondrian's studio, 26 rue du Départ, Summer
1926, On the easel *Composition, 1926* (?)
Photograph André Kertész

Mondrian's studio, 26 rue du Départ,
c. April 1926
Photographs Paul Delbo

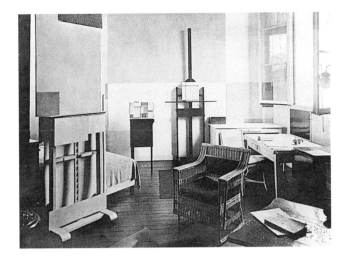

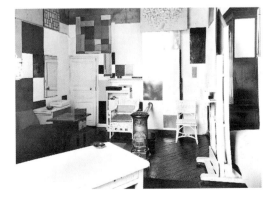

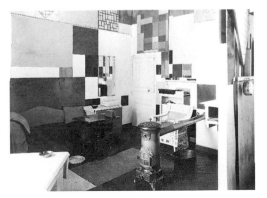

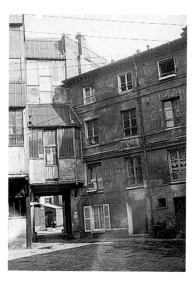

The rear of 26, rue du Départ; Mondrian's
window was on the top floor directly above
the passageway; on the right, the door to the
stairwell which led to Mondrian's studio
Photograph by Alfred Roth

Mondrian and Nelly van Doesburg in the
atelier, 26, rue du Départ, c. May 1923
Photograph courtesy of private collection,
Amsterdam

Nelly van Doesburg, Mondrian and Hannah
Höch in Van Doesburg's studio in Clamart,
April 1924
Photograph courtesy of Hannah Höch Archiv
Berlinische Galerie Berlin

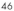

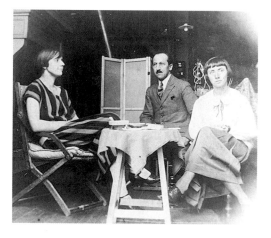

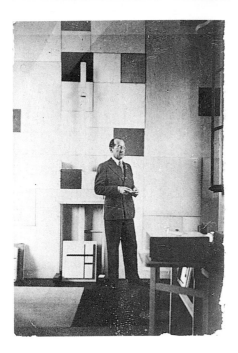

Mondrian in his studio, August 1931
Photograph Charles Karsten
Courtesy of Karsten Archives, Nederlands
Architectuur Instituut Rotterdam

Mondrian in his studio, c. October 1933
Photo: Charles Karsten
Courtesy of Karsten Archives, Nederlands
Architectuur Instituut Rotterdam

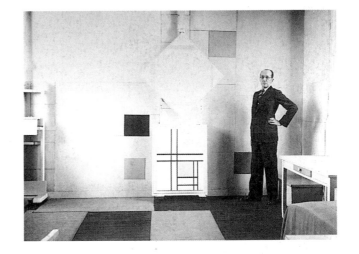

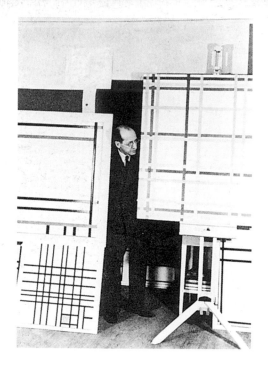

Mondrian in his New York studio at 353 East
52nd Street, *c.* October 1941
Photographs by Emery Muscetra, commis-
sioned by Sidney Janis

Mondrian in his East 52nd Street studio with
Broadway Boogie Woogie, early 1943
Photograph by Fritz Glarner

Mondrian's studio at 15 East 59th Street
after his death on 1 February 1944
Photograph by Fritz Glarner

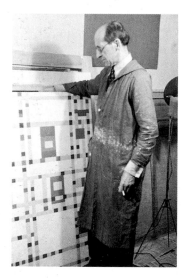

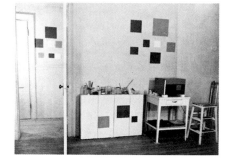

PIET MONDRIAN

Colour

50

WINTERSWIJK

1888–97

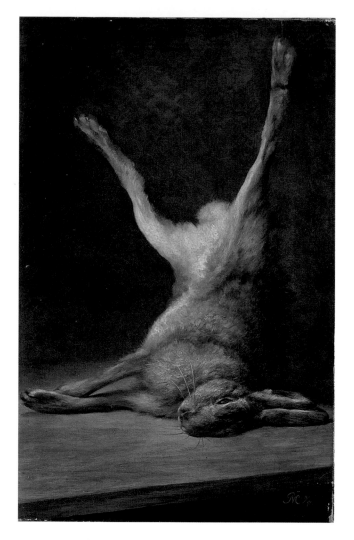

Geschoten Haas (Dead Hare), 1891
Oil on canvas
80 x 51 cm (31^1/$_2$ x 20")

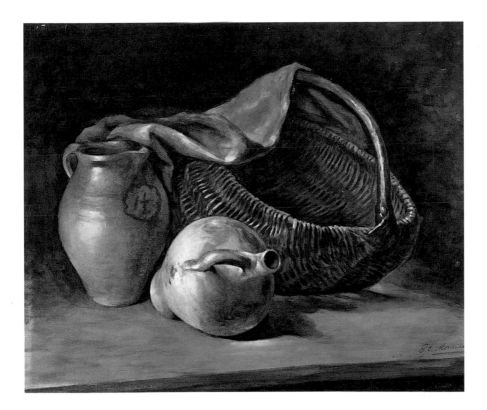

Pitcher, Jug and Basket, c.1891–2
Pastel on paper
62 x 75 cm (24³/₈ x 29¹/₂")

54

AMSTERDAM

1893–7

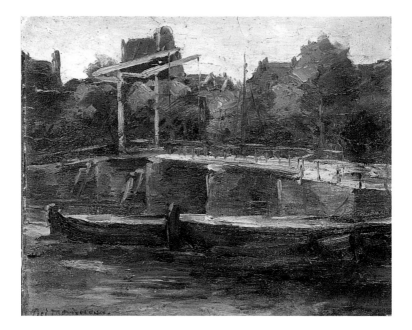

56

*Waals-Eilandgracht with Bridge
and Flat Barges, c.1895–6*
Oil on paper
22.5 x 27.5 cm (8$^7/_8$ x 10$^7/_8$")

*Farmyard with Laundry and Logs,
1895*
Watercolour on paper
29 x 45 cm (11$^3/_8$ x 17$^3/_4$")

*Irrigation Ditch, Bridge and Goat,
watercolour, c.1894–5*
Watercolour on paper
49 x 66 cm (19$^1/_4$ x 26")

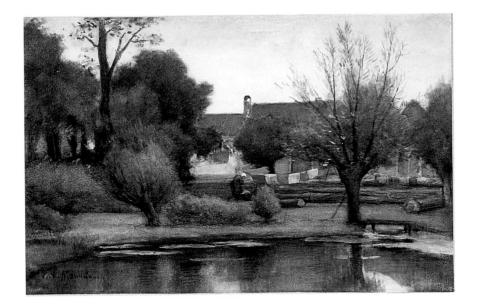

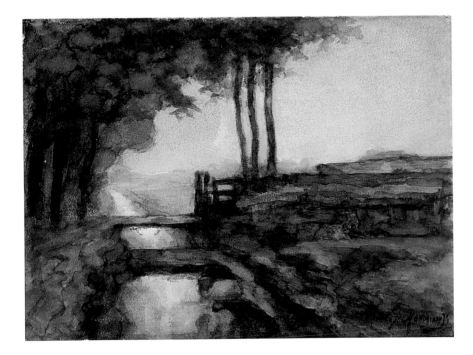

Women Doing the Wash, 1894–6
Oil on canvas
28.8 x 23.9 cm (11³/₈ x 9¹/₂″)

Princesje (Young Princess), 1896
Oil on canvas
59.5 x 50 cm (23 3/8 x 19 5/8")

60

WINTERSWIJK

1897–9

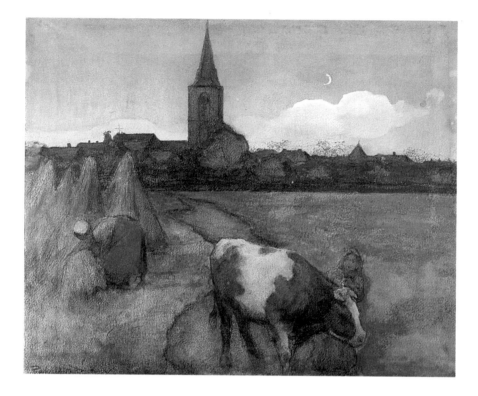

62

*Farm Scene with the St Jacob's
Church, c.1899*
Watercolour and gouache on paper
53 x 65 cm (20⁷/₈ x 25⁵/₈")

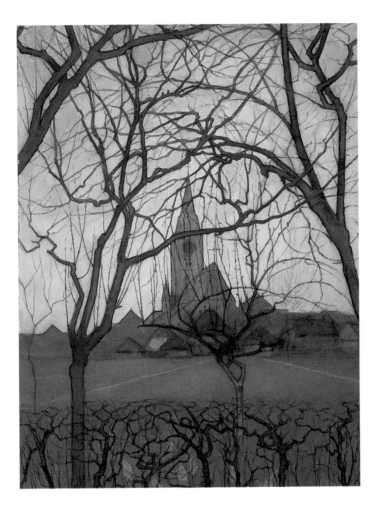

Dorpskerk (Village Church):
St Jacob's Church, c.1898
Gouache on paper
75 x 50 cm (29 1/2 x 19 5/8")

64

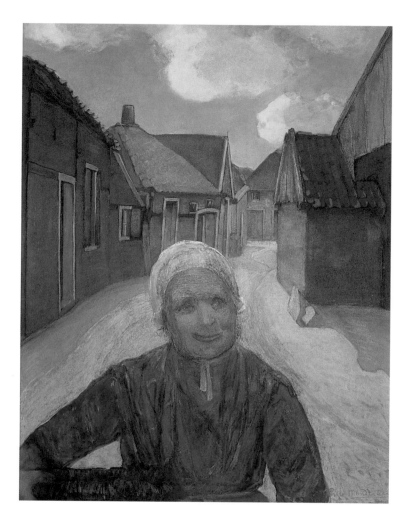

Op de Lappenbrink
(On the Lappenbrink), 1899
Gouache on paper
128 x 99 cm (50³/₈ x 39")

Rear Gables of Achterhoek Farm
Buildings with Figures, 1898–9
Oil on canvas
c.33.5 x 44.5 cm (13¹/₈ x 17¹/₂")

Farmyard with Carriage Barn
in the Achterhoek, c.1899
Oil on canvas
33 x 38 cm (13 x 15")

Winterswijk *1897–9*

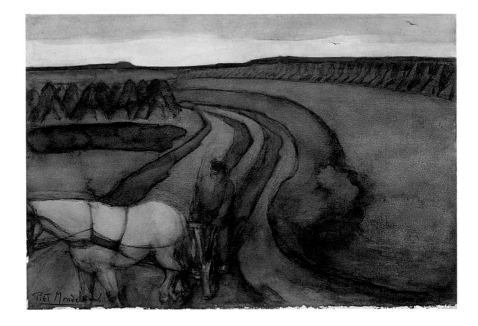

66

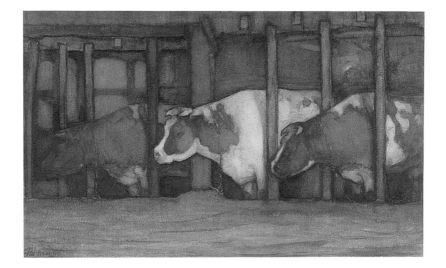

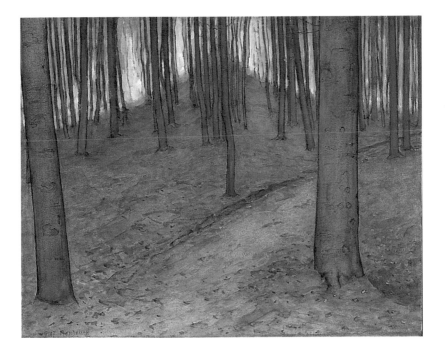

Aan den Arbeid (At Work):
Op het Land (In the Fields),
c.1899
Watercolour and gouache on paper
54 x 79 cm (21$^1/_2$ x 31$^1/_8$")

Three Cows in a Pot Stall,
c.1898–9
Watercolour on paper
39.5 x 66 cm (15$^1/_2$ x 26")

Wood with Beech Trees, c.1899
Watercolour and gouache on paper
45.5 x 57 cm (17$^7/_8$ x 22$^3/_8$")

68

AMSTERDAM

1897–1901

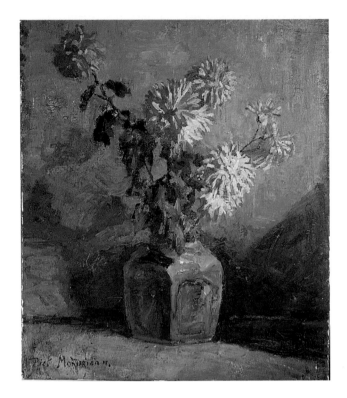

*Yellow Chrysanthemums in
a Ginger Pot, c.1898*
Oil on canvas
42 x 34.5 cm (16 1/2 x 13 5/8")

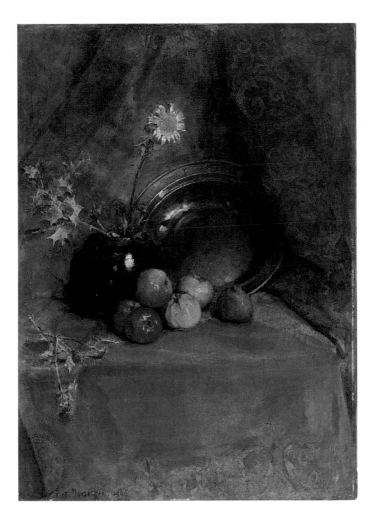

*Stilleven (Still Life): Apples, Pot
with Flowers and Metal Pan, 1900*
Oil on canvas
c. 94 x 68 cm (37 x 26 3/$_4$")

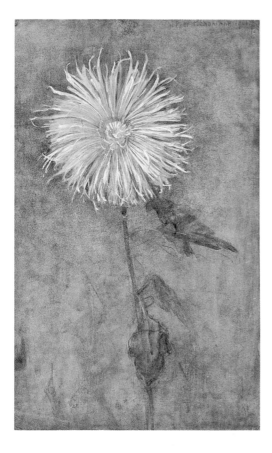

*Upright Chrysanthemum against
a Brownish Ground, 1900*
Watercolour on paper
37.6 x 22.8 cm (14³/₄ x 9")

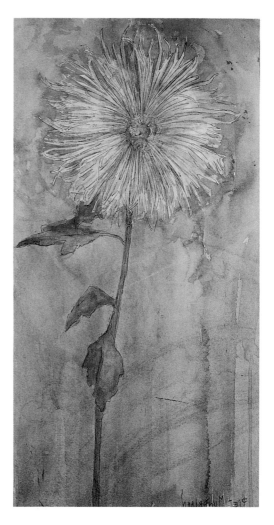

*Upright Chrysanthemum against
a Blue-Grey Ground, 1901*
Watercolour on paper
38.3 x 19.3 cm (15¹/₈ x 7⁵/₈")

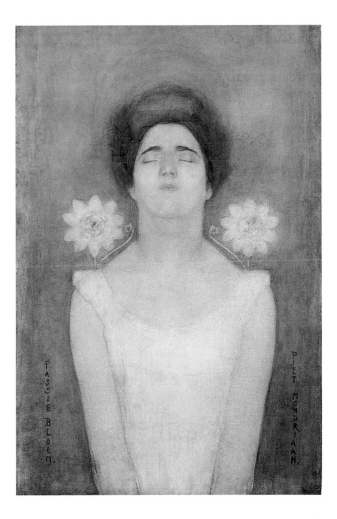

Passie Bloem (Passion Flower),
c.1901
Watercolour on paper
72.5 x 47.5 cm (28 1/2 x 18 3/4")

74

Female Torso in Profile with Book,
c.1898–1900
Watercolour on paper
89 x 50 cm (35 x 19 ⅝")

*Seated Woman with Arms
Crossed, c.1898–1900*
Watercolour on paper
59.5 x 44.7 cm (23^1/$_2$ x 17^5/$_8$")

Hooischelf (Haystack), 1897–8
Watercolour on paper
64 x 47 cm (24$^1/_4$ x 18$^1/_2$")

Haystack and Farm Sheds in a Field,
1897–8
Oil on canvas
37 x 52.5 cm (14⁵/₈ x 20⁵/₈")

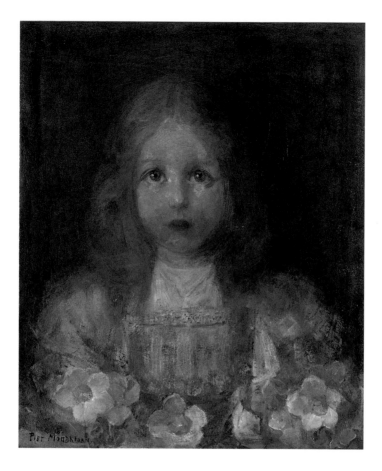

Kindje (Young Child), 1900–01
Oil on canvas
53 x 44 cm (20$^1/_8$ x 17$^3/_8$")

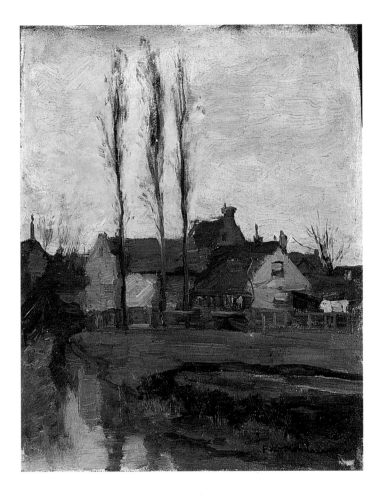

Three Italian Poplars and Buildings,
c.1898
Oil on canvas
31.5 x 40 cm (12³/₈ x 15³/₄")

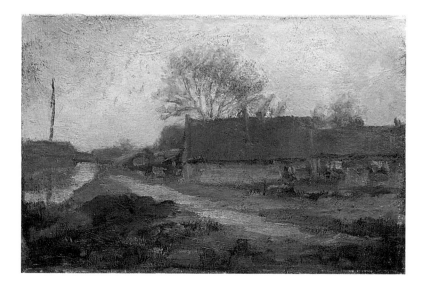

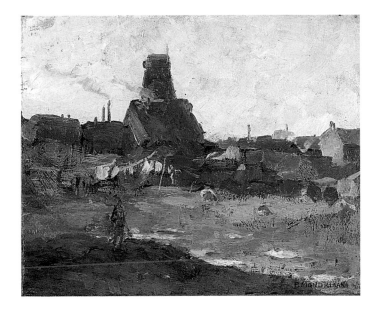

Farmyard in Het Gooi
Flanked by Saplings, 1901–02
Oil on canvas
20.5 x 43 cm (8^1/$_8$ x 16^7/$_8$")

Wingless 'Paltrok' Mill in the
Schinkelbuurt, c.1898
Oil on canvas
31 x 38.5 cm (12^1/$_4$ x 15^1/$_8$")

Farmstead along a Canal,
c.1897–8
Oil on canvas
34 x 52 cm (13^3/$_8$ x 20^1/$_2$")

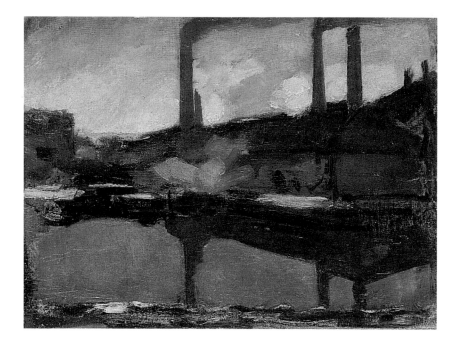

82

The Royal Wax Candle Factory,
1900–01
Oil on canvas
35 x 48 cm (13³/₄ x 18⁷/₈")

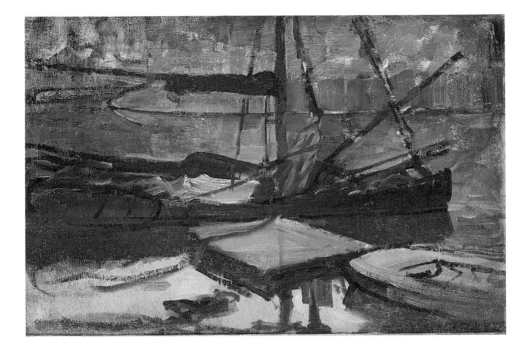

Stadhouderskade: Oil Sketch,
c.1899
Oil on canvas
40 x 61 cm (15³/₄ x 24")

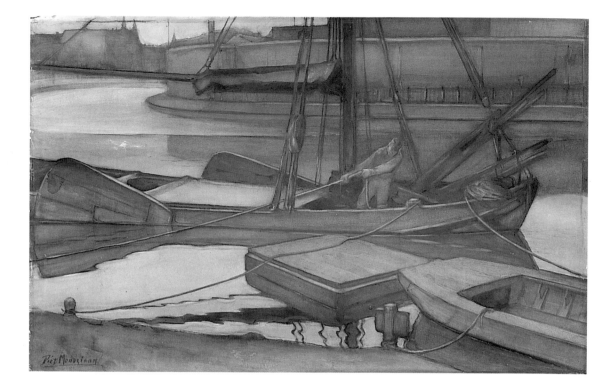

*Aan de Stadhouderskade te
Amsterdam (Stadhouderskade,
Amsterdam), 1900*
Charcoal, watercolour and pastel on paper
62 x 100 cm (24³/₈ x 39³/₈″)

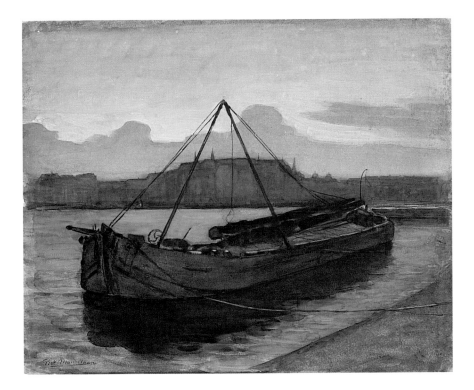

*Avond aan de Weesperzijde
(Evening on the Weesperzijde),
1901–02*
Watercolour and gouache on paper
55 x 66 cm (21 $^5/_8$ x 26")

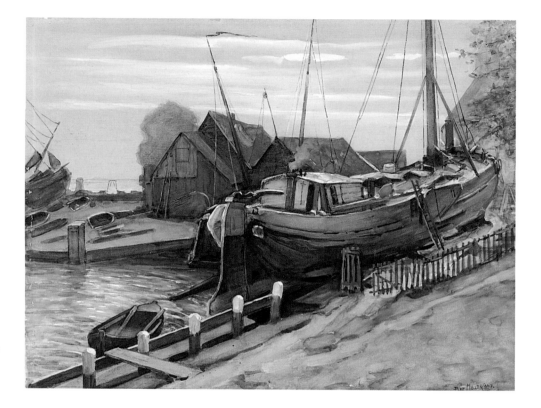

Dry Dock at Durgerdam,
Watercolour, 1898–9
Watercolour on paper
63 x 84 cm (24 3/4 x 33")

86

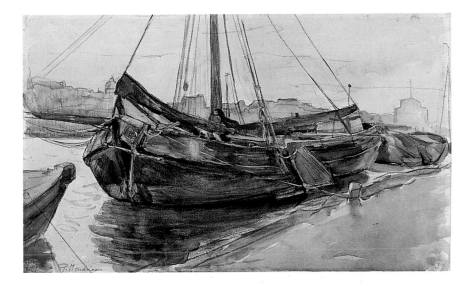

Tjalks Moored on the
Weesperzijde, 1902
Pencil and watercolour on paper
33 x 55 cm (13 x 21 $^5/_8$")

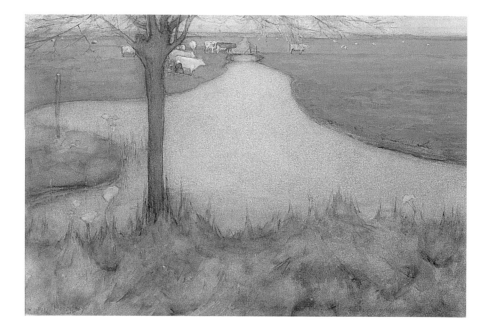

88

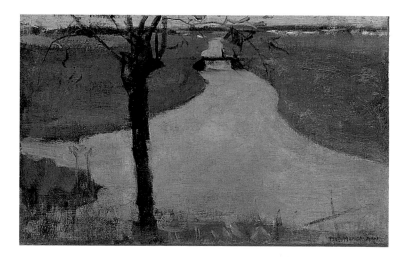

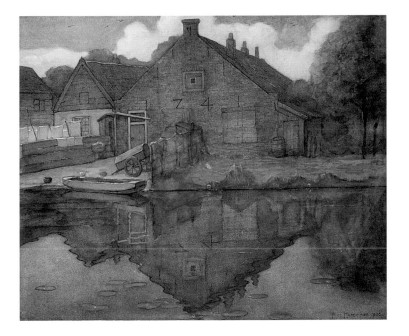

*Irrigation Ditch with Young
Pollarded Willow, Watercolour,
1900*
Watercolour on paper
43 x 62 cm (16⁷/₈ x 24³/₈")

*House on the Gein (1741),
Watercolour, 1900*
Watercolour and gouache on paper
46 x 57 cm (18¹/₈ x 22¹/₂")

*Irrigation Ditch with Young
Pollarded Willow, Oil Sketch II,
1900*
Oil on canvas
23.5 x 37.5 cm (9¹/₄ x 14³/₄")

90

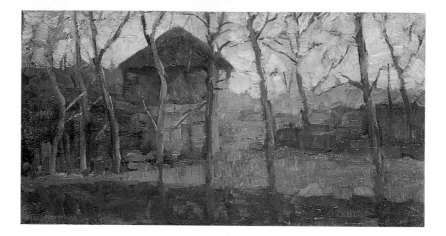

Op de Ringdijk, Watergraafsmeer
(On the Ringdijk, Watergraafsmeer),
1902
Oil on canvas
27.5 x 50 cm (10⁷/₈ x 19⁵/₈")

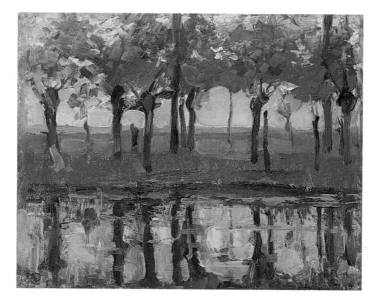

Row of Young Willows Reflected
in the Water, c.1905
Oil on canvas
31 x 38 cm (12¹/₄ x 15")

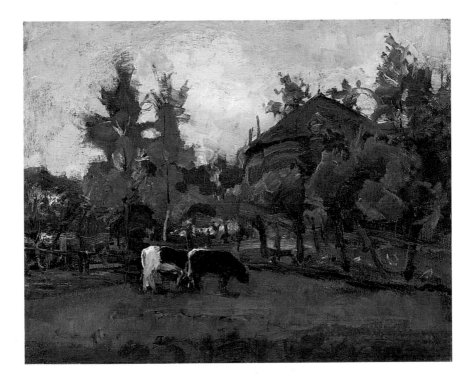

*Farmyard Sketch with Two Cows
Grazing, c.1905*

Oil on canvas
49.5 x 63 cm (19^1/$_2$ x 24^3/$_4$")

94

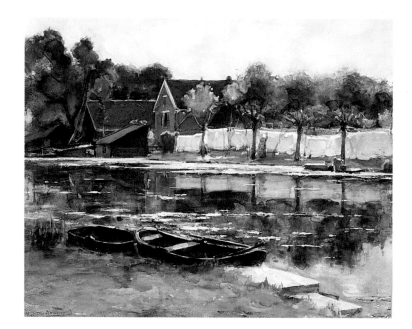

Bleekerij aan het Gein (Bleaching Works on the Gein), 1902
Watercolour on paper
48 x 59 cm (18⁷/₈ x 23¹/₄")

The White Bull Calf, 1905
Watercolour on paper
44.5 x 58.5 cm (17¹/₂ x 23")

The White Bull Calf, Sketch, 1905
Oil on canvas
31.5 x 39 cm (12³/₈ x 15³/₈")

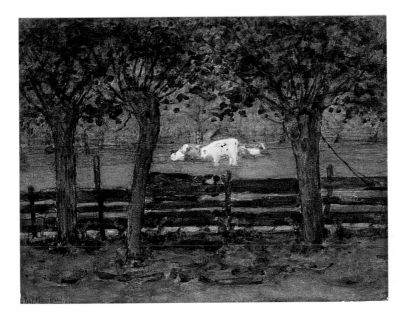

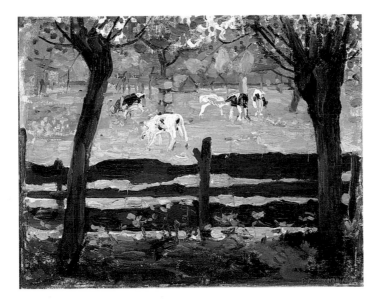

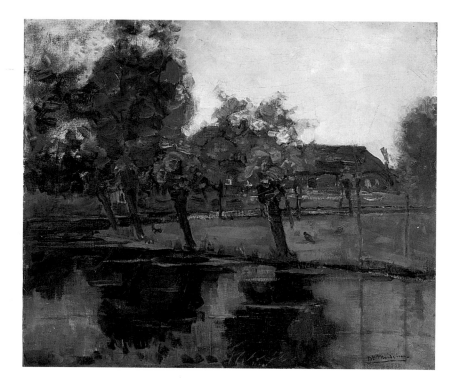

*Landzicht Farm Viewed from
Downstream with Horizontal
Format, c.1902–03*
Oil on canvas
30 x 36 cm (11 $^3/_4$ x 14 $^1/_8$")

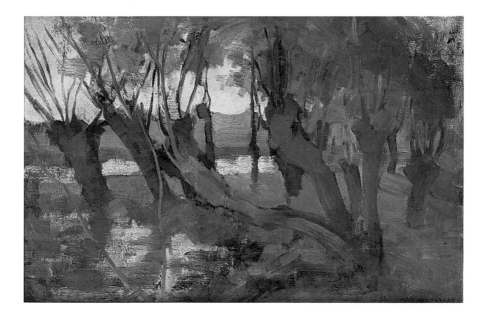

Willow Grove, Trunks Leaning Left I,
c.1902–03
Oil on canvas
40 x 60 cm (15³/₄ x 23⁵/₈")

98

BRABANT

1904–05

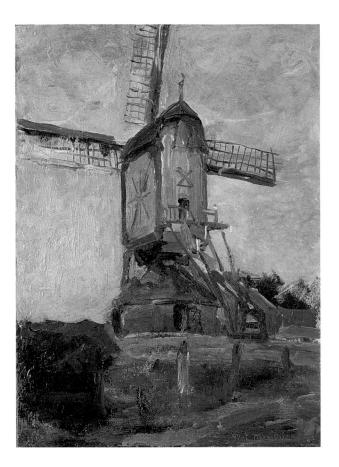

Post Mill at Heeswijk, Rear View,
1904
Oil on paper, mounted on canvas
36.2 x 26 cm (14^1/$_4$ x 10^1/$_4$")

Barn Doors of a Brabant Farm
Building, 1904
Oil on cardboard, mounted on panel
33 x 43 cm (13 x 16^7/$_8$")

Brabant Farm Building and Shed,
1904
Oil on canvas
38 x 45.5 cm (15 x 17^7/$_8$")

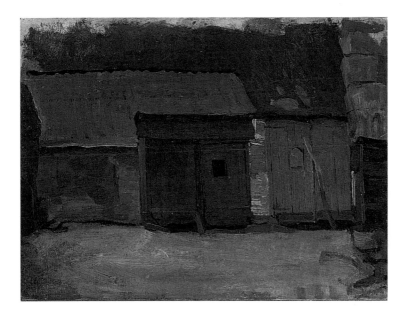

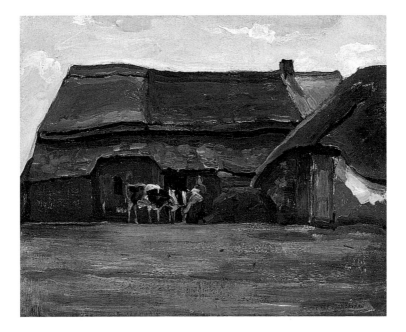

Brabant 1904-05

102

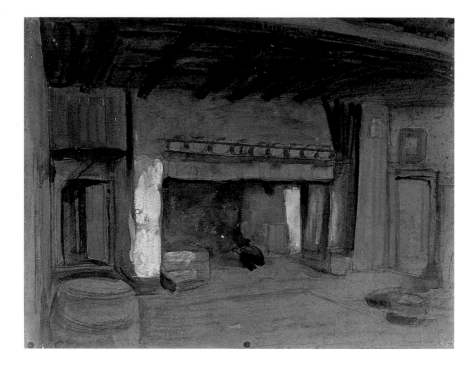

Interieur-keuken (Kitchen Interior):
Brabant Farmhouse Interior with
Hearth, 1904
Watercolour on paper
51 x 65 cm (20 1/$_8$ x 25 5/$_8$")

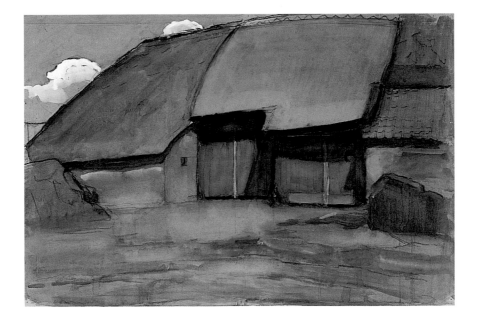

Farm Building at Nistelrode II,
1904
Watercolour on paper
41.5 x 62 cm (16³/₈ x 24³/₈")

104

AMSTERDAM

1905–08

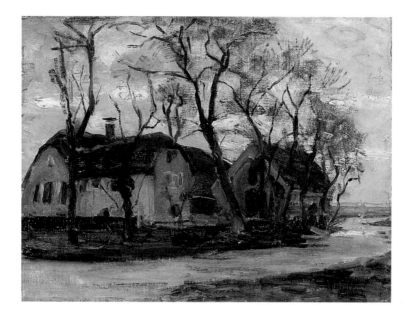

106

Farm at Duivendrecht, Oil Sketch,
c.1905
Oil on canvas
46 x 59 cm (18 1/8 x 23 1/4")

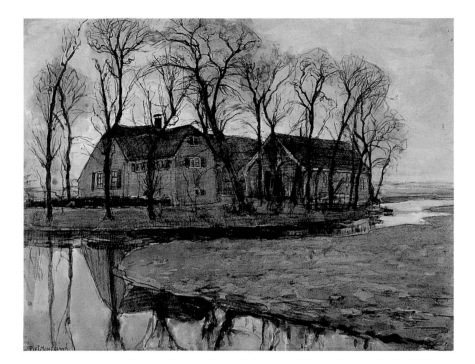

Farm at Duivendrecht,
Watercolour, 1905–06
Watercolour, gouache and crayon on paper
50 x 65.5 cm (19 5/8 x 25 3/4")

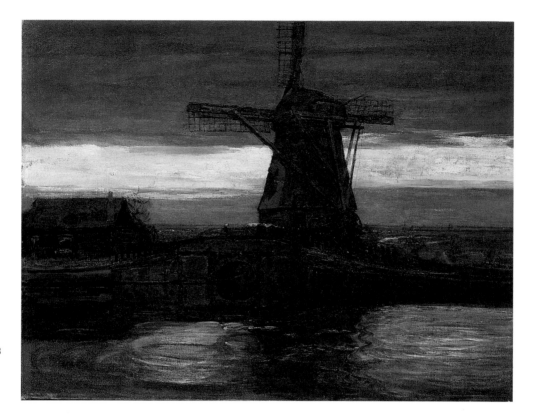

Stammer Mill with Streaked Sky,
1905–06
Oil on canvas
74.5 x 96.5 cm (29^3/$_8$ x 38")

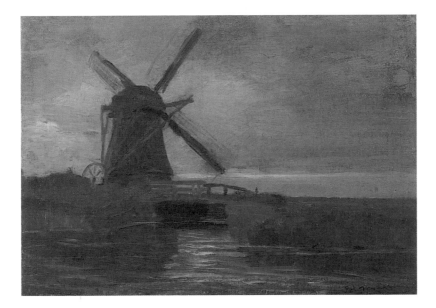

Broekzijder Mill in the Evening,
c.1906
Oil on canvas
35 x 47.5 cm (13³/₄ x 18³/₄")

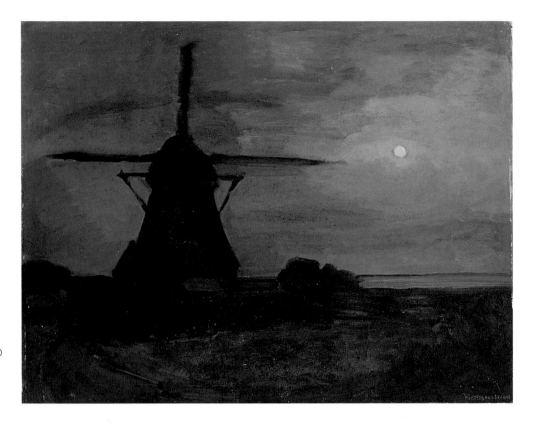

110

Oostzijdse Mill in Moonlight,
c.1907
Oil on canvas
99.5 x 125.5 cm (39^1/$_8$ x 49^3/$_8$")

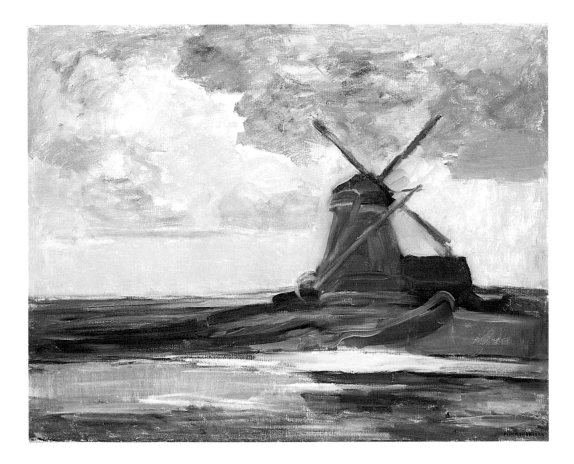

Oostzijdse Mill with Panoramic
Sunset and Brightly Reflected
Colours, 1907–08
Oil on canvas
99 x 120 cm (39 x 47 1/4")

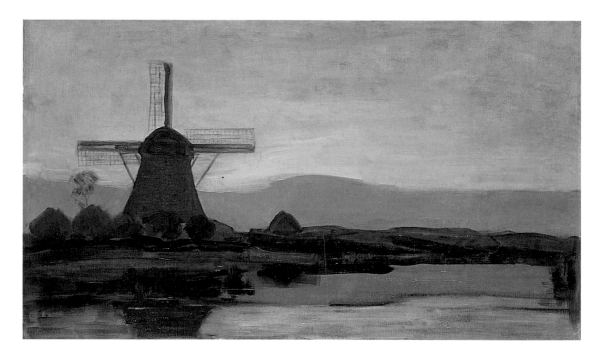

*Oostzijdse Mill with Extended Blue,
Yellow and Purple Sky, 1907–08*
Oil on canvas
67.5 x 117.5 cm (26^3/$_8$ x 46^1/$_4$")

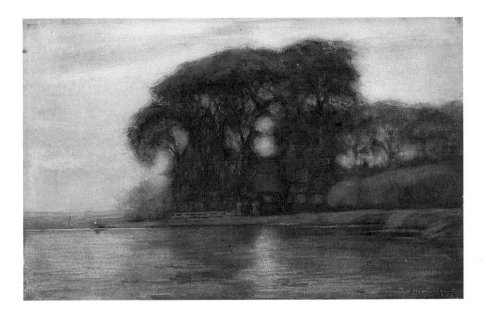

Landzicht Farm under Bluish-Grey Sky,
Watercolour, 1905
Watercolour on paper
38.5 x 61 cm (15^1/$_8$ x 24″)

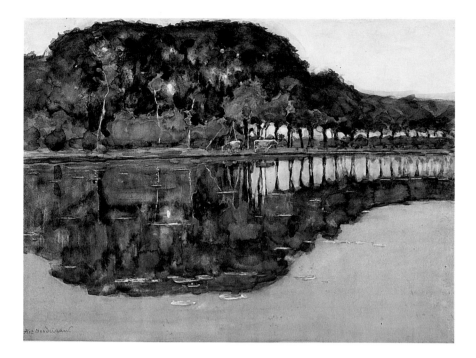

114

Geinrust with Two Cows at
Water's Edge, c.1905–06
Watercolour and gouache on paper
49.5 x 66 cm (19³/₈ x 25¹/₈")

Geinrust Farm in Watery
Landscape, c.1905–06
Watercolour on paper
48.5 x 67 cm (19¹/₈ x 26³/₈")

Geinrust Farm in the Mist,
c.1906–07
Oil on canvas
32.5 x 42.5 cm (12³/₄ x 16³/₄")

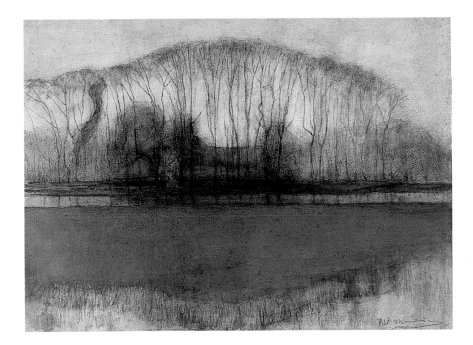

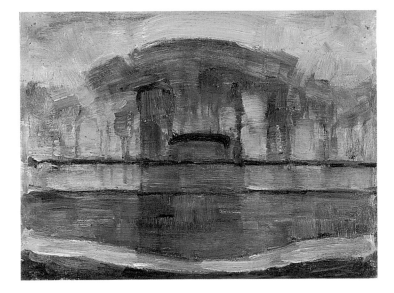

Amsterdam 1905–08

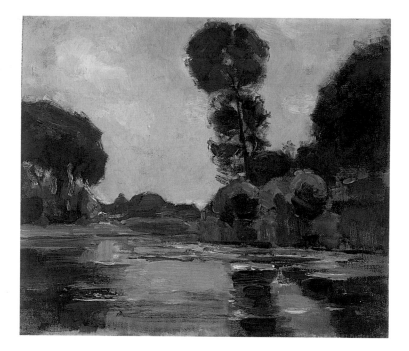

116

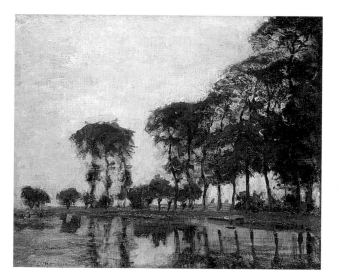

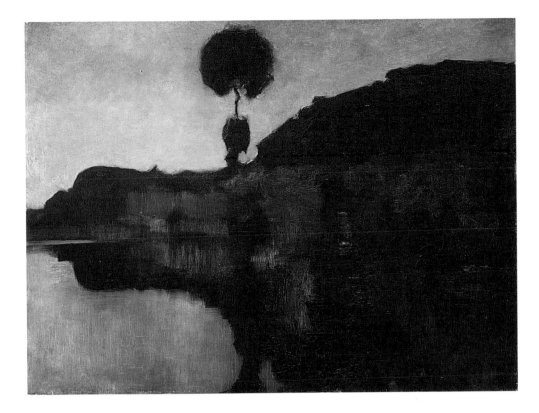

*Isolated Tree on the Gein: Oil
Study with Yellow-Orange Sky,
1906–07*
Oil on canvas
43 x 55.5 cm (16⁷/₈ x 21⁷/₈")

*Isolated Tree on the Gein:
Late Evening, 1907–08*
Oil on canvas
65 x 86 cm (25⁵/₈ x 33⁷/₈")

*Bend in the Gein Bordered by
Three Isolated Poplars: Oil Sketch II,
c.1905*
Oil on canvas
41 x 65 cm (16¹/₈ x 25⁵/₈")

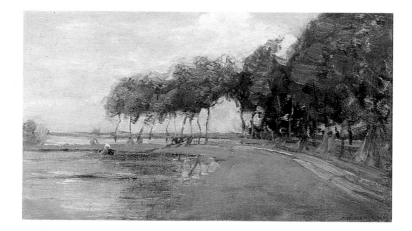

118

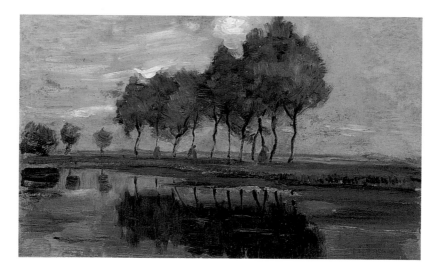

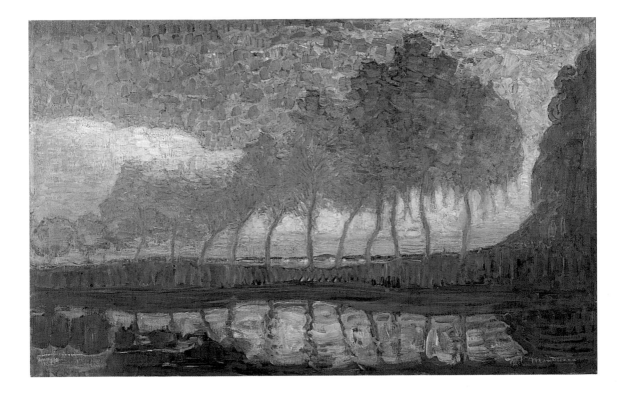

Bend in the Gein with Eleven Poplar
Trees, Oil Sketch, c.1905–06
Oil on canvas
27 x 48 cm (10⁵/₈ x 18⁷/₈")

Row of Eleven Poplars in Red,
Yellow, Blue and Green, 1908
Oil on canvas
69 x 112 cm (27¹/₈ x 44¹/₈")

Row of Eleven Poplars,
Oil on Cardboard III, c.1907
Oil on Cardboard
36 x 60 cm (14¹/₈ x 23⁵/₈")

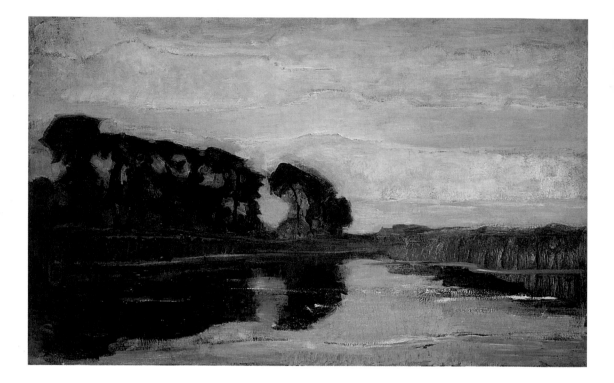

*Riverscape with Row of Trees at
Left, Sky with Pink and Yellow-
Green Bands, c.1907–early 1908*
Oil on canvas
75 x 120 cm (29 ¹/₂ x 47 ¹/₄")

*Willow Groves, Rounded Trunk
in the Foreground, c.1905*
Oil on canvas
25.5 x 30 cm (10 x 11 ³/₄")

*Willow Groves, Near the Water,
Oil Sketch, 1905–06*
Oil on canvas
54 x 63 cm (21 ¹/₄ x 24 ³/₄")

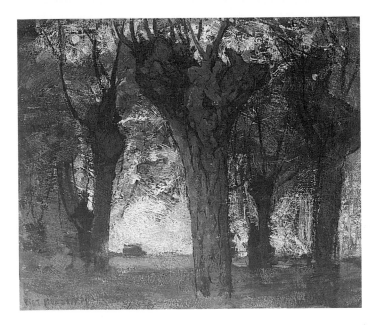

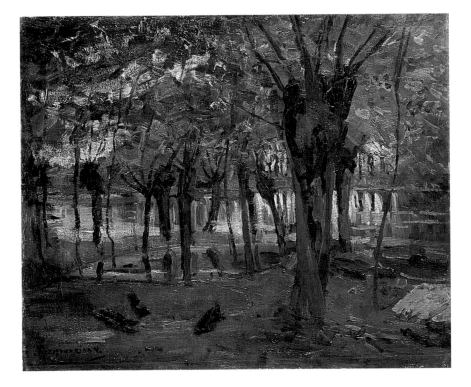

Amsterdam 1905–08

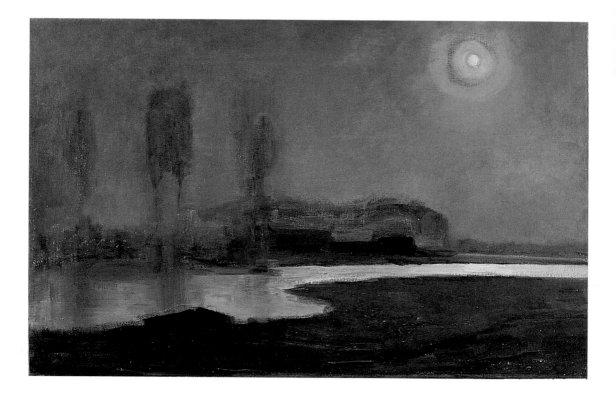

Zomernacht (Summer Night),
1907
Oil on canvas
71 x 110.5 cm (28 x 43 1/2")

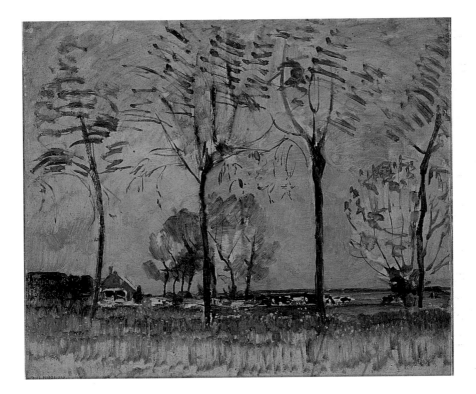

*Farm Setting with Four Tall Trees
in the Foreground I, c.1907*
Oil on cardboard, mounted on panel
64 x 74.5 cm (25 1/4 x 29 1/4")

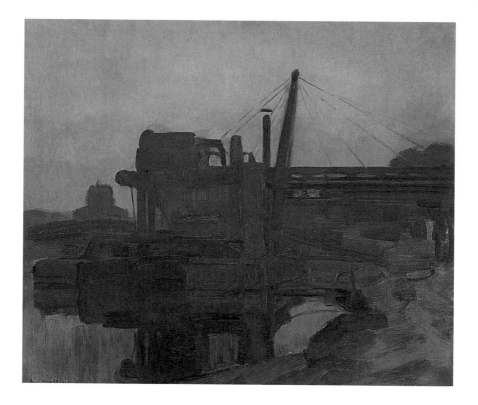

124

Dredger along the Amstel III, 1907
Oil on cardboard, mounted on panel
63.4 x 75.5 cm (25 x 29 3/4")

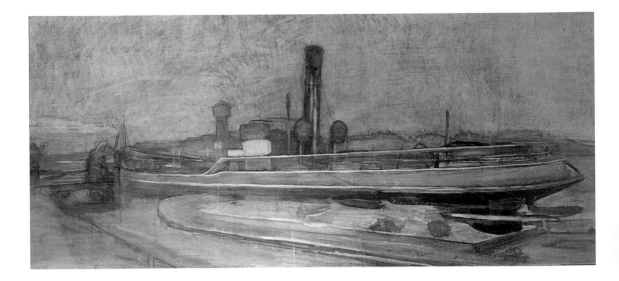

Steamboat Ferry Moored near the
Schollenbrug, 1907–08
Charcoal and watercolour on paper
80.2 x 173.8 cm (31^1/$_2$ x 68^1/$_2$")

126

TWENTE

1906–08

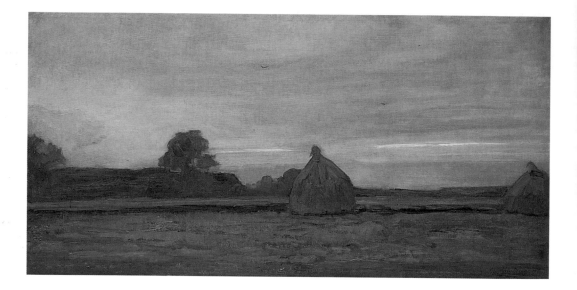

Two Haystacks in a Field II,
c.1907
Oil on canvas
55.5 x 117 cm (21^7/$_8$ x 46^1/$_8$")

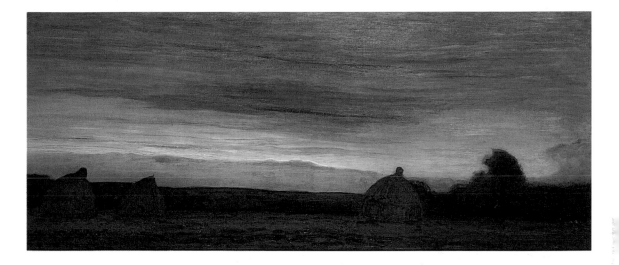

Avond (Evening), Haystacks in a Field, 1908
Oil on canvas
82 x 193 cm (32$\frac{1}{4}$ x 76")

129

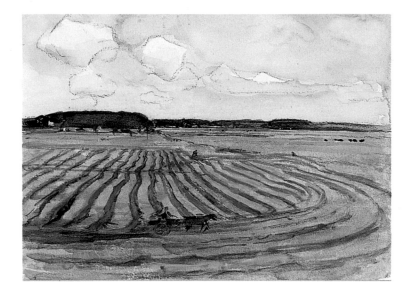

Landscape with Mowed Field II,
c.1907
Watercolour on paper
25.5 x 35.5 cm (10 x 14")

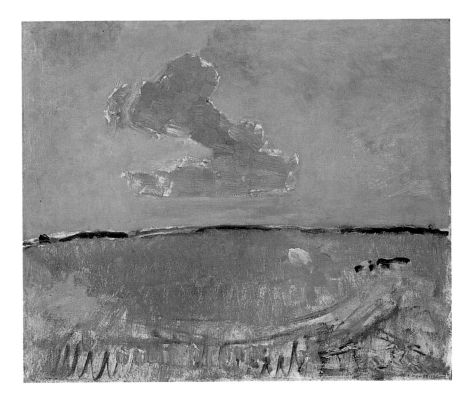

De Rode Wolk (The Red Cloud),
c.1907
Oil on cardboard
64 x 75 cm (25$^{1}/_{4}$ x 29$^{1}/_{2}$")

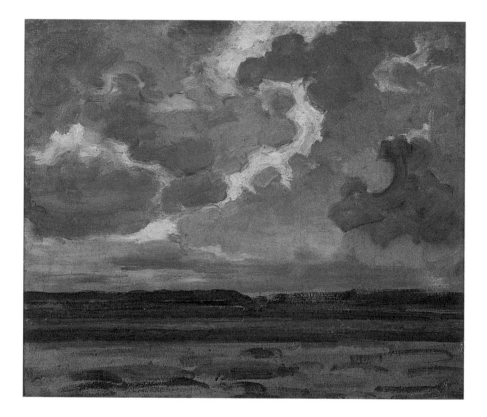

Evening Sky, c.1907
Oil on cardboard
64 x 74 cm (25 $^1/_4$ x 29 $^1/_8$")

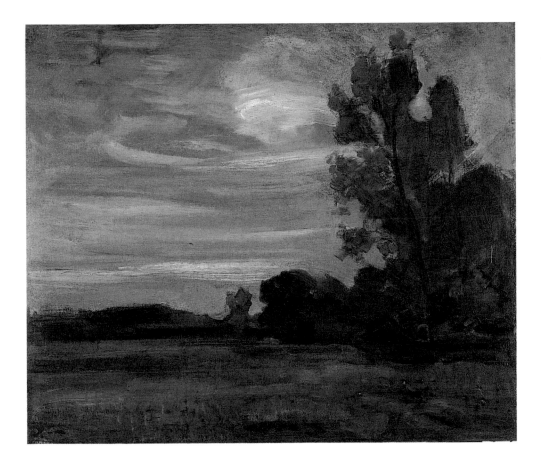

Field with Tree Silhouette at Right,
1906–07
Oil on canvas
78 x 91 cm (30³/₄ x 35⁷/₈")

134

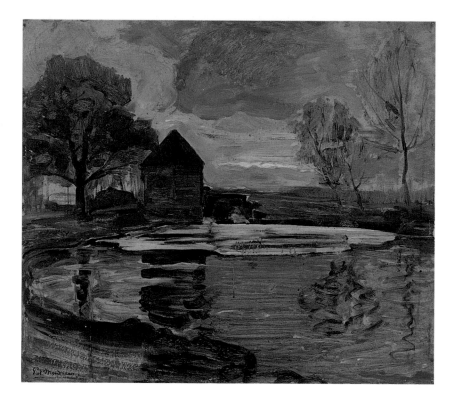

The Old Mill at Oele, c.1907–
early 1908
Oil on cardboard
64 x 73 cm (25 1/4 x 28 3/4")

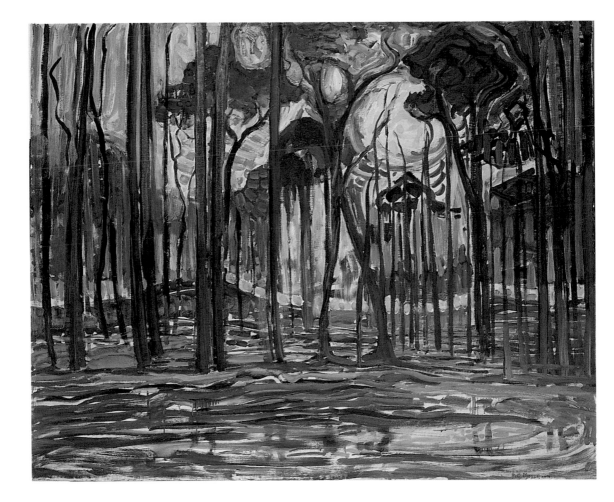

*Bosch (Woods); Woods near
Oele, 1908*
Oil on canvas
128 x 158 cm (50³/₈ x 62¹/₄")

136

138

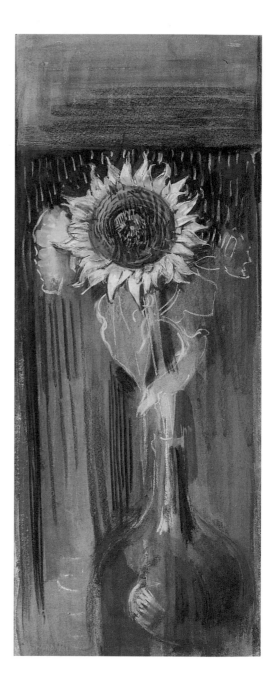

Dying Sunflower I, 1908
Oil on cardboard
63 x 31 cm (24³/₄ x 12¹/₄")

Upright Sunflower, 1908–09
Mixed media on paper
94.2 x 38.5 cm (37 x 15¹/₈")

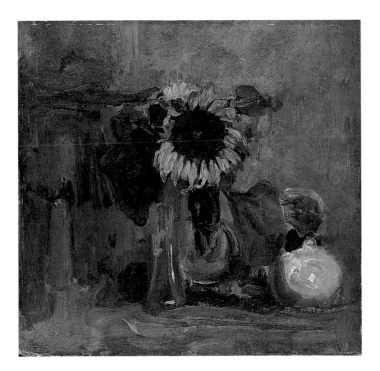

Sunflower in a Vase, 1907–early 1908
Oil on canvas
53.5 x 56.4 cm (21^1/$_8$ x 22^1/$_4$")

140

Metamorphose (Metamorphosis):
Dying Chrysanthemum, 1908
Oil on canvas
84.5 x 54 cm (33$^{1}/_{4}$ x 21$^{1}/_{4}$")

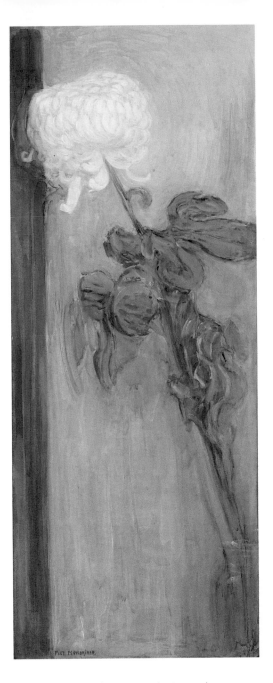

*Chrysanthemum with Vertical
Barrier at Left, c.1908*
Gouache on paper
94 x 37 cm (37 x 14⁵/₈")

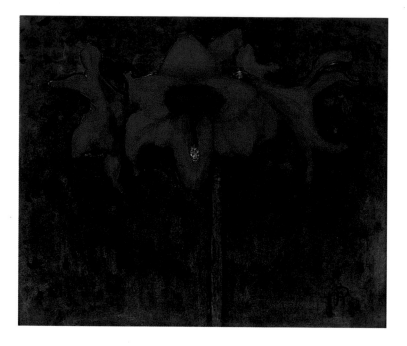

142

Amarilles (Amaryllis I), 1910
Watercolour
39 x 49 cm (15³/₈ x 19¹/₄")

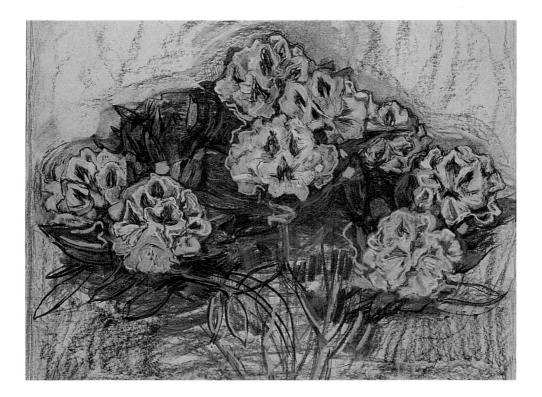

Rhododendrons, Pastel,
1909–10
Pastel and charcoal on paper
73 x 97.5 cm (28³/₄ x 38³/₈")

144

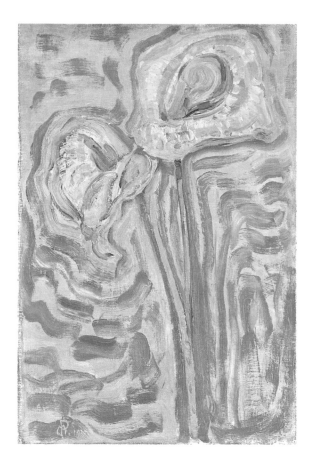

Aaronskelken (Arum Lilies), 1909–10
Oil on canvas
50 x 33.5 cm (19³/₄ x 13¹/₄")

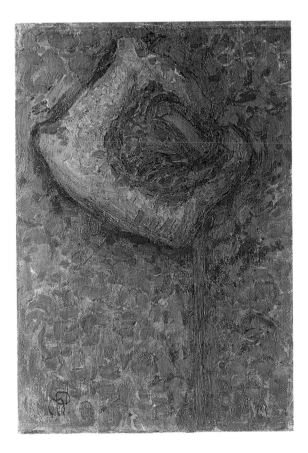

Aaronskelk (Arum Lily), 1909–10
Oil on canvas
46 x 32 cm (18^1/$_8$ x 12^5/$_8$")

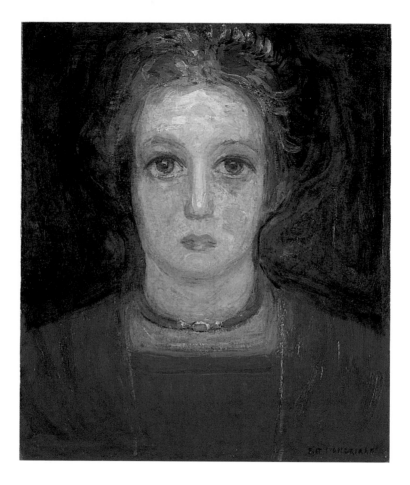

Portrait of Young Woman in Red,
1908–09
Oil on canvas, mounted on panel
49 x 41.5 cm (19$^{1}/_{4}$ x 16$^{3}/_{8}$")

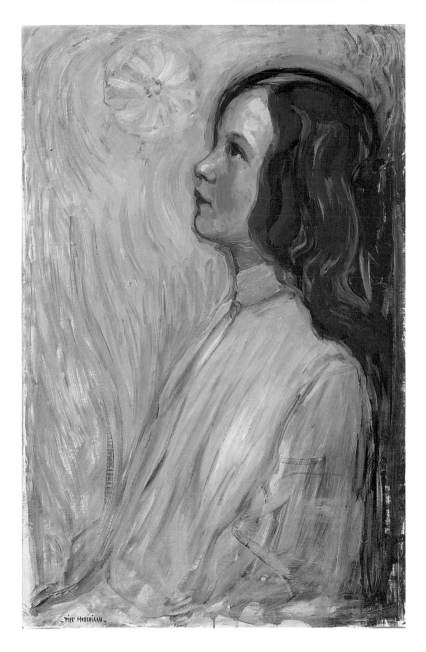

Devotie (Devotion), 1908
Oil on canvas
94 x 61 cm (37 x 24")

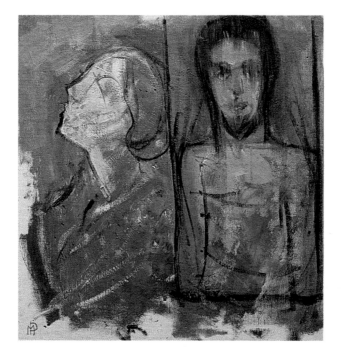

148

Images of Torsos (Female in Profile, Male Viewed Frontally), c.1908–09
Oil on canvas
34 x 31.5 cm (13³/₈ x 12³/₈")

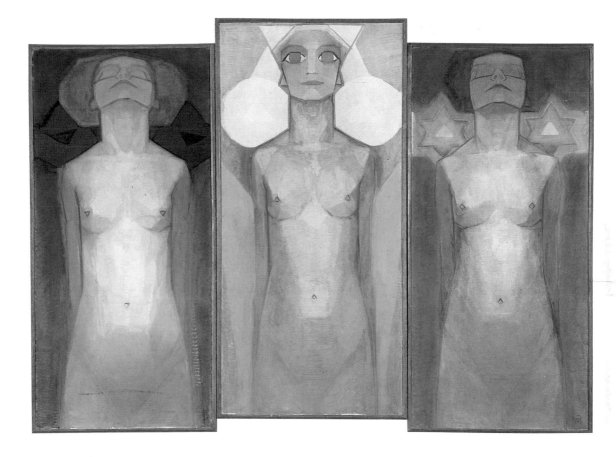

Evolutie (Evolution), 1911
Oil on canvas
central panel 183 x 87.5 cm (72 x 34^1/$_2$")
side panels 178 x 85 cm (70 x 33^1/$_2$")

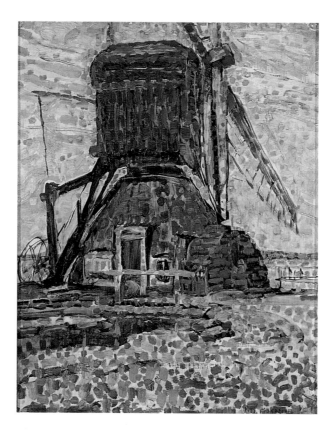

150

Pointillist Version of The Winkel Mill,
1908
Oil on canvas
44 x 34.5 cm (17³/₈ x 13⁵/₈")

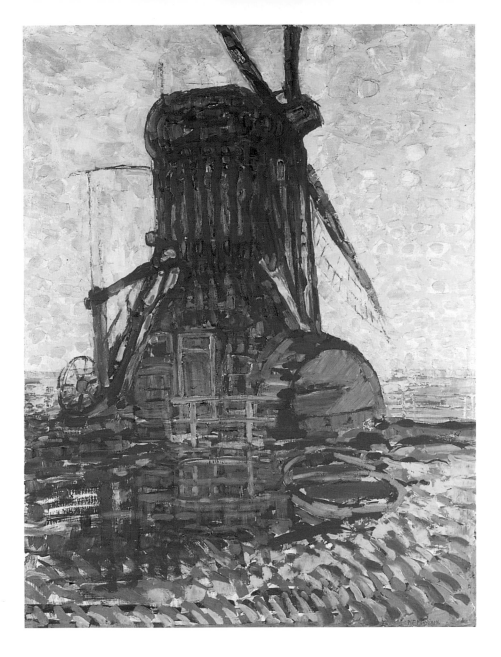

*Molen (Mill): The Winkel Mill
in Sunlight, 1908*
Oil on canvas
114 x 87 cm (44⁷/₈ x 34¹/₄")

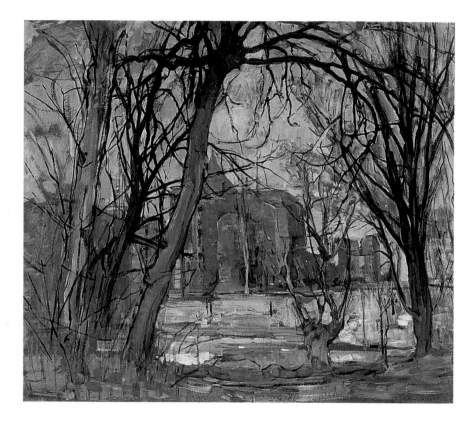

*Lentezon (Spring Sun): Ruin at
Brederode, c.1909–10*
Oil on board
62.2 x 72.3 cm (24$^1/_2$ x 28$^1/_2$")

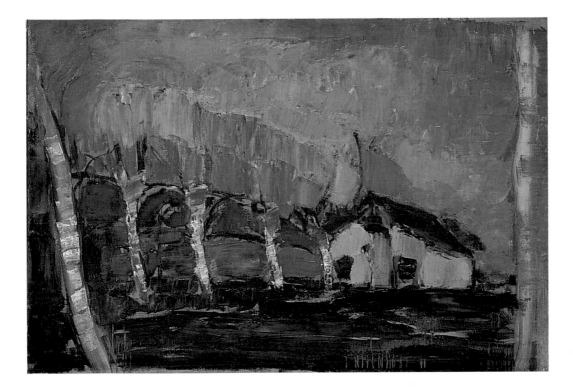

Night Landscape II, c.1908
Oil on canvas
64 x 93 cm (25^1/$_4$ x 36^5/$_8$")

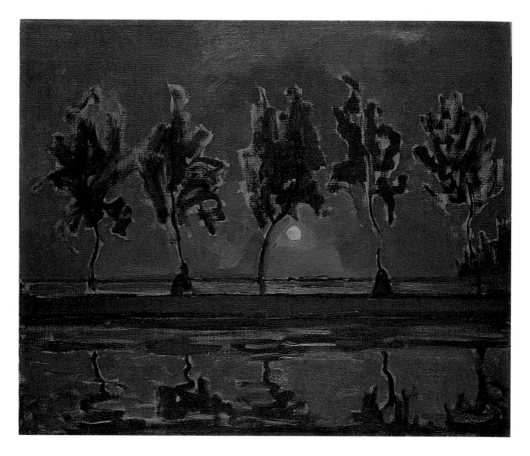

154

*Five Tree Silhouettes along the
Gein with Moon, 1907–08*
Oil on canvas
79 x 92.5 cm (31 x 36³/₈")

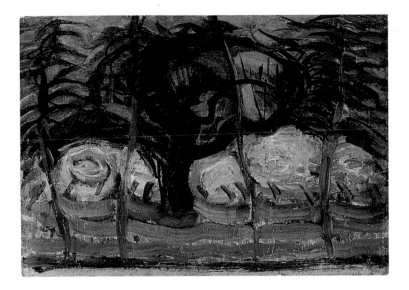

*Apple Trees in Blue with Wavy
Lines I, c.1908*
Oil on paper, mounted on canvas
27.2 x 38.4 cm (10^5/$_8$ x 15^1/$_8$″)

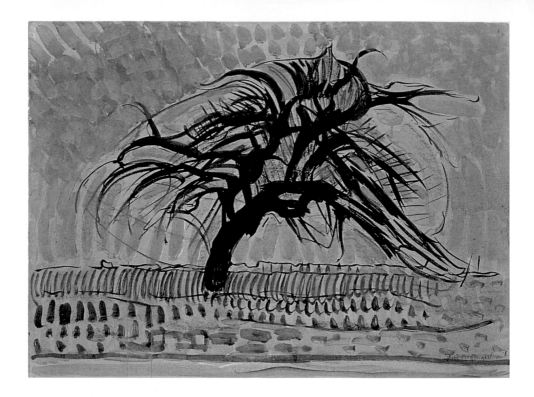

156

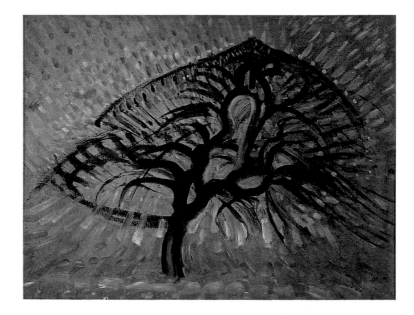

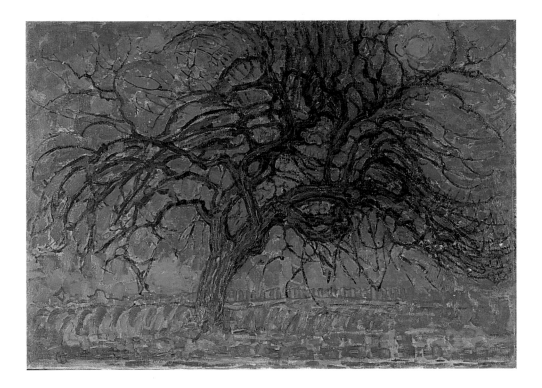

Apple Tree in Blue: Tempera, 1908–09
Tempera on cardboard
75.5 x 99.5 cm (29³/₄ x 39¹/₈")

Avond: The Red Tree, 1908–10
Oil on canvas
70 x 99 cm (27⁵/₈ x 38¹/₈")

Apple Tree, Pointillist Version, 1908–09
Oil on cardboard
55 x 75 cm (21⁵/₈ x 29¹/₂")

158

ZEELAND

1909–11

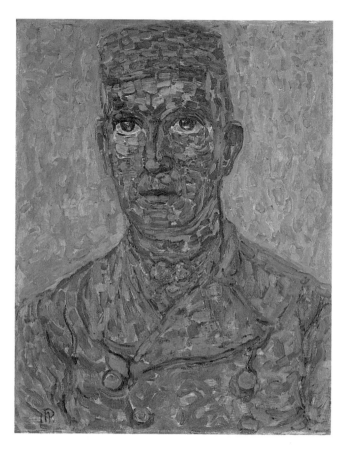

Zeeuws(ch)e Boer (Zeeland Farmer),
1909–early 1910
Oil on canvas
69 x 53 cm (27$^{1}/_{8}$ x 20$^{7}/_{8}$")

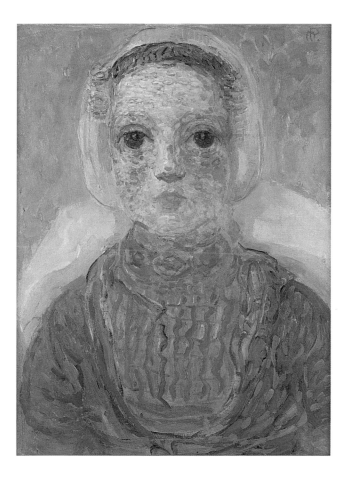

Zeeuws(ch) Meisje (Zeeland Girl),
1909–early 1910
Oil on canvas
63 x 48 cm (24^1/$_8$ x 18^1/$_8$")

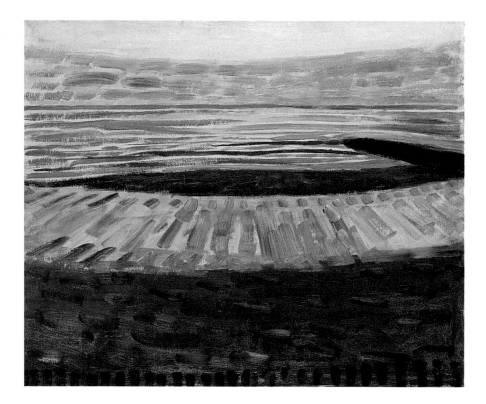

Sea after Sunset, 1909
Oil on cardboard
62.5 x 74.5 cm (24 $^5/_8$ x 29 $^3/_8$")

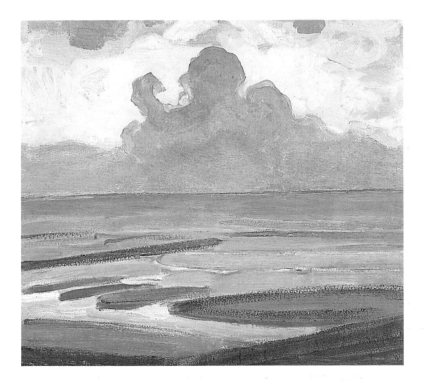

By the Sea, 1909
Oil on cardboard
40 x 45.5 cm (15³/₄ x 18")

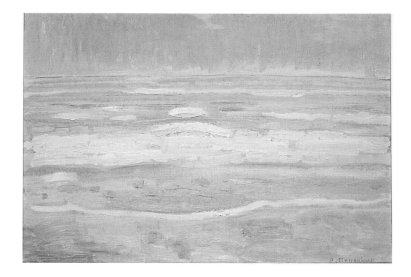

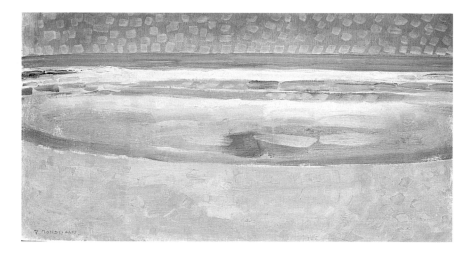

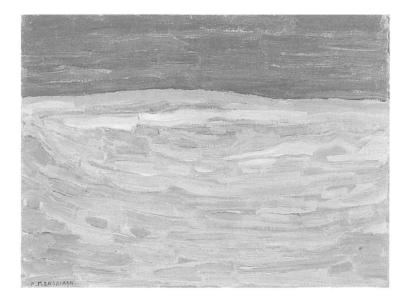

Seascape, 1909
Oil on cardboard
34.5 x 50.5 cm (13 1/2 x 19 7/8")

Sea towards Sunset, 1909
Oil on cardboard
41 x 76 cm (16 1/8 x 30")

Dune Sketch in Bright Stripes, 1909
Oil on cardboard
30 x 40 cm (11 3/4 x 15 3/4")

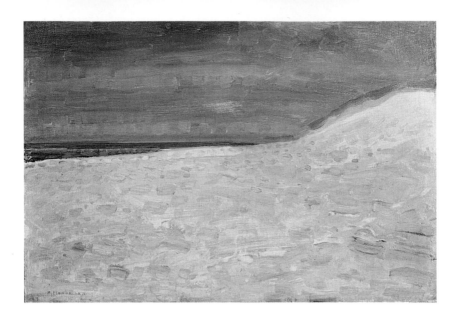

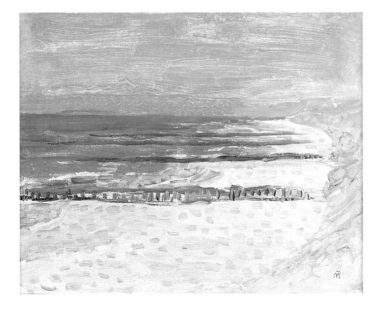

Beach with One Pier at
Domburg, 1909
Oil on canvas
45 x 61 cm (17³/₄ x 24")

Beach with Five Piers at
Domburg, 1909
Oil on canvas
36 x 44.8 cm (14¹/₈ x 17⁵/₈")

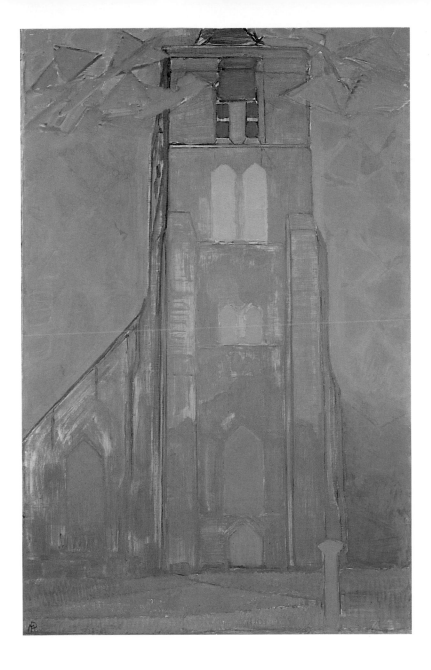

Zeeuws(ch)e kerktoren
(Zeeland Church Tower);
Church Tower at Domburg, 1911
Oil on canvas
114 x 75 cm (44⁷/₈ x 29¹/₂")

Zeeland 1909-11

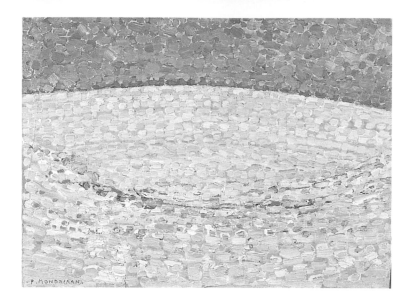

168

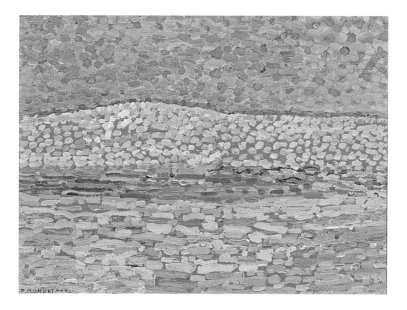

Pointillist Dune Study,
Crest at Centre, 1909
Oil on cardboard
29.5 x 39 cm (11 $^5/_8$ x 15 $^3/_8$")

Pointillist Dune Study,
Crest at Left, 1909
Oil on cardboard
28 x 38.1 cm (11 x 15")

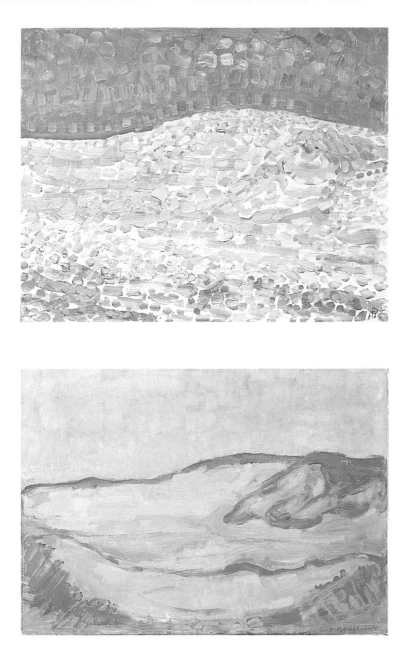

Pointillist Dune Study,
Crest at Right, 1909
Oil on canvas
37.5 x 46.5 cm (14³/₄ x 18¹/₄")

Dune Sketch in Orange,
Pink and Blue, 1909
Oil on cardboard
33 x 46 cm (13 x 18¹/₈")

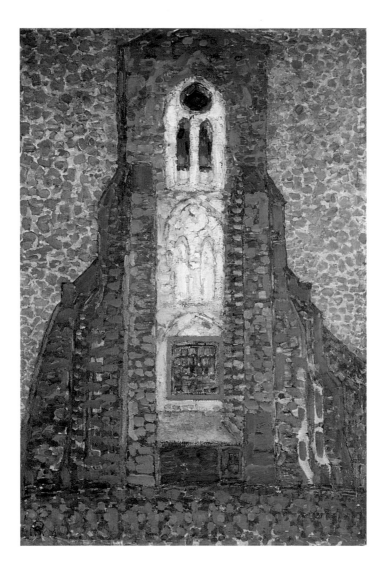

*Zon, Kerk in Zeeland (Sun, Church
in Zeeland); Zoutelande Church
Facade, 1909–early 1910*
Oil on canvas
90.7 x 62.2 cm (35 3/$_4$ x 24 1/$_2$")

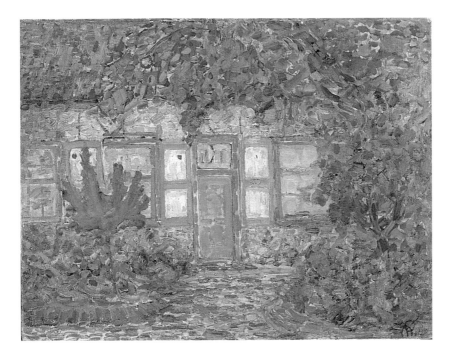

Huisje bij Zon (Little House in Sunlight), 1909–early 1910
Oil on canvas
52.5 x 68 cm (20 5/8 x 26 3/4")

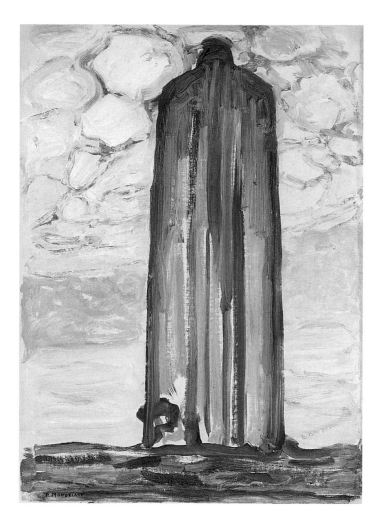

Lighthouse at Westkapelle with Clouds, 1908–09

Oil on canvas

71 x 52 cm (27 1/8 x 20 3/8")

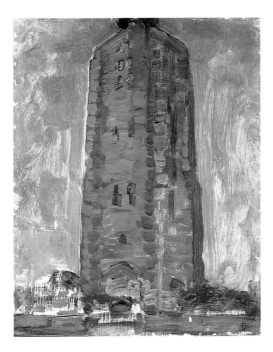

*Lighthouse at Westkapelle in
Brown, 1909*
Oil on canvas
45 x 35.5 cm (17³/₄ x 13¹/₈")

*Lighthouse in Westkapelle in Pink,
1909*
Oil on cardboard
39 x 29.5 cm (15³/₈ x 11⁵/₈")

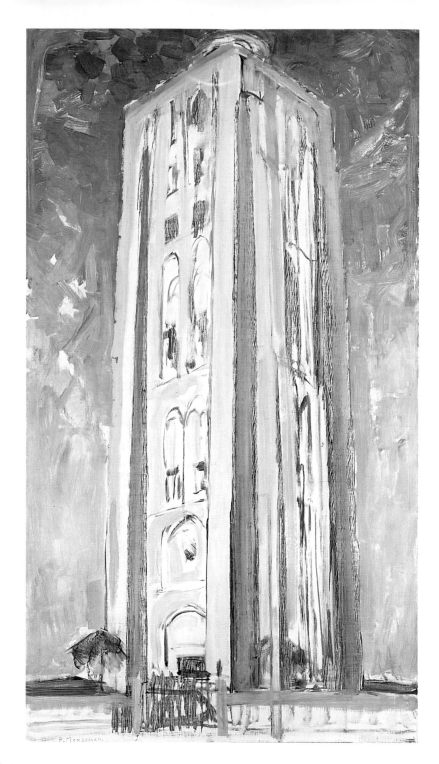

174

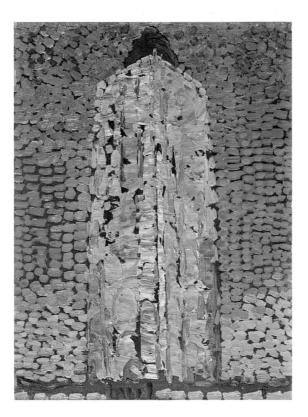

Lighthouse at Westkapelle in Orange,
Pink, Purple and Blue, c.1910
Oil on canvas
135 x 75 cm (53$^1/_8$ x 29$^1/_2$")

Lighthouse at Westkapelle in Orange,
1909–early 1910
Oil on cardboard
39 x 29 cm (15$^3/_8$ x 11$^3/_8$")

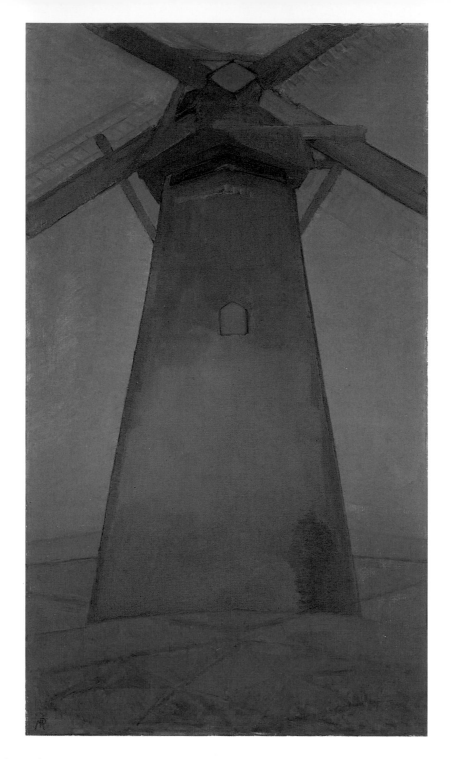

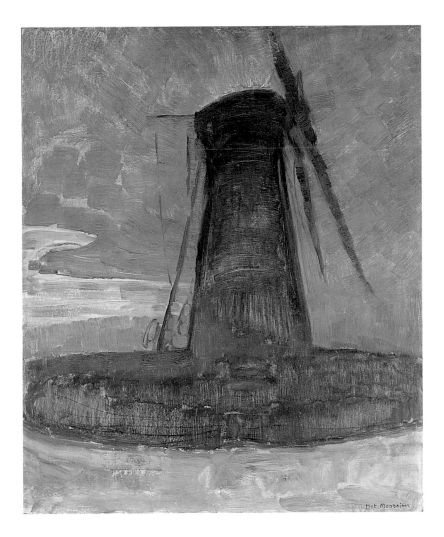

Molen (Mill); The Red Mill, 1911
Oil on canvas
150 x 86 cm (59 x 33^{7}/$_{8}$")

Mill at Domburg, 1909
Oil on cardboard
76.5 x 63.5 cm (30^{1}/$_{8}$ x 25")

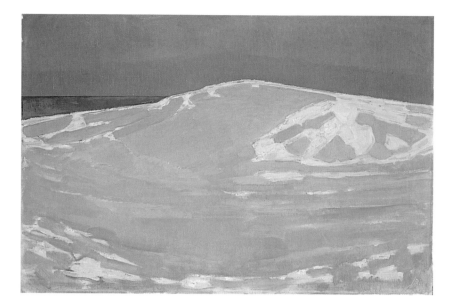

Duinen bij Domburg (Dunes near Domburg), c.1910
Oil on canvas
65.5 x 96 cm (25³/₄ x 37³/₄")

178

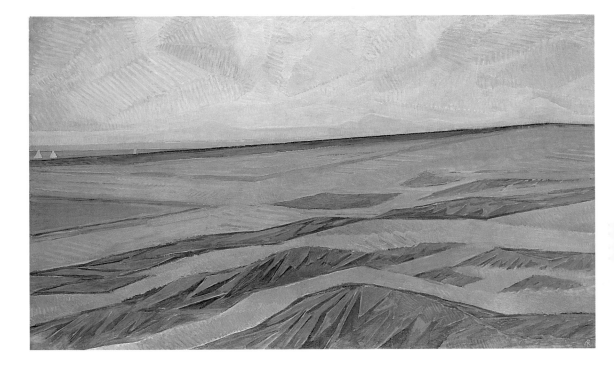

Duinlandschap (Dune Landscape),
(July–September) 1911
Oil on canvas
141 x 239 cm (55^1/$_2$ x 94^1/$_4$")

180

CUBISM

1911–14

182

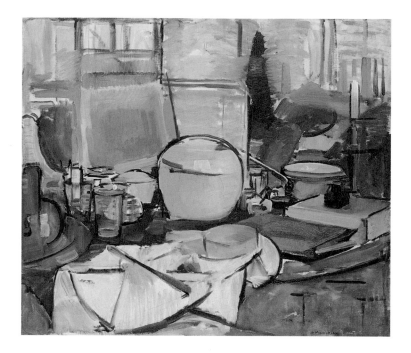

Still Life with Gingerpot 1, 1911
Oil on canvas
65.5 x 75 cm (25³/₄ x 29¹/₂")

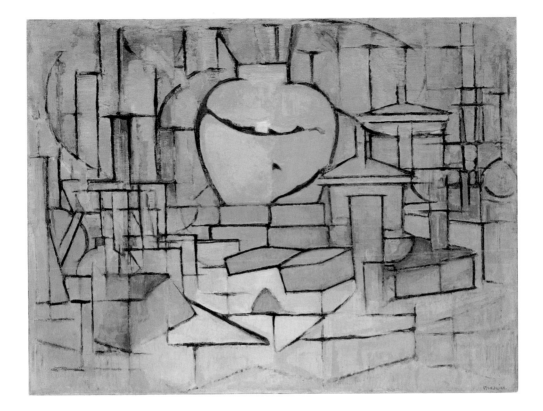

Still Life with Gingerpot 2, 1912
Oil on canvas
91.5 x 120 cm (36 x 47 $^1/_4$")

184

The Sea, 1912
Oil on canvas
82.5 x 92 cm (32^1/$_2$ x 36^1/$_4$")

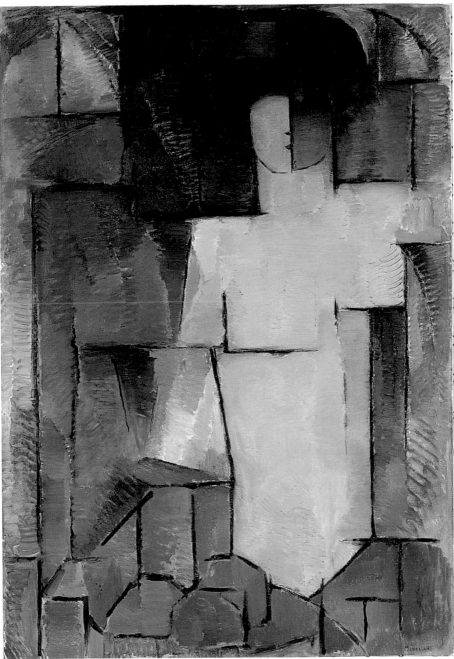

The Large Nude, 1912
Oil on canvas
140 x 98 cm (55 $\frac{1}{8}$ x 38 $\frac{5}{8}$")

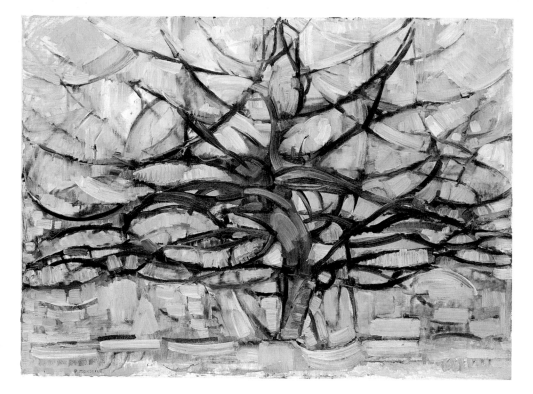

186

The Grey Tree, 1911
Oil on canvas
79.7 x 109.1 cm (31 $1/2$ x 42 $7/8$")

*Bloeiende appelboom
(Flowering Apple Tree), 1912*
Oil on canvas
78.5 x 107.5 cm (31 x 42 $3/8$")

*Bloeiende bomen
(Flowering Trees), 1912*
Oil on canvas
60 x 85 cm (23 $5/8$ x 33 $1/2$")

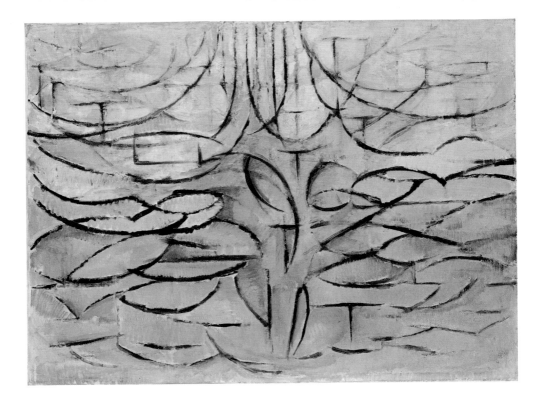

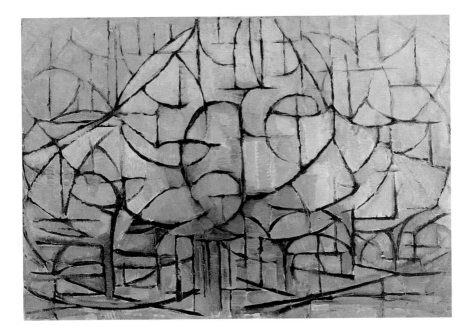

Cubism 1911–14

188

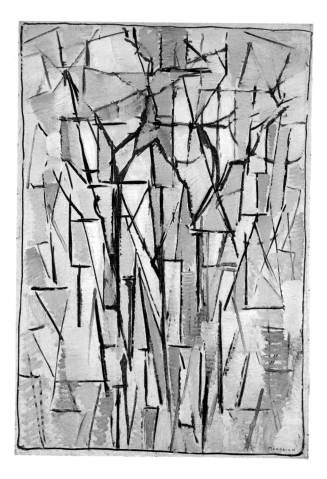

Composition Trees 2, 1912–13
Oil on canvas
98 x 65 cm (38⁵/₈ x 25⁵/₈")

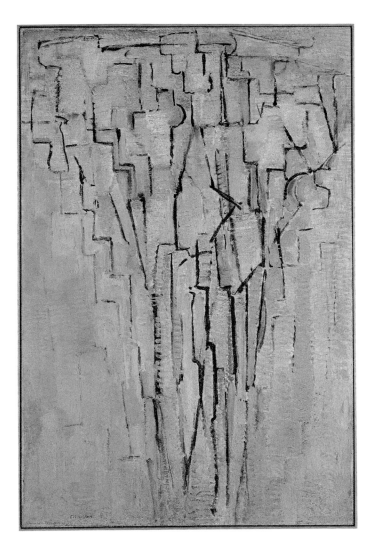

The Tree A, 1913
Oil on canvas
100.2 x 67.2 cm (39^1/$_2$ x 26^1/$_2$")

190

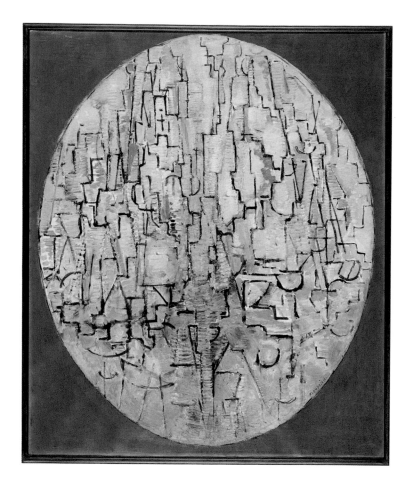

Tableau No.3: Composition in
Oval, 1913
Oil on canvas
94 x 78 cm (37 x 30³/₄")

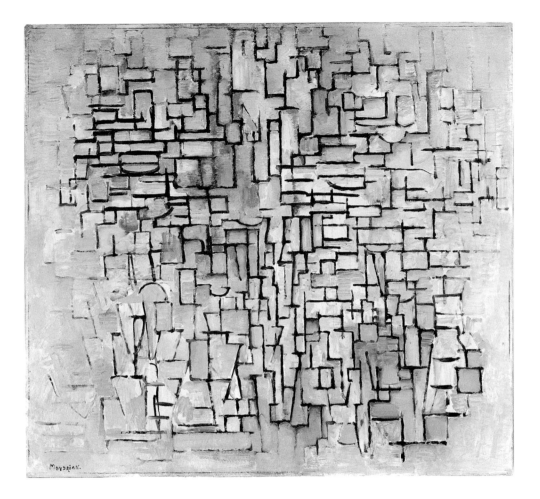

*Tableau No.2 / Composition
No.VII, 1913*
Oil on canvas
104.4 x 113.6 cm (41$^{1}/_{8}$ x 44$^{3}/_{4}$")

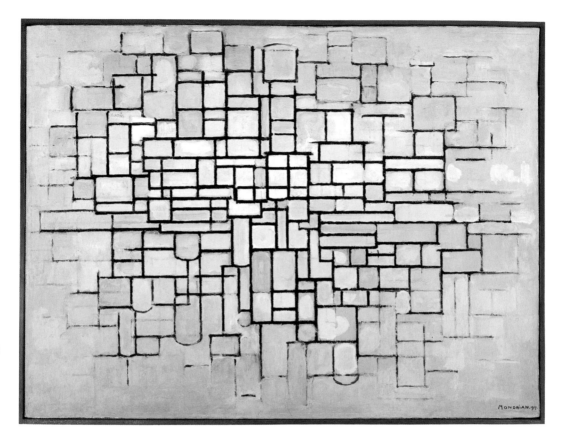

Composition No.II, 1913
Oil on canvas
88 x 115 cm (34³/₄ x 45¹/₄")

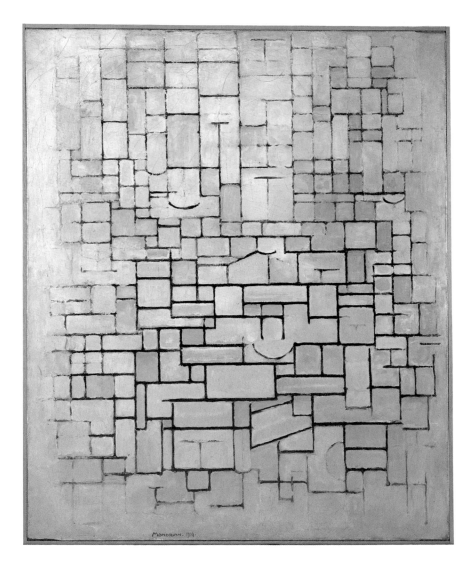

Tableau No.1/
Composition No.1/
Compositie 7, 1914
Oil on canvas
120 x 100 cm (47^1/$_4$ x 39^3/$_8$")

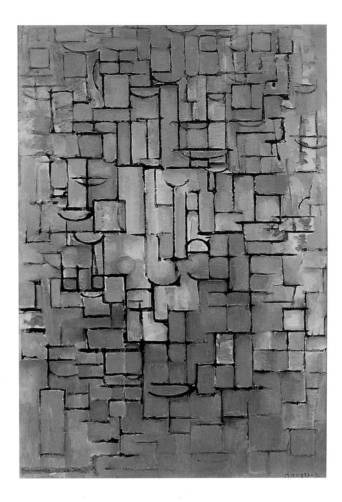

*Gemälde No.1 / Composition
No.XIV, 1913*
Oil on canvas
95 x 65 cm (37 x 25$^1/_8$")

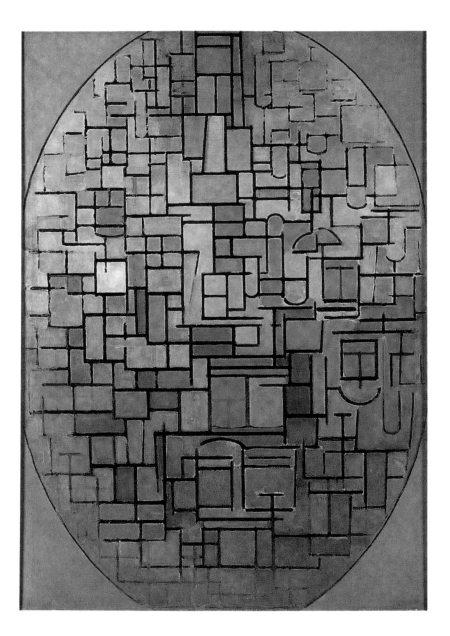

Tableau III: Composition in Oval, 1914
Oil on canvas
140 x 101 cm (55¹/₈ x 39³/₈")

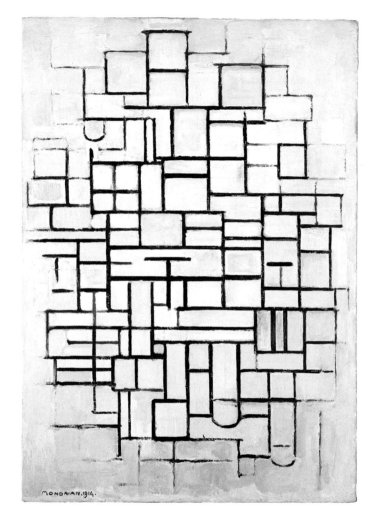

Composition No.IV/
Compositie 6, 1914
Oil on canvas
88 x 61 cm (34⁵/₈ x 24")

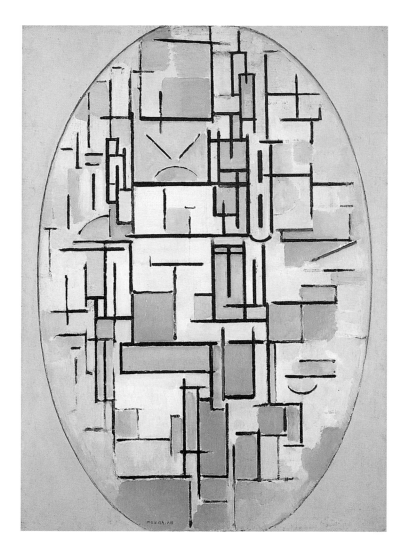

*Composition in Oval with Colour
Planes 1, 1914*

Oil on canvas
107.6 x 78.8 cm (42³/₈ x 31")

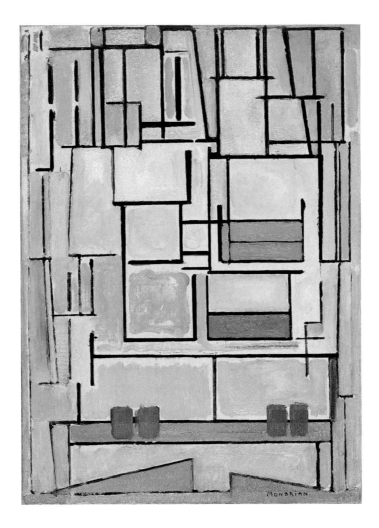

Composition No. VI/
Compositie 9, 1914
Oil on canvas
95.2 x 67.6 cm (37 1/2 x 26 5/8")

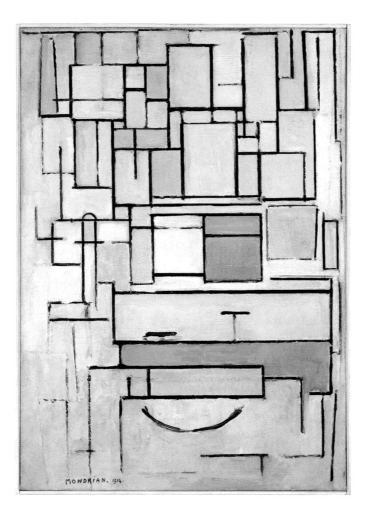

Composition with Colour Planes:
Façade, 1914
Oil on canvas
91.5 x 65 cm (36 x 25⅝")

200

LAREN / BLARICUM

1915–19

202

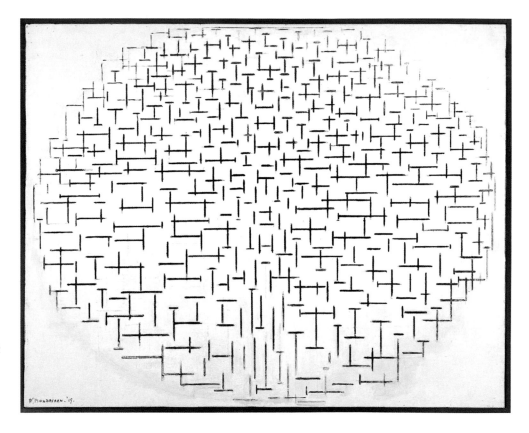

*Compositie 10 in zwart wit
(Composition 10 in Black and White),
1915*
Oil on canvas
85 x 108 cm (33^1/$_2$ x 42^1/$_2$")

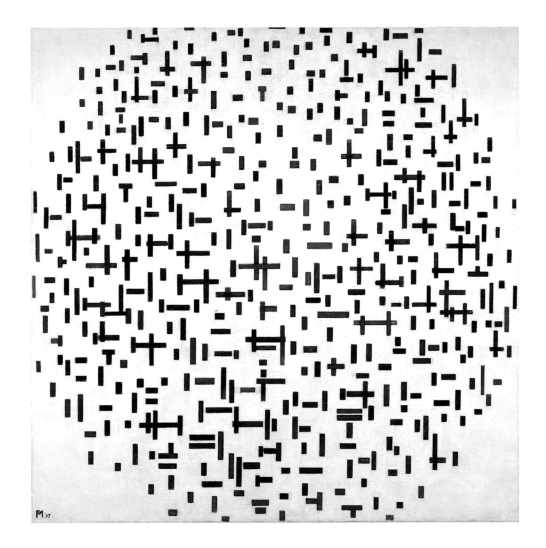

Composition in line, 1916/
Compositie in lijn, 1917,
1916/1917
Oil on canvas
108 x 108 cm (42¹/₂ x 42¹/₂")

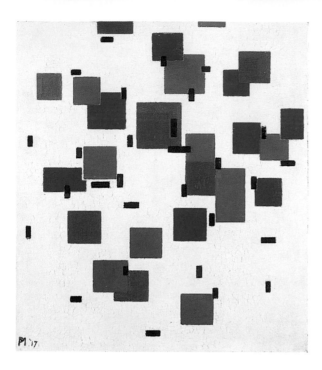

*Compositie in kleur A
(Composition in Colour A), 1917*
Oil on canvas
50.3 x 45.3 cm (19⁷/₈ x 17⁷/₈")

*Compositie in kleur B
(Composition in Colour B), 1917*
Oil on canvas
50/50.5 x 45 cm (19³/₄ / 19⁷/₈ x 17³/₄")

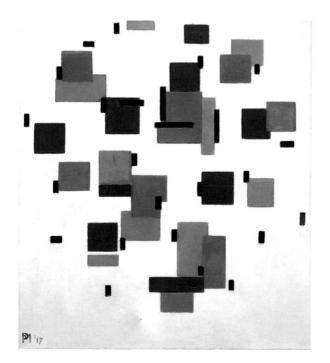

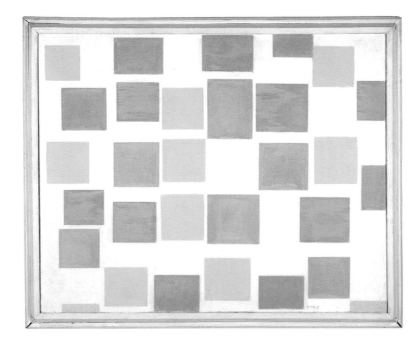

Composition with Colour Planes 2, 1917
Oil on canvas
48 x 61.5 cm (18^7/$_8$ x 24^1/$_4$")

Compositie No.3, with Colour Planes 3, 1917
Oil on canvas
48 x 61 cm (18^7/$_8$ x 24")

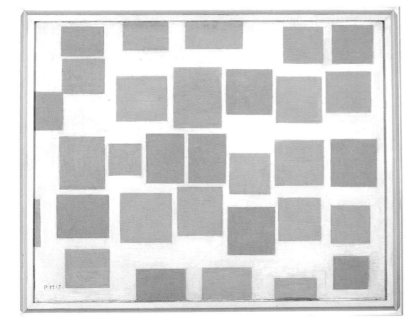

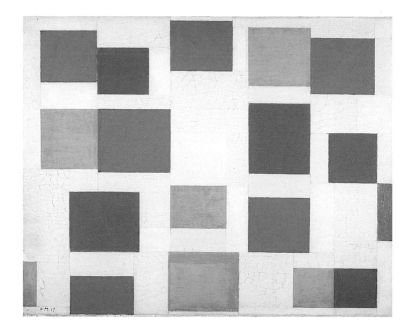

206

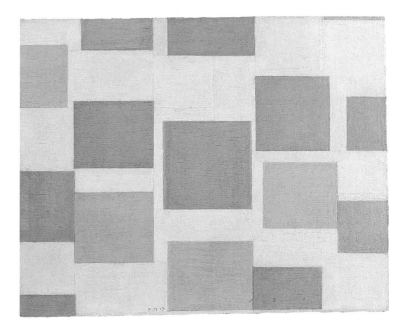

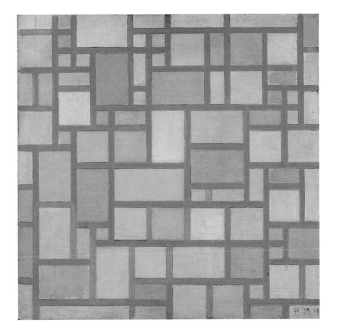

Composition with Colour Planes 4,
1917
Oil on canvas
48 x 61 cm (18⁷/₈ x 24")

Composition with Grid 7, 1919
Oil on canvas
48.5 x 48.5 cm (19¹/₈ x 19¹/₈")

Compositie No.5, with Colour
Planes 5, 1917
Oil on canvas
49 x 61.2 cm (19¹/₄ x 24¹/₈")

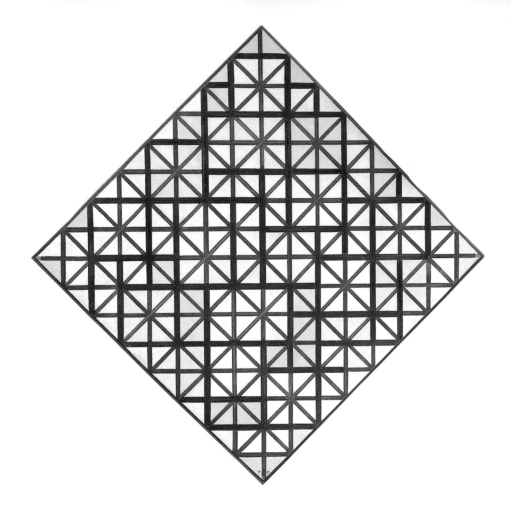

208

Composition with Grid 3:
Lozenge Composition, 1918
Oil on canvas
diagonal: 121 cm (47⁵/₈")
sides: 84.5 x 84.5 cm (33¹/₄ x 33¹/₄")

Composition with Grid 6: Lozenge
Composition with Colours, 1919
Oil on canvas
diagonal: 68.5/69 cm (27/27¹/₈")
sides: 49 x 49 cm (19¹/₄ x 19¹/₄")

Composition with Grid 5: Lozenge
Composition with Colours, 1919
Oil on canvas
diagonal: 84.5 cm (33¹/₄")
sides: 60 x 60 cm (23⁵/₈ x 23⁵/₈")

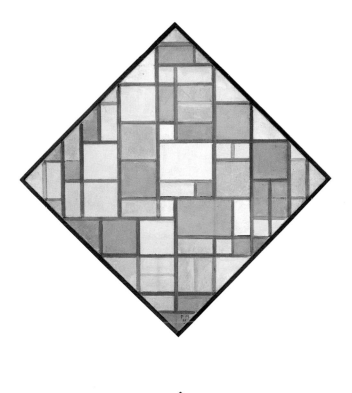

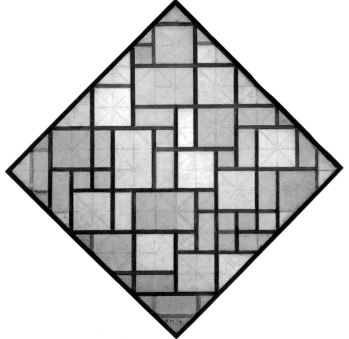

Laren/Blaricum *1915–19*

210

PARIS

1919–38

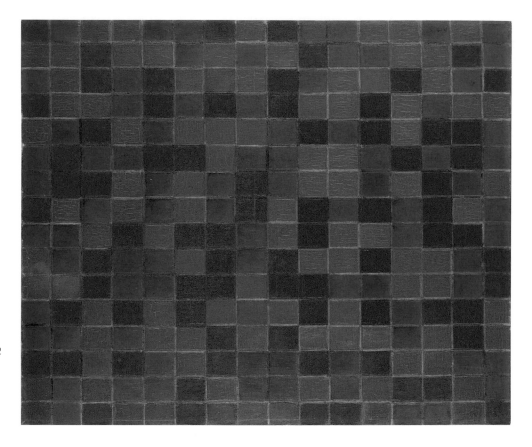

Composition with Grid 8:
Checkerboard Composition with
Dark Colours, 1919
Oil on canvas
84 x 102 cm (33$^{1}/_{8}$ x 40$^{1}/_{8}$")

Composition with Grid 9:
Checkerboard Composition with
Light Colours, 1919
Oil on canvas
86 x 106 cm (33^{7}/$_{8}$ x 41^{3}/$_{4}$")

214

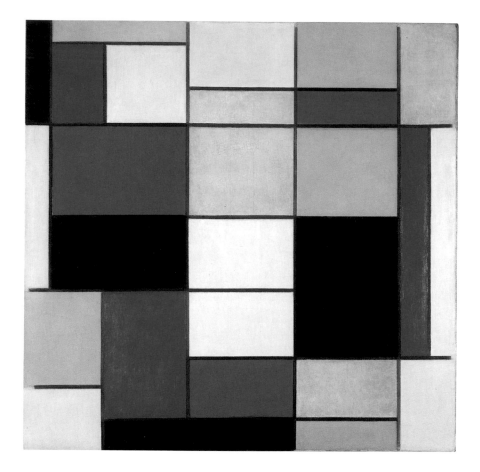

Composition A, 1920
Oil on canvas
90 x 91 cm (35 1/2 x 35 7/8")

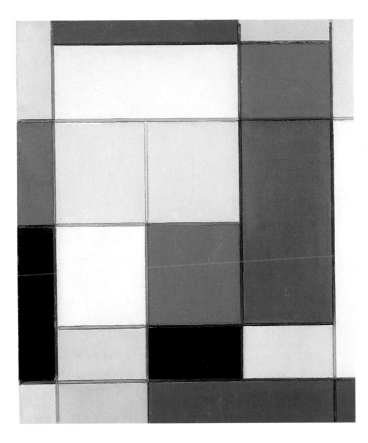

Composition B, 1920
Oil on canvas
67 x 57.5 cm (26³/₈ x 22⁵/₈")

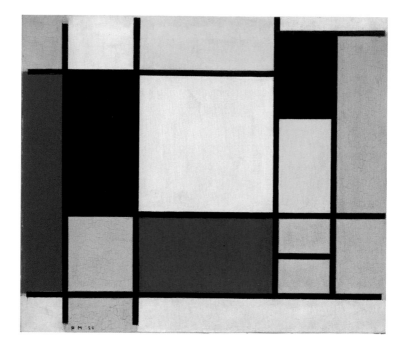

216

Composition with Yellow, Red,
Black, Blue and Grey, 1920
Oil on canvas
51.5 x 61 cm (20 1/4 x 24")

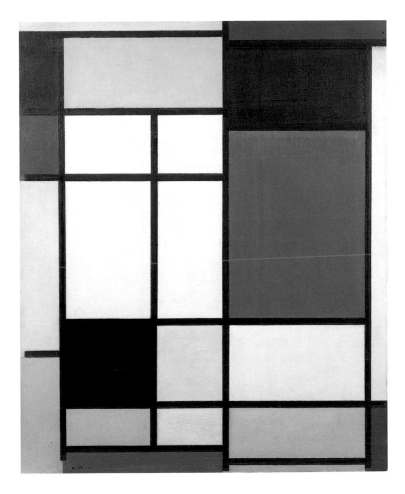

*Composition with Yellow, Blue,
Black, Red and Grey, 1921*
Oil on canvas
88.5 x 72.5 cm (34³/₄ x 28¹/₂")

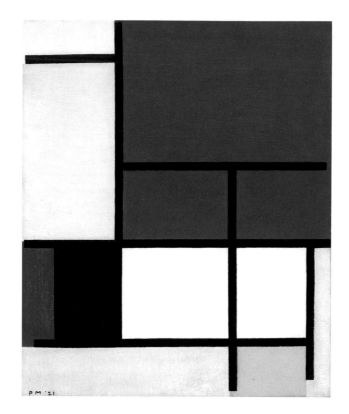

Composition with Large Blue Plane,
Red, Black, Yellow and Grey, 1921
Oil on canvas
60.5 x 50 cm (23³/₄ x 19⁵/₈")

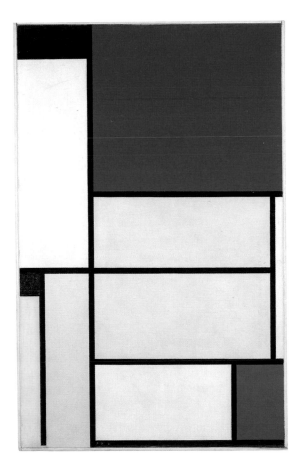

*Tableau I, with Black, Red, Yellow,
Blue and Light Blue, 1921*
Oil on canvas
96.5 x 60.5 cm (38 x 23³/₄")

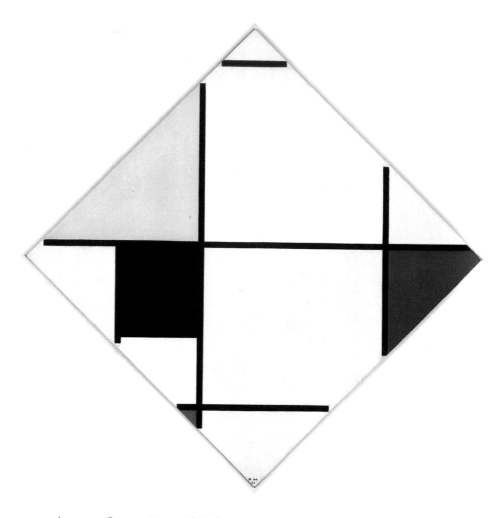

*Lozenge Composition with Yellow,
Black, Blue, Red and Grey, 1921*
Oil on canvas
diagonal: 84.5 cm (33 1/4")
sides: 60.1 x 60.1 cm (23 5/8 x 23 5/8")

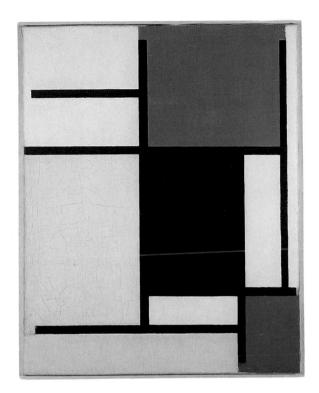

Composition with Red, Yellow,
Black, Blue and Grey, 1921
Oil on canvas
48 x 38 cm (18^7/$_8$ x 15")

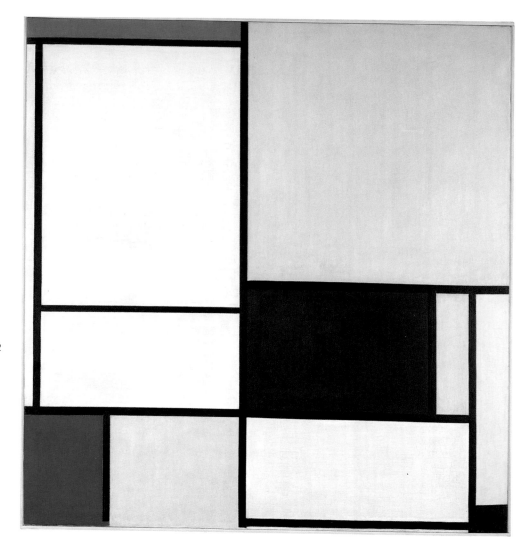

Tableau II, with Red, Black, Yellow,
Blue and Light Blue, 1921
Oil on canvas
101 x 99 cm (39³/₄ x 39")

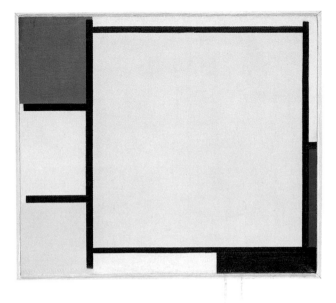

*Composition with Red, Blue,
Yellow, Black and Grey, 1922*
Oil on canvas
41.9 x 48.6 cm (16^1/$_2$ x 19^1/$_8$")

*Composition with Blue, Yellow,
Red, Black and Grey, 1922*
Oil on canvas
42 x 50 cm (16^1/$_2$ x 19^3/$_4$")

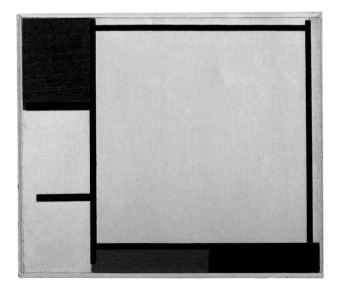

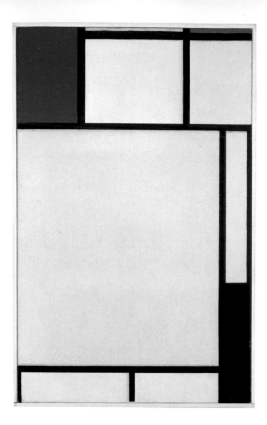

*Composition with Blue, Red,
Yellow and Black, 1922*
Oil on canvas
79 x 49.5 cm (31$^1/_8$ x 19$^1/_2$")

*Composition with Blue, Yellow,
Black and Red, 1922*
Oil on canvas
53 x 54 cm (20$^7/_8$ x 21$^1/_4$")

224

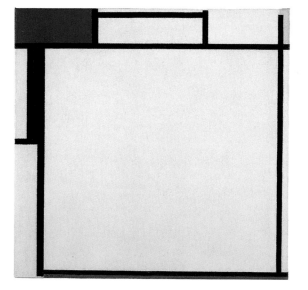

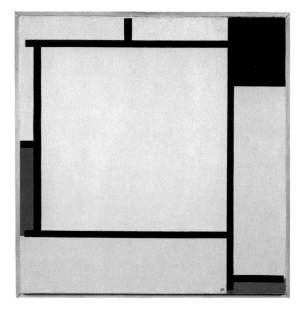

*Tableau 2, with Yellow, Black,
Blue, Red and Grey, 1922*
Oil on canvas
55.6 x 53.4 cm (21⁷/₈ x 21¹/₈")

*Tableau, with Yellow, Black,
Blue, Red and Grey, 1923*
Oil on canvas
54 x 53.5 cm (21¹/₄ x 21")

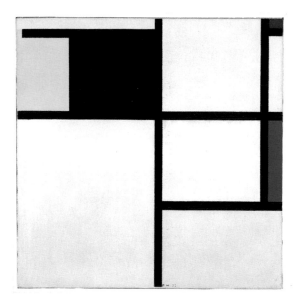

226

Lozenge Composition, 1924 /
Tableau No.IV. Losangique
Pyramidal, 1925, with Red, Blue,
Yellow and Black, 1924/1925

Oil on canvas
diagonals: 142.8 x 142.5 cm (56^1/$_4$ x 56^1/$_8$")
sides: 100.5 x 100.5 cm (39^1/$_2$ x 39^1/$_2$")

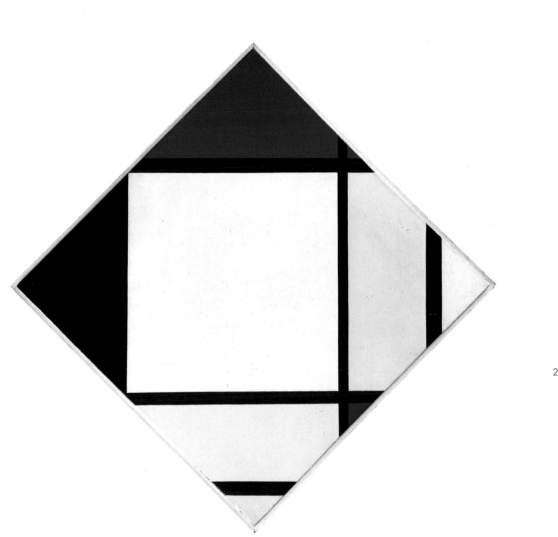

Lozenge Composition with Red,
Black, Blue and Yellow, 1925
Oil on canvas
diagonal: 109 cm (42⁷/₈")
sides: 77 x 77 cm (30³/₈ x 30³/₈")

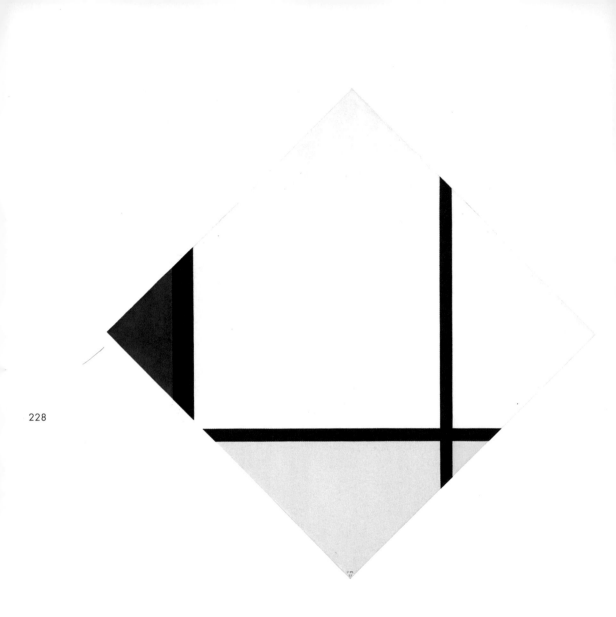

*Tableau No.I: Lozenge with Three Lines
and Blue, Grey and Yellow, 1925*
Oil on canvas
diagonal: 112 cm (44^1/$_8$")
sides: 80 x 80 cm (31^1/$_2$ x 31^1/$_2$")

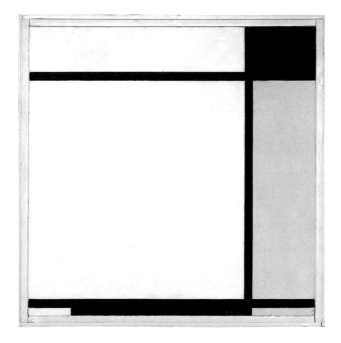

Tableau No.II with Black and Grey,
1925
Oil on canvas
50 x 50 cm (19⁶/₈ x 19⁶/₈")

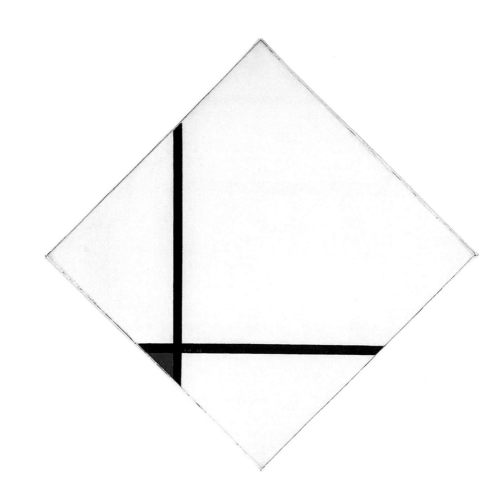

Schilderij No.1: Lozenge with
Two Lines and Blue, 1926
Oil on canvas
diagonals: 84.9 x 85 cm (33³/₈ x 33¹/₂″)
sides: 60 x 60.1 cm (23⁵/₈ x 23⁵/₈″)

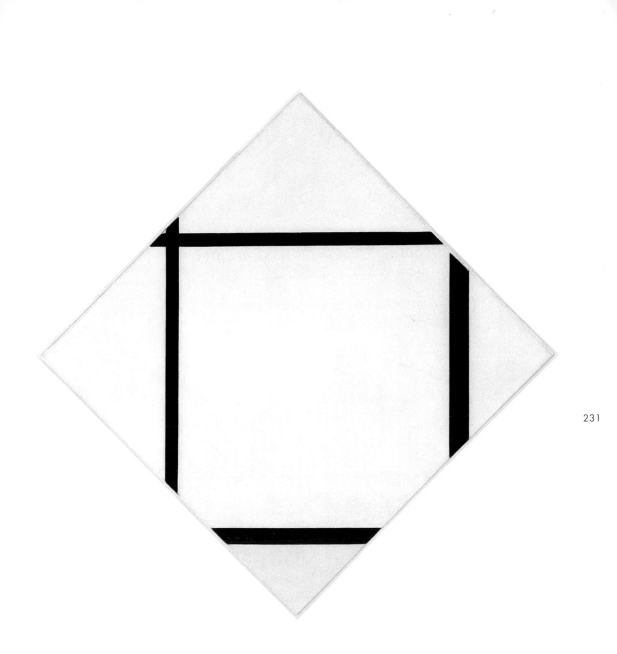

*Tableau I: Lozenge with Four Lines
and Grey, 1926*
Oil on canvas
diagonals: 113.7 x 111.8 cm (44³/₄ x 44")
sides: 80 x 80.4 cm (31⁵/₈ x 31³/₄")

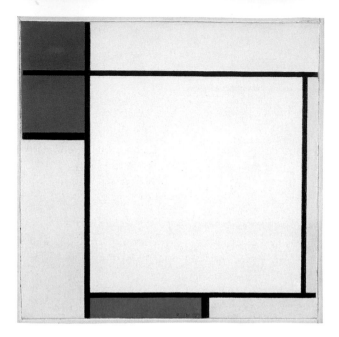

*Composition with Red,
Yellow and Blue, 1927*
Oil on canvas
51.1 x 51.1 cm (20¹/₈ x 20¹/₈")

*Composition with Black,
Red and Grey, 1927*
Oil on canvas
56 x 56 cm (22 x 22")

232

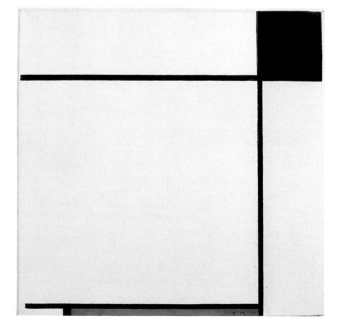

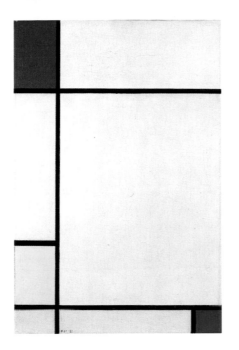

*Composition: No.III, with Red,
Yellow and Blue, 1927*
Oil on canvas
61 x 40 cm (24 x 15³/₄")

*Composition: No.I, with Black,
Yellow and Blue, 1927*
Oil on canvas
73.5 x 54 cm (28⁷/₈ x 21¹/₄")

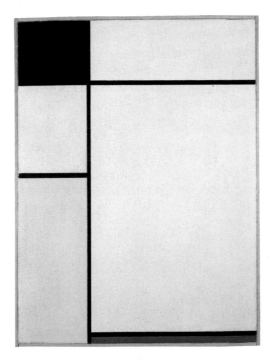

234

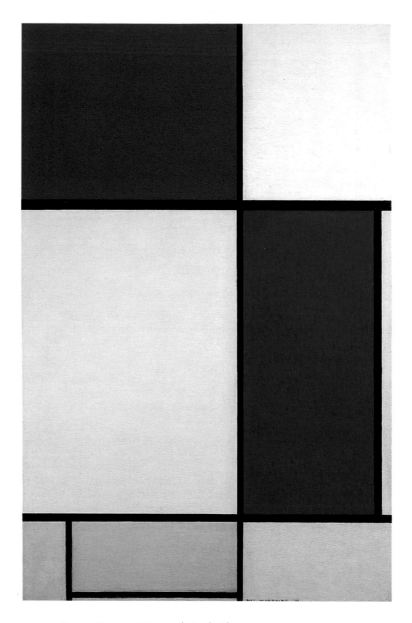

*Large Composition with Red, Blue
and Yellow, 1928*
Oil on canvas board mounted on canvas
122 x 79 cm (48 x 31¹/₈")

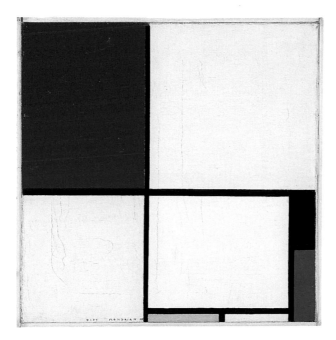

*Composition with Red, Black, Blue
and Yellow, 1928*
Oil on canvas
45 x 45 cm (17³/₄ x 17³/₄")

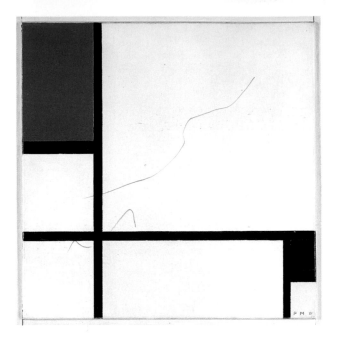

*Composition No.I, with
Red and Black, 1929*
Oil on canvas
52 x 52 cm (20$\frac{1}{2}$ x 20$\frac{1}{2}$")

*Composition with Red,
Blue and Yellow, 1930*
Oil on canvas
46 x 46 cm (18$\frac{1}{8}$ x 18$\frac{1}{8}$")

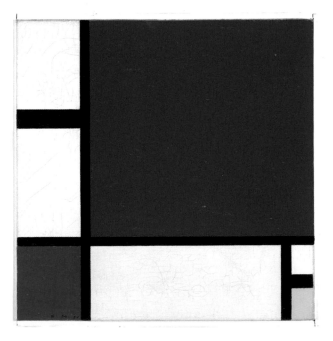

Composition No.I: Lozenge with
Four Lines, 1930
Oil on canvas
diagonal: 107 cm (42$^{1}/_{8}$")
sides: 75.2 x 75.2 cm (29$^{5}/_{8}$ x 29$^{5}/_{8}$")

238

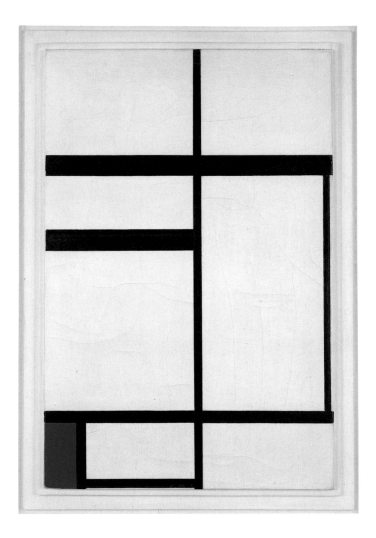

Composition No.I with Red, 1931
Oil on canvas
82.5 x 54.7 cm (32^1/$_2$ x 21^5/$_8$")

Lozenge Composition with Two Lines,
1931

Oil on canvas
diagonals: 112 x 112 cm (44^1/$_8$ x 44^1/$_8$")
sides: 80 x 80 cm (31^1/$_2$ x 31^1/$_2$")

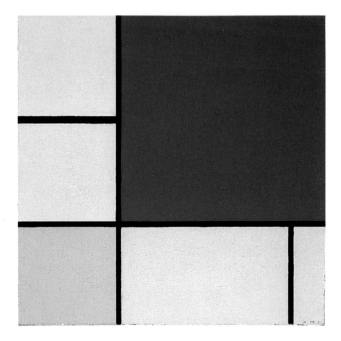

240

Composition with Blue and Yellow,
1932
Oil on canvas
45.4 x 45.4 cm (17⁷/₈ x 17⁷/₈")

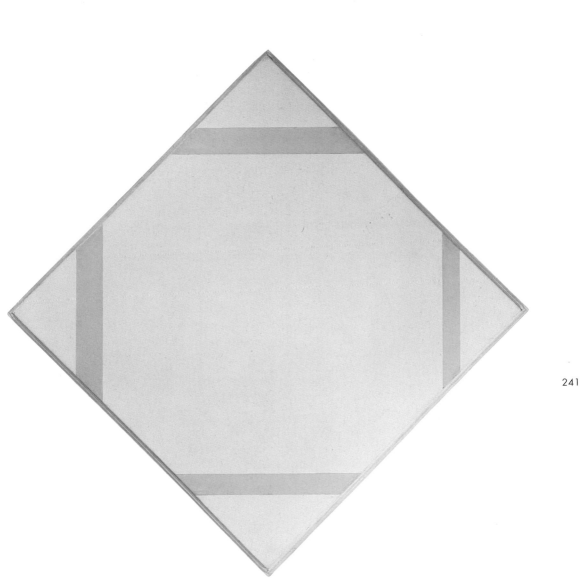

*Lozenge Composition with Four
Yellow Lines,* 1933
Oil on canvas
diagonal: 112.9 cm (44^1/$_4$")
sides: 80.2 x 79.9 cm (30^5/$_8$ x 30^1/$_2$")

Paris *1919–38*

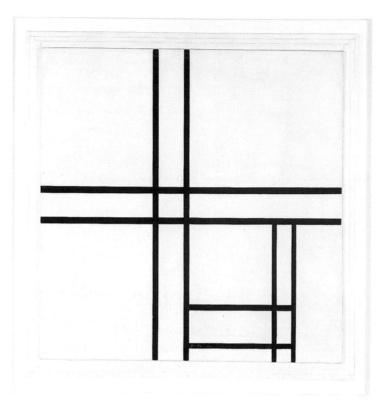

*Composition in Black and White,
with Double Lines, 1934*
Oil on canvas
59.4 x 60.3 cm (23³/₈ x 23³/₄")

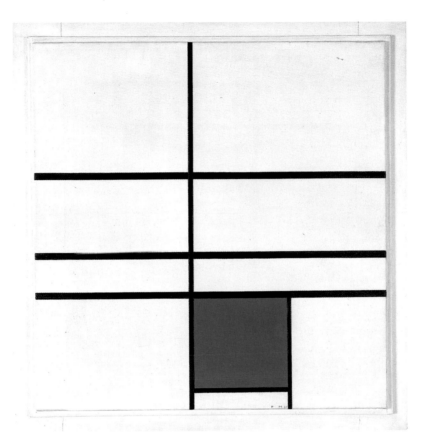

*Composition with Double Lines
and Blue, 1935*
Oil on canvas
71.1 x 68.9 cm (28 x 27$^{1}/_{8}$")

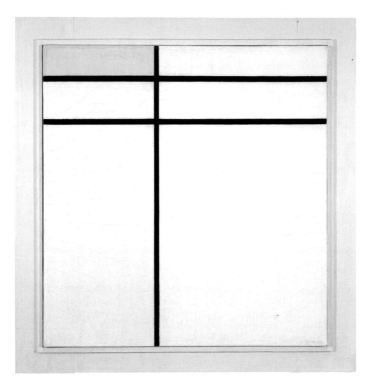

244

*Composition A with Double Lines
and Yellow, 1935*
Oil on canvas
59 x 56 cm (23^1/$_4$ x 22^1/$_8$")

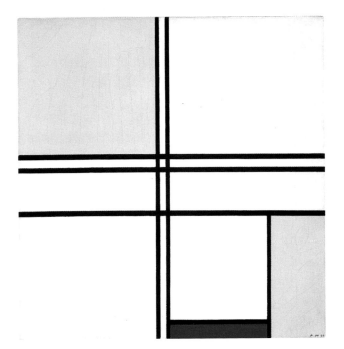

Composition (No.I), gris-rouge,
1935
Oil on canvas
56.9 x 55 cm (22^3/$_8$ x 21^5/$_8$")

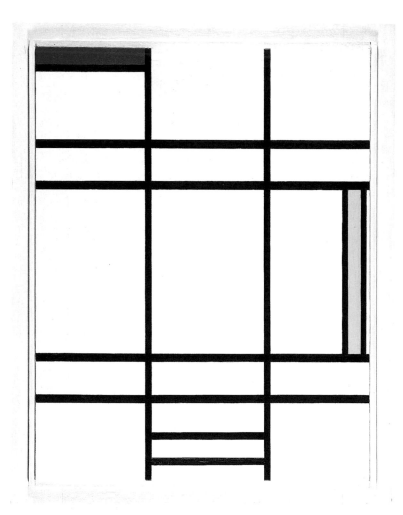

Composition – blanc, rouge et jaune:
A, 1936
(Composition – White, Red and
Yellow: A, 1936)
Oil on canvas
80 x 62.2 cm (31^1/$_2$ x 24^1/$_2$")

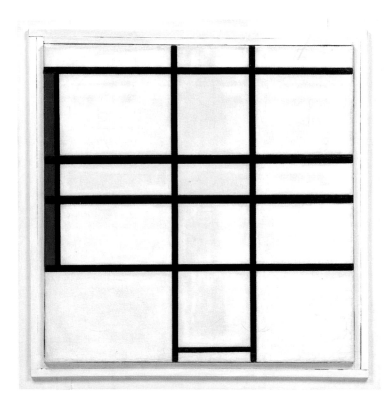

Composition – blanc et rouge: B, 1936
(Compostion – White and Red: B, 1936)
Oil on canvas
51.5 x 50.5 cm (20^1/$_4$ x 19^7/$_8$")

248

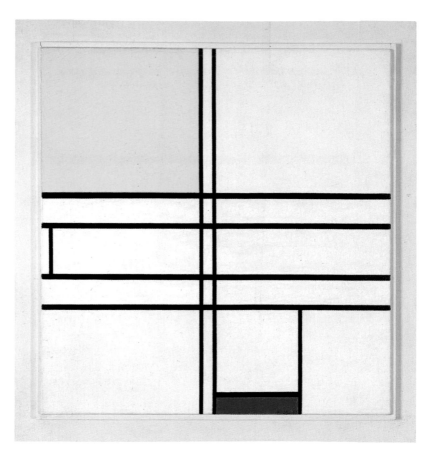

*Composition in White, Blue and
Yellow: C, 1936*
Oil on canvas
72 x 69 cm (28³/₈ x 27¹/₄")

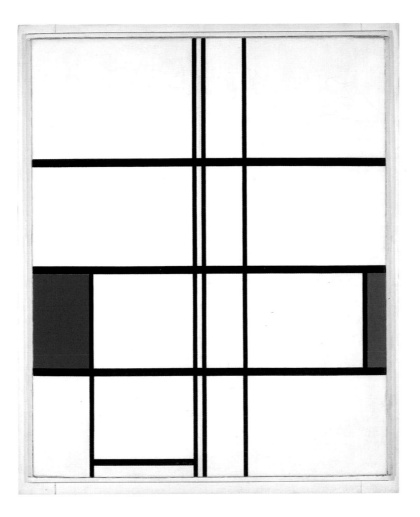

Composition en blanc, rouge et bleu,
1936
(Composition in White, Red and Blue,
1936)
Oil on canvas
98.5 x 80.3 cm (38³/₄ x 31⁵/₈")

250

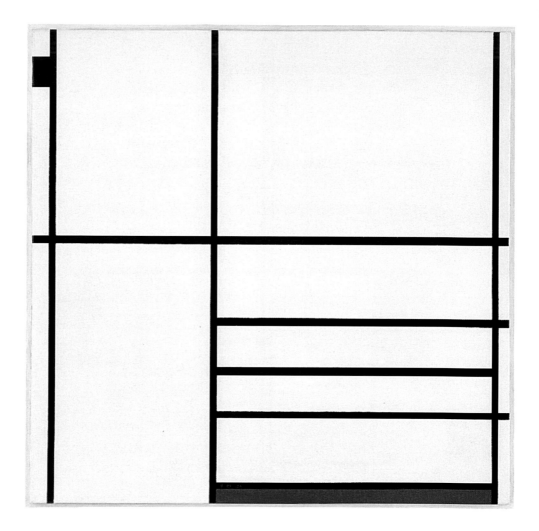

*Composition en blanc, noir et
rouge, 1936
(Composition in White, Black
and Red, 1936)*
Oil on canvas
102 x 104 cm (40^1/$_8$ x 41")

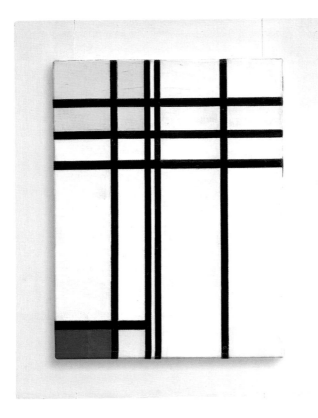

*No.I: Opposition de lignes, de rouge
et jaune, 1937*
*(Contrasting Lines, Red and Yellow,
1937)*
Oil on canvas
43.5 x 33.5 cm (17¹/₈ x 13¹/₄")

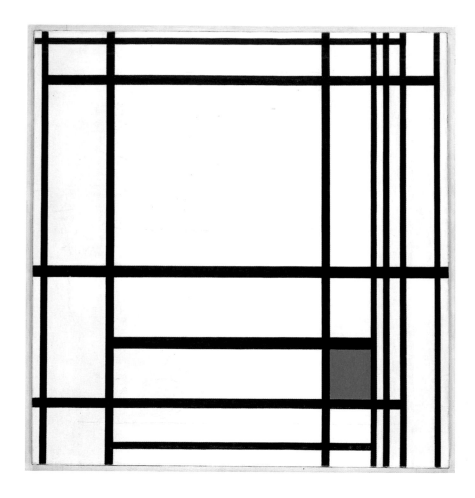

*Composition de lignes et couleur: III,
1937*
*(Composition in Line and Colour: III,
1937)*
Oil on canvas
80 x 77 cm (31^1/$_2$ x 30^3/$_8$")

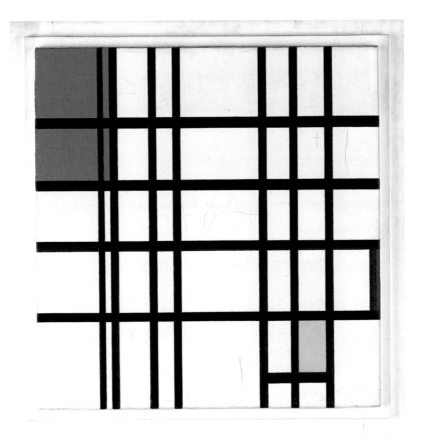

Rythme de lignes droites (et Couleur?),
1937 /
Composition with Blue, Red and Yellow,
1935–42, 1937/1942
Oil on canvas
72.2 x 69.5 cm (28$^7/_{16}$ x 27$^3/_8$")

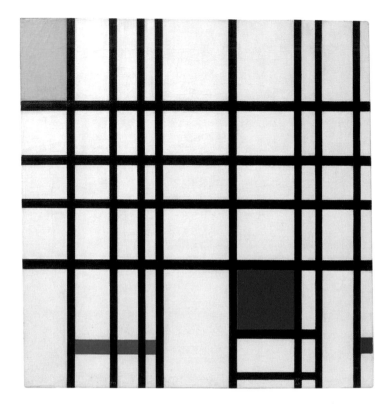

Composition (with Red ?)
(unfinished ?), 1937 /
Composition with Yellow, Blue
and Red, 1939–42, 1937/1942
Oil on canvas
72.5 x 69 cm (28⁵/₈ x 27¹/₄")

*Lozenge Composition with Eight
Lines and Red /
Picture No.III, 1938*
Oil on canvas
diagonal: 140 cm (55$\frac{1}{4}$")
sides: 100 x 100 cm (39$\frac{3}{8}$ x 39$\frac{3}{8}$")

256

LONDON 1938–40

NEW YORK 1940–4

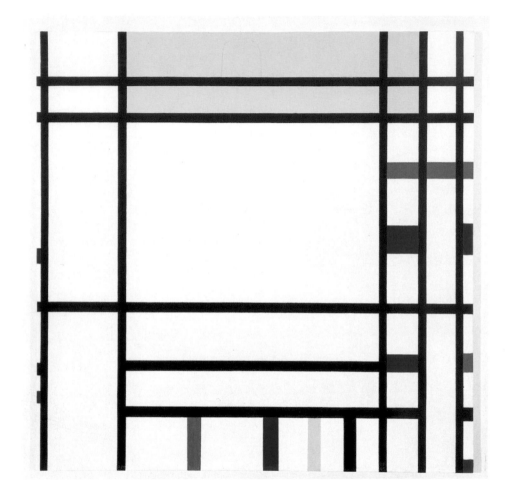

*Composition, 1938 /
Place de la Concorde,
1938–43, 1938/1943*
Oil on canvas
94 x 94.4 cm (37 x 37³/₁₆″)

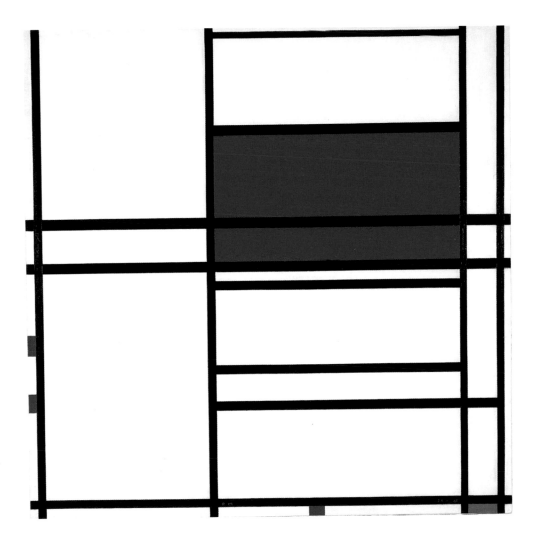

Composition of Red and White:
No.I, 1938 /
Composition No.4, 1938–42,
with Red and Blue, 1938/1942
Oil on canvas
100.3 x 99.1 (39^1/$_2$ x 39")

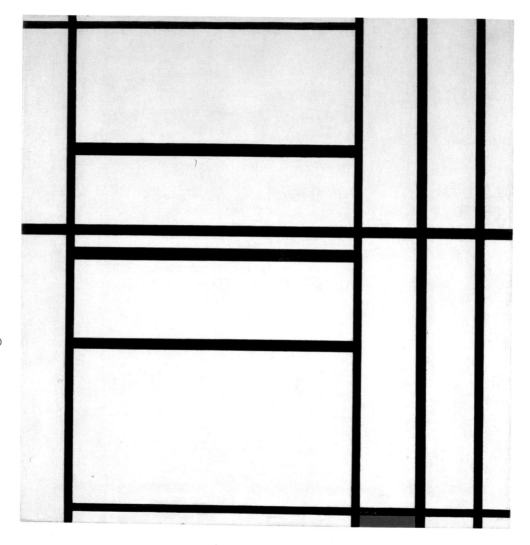

*Composition No.1 with Grey
and Red, 1938 /
Composition with Red, 1939*
Oil on canvas
105.2 x 102.3 cm (41⁷/₁₆ x 40⁵/₁₆")

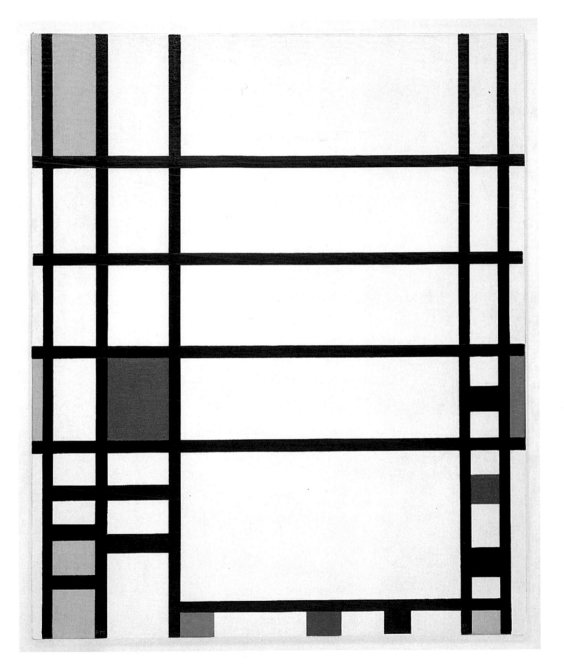

*Compositie, 1939 / Trafalgar
Square, 1939–43, 1939/1943*

Oil on canvas

145.2 x 120 cm (57^1/$_4$ x 47^1/$_4$″)

London *1938–40* New York *1940–4*

262

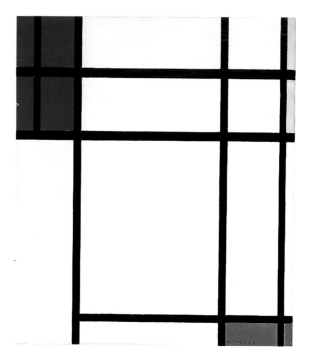

Composition No.2, 1938/
Composition of Red, Blue, Yellow
and White: No.III, 1939
Oil on canvas
44.6 x 38.2 cm (17⁹/₁₆ x 15¹/₁₆")

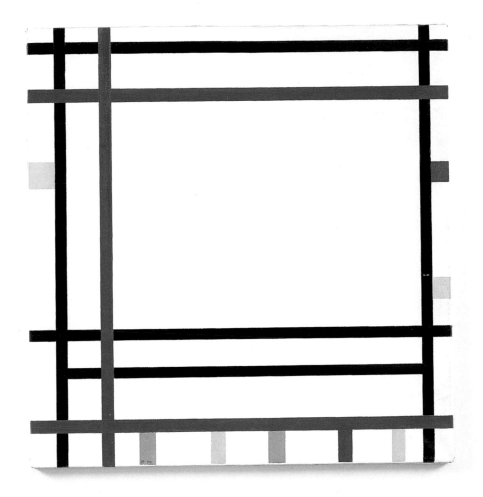

New York, 1941/
Boogie Woogie, 1941–2,
1941/1942
Oil on canvas
95.2 x 92 cm (37^1/$_2$ x 36^1/$_4$")

264

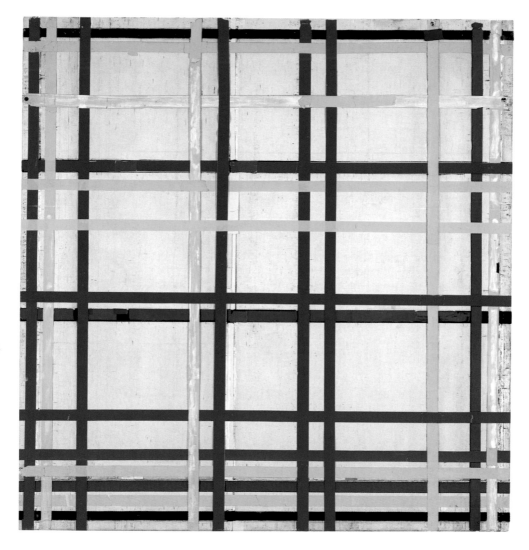

New York City 1 (unfinished), 1941
Oil and painted paper strips on canvas
119 x 115 cm (46^7/$_8$ x 45^1/$_4$")

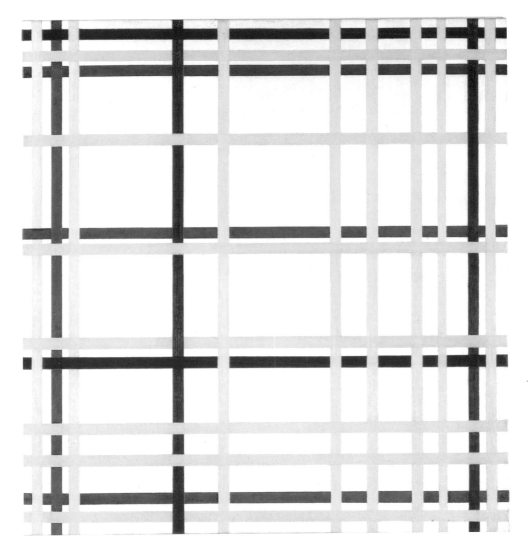

New York City, 1942
Oil on canvas
119.3 x 114.2 cm (47 x 45")

London *1938–40* New York *1940–4*

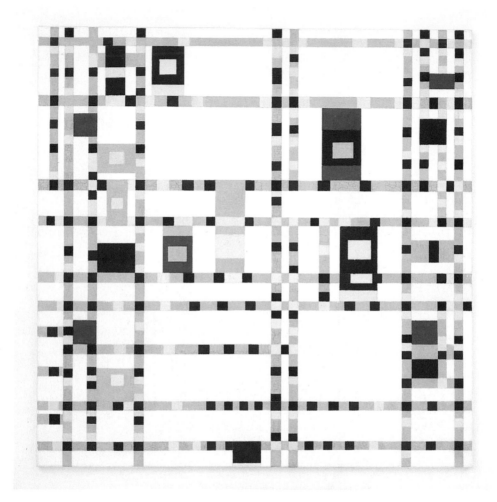

Broadway Boogie Woogie, 1942–3
Oil on canvas
127 x 127 cm (50 x 50″)

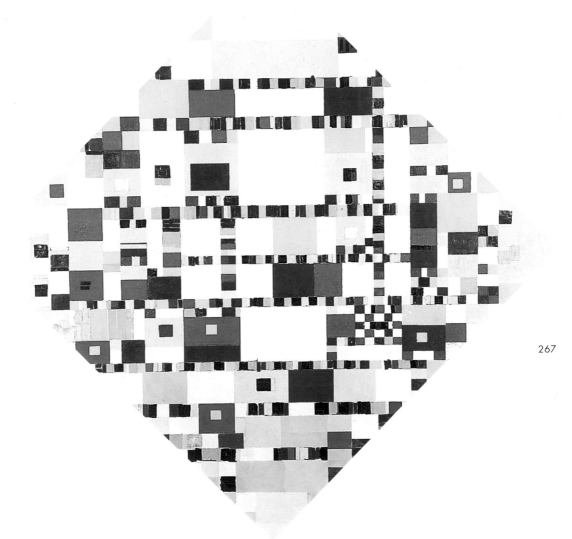

Victory Boogie Woogie
(unfinished), 1942–4/1944
Oil and paper on canvas
diagonal: 178.4 cm (70¹/₄")
sides: 126 x 126 cm (49⁵/₈ x 49⁵/₈")

268

TERSWIJK

1897

Woods with Stream, 1888
Charcoal and crayon on paper
62 x 48 cm (24³/₈ x 18⁷/₈")

Mountain Forest with Cottage, c.1888
Black crayon on paper
54 x 40 cm (21¹/₄ x 15³/₄")

Ships in the Moonlight, 1890
Oil on canvas
30.5 x 40.6 cm (12 x 16")

Church by the Water, 1890
Oil on canvas
dimensions unknown

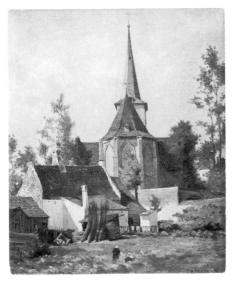

Church Seen from the Rear, c.1890–2
Oil on canvas
60 x 49.3 cm (23⁵/₈ x 19⁷/₈")

*Barn Interior in the Eastern
Netherlands, c.1890–2*
Charcoal (?) on paper
57 x 83 cm (22¹/₂ x 32⁵/₈")

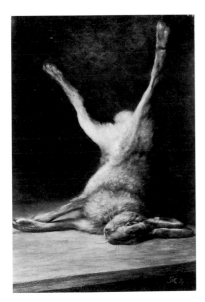

Geschoten haas (Dead Hare), 1891
Oil on canvas
80 x 51 cm (31¹/₂ x 20")

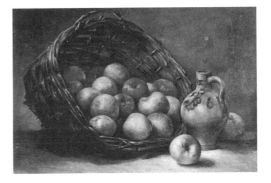

*Mand met appels (Basket with Apples),
1891*
Oil on canvas
49 x 73 cm (19¹/₄ x 28³/₄")

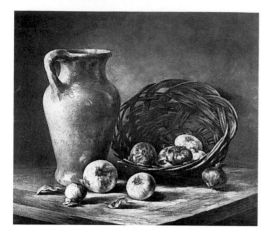

Kan met uijen (Pitcher with Onions),
1892
Oil on canvas
65 x 72 cm (25⁵/₈ x 28³/₈")

Pitcher, Jug and Basket, c.1890–2
Pastel on paper
62 x 75 cm (24³/₈ x 29¹/₂")

Uw woord is de waarheid
(Thy Word Is the Truth), 1894
Oil on canvas
150 x 250 cm (59 x 98³/₈")

Puppy, 1891
Oil on canvas
52 x 40 cm (20¹/₂ x 15³/₄")

Farm Interior with Hearth in the
Achterhoek, c.1890–2
Oil on canvas
56 x 62 cm (22 x 24³/₈")

Woman Peeling Potatoes, c.1892–4?
Oil on canvas
80 x 65 cm (31¹/₂ x 25⁵/₈")

Woman with Spindle, c.1893–6
Oil on canvas
36.8 x 29.8 cm (14¹/₂ x 11³/₄")

Lane with Sheaves of Rye, c.1890–2
Oil on canvas, mounted on board
37.5 x 27.5 cm (14³/₄ x 10⁷/₈")

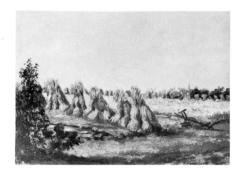

Sheaves of Rye with Plough,
c.1890–2
Oil on cardboard
29 x 39 cm (11³/₈ x 15³/₈")

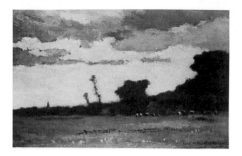

Dusk (Schemering), c.1890
Oil on canvas, remounted on board
26.6 x 43.1 cm (10¹/₂ x 17")

274

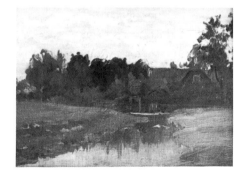

Brook with Sluice near Winterswijk,
c.1891–3
Oil on board
26 x 36 cm (10¹/₄ x 14")

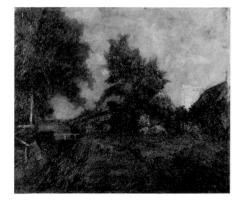

Warmte (Warmth): Farm in the
Achterhoek, c.1893–4
Oil on canvas
63.5 x 75 cm (25 x 29¹/₂")

Stream Bordered by Wooded Landscape, c.1894–6
Oil on canvas, mounted on board
28.5 x 37 cm (11$^1/_4$ x 14$^5/_8$")

Achterhoek Farmhouse with Haystack, c.1894–6
Oil on canvas
39 x 24 cm (15$^3/_8$ x 9$^1/_2$")

275

276

Christ's Heirs, 1894
Printed lithographs [?]
21.5 x 14 cm (8^1/$_2$ x 5^1/$_2$")

D.P. Rossouw, *Medeërfgenamen van Christus.*
Geschiedenis van de vervolgingen der Christelijke
Kerk. Met eene voorrede van Dr Andrew Murray.
(Christ's Heirs. History of the Persecutions of the
Christian Church, with a Preface by Dr Andrew
Murray). Amsterdam, n.d. [1896–7], cover (left).

278

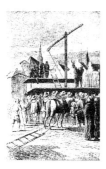

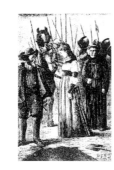

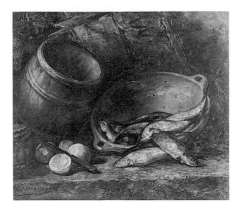

Stilleven (Still Life); Herring, 1893
Oil on canvas
66.5 x 77.5 cm (26¹/₈ x 29³/₄")

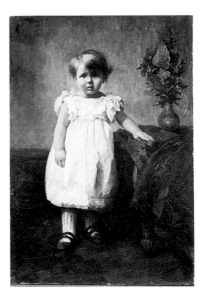

Dorothy Gretchen Biersteker, 1894
Oil on canvas
110.5 x 75 cm (43¹/₂ x 29¹/₂")

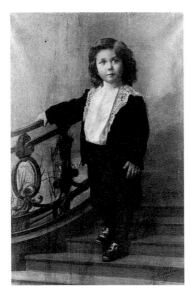

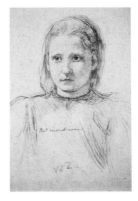

Head of a Girl, c.1896?
Black crayon on paper
21.5 x 15.5 cm (8¹/₂ x 6¹/₈")

Noel Biersteker, c.1897
Charcoal and chalk on paper
106.5 x 72.5 cm (42 x 28¹/₂")

Princesje (Young Princess), 1896
Oil on canvas
59.5 x 50 cm (23³/₈ x 19⁵/₈")

Women Doing the Wash, 1894–6
Oil on canvas
28.8 x 23.8 cm (11³/₈ x 9³/₈")

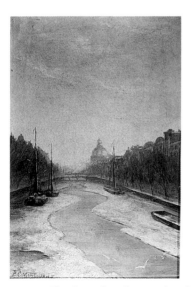

The Singel with Round Lutheran Church, 1893–5
Oil on canvas
69 x 46 cm (27¹/₈ x 18¹/₈")

The Broeker House, c.1895–8
Oil on canvas
82 x /1 cm (32¹/₄ x 28")

Farmyard with Laundry and Logs,
1895
Watercolour on paper
29 x 45 cm (11³/₈ x 17³/₄")

Church with Canal and Bridges, 1894–6
Charcoal and wash on paper
24 x 32.5 cm (9¹/₂ x 12³/₄")

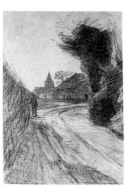

Village Church at Blaricum, c.1896–7
Charcoal
34.5 x 23 cm (13¹/₂ x 9¹/₂")

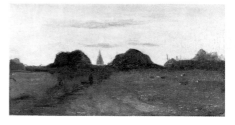

Field with Church Tower and Haystack,
c.1894–6
Oil on panel
15.5 x 30 cm (6¹/₈ x 11³/₄")

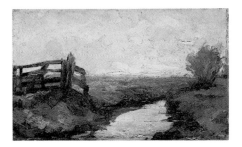

*Irrigation Ditch with Wooden Gate
at Left, c.1894–5*
Oil on cardboard
23 x 37.5 cm (9 x 14³/₄")

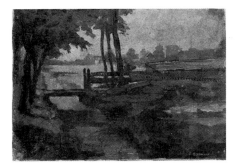

*Irrigation Ditch with Bridge, Sketch,
c.1894–5*
Oil on canvas (mounted on board)
26.5 x 37.5 cm (10¹/₂ x 14³/₄")

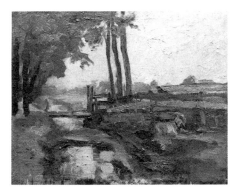

*Irrigation Ditch, Bridge and Goat,
Sketch, c.1894–5*
Oil on canvas
34 x 41 cm. (13³/₈ x 16¹/₈")

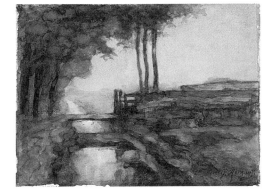

*Irrigation Ditch, Bridge and Goat,
Watercolour, c.1894–5*
Watercolour on paper, charcoal underdrawing
49 x 66 cm (19¹/₄ x 26")

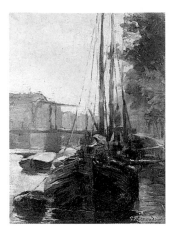

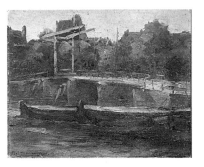

Waals-Eilandgracht with Bridge
and Flat Barges, c.1895–6
Oil on paper, laid down on panel
22.5 x 27.5 cm (8⁷/₈ x 10⁷/₈")

Waals-Eilandgracht with Bridge and
Moored Tjalks, c.1895–6
Oil on canvas, mounted on board
29.2 x 21.6 cm (11¹/₂ x 8¹/₂")

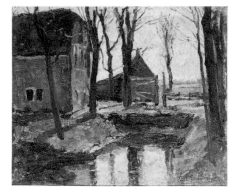

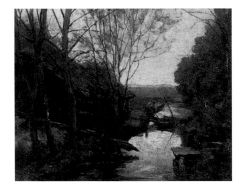

Farm Buildings with Trees
and Water Ditch, c.1895–6
Oil on canvas
29.2 x 39.4 cm (11¹/₂ x 15¹/₂")

Farm Building near Irrigation Ditch
with Farmer at Work, c.1895–6
Oil on canvas, laid down on cardboard
30.5 x 39.4 cm (12 x 15¹/₂")

*Scattered Trees on Sloping Land,
c.1894–6*
Oil on [?]
24.5 x 32.4 cm (9⁵/₈ x 12³/₄")

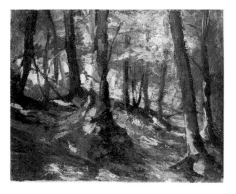

Tree Trunks on Sloping Land, c.1895–6
Oil on canvas
33 x 41 cm (13 x 16¹/₈")

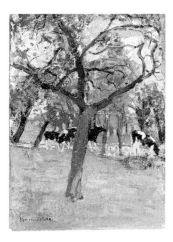

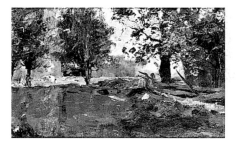

Trees and Cows in a Field, c.1895–7
Oil on canvas, laid down on wood
15 x 25 cm (5⁷/₈ x 9⁷/₈")

*Trees and Cows along a Stream,
c.1895–7*
Oil on canvas, laid down on cardboard
37 x 27 cm (14¹/₂ x 10⁵/₈")

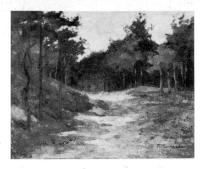

Wood near Driebergen, c.1896–7
Oil on canvas
34.6 x 35 cm (13^5/$_8$ x 13^3/$_4$")

*Three Farm Workers near a Gateway,
c.1896–7*
Oil on canvas
44.5 x 34.5 cm (17^1/$_2$ x 13^1/$_2$")

286

WINTERSWIJK

1897–9

Head of Farm Woman with
'Polkamuts,' c.1899
Charcoal and crayon on paper
40 x 30 cm (15³/₄ x 11³/₄")

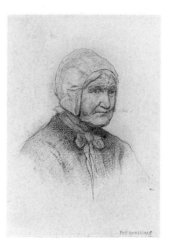

Head of an Achterhoek Farm
Woman, c.1899
Recto: Charcoal and pencil on white paper
34 x 23.5 cm (13³/₈ x 9¹/₄")
Verso: Pencil on white paper
34 x 23.5 cm (13³/₈ x 9¹/₄")

288

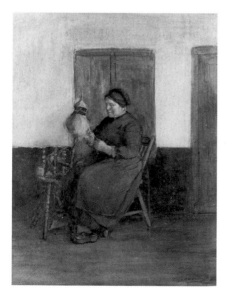

Woman Spinning, 1897–9
Charcoal and watercolour on paper
53 x 40.6 cm (20⁷/₈ x 16")

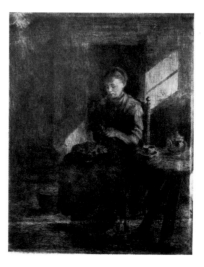

Young Woman Peeling Potatoes,
Etching, c.1897
Etching on paper
27.7 x 21.7 cm (10⁷/₈ x 8¹/₂")

Two Cows in a Pot Stall, c.1898–9
Charcoal and crayon on paper
33 x 45 cm (13 x 17³/₄")

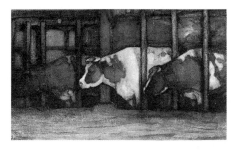

Three Cows in a Pot Stall, c.1898–9
Watercolour on paper
39.5 x 66 cm (15¹/₂ x 26")

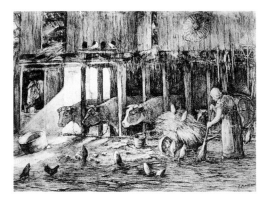

Threshing Area in an Achterhoek Farm Building, c.1898–9
Charcoal and crayon on paper
65 x 90 cm (25⁵/₈ x 35³/₈")

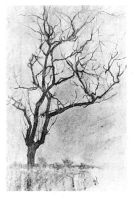

Tree Sketch for St Jacob's Church, Winter 1897–8
Charcoal and crayon on paper
16.3 x 11.5 cm (6³/₈ x 4¹/₂")

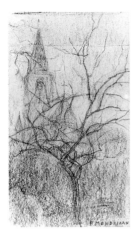

St Jacob's Church with Small Tree,
Winter 1897–8
Charcoal and crayon on paper
21 x 12 cm (8¹/₄ x 4³/₄")

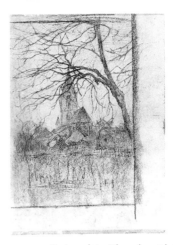

St Jacob's Church with Tree at Right,
Winter 1897–8
Pencil and crayon with touches of red
and blue watercolour on paper
(sheet) 48.5 x 33.6 cm (19¹/₈ x 13¹/₄")
(drawing) 40.5 x 25.5 cm (16 x 10")

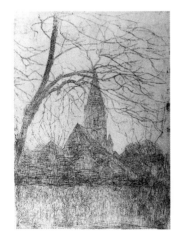

St Jacob's Church: Etching, c.1898
Etching on paper
37 x 26 cm (14¹/₂ x 10¹/₄")

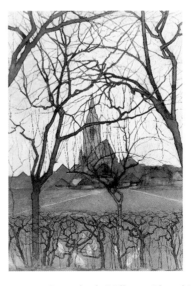

Dorpskerk (Village Church):
St Jacob's Church, c.1898
Gouache on paper
75 x 50 cm (29¹/₂ x 19⁵/₈")

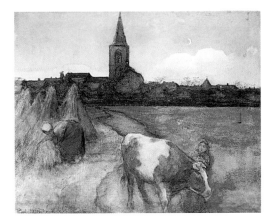

Farm Scene with St Jacob's Church,
c.1899
Watercolour and gouache on paper
53 x 65 cm (20^7/$_8$ x 25^5/$_8$")

Farm Setting at Winterswijk, c.1899
Charcoal on paper
56 x 76 cm (22 x 29^7/$_8$")

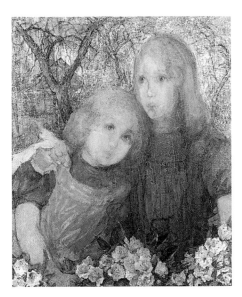

Lente idylle (Spring Idyll), 1900–01
Oil on canvas
c.75 x 64 cm (29^1/$_2$ x 25^1/$_2$")

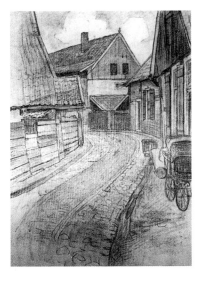

The Lappenbrink, View toward the
Meddosestraat, Drawing, c.1899
Red and black Conté crayon on buff blue paper
59 x 43 cm (23^1/$_4$ x 16^7/$_8$")

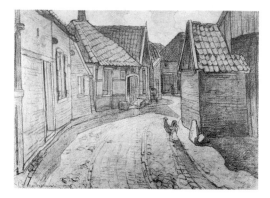

The Lappenbrink, View toward the
Nieuwstraat, Oil Sketch, c.1899
Oil on canvas, mounted on board
33.5 x 45 cm (13¹/₄ x 17³/₄")

The Lappenbrink, View toward the
Nieuwstraat, Drawing, c.1899
Red and black Conté crayon on paper
45 x 61 cm (17³/₄ x 24")

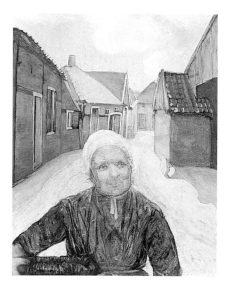

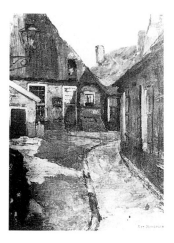

Op de Lappenbrink
(On the Lappenbrink), 1899
Gouache on paper
128 x 99 cm (50³/₈ x 39")

Near the Lappenbrink, 1898–9
Oil on canvas
44 x 32.5 cm (17³/₈ x 12³/₄")

*Farm Buildings in Winterswijk,
1898–9*
Oil on canvas, mounted on cardboard
dimensions unknown

The Weavers' House, Drawing, 1899
Pencil on paper
11.5 x 16.6 cm (4^1/$_2$ x 6^1/$_2$")

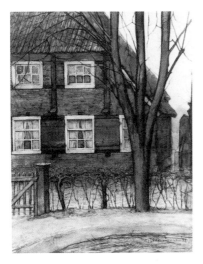

The Weavers' House, 1899
Gouache on paper
42.5 x 55.9 cm (16^3/$_4$ x 22")

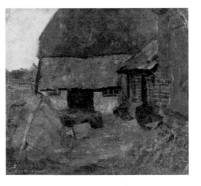

Farmyard in the Achterhoek, 1897–9
Oil on paper, mounted on canvas
dimensions unknown

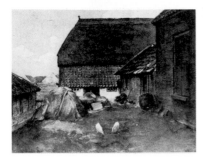

Farmyard in the Achterhoek, 1897–9
Watercolour on paper
dimensions unknown

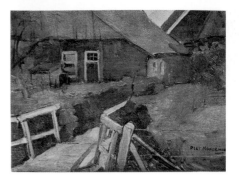

Farm Buildings with Bridge, c.1899
Oil on canvas
33.5 x 43.5 cm (13^1/$_4$ x 17^1/$_8$")

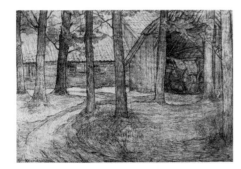

*Farmyard with Carriage Barn in the
Achterhoek, Drawing, c.1899*
Chalk and crayon [?] on cardboard
43.2 x 61 cm (17 x 24")

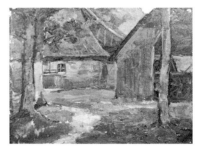

*Farmyard with Carriage Barn in the
Achterhoek, c.1899*
Oil on canvas
32.8 x 38.2 cm (12^7/$_8$ x 15")

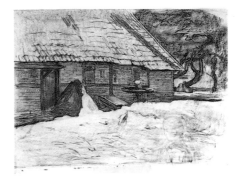

Woman and Farm Building in the Achterhoek, 1898–9
Oil on paper
37 x 23 cm (14^1/$_2$ x 9")

Side View of a Farm Building near Winterswijk, Drawing, c.1898–9
Black chalk, red Conté crayon and pencil on drawing cardboard
37.6 x 46.2 cm (14^3/$_4$ x 18^1/$_4$")

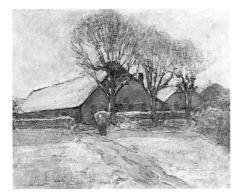

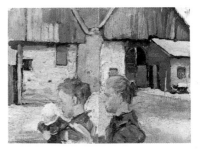

Winter Landscape with Three Farm Buildings, c.1899
Oil on canvas
50 x 59.5 cm (19^3/$_4$ x 23^1/$_2$")

Rear Gables of Farm Buildings with Figures, 1898–9
Oil on canvas
c.33 x 44 cm (c.13 x 17^1/$_4$")

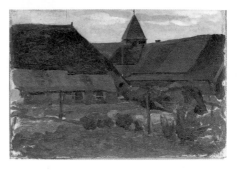

*Rear Gable of an Achterhoek Farm
Building, c.1899*
Oil on canvas (remounted)
31.5 x 27.3 cm (12³/₈ x 10¹/₂")

*Farm Buildings in an Achterhoek
Village, c.1898–9*
Oil on panel, mounted on cardboard
32 x 46.5 cm (12⁵/₈ x 18¹/₄")

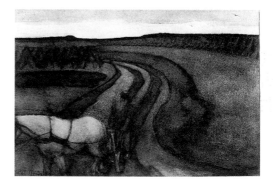

Horse and Cart: Study, c.1899
Charcoal on paper
21.5 x 30 cm (8¹/₂ x 11³/₄")

*Aan den arbeid (At Work):
Op het land (In the Fields), c.1899*
Watercolour/gouache on paper
54.4 x 78.7 cm (21³/₈ x 31")

Fields with Stacked Sheaves of Rye,
c.1899
Oil on canvas
45 x 59 cm (17³/₄ x 23¹/₄")

Wood with Beech Trees, Drawing,
c.1899
Pencil highlighted by white chalk on paper
32 x 40 cm (12⁵/₈ x 15³/₄")

297

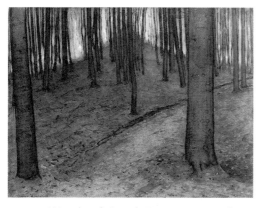

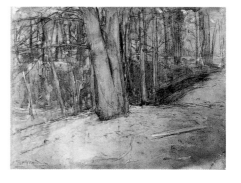

Wood with Beech Trees, Watercolour,
c.1899
Watercolour and gouache on paper
45.5 x 57 cm (17⁷/₈ x 22³/₈")

Birch Trees along a Pathway, 1898–9
Watercolour over crayon on paper
47.3 x 63.5 cm (18⁵/₈ x 25")

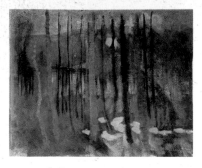

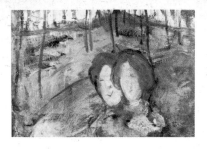

Woods, c.1898–9
Oil on canvas, mounted on cardboard
36.5 x 44.5 cm (14³/₈ x 17¹/₂")

Two Girls in a Wood, c.1898–9
Oil on paper, mounted on cardboard
27.3 x 37.9 cm (10³/₄ x 14⁷/₈")

298

AMSTERDAM

1897–1901

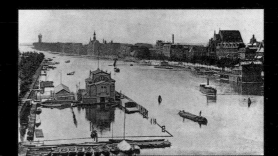

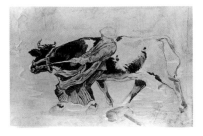

*Farm Woman with Cow
(after Julien Dupré), c.1898–9*
Washed pencil drawing on paper
32.2 x 48.5 cm (12⁵/₈ x 19")

Appelstudie (Study of Apples), 1897
Oil on canvas
29 x 45 cm (11¹/₂ x 19¹/₄")

*Apples on a Table, Two on a Plate,
c.1898–9*
Watercolour on paper
33.5 x 45.5 cm (13¹/₈ x 17⁷/₈")

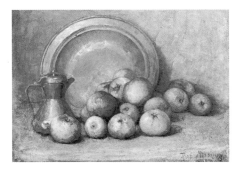

*Apples, Coffee Pot and Large
Copper Pan, 1900*
Oil on canvas
45 x 65 cm (17³/₄ x 25⁵/₈")

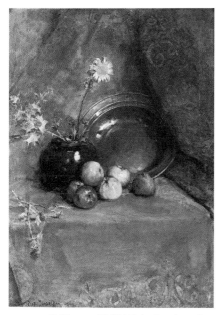

Stilleven (Still Life): Apples, Pot with Flowers and Metal Pan, 1900
Oil on canvas
94 x 68 cm (37 x 26³/₄")

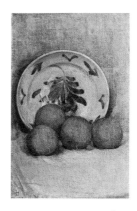

Sinaasappelen (Oranges): Oranges and Decorated Plate, 1900
Oil on canvas
45 x 29 cm (17³/₄ x 11¹/₂")

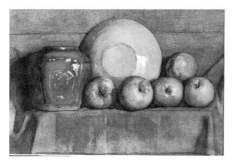

Apples, Ginger Pot and Plate on a Ledge, 1901
Watercolour on paper
37 x 55 cm (14¹/₂ x 25⁵/₈")

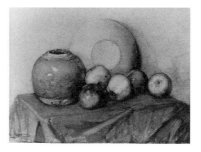

Apples, Round Pot and Plate on a Table, c.1901
Watercolour on paper
dimensions unknown

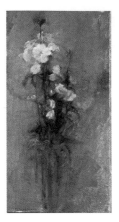

White Roses, c.1899–1900
Oil on canvas
46.5 x 24 cm (18¹/₈ x 9¹/₂")

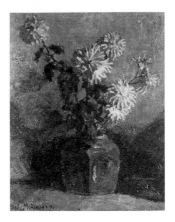

Yellow Chrysanthemums in a Ginger Pot, c.1898
Oil on canvas
42 x 34.5 cm (16¹/₂ x 13⁵/₈")

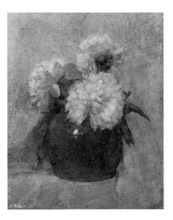

Three Chrysanthemum Blossoms in a Round Pot, c.1898–9
Oil on cardboard
46 x 38 cm (18¹/₈ x 15")

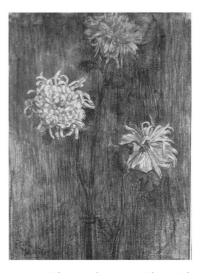

Chrysanthemums: Three Chrysanthemums, c.1899–1900
Black crayon on grey paper
59 x 43 cm (23¹/₄ x 16⁷/₈")

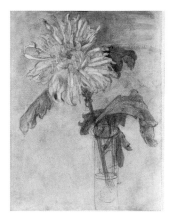

Chrysanthemum in a Tube Vase,
Drawing, c.1899
Pencil, watercolour on paper
29.8 x 22.6 cm (11³/₄ x 8⁷/₈")

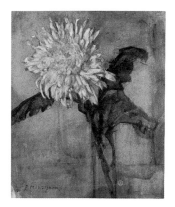

Chrysanthemum in a Tube Vase,
c.1899
Watercolour on paper
28.5 x 24.5 cm (11¹/₄ x 9⁵/₈")

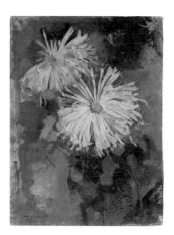

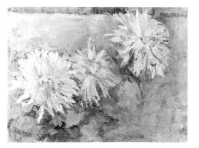

Three Chrysanthemum Blossoms,
c.1899–1900
Oil, support and dimensions unknown

Two Chrysanthemum Blossoms,
c.1899–1900
Oil on canvas mounted on cardboard
45 x 33.5 cm (17³/₄ x 13¹/₈")

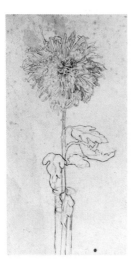

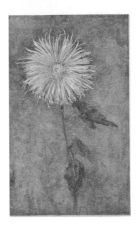

*Upright Chrysanthemum against
a Brownish Ground, 1900*
Watercolour on paper
36.8 x 22.9 cm (14¹/₂″ x 9″)

*Oriental Chrysanthemum in a Glass
Tube, c.1900*
Pencil and ink on paper
49 x 35 cm (19³/₈ x 13³/₄″)

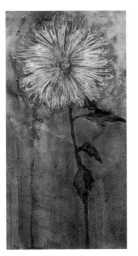

Water Lily Blossom, 1900
Crayon on paper
21.6 x 30.6 cm (8¹/₂ x 12″)

*Upright Chrysanthemum against
a Blue-Grey Ground, 1901*
Watercolour on paper
38.3 x 19.3 cm (15¹/₈″ x 7⁵/₈″)

Bust Portrait of an Old Man, c.1899?
Oil on canvas
50.3 x 40 cm (19³/₄ x 15³/₄")

Egbert Kuipers, c.1900–01
Oil on canvas
82.5 x 51.5 cm (32¹/₂ x 20¹/₄")

Egbert Kuipers and Wife, c.1900–01
Oil on canvas
84 x 54 cm (33 x 21¹/₄")

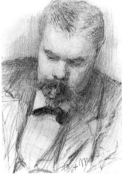

Frits Mondriaan, 1898
Crayon [?] on paper
13.8 x 9.7 cm (5³/₈ x 3³/₄")

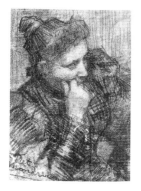

J.M. Mondriaan-Destrée, 1898
Crayon [?] on paper
13.8 x 9.7 cm (5³/₈ x 3³/₄")

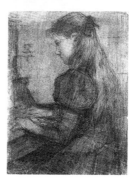

Johanna Mondriaan at the Piano, 1898
Crayon [?] on paper
13.8 x 9.7 cm (5³/₈ x 3³/₄")

306

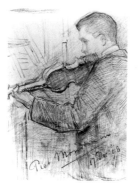

F.H. Mondriaan Playing the Violin, 1898
Crayon on paper
14.3 x 10.3 cm (5⁵/₈ x 4") incl. passe-partout

Rinus Ritsema van Eck at the Piano,
1900
Charcoal, crayon and touches of gouache on
paper
46 x 53 cm (18¹/₈ x 20⁷/₈")

Reindert Jacobus Nicolaas Solkamans,
c.1900
Black and white crayon on paper
54 x 40.5 cm (21 1/4 x 16")

Jan Coenraad Holtzappel, c.1900–01
Black Conté crayon and white chalk on paper
32.5 x 22.5 cm (12 3/4 x 8 7/8")

Resting Dog, c.1898–9
Charcoal and crayon on paper
c. 9.9 x 17 cm (3 7/8 x 6 3/4")

Alida and Marie Holtzappel, c.1900
Watercolour on paper
72 x 85 cm (28 3/8 x 33 1/2")

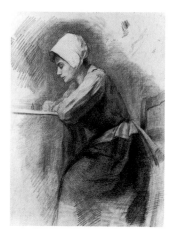

Girl with Bonnet Writing, c.1896–7
Black crayon on paper
57 x 44.5 cm (22³/₈ x 17¹/₂")

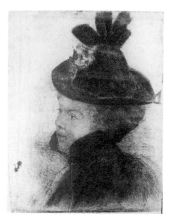

*Young Woman with Cape and Hat:
Etching, c.1899–1900*
Etching on paper
38 x 28.5 cm (15 x 11¹/₄")

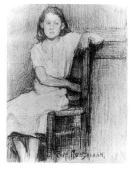

Seated Girl on a Chair, c.1900
Charcoal on paper
15.5 x 11.5 cm (6¹/₈ x 4¹/₂")

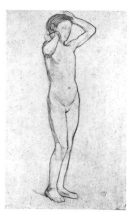

*Standing Nude Girl with Raised Arms,
c.1900*
Pencil on paper
47 x 30.5 cm (18¹/₂ x 12")

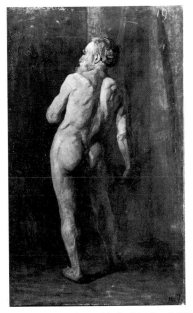

Standing Male Nude, 1901
Oil on canvas
100 x 60 cm (39³/₈ x 23³/₈")

Female Head in Profile, c.1898–9
Oil on canvas mounted on cardboard
c.42.5 x 39.5 cm (16³/₄ x 15¹/₈")

*Woman with Closed Eyes and Land-
scape with Figure, c.1899*
Pencil on white paper
34 x 23.5 cm (13³/₈ x 9¹/₄")

*Three Standing Female Figures,
c. Winter 1897–8*
Charcoal and crayon on paper
21 x 12 cm (8¹/₄ x 4³/₄")

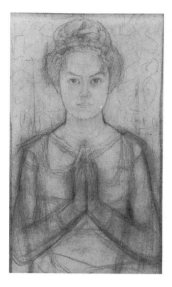

*Female Torso with Folded Hands,
c.1898–1900*
Charcoal on paper
70 x 50 cm (27¹/₂ x 19³/₄")

*Pulpit Decorations for the English
Church, Amsterdam (as executed in
wood by L.F. Edema Van der Tuuk), 1898*
Wood panels executed on the basis of drawings
commissioned from Mondrian
c. 73 x 45 cm (28³/₄ x 17³/₄") each

310

*Ceiling Decoration: The Four Seasons,
1899*
Oil on canvas
430 x 510 cm (169¹/₄ x 200³/₄")

*Gedenkplaat ter gelegenheid van
het huwelijk van Koningin Wilhelmina
(Commemorative Plate for the Mar-
riage of Queen Wilhelmina), 1901*
Pen and collage on paper
74 x 54 cm (29¹/₈ x 21¹/₄")

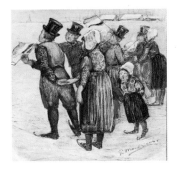

Skating Scene: Marken, c.1898–1901?
Pen and gouache on paper
14.5 x 14.5 cm (5³/₄ x 5³/₄")

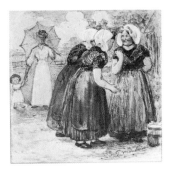

Summer Conversation: Zuid-Beveland in Zeeland, c.1898–1901?
Pen and gouache on paper
14.5 x 14.5 cm (5³/₄ x 5³/₄")

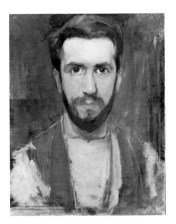

Self portrait, c.1900
Oil on canvas mounted on masonite
55 x 39 cm (19⁷/₈ x 15¹/₂")

Kindje (Young Child), 1900–01
Oil on canvas
53 x 44 cm (20⁷/₈ x 17¹/₄")

Girl Looking to Her Left, c.1901
Oil on canvas
52 x 43 cm (20^1/$_2$ x 16^7/$_8$")

*Female Portrait Bust in Exotic Costume,
1899*
Charcoal and white crayon on paper
51.8 x 41 cm (20^3/$_8$ x 16^1/$_8$")

Young Woman Resting, c.1898–1900
Charcoal on paper
78 x 59.5 cm (30^3/$_4$ x 23^3/$_8$")

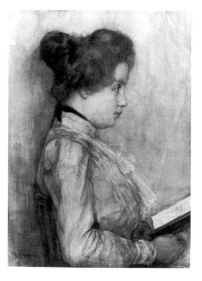

*Female Torso in Profile with Book,
c.1898–1900*
Watercolour on paper
89 x 50 cm (35 x 19^5/$_8$")

Young Woman (with Bulging Eyes)
Leaning to Her Left, c.1898–1900
Charcoal on paper
dimensions unknown

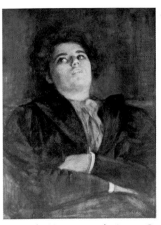

Seated Woman with Arms Crossed,
c.1898–1900
Watercolour on paper
59.5 x 44.7 cm (23¹/₂ x 17⁵/₈")

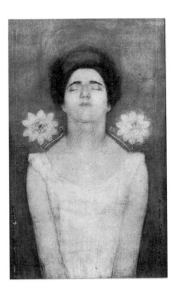

Passie bloem (Passion Flower), c.1901
Watercolour on paper
72.5 x 47.5 cm (28¹/₂ x 18⁵/₈")

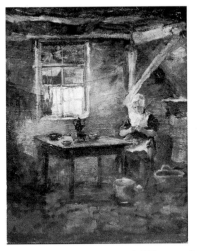

Farm Interior with Woman Peeling
Potatoes, c.1898–9
Oil on canvas
57 x 43 cm (22³/₈ x 17")

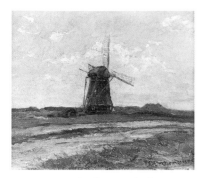

Windmill in Sunlight near a Stream, c.1897–8
Oil on canvas
29.8 x 35.6 cm (11³/₄ x 14")

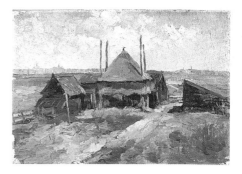

Haystack and Farm Sheds in a Field, 1897–8
Oil on canvas
36.5 x 52 cm (14³/₈ x 20¹/₂")

314

Haystack in Farmyard with Chickens and Ducks, 1897–8
Charcoal on paper
49.5 x 30.5 cm (19¹/₂ x 12")

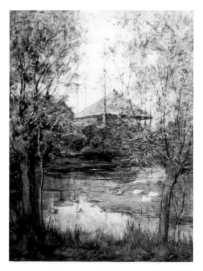

Hooischelf (Haystack), 1897–8
Watercolour on paper
64 x 47 cm (25¹/₄ x 18¹/₂")

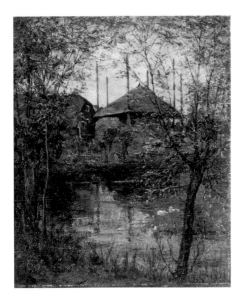

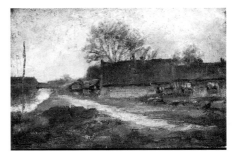

Farmstead along a Canal, c.1897–8
Oil on canvas (remounted)
34 x 52 cm (13³/₈ x 20¹/₂")

Haystack with Willow Trees, 1897–8
Oil on canvas
70 x 58 cm (27¹/₂ x 22⁷/₈")

315

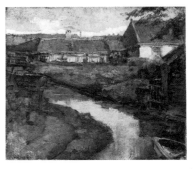

Farmstead along a Canal with Bridge and Farmer, c.1897–9
Watercolour on paper
41 x 56 cm (16¹/₈ x 22")

Farmstead and Irrigation Ditch with Prow of Rowing Boat, 1898–9
Oil on canvas mounted on panel
39.5 x 47 cm (15¹/₂ x 18¹/₂")

Small House along a Canal, c.1898–9
Oil mounted on panel (then remounted on canvas)
30 x 40.8 cm (11³/₄ x 16")

Country Lane with Houses, 1898–9
Oil on canvas mounted on cardboard
30 x 42 cm (11³/₄ x 16¹/₂")

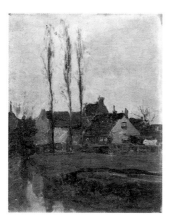

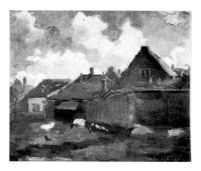

Three Italian Poplars and Buildings,
c.1898
Oil on canvas laid down on panel
31.5 x 40 cm (12³/₈ x 15³/₄")

Goats Grazing near Buildings, c.1898
Oil on canvas
29.5 x 35.5 cm (11⁵/₈ x 14")

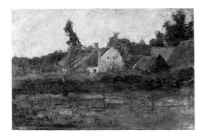

*Farm Buildings with Fence in
Foreground, c.1898*
Oil on cardboard mounted on panel
33.5 x 52 cm (13^1/$_8$ x 20^1/$_2$")

*Farm Building with Haystack Viewed
along the Horizon, 1898–9*
Oil on paper
37 x 54 cm (14^1/$_2$ x 21^1/$_4$")

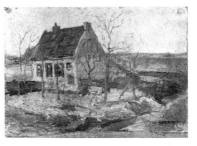

House in the Countryside, c.1898
Oil on canvas laid down on board
21 x 30 cm (8^1/$_4$ x 11^3/$_4$")

*Country Lane with Row of Workers'
Houses, c.1898–9*
Oil on paper
39 x 29.5 cm (15^3/$_8$ x 11^5/$_8$")

Wijk aan Zee, c.1900–01
Oil on paper laid down on board
31.5 x 21.3 cm (12³/₈ x 10³/₈")

Farm Sheds and Haystacks in the Dunes, c.1898–1900
Oil on canvas mounted on board
31.5 x 38.5 cm (12³/₈ x 15¹/₈")

318

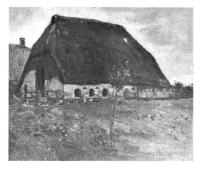

Farm Building in Overijssel, c.1898
Oil on canvas mounted on wood
21 x 25.7 cm (8⁵/₁₆ x 10¹/₈")

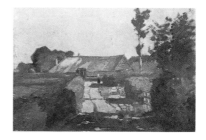

Farm Building near Laren, c.1898–9
Oil on canvas mounted on cardboard
31 x 43 cm (12¹/₄ x 15⁵/₈")

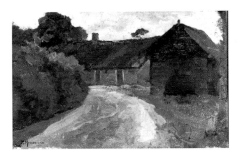

*Farm Complex in Het Gooi, Roadway
in Foreground, c.1898–9*
Oil on canvas
46 x 55 cm (10³/₈ x 15³/₄")

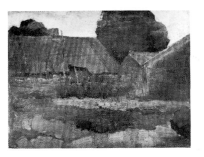

*Farmstead in Het Gooi with Three
Buildings, c.1898–9*
Oil on canvas mounted on board
26.7 x 36.5 cm (10¹/₂ x 14¹/₃")

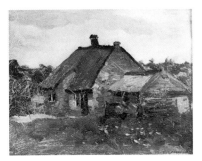

*Small Farm Buildings in Het Gooi,
c.1898*
Oil on cardboard
32.5 x 40 cm (12³/₄ x 15³/₄")

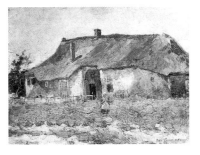

*Farm Building in Het Gooi with Child,
c.1898*
Oil on canvas mounted on panel
38.5 x 49 cm (15¹/₈ x 19¹/₄")

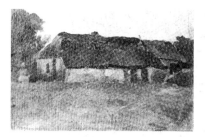

Farm Building in Het Gooi,
Viewed from a Field, c.1898
Oil on canvas mounted on board
29 x 42 cm (11³/₈ x 16¹/₂")

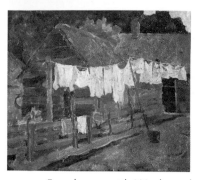

Farmhouse with Wash on the Line,
c.1898
Oil on cardboard
31.5 x 37.5 cm (12³/₈ x 14³/₄")

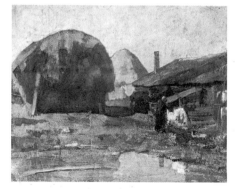

Haystacks, Farm Building and Farm
Woman with the Wash, c.1898
Oil on canvas
46 x 55 cm (18¹/₈ x 21⁵/₈")

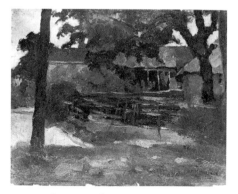

Farmstead in Het Gooi, Viewed between
Trees and over a Fence, 1898–9
Oil on cardboard
45.5 x 56 cm (17⁷/₈ x 22")

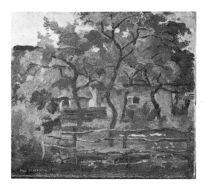

Farm Building in Het Gooi, Fence and Trees in the Foreground, c.1898–1902
Oil on canvas
38 x 42 cm (15 x 16¹/₂″)

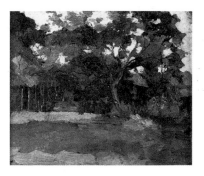

Farm Buildings in Het Gooi Veiled by Trees, c.1898–1902
Oil on paper mounted on board
32 x 38.5 cm (12³/₄ x 15¹/₈″)

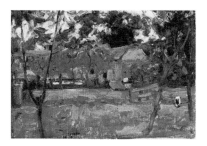

Farmyard in Het Gooi Flanked by Saplings, 1901–02
Oil on canvas
30.3 x 43 cm (11⁷/₈ x 16⁷/₈″)

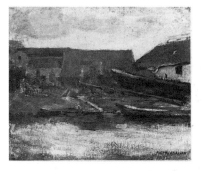

Scheepstimmerwerf (Shipworks), 1898
Oil on canvas
31 x 37 cm (12¹/₄ x 14⁵/₈″)

The Kostverlorenvaart, c.1898
Oil on canvas mounted on cardboard
28.5 x 39 cm (11 1/4 x 15 3/8")

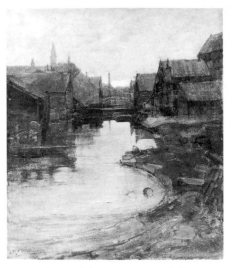

*Lange Bleekerssloot with Tower
of the West Church, 1898*
Oil on canvas
81 x 68 cm (31 7/8 x 26 3/4")

322

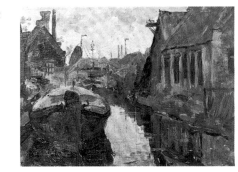

Lange Bleekerssloot with Barge, c.1898
Oil on canvas
dimensions unknown

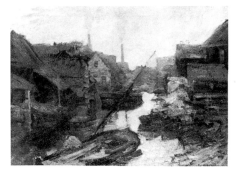

*Lange Bleekerssloot: View toward
the Kostverlorenvaart, c.1898*
Oil on canvas (mounted on panel)
50.8 x 67.3 cm (20 x 26 1/2")

*View from a Bridge on the Achterweg,
c.1898–9*
Red and black crayon
(plus touches of wash on paper)
27 x 23 cm (10⁵/₈ x 9")

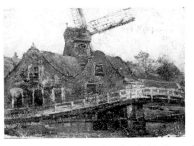

Bridge on the Achterweg, c.1898–9
Crayon and watercolour on blue-grey paper
40.5 x 62 cm (16 x 24³/₈")

Bridge on the Middenweg, c.1898–9
Black, white and red chalk on paper
32 x 63 cm (12¹/₂ x 24³/₄")

*Houses and Paltrok Mill on the
Voorweg, 1898–9*
Oil on canvas (mounted on board?)
27.3 x 38 cm (10³/₄ x 15")

Wingless Paltrok Mill in the
Schinkelbuurt, c.1898
Oil on canvas
31 x 38.5 cm (12$^1/_8$ x 15$^1/_8$")

Footbridge in the Schinkelbuurt,
c.1899–1900
Oil on canvas
28.5 x 37.5 cm (11$^1/_4$ x 14$^3/_4$")

Houses Viewed from a Bridge in
the Schinkelbuurt, 1898–9
Watercolour on paper
42 x 52 cm (16$^1/_2$ x 20$^1/_2$")

The Royal Wax Candle Factory,
Drawing, 1900–01
Crayon on paper
18 x 26 cm (7$^1/_2$ x 10$^5/_8$")

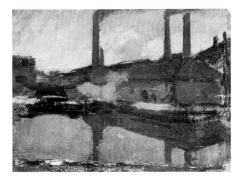

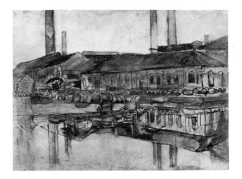

*The Royal Wax Candle Factory,
Oil Sketch, 1900–01*
Oil on canvas mounted on cardboard
35 x 48 cm (13 3/4 x 18 7/8")

*The Royal Wax Candle Factory,
1900–01*
Watercolour on paper
42 x 58.5 cm (17 x 23")

*The Boerenwetering with Shed of the
Royal Wax Candle Factory, c.1898–9*
Oil on canvas mounted on cardboard
33 x 43 cm (13 x 16 7/8")

*Factory District near the
Boerenwetering, c.1898–9*
Oil on canvas
29 x 57 cm (11 3/8 x 22 1/2")

*Study for Stadhouderskade,
Two-Page Drawing, c.1899*
Pencil and Conté crayon on paper
11.5 x 32 cm (4 1/2 x 12 5/8")

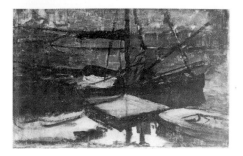

Stadhouderskade, Oil Sketch, c.1899
Oil on canvas
40 x 61 cm (15 3/4 x 24")

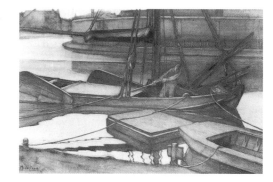

*Aan de Stadhouderskade te Amsterdam,
(Stadhouderskade, Amsterdam), 1900*
Charcoal, watercolour and pastel on cardboard
62 x 100 cm (24 3/4 x 39 3/8")

*Moored Small Barges among
Buildings, c.1900*
Charcoal and crayon on two sheets of paper
joined together
c.15.5 x 17 cm (6 1/8 x 6 5/8")

Group of Moored Barges, c.1900
Charcoal and crayon on paper
17 x 11 cm (6⁵/₈ x 4¹/₄")

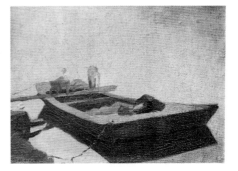

Unloading a Sand Barge, c.1900
Oil on canvas
37 x 50 cm (14¹/₂ x 19⁵/₈")

Horse on the Bank, c.1900
Charcoal and crayon on paper
17 x 11 cm (6⁵/₈ x 4¹/₄")

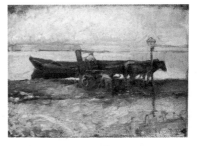

*Moored Barge with Horses,
1898–1900*
Oil on canvas mounted on cardboard
35.5 x 49.5 cm (14 x 19¹/₂")

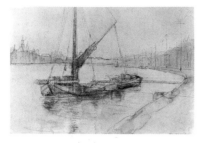

Moored Tjalk, Amsteldijk and Weesper-
zijde as Background, c.1897–9
Charcoal and watercolour on paper
32.5 x 45.5 cm (12 3/$_4$ x 18")

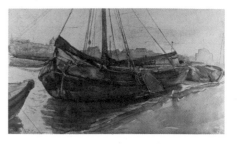

Tjalk with Rigging Moored on the
Weesperzijde, c.1901–02
Washed drawing (crayon plus watercolour)
on paper
33 x 55 cm (13 x 21 5/$_8$")

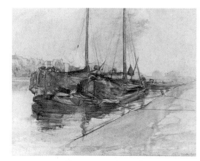

Tjalks moored on the Weesperzijde, 1902
Watercolour on paper mounted on cardboard
43 x 54 cm (17 x 21 1/$_4$")

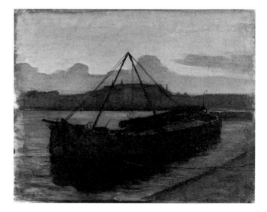

Avond aan de Weesperzijde (Evening
on the Weesperzijde), 1901–02
Crayon, watercolour and gouache on paper
55 x 66 cm (22 x 26")

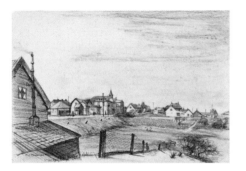

*View near the Weesperzijde, Tower
of Blooker Chocolate Factory in the
Distance, 1899*
Pastel on paper
45.5 x 65 cm (17⁷/₈ x 25⁵/₈")

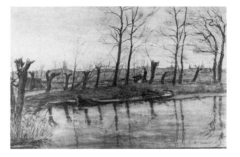

*Amsterdam Skyline Viewed from
the West, c.1899*
Charcoal and watercolour on paper
39.7 x 58.4 cm (15⁵/₈ x 23")

*Dry dock at Durgerdam, Oil Sketch,
c.1898–9*
Oil on cardboard
36.5 x 46 cm (14³/₈ x 18¹/₈")

*Dry Dock at Durgerdam, Mixed Media,
c.1898–9*
Charcoal, watercolour and gouache on paper
45 x 61 cm (17³/₄ x 24")

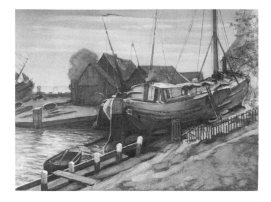

*Dry Dock at Durgerdam, Watercolour,
c.1898–9*
Watercolour on paper
63 x 84 cm (24³/₄ x 33")

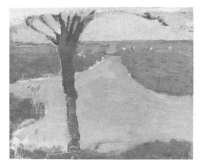

*Irrigation Ditch with Young Pollarded
Willow, Oil Sketch I, 1900*
Oil on canvas
dimensions unknown

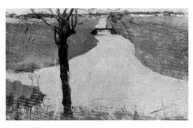

*Irrigation Ditch with Young Pollarded
Willow, Oil Sketch II, 1900*
Oil on canvas
23.5 x 37.5 cm (9¹/₄ x 14³/₄")

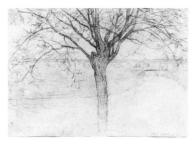

*Irrigation Ditch with Young Pollarded
Willow, Drawing I, 1900*
Black Conté crayon on paper
21.6 x 30.6 cm (8¹/₂ x 12")

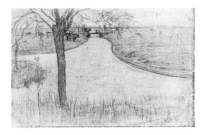

*Irrigation Ditch with Young Pollarded
Willow, Drawing II, 1900*
Pencil on paper
32 x 37.7 cm (12⁵/₈ x 14⁷/₈")

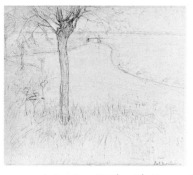

*Irrigation Ditch with Young Pollarded
Willow, Drawing III, 1900*
Pencil on paper
39.2 x 61.6 cm (15¹/₂ x 24¹/₄")

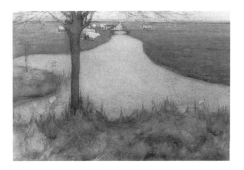

*Irrigation Ditch with Young Pollarded
Willow, Watercolour, 1900*
Watercolour on paper
43 x 62 cm (16⁷/₈ x 24³/₈")

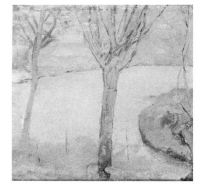

*Irrigation Ditch with Two Willows,
c.1900*
Oil on canvas
28.5 x 28.5 cm (11¹/₄ x 11¹/₄")

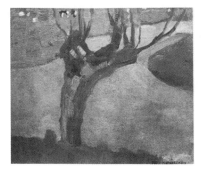

*Irrigation Ditch with Mature Willow,
c.1900*
Oil on board
25 x 30 cm (9³/₄ x 11³/₄″)

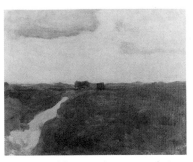

*Polder Landscape with Irrigation Ditch,
1900–01*
Oil on canvas mounted on panel
31.5 x 39.5 cm (12³/₈ x 15¹/₂″)

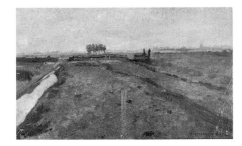

*Polder Landscape with Irrigation Ditch
and Fence, 1900–01*
Oil on canvas
28 x 47.5 cm (11¹/₈ x 18⁷/₈″)

*Sketches of Cows Standing and Lying
Down, c.1900–01*
Pencil on paper
11.5 x 16.5 cm (4¹/₂ x 6¹/₂″)

Sketch of Cows Standing Facing Right,
c.1900–01
Crayon on paper
23 x 30 cm (9 x 11 $3/4$")

Polder Landscape with Irrigation Ditch
and Two Cows, 1900–01
Oil on canvas
20.5 x 38.5 cm (8 x 15 $1/8$")

Outline Drawing for Polder Landscape
with Irrigation Ditch and Two Cows,
1900–02
Crayon on paper
26.5 x 35.5 cm (10 $3/8$ x 14")

Polder Landscape with Irrigation Ditch
and Five Cows, 1900–01
Oil on canvas mounted on cardboard
27 x 35 cm (10 $5/8$ x 13 $3/4$")

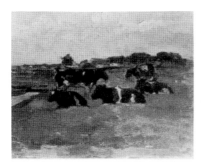

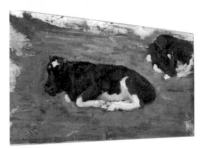

Polder Landscape with Group of Five Cows, c.1901–02
Oil on canvas mounted on panel
32 x 38 cm (12 $\frac{5}{8}$ x 15")

Polder Landscape with Two Cows, c.1901–02?
Oil on canvas mounted on board
21 x 36 cm (8 $\frac{1}{4}$ x 14 $\frac{1}{4}$")

334

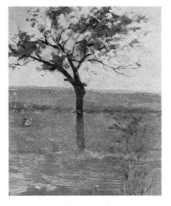

Landscape with Four Cows in Profile, c.1900–01
Oil on paper mounted on cardboard
25.5 x 29 cm (10 x 11 $\frac{3}{8}$")

Polder Landscape with Silhouetted Young Tree, 1900–01
Oil on cardboard
32.5 x 28 cm (12 $\frac{3}{4}$ x 11")

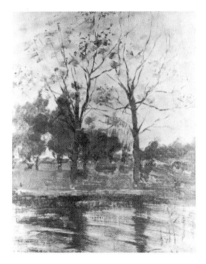

Two Trees Silhouetted behind a water-course, 1900–02
Oil on canvas laid down on board
46.5 x 36 cm (18 $1/4$ x 14 $1/8$")

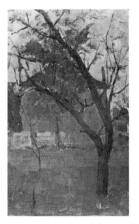

Haystack behind Silhouetted Tree, 1900–01
Oil on canvas
40.5 x 25 cm (16 x 9 $7/8$")

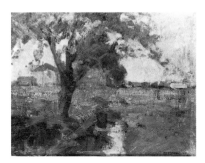

Farm Setting with Foreground Tree and Irrigation Ditch, 1900–02
Oil on cardboard
36.5 x 47.5 cm (14 $3/8$ x 18 $3/4$")

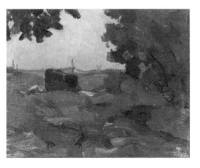

Free Impression of a Polder Landscape, c.1901–02
Oil on canvas mounted on cardboard
29 x 36.5 cm (11 $3/8$ x 14 $3/8$")

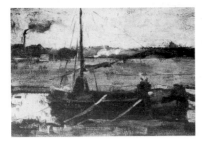

Polder with Moored Boat near Amsterdam I, 1899–1900
Oil on cardboard
24 x 37 cm (13 3/8 x 21 5/8")

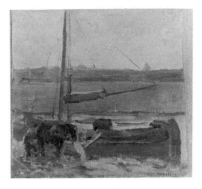

Polder with Moored Boat near Amsterdam II, 1900–01
Oil on canvas
31.7 x 32.3 cm (12 1/2 x 12 3/4")

336

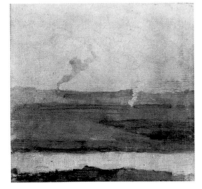

Polder Landscape, Smoke Rising in Background, 1900–01
Oil on cardboard
27.5 x 29.5 cm (10 7/8 x 11 5/8")

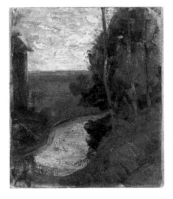

Fragment of an Irrigation Ditch, c.1901–02
Oil on canvas
31 x 26.5 cm (12 3/8 x 10 3/8")

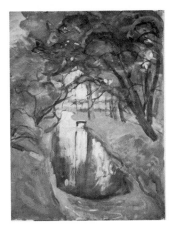

Shaded Irrigation Ditch, c.1901–02
Watercolour on paper
42.5 x 31 cm (16³/₄ x 12¹/₄")

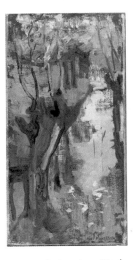

Irrigation Ditch with Pollarded Willows, c.1901–02
Oil on paper laid down on masonite
40 x 21 cm (15³/₄ x 8¹/₄")

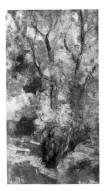

Tree Growth, c.1901–02
Oil on cardboard
31 x 17 cm (12¹/₄ x 6³/₄")

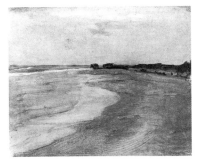

Beach Scene, c.1900–02
Oil on wood panel
29.3 x 36.1 cm (11¹/₂ x 14¹/₄")

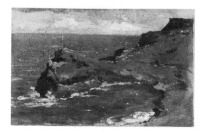

Rocky Coast in England, 1900
Oil on canvas
25.5 x 39 cm (10 x 15")

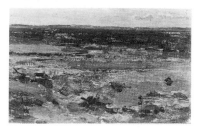

Sketch of Uncultivated Open Landscape, c.1901–02?
Oil on canvas
24 x 38.5 cm (9 1/2 x 15 1/8")

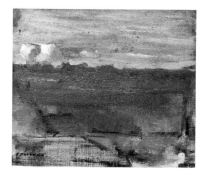

Underpainting of Landscape with High Horizon, 1900–01?
Oil on canvas mounted on board
27 x 32 cm (11 x 13")

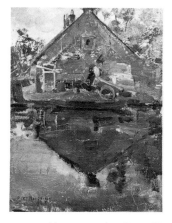

House on the Gein (1741) Sketch, 1900
Oil on canvas
41.8 x 31 cm (16 1/2 x 12 1/4")

House on the Gein (1741)
Reversed Sketch, 1900
Oil [on board?]
19.5 x 30.5 cm (7³/₄ x 12″)

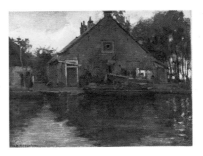

House on the Gein (1741), 1900
Oil on canvas
24.5 x 32.5 cm (9⁵/₈ x 12⁷/₈″)

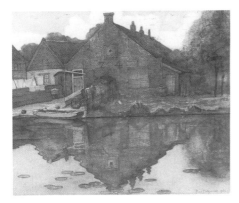

House on the Gein (1741)
Watercolour, 1900
Watercolour and gouache on paper
46 x 57 cm (18¹/₈ x 22¹/₂″)

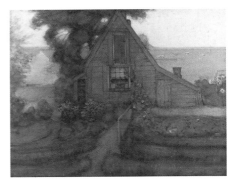

Triangulated Farmhouse Façade
with Polder in Blue, c.1900
Watercolour and gouache on paper
45.5 x 58.5 cm (17⁷/₈ x 23″)

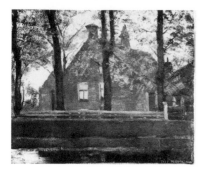

*Façade of Maria's Hoeve Farm
Building on the Gein, c.1900–02*
Oil on canvas (remounted)
32 x 37 cm (12⁵/₈ x 14⁵/₈")

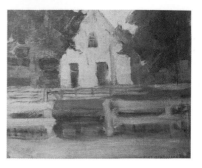

*Gabled Farmhouse Façade in White,
c.1900–02*
Oil on canvas mounted on cardboard
25.4 x 35 cm (10 x 12")

340

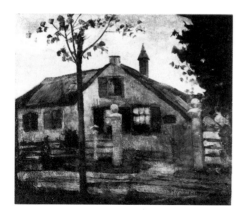

*Gabled Farmhouse Façade with Large
Gateposts, c.1901–02*
Oil on [?]
48 x 56 cm (18⁷/₈ x 22")

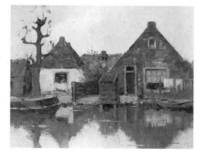

*Two Gabled House Façades along
a Canal, c.1900–02*
Oil on panel
30.5 x 39.4 cm (12 x 15¹/₂")

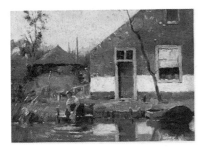

*Truncated View of a Gabled House
Façade on a Canal, c.1900–02*
Oil on panel
31 x 38 cm (12^1/$_4$ x 15")

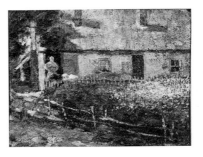

Farmhouse with Garden, c.1900–02
Oil [on?]
31 x 42 cm (12^1/$_4$ x 16^1/$_2$")

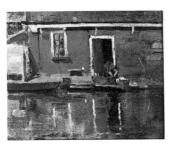

*House Façade on the Water with
Woman doing the Washing,
c.1900–02*
Oil on canvas mounted on panel
22.5 x 27.5 cm (8 x 10^7/$_8$")

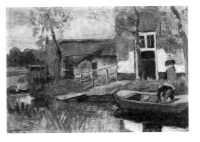

*Farm Buildings near a Canal
with Small Boat, 1900–01*
Oil in canvas mounted of board
22.7 x 33.5 cm (8^{11}/$_{16}$ x 13^3/$_{16}$")

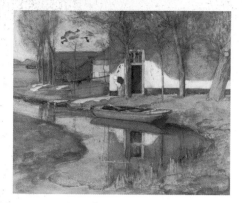

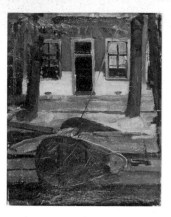

Farm Buildings near a Canal with Small Boat, Watercolour, 1900–01
Watercolour on paper
45 x 53 cm (17$^{3}/_{4}$ x 20$^{7}/_{8}$")

Truncated View of Tjalk and House Façade, c.1900–01
Oil on canvas
49 x 35.5 cm (19$^{1}/_{4}$ x 14")

Upper Façade of House on the Hemonylaan, Amsterdam, c.1900
Black crayon on paper
17 x 11.8 cm (6$^{3}/_{4}$ x 4$^{5}/_{8}$")

Truncated View of Tjalk and House Façade, Watercolour, c.1900–01
Watercolour on paper
53.5 x 39 cm (21 x 15$^{3}/_{8}$")

AMSTERDAM

1902–05

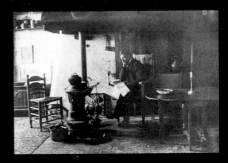

A Stage Design, c.1902–03
Pencil on cardboard
17 x 31 cm (6³/₄ x 12¹/₄")

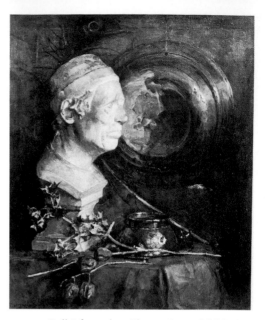

Still Life with a Plaster Bust, 1902–03
Oil on canvas
73.5 x 61.5 cm (29 x 24¹/₄")

344

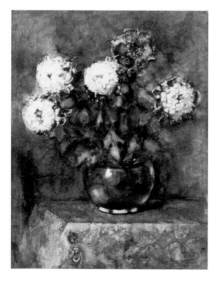

*Five Chrysanthemums in a Round Vase,
c.1903?*
Watercolour, gouache, chalk on paper
64 x 49 cm (25 x 19")

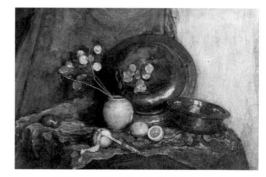

*Stilleven (Still Life): Still Life with a Pot
of Honesty, Containers and Fruit, 1905*
Oil on canvas
58 x 87 cm (22⁷/₈ x 34¹/₄")

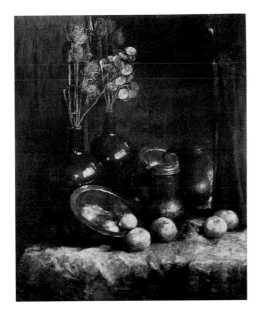

Still Life with Mirror, Containers, Honesty and Fruit, 1905
Oil on canvas
100 x 75 cm (39³/₈ x 29¹/₂")

Ex Libris for H.H. Crabb, c.1900–05
Lithograph
10.5 x 11.8 cm (4¹/₈ x 4⁵/₈")

Ex Libris for E.E. Seelig: Strebe zum Licht, c.1905?
Lithograph
13.4 x 10.5 cm (5¹/₄ x 4¹/₈")

Ex Libris for E.E. Seelig: Strebe zum Licht with Figure, c.1905?
Lithograph
8.6 x 11.7 cm (3³/₈ x 4⁵/₈")

Ex Libris for E.E. Seelig: Carpe Diem,
c.1905?
Lithograph
10.0 x 13.3 cm (4 x 5^1/$_4$")

Ex Libris for E.E. Seelig: Life is a
Comedy, c.1905?
Etching, interior measurements:
9.4 x 17.1 cm (3^3/$_4$ x 6^3/$_4$")
measurement of paper:
18.4 x 28.4 cm (7^1/$_4$ x 11^1/$_4$")

Rijmpje Kessler, c.1903
Pencil on paper
13.8 x 9 cm (5^1/$_2$ x 3^1/$_2$")

C.M. J.W. Rijnen, c.1900–05?
Oil on panel
49.75 x 39 (19^5/$_8$ x 15^3/$_8$")

L.C.M. Rijnen-van den Bosch,
c.1900–05?
Oil on panel
49.75 x 39 cm (19⁵/₈ x 15³/₈")

Rear Admiral J.C. de Ruyter de Wildt,
c.1900–04
Oil on canvas
69 x 87.5 cm (27¹/₈ x 34¹/₂")

Frits Mondriaan, c.1905? (Ludwig
Wilhelm Schöffer, c.1831–1904), c.1905
Oil on canvas
68 x 52.5 cm (26³/₄ x 20⁵/₈")

D.J. Hulshoff Pol, 1905
Oil on canvas
75 x 55.5 cm (29¹/₂ x 21⁷/₈")

J.P.G. Hulshoff Pol, 1905
Oil on canvas
75 x 55.5 cm (29 1/2 x 21 7/8'")

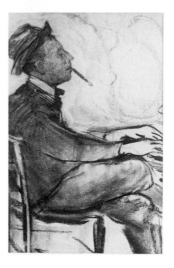

J. Siedenburg at the Piano, 1903–05
Charcoal on paper
51 x 28 cm (20 x 11")

Op het land: (On the Land, Oil Study),
1903
Oil on cardboard
30.5 x 38 cm (12 x 15")

Tip-up Bridge in a Meadow, c.1903
Oil on canvas
21.5 x 28 cm (8 3/8 x 11")

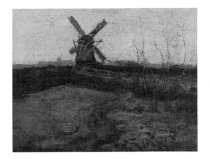

*Windmill with Church Towers in
the Distance, c.1902–03*
Oil on canvas
22 x 30 cm (8¹/₄ x 11")

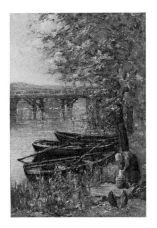

*Vinkenbrug te Diemen:
(Vinken Bridge at Diemen), 1902*
Oil on canvas
52 x 36.1 cm (21¹/₂ x 14¹/₄")

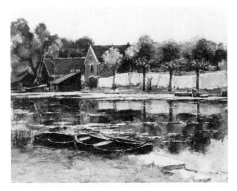

*Bleekerij aan het Gein
(Bleaching Works on the Gein), 1902*
Watercolour on paper
48 x 59 cm (18⁷/₈ x 18¹/₄")

*Curved Irrigation Ditch Bordering
Farmyard with Flowering Trees,
c.1902*
Oil on canvas
50 x 68.5 cm (20 x 27")

*Fields Overlooking Arnhem from
the North, c.1901–02*
Oil on paper laid down on panel
34 x 45.4 cm (13³/₆ x 17⁷/₈")

Bij Arnhem (Near Arnhem), 1902
Watercolour on paper
47.5 x 66 cm (18³/₄ x 26")

*Roadway and Farm Building
near Arnhem, c.1902?*
Oil on panel
35.5 x 26.5 cm (14 x 10¹/₂")

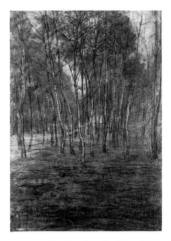

Berkenbosje (Small Birch Forest), 1902?
Charcoal and gouache
58.5 x 42 cm (23 x 16¹/₂")

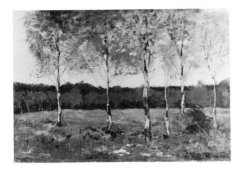

*Six Young Birch Trees in a Field,
c.1902–03*
Oil on canvas
33 x 49 cm (13 x 19^1/$_4$")

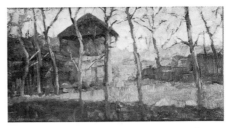

*Op de Ringdijk, Watergraafsmeer
(On the Ringdijk, Watergraafsmeer),
1902*
Oil on canvas mounted on board
27.5 x 50.5 cm (10^7/$_8$ x 19^7/$_8$")

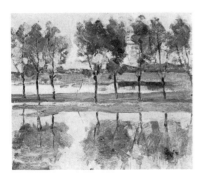

*Row of Eight Young Willows Reflected
in the Water, c.1905*
Oil on cardboard mounted on panel
31 x 35 cm (12^1/$_8$ x 13^3/$_4$")

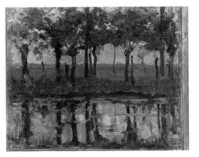

*Row of Young Willows Reflected
in the Water, c.1905*
Oil on canvas mounted on board
31 x 38 cm (12^1/$_4$ x 15")

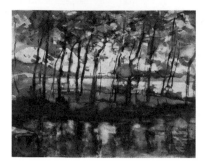

*Young Tree Grove amidst Water
Reflections, 1902–05*
Watercolour on paper
30.3 x 39.7 cm (11¹¹/₁₆ x 15⁵/₈")

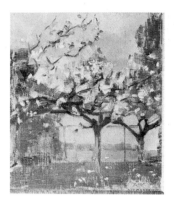

*Blossoming Trees before a Haystack,
c.1902–05*
Oil on canvas laid down on cardboard
28 x 24 cm (11 x 9¹/₂")

*Farmyard with Fruit Trees and
Haystack, c.1902–03*
Gouache and crayon on paper
34 x 59.5 cm (13³/₈ x 23³/₈")

Trees near a Hedge, c.1903 or 1905
Oil on canvas mounted on cardboard
19.5 x 32 cm (7⁵/₈ x 12⁵/₈")

*Narrow Farm Building and Trees
along the Water, c.1905*
Oil on canvas mounted on cardboard
25.5 x 38.5 cm (10 x 15^1/$_8$")

*Farm Building with White Façade,
c.1905*
Oil on [paper mounted on?] canvas
31 x 38.5 cm (12^1/$_4$ x 15^1/$_4$")

*Farm Building with Fence Reaching
to the Water, c.1905*
Oil on canvas mounted on cardboard
23.5 x 37 cm (9^1/$_4$ x 14^1/$_2$")

*Curved Canal with Farm Building
at Right, c.1905*
Oil on paper
26 x 32.5 cm (10^1/$_4$ x 12^3/$_4$")

*Farmhouse Façade with Curb Roof,
c.1905*
Oil on canvas
33 x 45 cm (13 x 17³/₄")

*Gabled Farmhouse Façade with Tree,
Fence and Gateposts in Front, c.1905*
Oil on canvas originally mounted on cardboard
36.4 x 48.2 cm (14³/₈ x19")

*Gabled Farmhouse Façade with Row
of Trees and Blue Sky, c.1905*
Oil on cardboard laid down on canvas
19.5 x 31.7 cm (7¹/₂ x 12¹/₂")

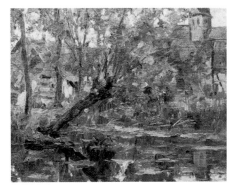

*Willow Suspended over the Water
before Farm Building and Church
Tower, c.1905*
Oil on canvas
39.4 x 50.2 cm (15¹/₂ x 19³/₄")

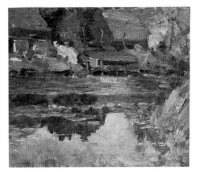

*Buildings along the Water with
a Wash Stoop, c.1905*
Oil on canvas laid down on board
33.5 x 33.3 cm (13 1/4 x 13")

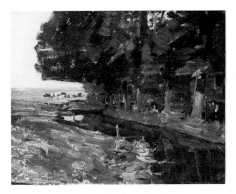

*Irrigation Ditch with Cows and
Sheltered Farm Complex, c.1903*
Oil on canvas
dimensions unknown

At the Wash Stoop, c.1903/1905
Charcoal on paper
26.5 x 35.5 cm (10 3/8 x 14")

*Tall Tree and Gabled Building behind
a watercourse, c.1905*
Charcoal on paper
47 x 31.5 cm (18 1/2 x 12 3/8")

Truncated View of Two Farm Buildings
Screened by Tree Growth, c.1905
Charcoal with stumping on paper
19 x 27.5 cm (7^1/$_2$ x 10^7/$_8$")

Sketch of Two Willows with Buildings
at Left, c.1905?
Charcoal on grey paper
26 x 36.5 cm (10^1/$_4$ x 14^3/$_4$")

Leafless Tree Growth, c.1905?
Charcoal on paper
33.5 x 47 cm (12 x 18^1/$_5$")

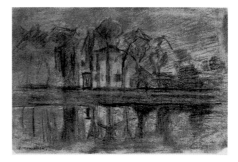

Tall Building on the Water Sheltered
by Trees, c.1905
Charcoal on paper
34 x 49 cm (13^3/$_8$ x 19^1/$_4$")

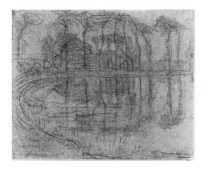

*Bend in a River with Farmstead
Sheltered by Trees, c.1905*
Crayon on paper
24 x 29 cm (9¹/₂ x 11³/₈")

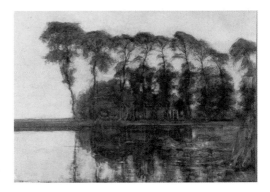

*Farmstead along the Water Screened
by Nine Tall Trees, c.1905*
Watercolour on paper
53.5 x 74 cm (21¹/₈ x 29¹/₈")

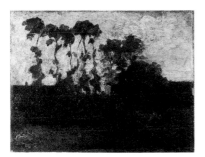

*Sheltered Farmhouse with Tall
Manicured Trees at Left, c.1905?*
Oil on paper mounted on cardboard
30.5 x 39.5 cm (12 x 15¹/₂")

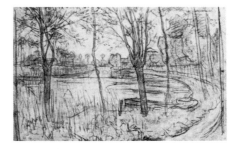

*Bend in the Gein with Young Willows,
c.1902–03/1905*
Charcoal and red crayon on buff paper
29.8 x 47.6 cm (11³/₄ x 18³/₄")

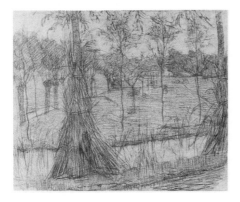

Farmyard with Sheep, Oil Sketch,
c.1905
Oil on canvas
31 x 43 cm (12 1/4 x 17")

Farmyard with Sheep, Drawing,
c.1905
Pencil, charcoal and Conté crayon on paper
33.5 x 40.5 cm (13 1/4 x 16")

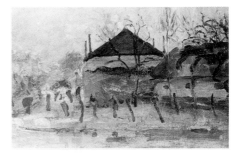

Barn and Haystack behind Row
of Willows, Drawing, c.1905
Charcoal with stumping on paper
24.7 x 33.3 cm (9 3/4 x 13 1/8")

Barn and Haystack behind Row
of Willows, Oil Sketch, c.1905
Oil on canvas mounted on board
33 x 49 cm (13 x 19 1/4")

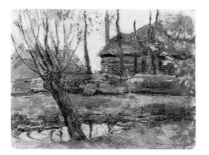

*Farmyard Sketch with Pollarded
Willow at Left, c.1905*
Oil on paper
24 x 31 cm (9¹/₂ x 12¹/₄")

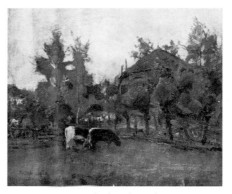

*Farmyard Sketch with Two Cows
Grazing, c.1905*
Oil on canvas
51 x 63.5 cm (20 x 25")

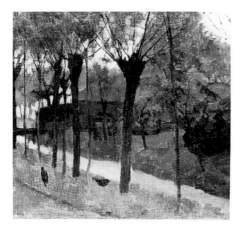

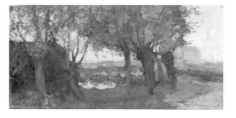

*Willows Bordering a Watercourse,
Buildings Left and Right, c.1902–03*
Oil on canvas mounted on panel
27 x 53 cm (9 x 20⁷/₈")

*Willows Bordering an Irrigation Ditch
near a Farm Building, c.1902–03*
Oil on canvas mounted on cardboard
48.5 x 52 cm (19¹/₈ x 20¹/₂")

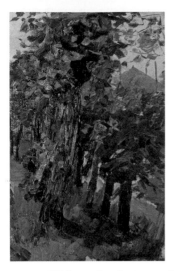

*Willows Bordering an Irrigation Ditch
near a Haystack, c.1903*
Oil on canvas
38.1 x 24.8 cm (15 x 9³/₄")

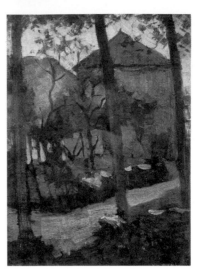

*Tree Trunks, Irrigation Ditch
and Haystacks, c.1903*
Oil on cardboard
47 x 36 cm (18¹/₂ x 14¹/₈")

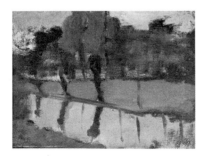

*Farmstead with Willows on the Water
I, c.1902–03*
Oil on cardboard
24 x 32 cm (9¹/₂ x 12⁵/₈")

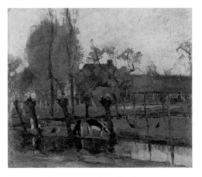

*Farmstead with Willows on the Water
II, c.1903*
Oil on canvas mounted on panel
31 x 35 cm (12¹/₄ x 13³/₄")

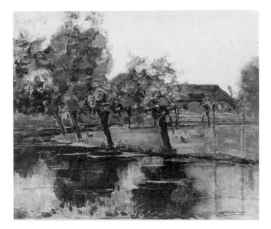

Farmstead with Willows on the Water III, c.1903
Oil on canvas [cardboard?]
62.5 x 75 cm (24⁵/₈ x 29¹/₅")

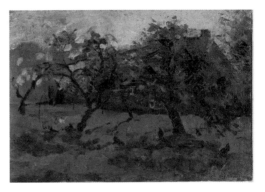

Apple Trees and Chickens in a Farmyard, c.1905
Oil on canvas
49 x 68.5 cm (19¹/₄ x 27")

Farm Building behind Arched Trees, c.1905
Pencil on paper
11.5 x 16.5 cm (4¹/₂ x 6¹/₂")

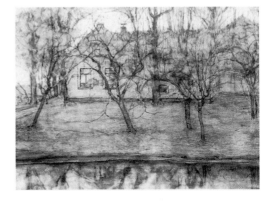

Farmstead behind Waterway and Orchard, c.1905
Watercolour on paper
51 x 65.5 cm (20¹/₈ x 25³/₄")

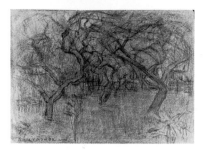

*Orchard with Enmeshed Tree Branches,
c.1905*
Crayon on paper
22.5 x 31 cm (8⁷/₈ x 12¹/₈")

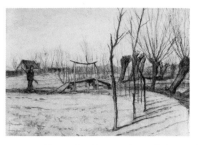

Farm Setting at Loosduinen, 1905
Charcoal and watercolour
25 x 35 cm (9⁷/₈ x 13³/₄")

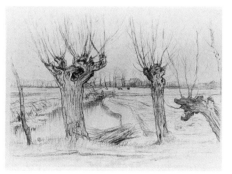

*Three Pollarded Willows, Irrigation
Ditch and Farmstead in the Distance,
c.1905*
Black chalk on paper
44.5 x 60 cm (17¹/₂ x 22⁵/₈")

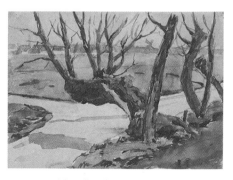

*Old Pollarded Willow, Irrigation
Ditches and Buildings in the Distance,
c.1905*
Crayon and watercolour on paper
28.5 x 40 cm (11¹/₄ x 15³/₄")

Cow Sketches, c.1905
Crayon on paper
47.5 x 65 cm (18³/₄ x 24¹/₄")

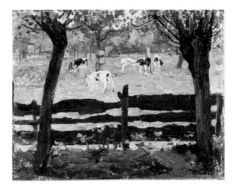

The White Bull Calf, Sketch, 1905
Oil on canvas mounted on board
31.5 x 39 cm (12³/₈ x 15 ³/₈")

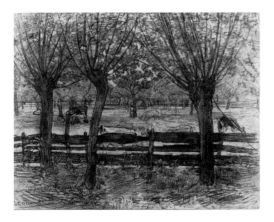

The White Bull Calf, Drawing 1905
Crayon on paper
46.5 x 68 cm (18¹/₄ x 22⁷/₈")

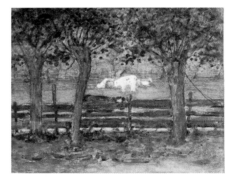

The White Bull Calf, 1905
Watercolour on paper
44.5 x 58.5 cm (17¹/₂ x 23")

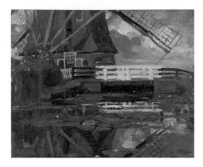

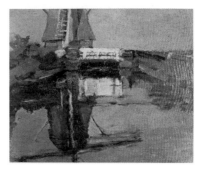

Truncated View of the Broekzijder Mill on the Gein, Wings Facing West, c.1902–03
Oil on canvas mounted on board
30 x 38 cm (11⁷/₈ x 15")

Truncated View of the Broekzijder Mill on the Gein, c.1902–03?
Oil on canvas mounted on board
24 x 30 cm (9¹/₂ x 11³/₄")

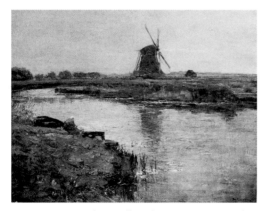

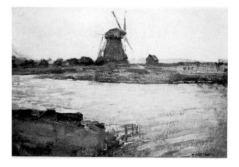

Oostzijdse Mill with Woman at Dock of Landzicht Farm, c.1902–03?
Oil on canvas
58 x 73 cm (22⁷/₈ x 28³/₄")

Oostzijdse Mill Viewed from Dock at Landzicht Farm, c.1902–03
Oil on canvas
27.5 x 40 cm (10⁷/₈ x 15³/₄")

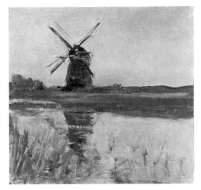

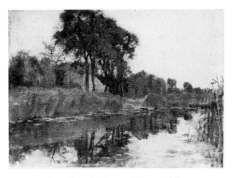

Oostzijdse Mill, Oil Sketch in Square
Format, c.1902–03
Oil on board
30 x 30.5 cm (11³/₄ x 12")

Landzicht Farm Viewed from
Downstream with Visible House Gable,
c.1902–03?
Oil on canvas
32.5 x 43.5 cm (12³/₄ x 17¹/₈")

Landzicht Farm Viewed from
Downstream with Horizontal Format,
c.1902–03?
Oil on canvas
30 x 36 cm (11³/₄ x 14¹/₄")

Landzicht Farm Viewed from Upstream,
Drawing in Vertical Format, c.1902–03
Crayon on paper
16 x 10 cm (6¹/₄ x 3⁷/₈")

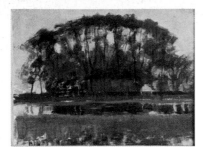

Farmhouse along the Water Shielded by Arch of Trees I, c.1902–03
Oil on canvas (remounted)
30.2 x 40 cm (11⁷/₈ x 15³/₄")

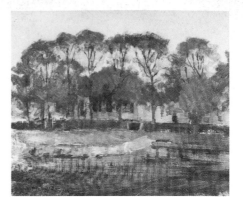

Farmhouse along the Water Shielded by Arch of Trees II, c.1902–03
Oil on canvas
40 x 47.2 cm (15³/₄ x 18⁵/₈")

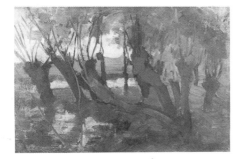

Willow Grove, Trunks Leaning Left I, c.1902–03
Oil on canvas
40.5 x 60.3 cm (16 x 23³/₄")

Willow Grove, Trunks Leaning Left II, c.1902–03
Oil on canvas
23 x 39.5 cm (9 x 15¹/₂")

BRABANT

1904–05

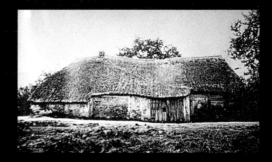

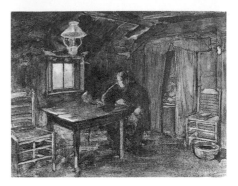

Louis van Zwanenbergh (Lewieken),
1904
Printed post card, 14.1 x 9.2 cm (5$^1/_2$ x 3$^5/_8$")
Illustration, 8.2 x 5.9 cm (3$^1/_4$ x 2$^3/_8$")

Hannes van Nistelrode Seated in
His Farmhouse, 1904
Watercolour on paper
48 x 62 cm (18$^7/_8$ x 24$^3/_8$")

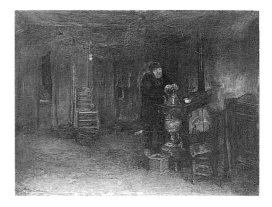

Hannes van Nistelrode at His Pot Stove,
1904
Charcoal on paper
23 x 16 cm (9 x 6$^1/_4$")

De Herd (The Home): Hannes van
Nistelrode at His Pot Stove, 1904
Oil on canvas
65 x 102 cm (25$^5/_8$ x 40$^1/_8$")

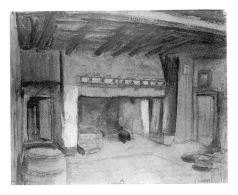

Interieur-Keuken (Kitchen Interior):
Brabant Farmhouse Interior with Hearth,
1904
Watercolour on paper
51 x 65 cm (20^1/$_8$ x 25^5/$_8$")

Brabant Barn Interior, 1904
Oil on canvas
32 x 50 cm (12^5/$_8$ x 19^3/$_4$")

Two Cows Lying in a Brabant Barn,
1905?
Oil on canvas
47 x 61 cm (18^1/$_2$ x 24")

Brabant Farm Building and Shed,
1904
Oil on canvas
40 x 48.2 cm (15^3/$_4$ x 19")

Brabant Farm Building with Haystacks,
1904
Charcoal and pastel on paper
44.5 x 57 cm (17$^1/_2$ x 22$^1/_2$")

Brabant Farm Building with Pump, 1904
Oil on panel
32 x 36 cm (12$^5/_8$ x 14$^1/_8$")

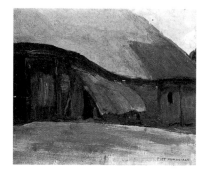

Truncated Farm Building in Brabant,
1904
Oil on paper [or 'karton']
28.5 x 34 cm (11$^1/_4$ x 13$^3/_8$")

Barn Doors of a Farm Building
at Nistelrode I and II, 1904
Pencil on paper
56.5 x 111.5 cm (22$^1/_4$ x 43$^7/_8$")

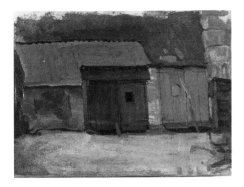

Barn Doors of a Brabant Farm Building, 1904
Oil on cardboard (remounted on panel)
33 x 43 cm (13 x 16$^7/_8$")

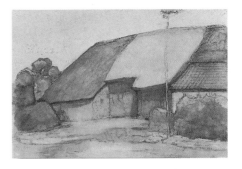

Farm Building at Nistelrode I, 1904
Watercolour on paper
44.5 x 63 cm (17$^1/_2$ x 23$^3/_4$")

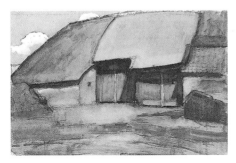

Farm Building at Nistelrode II, 1904
Watercolour on paper
41.5 x 62 cm (16$^3/_8$ x 24$^3/_8$")

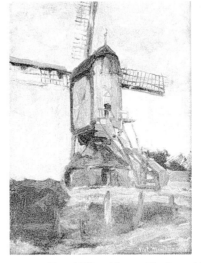

Post Mill at Heeswijk, Rear View, 1904
Oil on paper
remounted on canvas
c.36 x 26 cm (14$^1/_4$ x 10$^1/_4$")

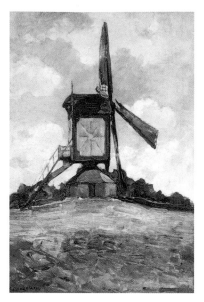

Post Mill at Heeswijk, Side View, 1904
Oil on canvas
59.6 x 39.5 cm (23^1/$_2$ x 15^1/$_2$")

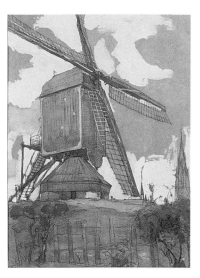

Post Mill at Veghel, 1904
Black chalk, watercolour and gouache
on brown paper
57.5 x 41.5 cm (22^3/$_4$ x 16^3/$_8$")

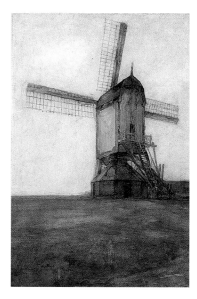

Post Mill at Uden, 1904
Watercolour on paper
77 x 53.5 cm (30^3/$_8$ x 21^1/$_8$")

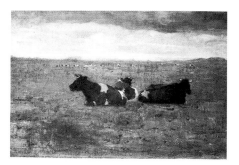

*Landscape with Three Reclining Cows,
1904*
Oil on canvas
30.5 x 45.7 cm (12 x 18")

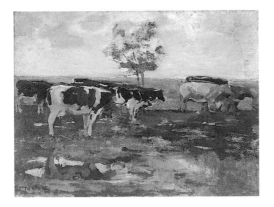

Cows in a Meadow with Tree, 1904
Oil on canvas
45 x 60 cm (17³/₄ x 25⁵/₈")

Study of Two Cows, 1904
Oil on canvas, mounted on cardboard
31.5 x 41.5 cm (12³/₈ x 16³/₈")

Black and White Heifer, 1904
Oil on paper, mounted on panel
23.5 x 28.5 cm (9¹/₄ x 11¹/₄")

Brown and White Heifer, 1904
Oil on paper, mounted on [?]
26.5 x 32 cm (10³/₈ x 12⁵/₈")

Brown and White Ox Steer, 1904
Oil on cardboard
31.5 x 38.5 cm (12^3/$_8$ x 15^1/$_8$")

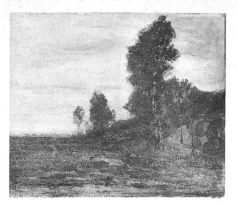

Landschap bij Uden
(Landscape near Uden), 1904
Oil on canvas
44 x 52 cm (17^1/$_4$ x 20^1/$_8$")

Near the Ox Stall, Hilvarenbeek, 1904
Oil on cardboard (pasted on panel)
30.5 x 38 cm (12 x 15")

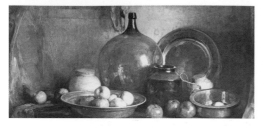

Still Life with Glass Bottle, Metal and Ceramic Vessels and Fruit, c.1908
Oil on canvas
66 x 120 cm (26 x 47^1/$_4$")

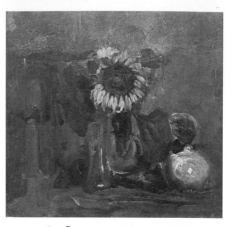

Sunflower in a Vase, c.1907– early 1908
Oil on cardboard
53.5 x 56.4 cm (21 x 22^1/$_4$")

Isar Harlemia: A Saint Bernard: 1905–08
Oil on canvas
45 x 35 cm (17^3/$_4$ x 13^3/$_4$")

Cornelia H.M. Maris-den Breejen, c.1906–08
Black chalk and pencil on paper
22.5 x 14 cm (8^3/$_4$ x 5^1/$_2$")

Reverend Hendricus Vredenrijk Hoogerzeil, c.1907
Black chalk on paper
54.5 x 38,5 cm (21$^1/_2$ x 15$^1/_8$"

Cornelis Bergman, c.1908
Oil on canvas
60 x 48 cm (23$^5/_8$ x 18$^7/_8$")

Cornelis Bergman, Jr, c.1907
Oil on canvas
c.50 x 40 cm (19$^5/_8$ x 15$^3/_4$")

Farm at Duivendrecht: Detail Study of Shed, c.1905
Pencil on paper
16.5 x 11.5 cm (6$^1/_2$ x 4$^1/_2$")

Farm at Duivendrecht: Detail Study
of Right Half of Composition, c.1905
Pencil on paper
13.5 x 15.8 cm (5⁵/₁₆ x 5¹³/₁₆")

Farm at Duivendrecht: Detail Study
of Shed and Water, c.1905
Pencil on paper
16.5 x 11.5 cm (6¹/₂ x 4¹/₂")

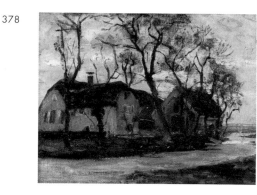

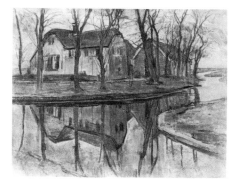

Farm at Duivendrecht, Oil Sketch,
c.1905–06
Oil on canvas
46 x 59 cm (18¹/₈ x 23¹/₄")

Compositional Study for Farm
at Duivendrecht, 1905
Charcoal and stumping on bluish-grey paper
46.3 x 60 cm (18¹/₄ x 23⁵/₈")

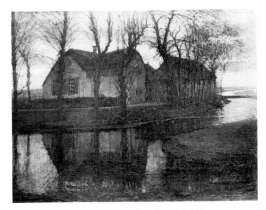

Farm at Duivendrecht, 1905
Oil on canvas
89 x 116 cm (35 x 45 $^5/_8$")

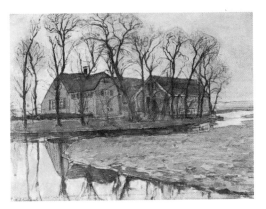

Farm at Duivendrecht, 1905–06
Chalk, watercolour and gouache on tinted paper
50 x 65.5 cm (19 $^5/_8$ x 25 $^3/_4$")

Farm at Duivendrecht: Study for Mixed Media Drawing, c.1906
Pencil on paper
12 x 22 cm (4 $^3/_4$ x 8 $^5/_8$")

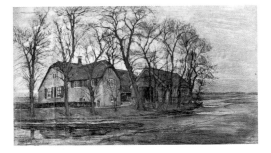

Farm at Duivendrecht: Mixed Media Drawing, c.1906–07
Charcoal, crayon and chalk on joined paper
44 x 76.5 cm (17 $^3/_8$ x 30 $^1/_8$")

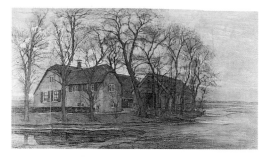

Farm at Duivendrecht. Study for a Lost Painted Version, c.1908
Exact medium and dimensions unknown

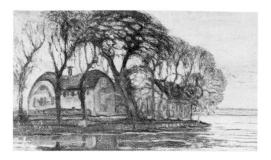

Farm at Duivendrecht, Lost Painted Version, c.1908?
An apparent oil painting with support and dimensions unknown

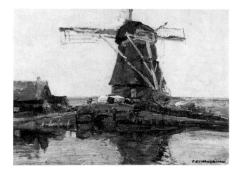

Stammer Mill with Summer House, Oil Sketch, 1905
Oil on canvas (mounted on cardboard?)
35 x 49 cm (13³/₄ x 19¹/₄")

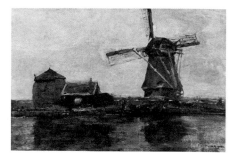

Stammer Mill with Summer House and Haystack, Oil Sketch, late 1905
Oil on cardboard
35.5 x 54 cm (14 x 21¹/₂")

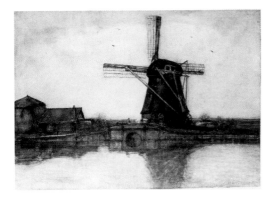

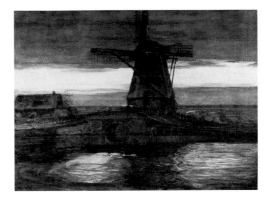

*Stammer Mill with Summer House and
Haystack, Watercolour, c.1905*
Watercolour over charcoal on paper
60 x 82 cm (23⁵/₈ x 32¹/₄")

*Stammer Mill with Streaked Sky,
1905–07*
Oil on canvas
74.6 x 96.5 cm (29³/₈ x 38")

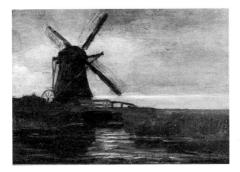

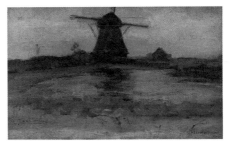

*Broekzijder Mill in the Evening,
c.1906*
Oil on canvas
35 x 50 cm (13³/₄ x 19³/₄")

*Oostzijdse Mill Viewed from Down-
stream with Mill at Centre, c.1905–06*
Oil on canvas
27.5 x 45.5 cm (10³/₄ x 17⁷/₈")

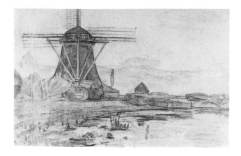

Oostzijdse Mill Viewed from Downstream: Compositional Study, c.1905–06
Charcoal on joined paper
dimensions unknown

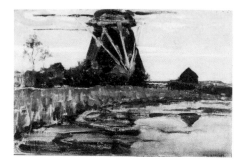

Oostzijdse Mill Viewed from Downstream with Streaked Pinkish-Blue Sky, c.1906–07
Oil on canvas mounted on cardboard
34 x 49.5 cm (13³/₈ x 19¹/₂″)

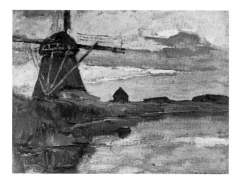

Oostzijdse Mill Viewed from Downstream with Streaked Blue and Yellow Sky, c.1906–07
Oil on canvas mounted on panel
34.5 x 44.5 cm (13⁵/₈ x 17¹/₂″)

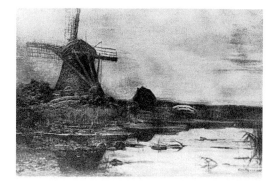

Oostzijdse Mill from Downstream with Evenly Streaked Sky, c.1906–07
Oil on canvas
50 x 75 cm (19³/₄ x 29¹/₂″)

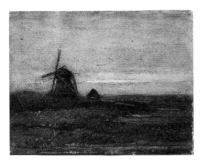

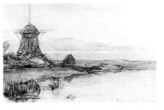

*Oostzijdse Mill with Extended Sky,
Small Washed Drawing, c.1907*
Watercolour on paper
11 x 17 cm (4 x 7")

*Oostzijdse Mill with Streaked Reddish
Sky, c.1906–07*
Oil on canvas
30 x 41 cm (11 3/4 x 16 1/8")

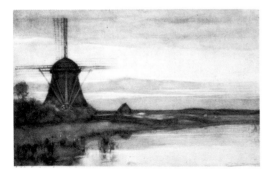

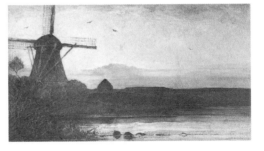

*Oostzijdse Mill with Extended Sky,
Watercolour, c.1907*
Watercolour on paper
57 x 90 cm (22 1/2 x 35 3/8")

*Oostzijdse Mill with Extended Light
Blue, Yellow and Violet Sky, c.1907*
Oil on canvas
75 x 132 cm (29 1/2 x 52")

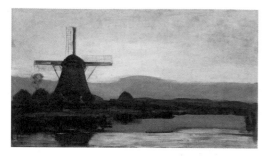

Oostzijdse Mill with Extended Blue, Yellow and Purple Sky, c.1907–early 1908
Oil on canvas
67.5 x 117.5 cm (27 1/8 x 44 1/8")

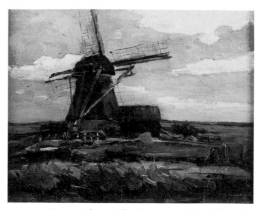

Oostzijdse Mill, Horizontal Oil Sketch with Blue Sky, c.1906–07
Oil on canvas mounted on cardboard
49 x 62 cm (19 1/4 x 24 3/8")

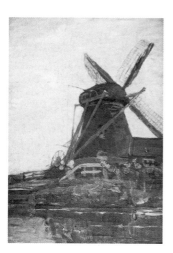

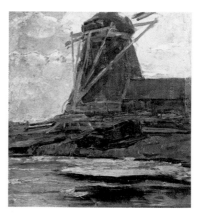

Oostzijdse Mill, Vertical Oil Sketch with Blue Sky, c.1906–07
Oil on canvas
69.2 x 47 cm (27 1/4 x 18 1/2")

Oostzijdse Mill with Cropped Wings, c.1906–07
Oil on canvas mounted on panel
48 x 45.8 cm (18 7/8 x 18")

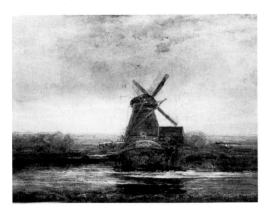

Oostzijdse Mill with Panoramic Sunset, Mill at Centre, 1907
Oil on canvas
100 x 142 cm (39³/₈ x 55⁷/₈")

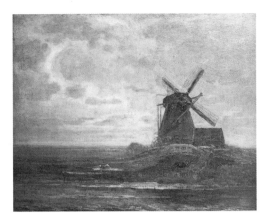

Oostzijdse Mill with Panoramic Sunset, Mill at Right, c.1907
Oil on canvas (relined)
101 x 125 cm (39³/₄ x 49¹/₂")

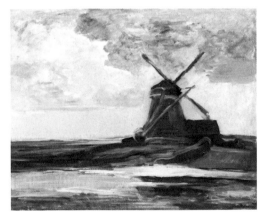

Oostzijdse Mill with Panoramic Sunset and Brightly Reflected Colours, 1907–08
Oil on canvas
99 x 120 cm (39 x 47¹/₄")

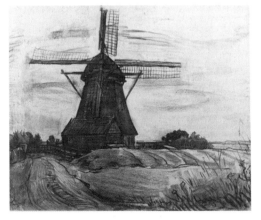

Oostzijdse Mill In Moonlight: Compositional Study, c.1907
Charcoal with stumping on buff paper mounted on board
72.4 x 94 cm (28¹/₂ x 37")

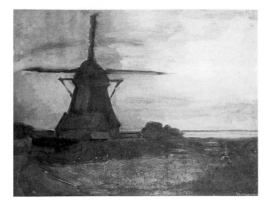

Oostzijdse Mill in Moonlight, c.1907
Oil on canvas
99.5 x 125.5 cm (39 1/8 x 49 3/8")

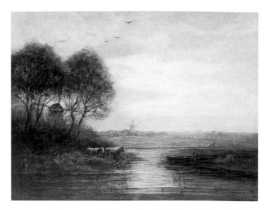

*Panoramic Sunset with Two Windmills,
c.1907*
Oil on canvas (relined)
88.3 x 114.5 cm (34 3/4 x 45 1/8")

*Windmill near Tall Trees, Other Trees
at Right, c.1906–07*
Oil on canvas
35.5 x 49.5 cm (14 x 19 1/2")

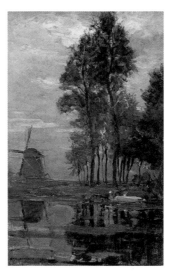

*Windmill near Tall Trees with Woman
at the Wash Stoop, c.1907*
Oil on cardboard
62.5 x 38.7 cm (24 1/2 x 15 1/4")

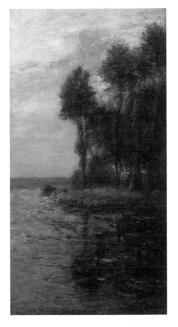

Windmill near Tall Trees, c.1906–07
Oil on canvas
122 x 64 cm (48 x 25¹/₈")

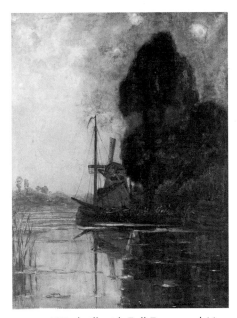

Windmill with Tall Trees and Moored Barges, c.1907
Oil on canvas
162.5 x 122 cm (64 x 48")

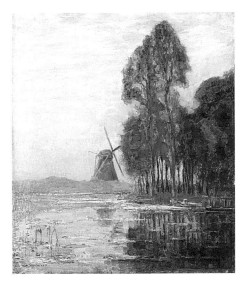

Mill near Tall Trees with Bright Colour Reflections, c.1907
Oil on canvas
75 x 63 cm (29¹/₂ x 24³/₄")

Wip Mill and Fields, c.1907–08
Charcoal on paper
25 x 36 cm (9⁷/₈ x 14³/₁₆")

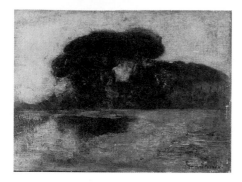

Drawing of Landzicht Farm on verso of a Music Programme, c.1906
Charcoal on paper
16.7 x 12 cm (6$^1/_2$ x 4$^1/_4$)

*Oil Sketch of the Landzicht Farm,
c.1905*
Oil on canvas mounted on paper
31.5 x 43 cm (12$^3/_4$ x 16$^7/_8$")

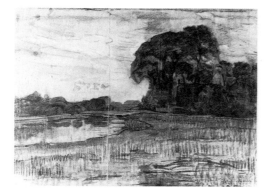

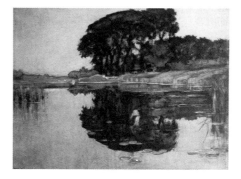

*Compositional Study for Landzicht
Farm, c.1905–07*
Charcoal with traces of chalk on joined buff
paper
59 x 80 cm (23$^1/_4$ x 33$^1/_2$")

*Landzicht Farm under Unclouded
Blue Sky, c.1905*
Watercolour on paper
50 x 63.5 cm (19$^5/_8$ x 25")

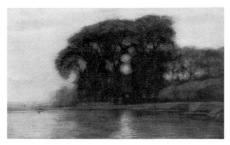

Landzicht Farm under Bluish-Grey Sky,
1905
Watercolour on paper
38.5 x 61 cm (15 1/8 x 24")

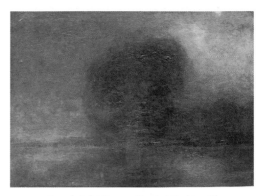

Landzicht Farm, Dark Night with
Moon, c.1907–early 1908
Oil on canvas
100 x 120 cm (39 3/8 x 47 1/4")

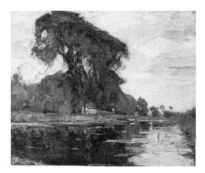

Landzicht Farm, Oil Sketch with Fence
and Gateposts, c.1905
Oil on paper
30.5 x 36.5 cm (12 x 14 3/8")

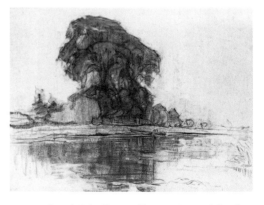

Landzicht Farm: Compositional Study,
c.1905
Charcoal on blue-grey paper
46.7 x 62.2 cm (18 3/8 x 24 1/2")

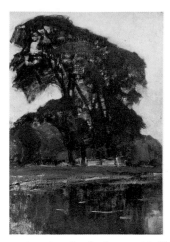

Landzicht Farm with White Sky,
c.1905
Oil on canvas mounted on cardboard
48 x 33.5 cm (18⁷/₈ x 13¹/₄")

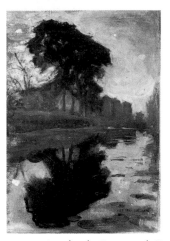

Landzicht Farm with Reflection in the
Water, c.1905
Oil on canvas mounted on cardboard
46 x 32 cm (18¹/₈ x 12⁵/₈")

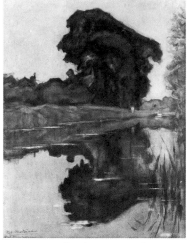

Landzicht Farm with Mirror Reflection
in the Water, c.1905
Watercolour on paper
62 x 48 cm (24³/₈ x 18⁷/₈")

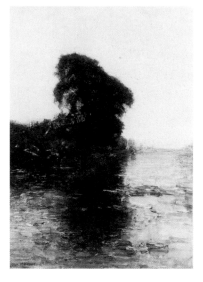

Landzicht Farm under Light Blue Sky,
c.1906
Oil on canvas
85 x 59.5 cm (33¹/₂ x 23³/₈")

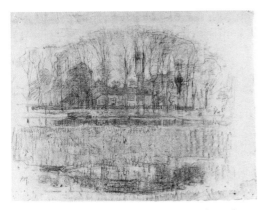

Geinrust Farm: Compositional Study,
c.1906
Crayon, sanguine and pastel on paper
47.5 x 65 cm (18 $^3/_4$ x 24 $^1/_4$")

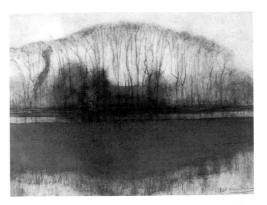

Geinrust Farm in Watery Landscape,
c.1905–06
Watercolour, crayon and pastel on grey paper
48.5 x 67 cm (19 $^1/_8$ x 26 $^3/_8$")

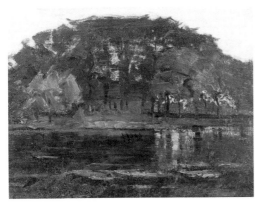

Geinrust Farm, Oil Sketch with Three
Small Trees at Left, c.1905–06
Oil on canvas
46.6 x 63.2 cm (18 $^1/_2$ x 25")

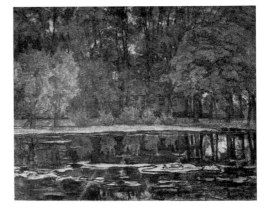

Geinrust Farm: Close Frontal View,
c.1905–06
Charcoal, chalk and pastel on brownish paper
47.8 x 60.3 cm (18 $^7/_8$ x 18 $^3/_4$")

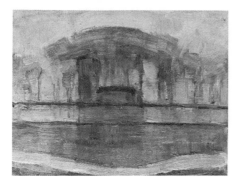

Geinrust Farm in the Mist, c.1906–07
Oil on canvas
32.5 x 42.5 cm (12³/₄ x 16³/₄")

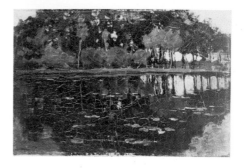

Geinrust Farm with Truncated Tall Trees and Saplings, 1905–07
Oil on canvas
37 x 55 cm (13³/₄ x 21⁵/₈")

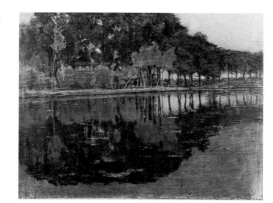

Geinrust Farm with Saplings, Black Chalk, c.1905–06
Black chalk and pastel on laid paper
46.2 x 62 cm (18¹/₄ x 24³/₈")

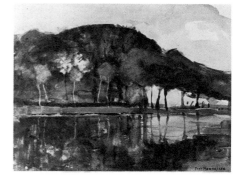

Geinrust Farm with Saplings, Watercolour Sketch, 1905–07
Watercolour on paper
31 x 41 cm (12¹/₄ x 15¹/₈")

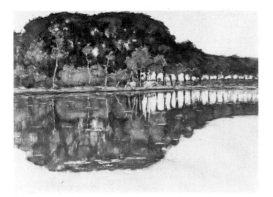

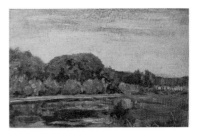

Geinrust Farm Surrounded by Dense
Foliage, c.1905–06
Oil on canvas
26 x 39.5 cm (10¼ x 15½")

Geinrust Farm with Two Cows at the
Water's Edge, c.1905–06
Watercolour on paper
49.5 x 66 cm (19½ x 26")

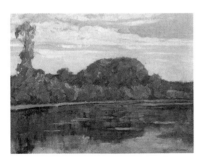

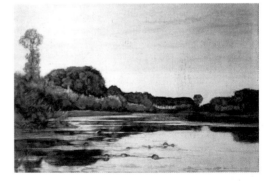

Geinrust Farm with Isolated Tree
at Left, c.1905–06
Oil on canvas mounted on cardboard
31.2 x 38.7 cm (12¼ x 15¼")

Geinrust Farm with Isolated Trees
under Pink Sky, c.1906–07
Watercolour on paper
51 x 75 cm (20⅛ x 29½")

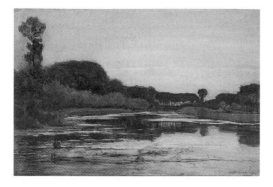

*Geinrust Farm with Isolated Trees
under a Grey Sky, c.1906–07*
Charcoal, watercolour and pastel on paper
43 x 64 cm (16⁷/₈ x 25¹/₄")

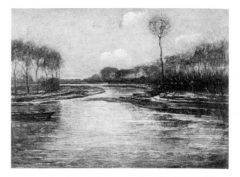

*Isolated Tree on the Gein in Winter,
c.1905–06*
Oil on canvas
43 x 57 cm (16⁷/₈ x 22¹/₂")

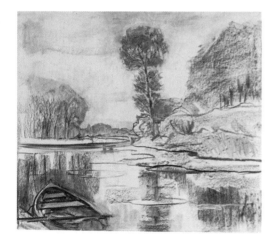

*Isolated Tree on the Gein with Rowing
Boat, 1906–07*
Charcoal and stomping on paper
58.8 x 65.5 cm (23¹/₈ x 25³/₄")

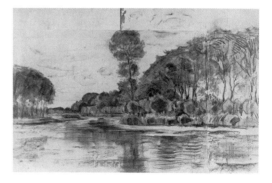

*Isolated Tree on the Gein: Composi-
tional Study, 1906–07*
Charcoal and stomping on joined paper
56.2 x 83.5 cm (22¹/₈ x 32⁷/₈")

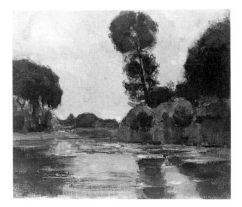

Isolated Tree on the Gein with Yellow-Orange Sky, 1906–07
Oil on canvas
43 x 55.5 cm (16⁷/₈ x 21⁷/₈")

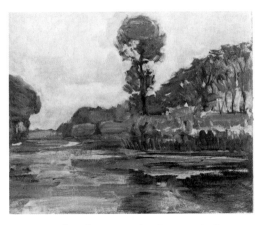

Isolated Tree on the Gein with Grey Sky, 1906–07
Oil on cardboard paper laid down on board
64 x 74 cm (25⁷/₈ x 29¹/₈")

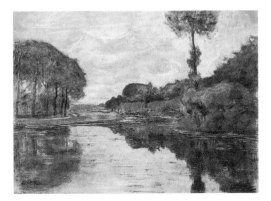

Isolated Tree on the Gein, 1906–07
Pastel on paper
46 x 62 cm (18¹/₈ x 24³/₈")

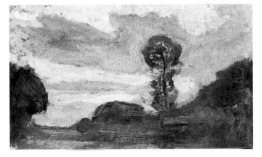

Isolated Tree on the Gein with Streaked Sky, c.1907
Oil on cardboard
40 x 65 cm (15³/₄ x 25¹/₂")

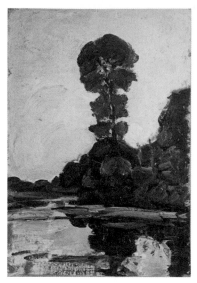

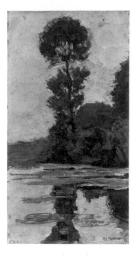

Isolated Tree on the Gein, Oil Sketch I,
1906–07
Oil on cardboard [canvas?]
53 x 36 cm (20⁷/₈ x 14¹/₈")

Isolated Tree on the Gein, Oil Sketch II,
1906–07
Oil on canvas mounted on cardboard
58.4 x 31.5 cm (23 x 12³/₈")

396

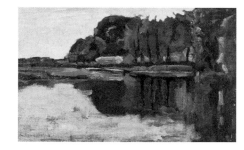

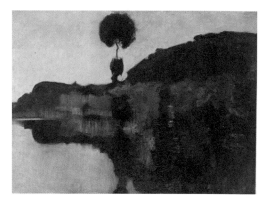

Isolated Tree on the Gein: Detail Study.
c.1906–07
Oil on canvas
27.5 x 45.5 cm (10³/₄ x 18")

Isolated Tree on the Gein in Late
Evening, c.1907–08
Oil on canvas
65 x 86 cm (25⁵/₈ x 33³/₄")

Isolated Tree on the Gein: Silhouette Drawing, c.1908
Crayon on paper; 14 x 19 cm (5 1/2 x 7 1/2")

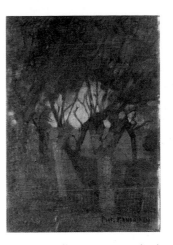

Willow Grove with Flattened Images, c.1905
Oil on canvas mounted on cardboard
43.5 x 31 cm (17 1/8 x 12 1/4")

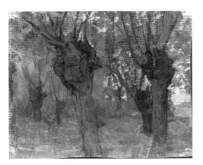

Willow Grove with Two Prominent Trees, c.1905
Oil on canvas
22.5 x 27.5 cm (8 7/8 x 10 3/4")

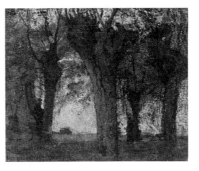

Willow Grove with Prominent Trunk at Centre, c.1905
Oil on canvas
25.3 x 29.8 cm (10 x 11 3/4")

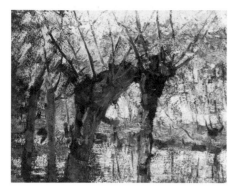

Willow Grove: Impression of Light and Shadow, c.1905
Oil on canvas
35.1 x 45.4 cm (13⁷/₈ x 17⁷/₈")

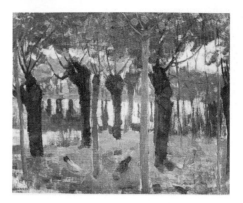

Willow Grove near the Water with Chickens, c.1905
Oil on canvas
40.5 x 48 cm (16 x 18⁷/₈")

398

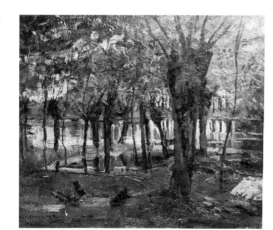

Willow Grove near the Water, Prominent Tree at Right, c.1905
Oil on canvas
54 x 63 cm (21¹/₄ x 24³/₄")

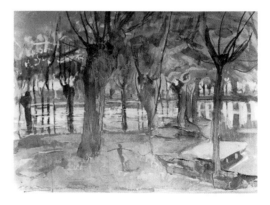

Willow Grove on the Water, Watercolour, c.1905
Watercolour on paper
47.5 x 61 cm (18³/₄ x 24")

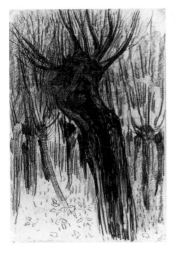

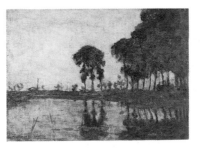

Bend in the Gein with Poplars,
Three Isolated, Sketch I, c.1905
Oil on canvas mounted on cardboard
29 x 40.8 cm (11³/₈ x 16″)

Willow Grove, Drawing. c.1905
Charcoal and crayon on paper
60 x 40 cm (23⁵/₈ x 15³/₄″)

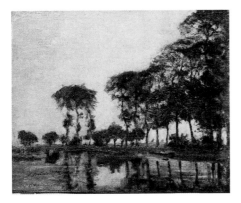

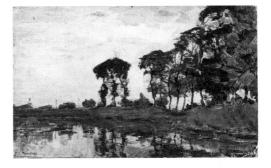

Bend in the Gein with Poplars,
Sketch II, c.1905
Oil on canvas (remounted on canvas?)
45 x 55 cm (17³/₄ x 21⁵/₈″)

Bend in the Gein with Poplars,
Three Isolated, Sketch III, c.1905
Oil on canvas mounted on cardboard
68 x 62.5 cm (16³/₈ x 24⁵/₈″)

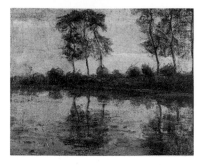

Bend in the Gein: Detail Study, c.1905
Oil on canvas mounted on panel
25 x 32 cm (9$^7/_8$ x 12$^5/_8$")

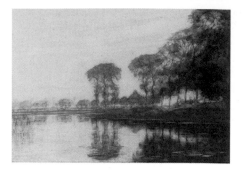

Bend in the Gein with Poplars,
Three Isolated, Watercolour, 1905?
Watercolour on paper
51 x 73.5 cm (20$^1/_8$ x 28$^7/_8$")

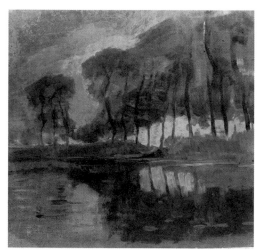

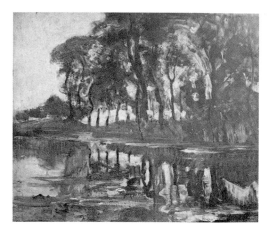

Bend in the Gein with Poplars,
Three Isolated, Late 1906–07
Oil on cardboard
63 x 78 cm (24$^3/_4$ x 30$^3/_4$")

Bend in the Gein with Poplars, 1907
Oil on cardboard
66 x 78.7 cm (26 x 31")

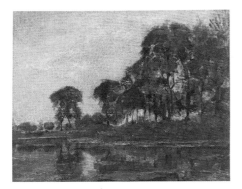

*Bend in the Gein with Poplars,
Three Isolated: Oil Study, 1906–07*
Oil on canvas
48 x 58 cm (17⁷/₈ x 22⁷/₈")

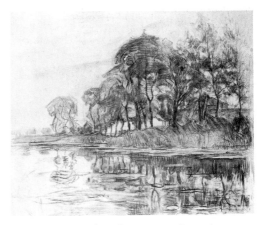

*Bend in the Gein with Poplars,
Three Isolated: Charcoal Study,
1907*
Charcoal and estompe on joined paper
dimensions unknown

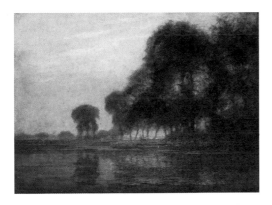

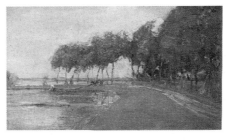

*Bend in the Gein with Row of
Ten Poplars, c.1905*
Oil on canvas
27 x 48 cm (10⁵/₈ x 18⁷/₈")

*Bend in the Gein with Poplars,
Three Isolated and Farm Woman
with Cows, 1907*
Oil on canvas
100 x 136 cm (39³/₈ x 53¹/₂")

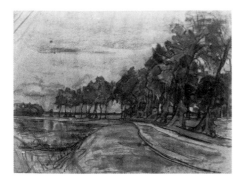

*Bend in the Gein with Row of Ten
or Eleven Poplars, c.1905–06*
Charcoal and estompe on paper
47.5 x 62 cm (18³/₄ x 24¹/₂")

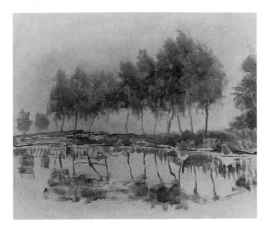

*Bend in the Gein with Row of
Eleven Poplars I, 1905–07*
Oil on cardboard
64.5 x 77 cm (25³/₈ x 30³/₈")

402

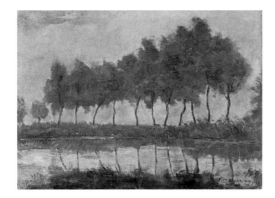

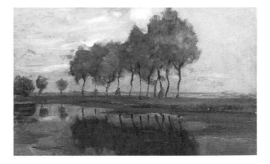

*Bend in the Gein with Row of
Eleven Poplars II, c.late 1906–07*
Oil on cardboard
54.5 x 73.6 cm (21¹/₂ x 29")

*Bend in the Gein with Row of
Eleven Poplars III, c.1907*
Oil on cardboard
38 x 63.5 cm (15 x 25")

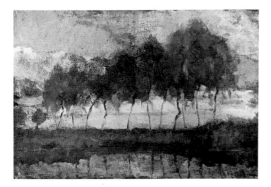

Bend in the Gein with Row of
Eleven Poplars IV, late 1906–07
Oil on canvas
45 x 66 cm (17³/₄ x 26")

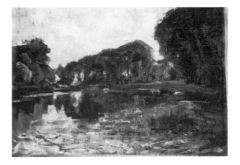

Farmstead with Long Row of Trees
on the Gein, Oil Sketch, 1905–07
Oil on canvas
dimensions unknown

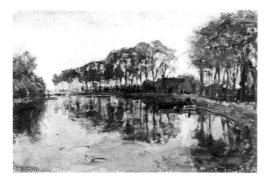

Farmstead with Long Row of Trees
on the Gein, 1905–07
Oil on paper mounted on panel:
39.5 x 62 cm (15¹/₂ x 24³/₈")

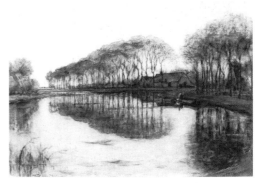

Farmstead with Long Row of Trees
on the Gein, Watercolour, 1905–07
Watercolour on paper
51 x 74 cm (20¹/₈ x 29¹/₈")

*Farmstead along the Gein Screened
by Tall Trees, Oil Sketch, 1906–07*
Oil on canvas
33.3 x 56.6 cm (13 1/8 x 22 1/4")

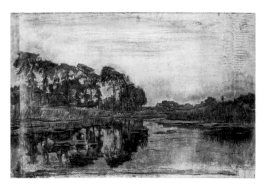

*Farmstead along the Gein Screened
by Tall Trees, Charcoal Drawing,
1906–07*
Charcoal and estompe on joined paper
63 x 95.3 cm (24 3/4 x 37 1/2")

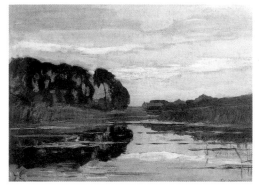

*Farmstead on the Gein Screened by
Tall Trees with Streaked Sky, c.1907*
Oil on canvas
65 x 92 cm (24 3/8 x 36 1/4")

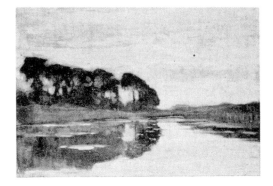

*Farmstead on the Gein Screened by Tall
Trees: Ultramarine Sky with Yellow Ray
of Sunset, c.1907*
Oil on canvas
85 x 190 cm (33 1/2 x 74 3/4")

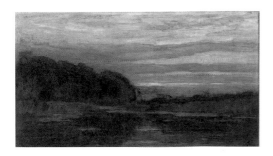

*Farmstead on the Gein Screened by
Tall Trees: Greenish Streaks in Sky
with Crescent Moon, c.1907*
Oil on canvas
76 x 135.5 cm (29⁷/₈ x 53³/₈")

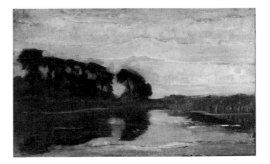

*Riverscape with Row of Trees at Left,
Sky with Pink and Yellow-Green Bands:
Farmstead on the Gein Screened by
Tall Trees, c.late 1907–08*
Oil on canvas
75 x 120 cm (29¹/₂ x 47¹/₄")

*Landscape with Apple Tree at Left,
Oil Sketch, c.1907*
Oil on canvas mounted on cardboard
21 x 41.5 cm (8¹/₄ x 16¹/₄")

*Landscape with Apple Tree at Left:
Winter Landscape, c.1907*
Oil on canvas
35.5 x 61.5 cm (14 x 24¹/₄")

*Landscape with Apple Tree at Left
and Farm Building, c.1907*
Oil medium, dimensions unknown

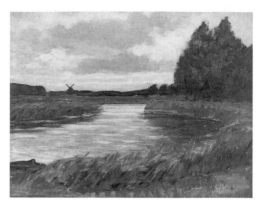

*Meandering River, Windmill in the
Distance, c.1906–07*
Oil on canvas
62 x 80 cm (24³/₈ x 31¹/₂")

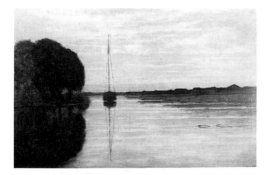

*Sailing Boat Moored on a River,
c.1907*
Oil on canvas
65.5 x 102 cm (25³/₄ x 40¹/₈")

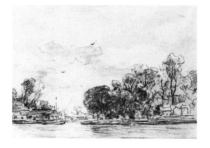

*Riverscape with Buildings Left
and Right, c.1906–07*
Crayon on paper
dimensions unknown

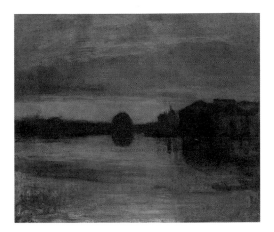

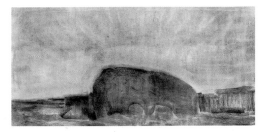

Haystack in the Evening, Drawing,
c.1907
Charcoal and crayon on paper
57 x 112 cm (22 3/8 x 44 1/8")

Riverscape in the Evening, Buildings
at Right, c.1907
Oil on canvas
66 x 76 cm (26 x 29 7/8")

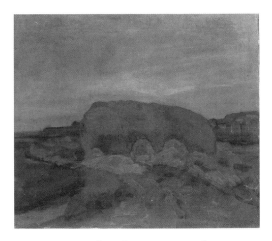

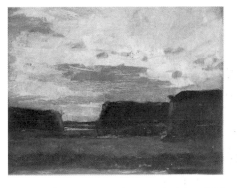

Three Haystacks in a Field, c.1907
Oil on canvas
36 x 46 cm (14 1/8 x 18 1/8")

Haystack in the Evening, Oil Version,
c.1907
Oil on canvas
66 x 76 cm (26 x 29 7/8")

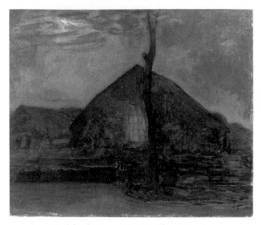

Gabled Farm Hut in the Evening, c.1907
Oil on cardboard
63.5 x 74.5 cm (25 x 29¹/₄")

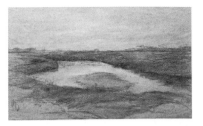

Meandering Watercourse, Drawing, c.1906–07
Charcoal and coloured crayon on paper
24 x 38.5 cm (9¹/₂ x 15¹/₈")

408

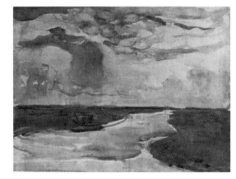

Meandering Watercourse, Watercolour, c.1906–07
Watercolour on paper
dimensions unknown

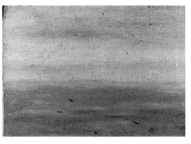

Underpainting for Land and Sky, 1906–07?
Oil on panel
10 x 14 cm (4 x 5¹/₂")

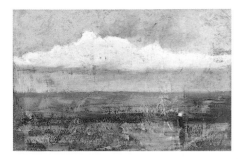

Landscape with Pink Cloud, 1906–07
Oil on canvas
30.5 x 44.5 cm (12 x 17^1/$_2$")

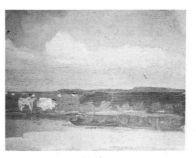

Watercourse, Field with Cows and Sky with Cloud, 1906–07
Oil on paper mounted on cardboard
25.5 x 32.5 cm (10 x 12^3/$_4$")

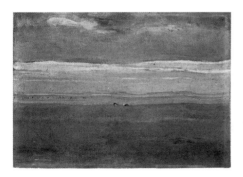

Evening Landscape with Cows, c.1906–07
Oil on canvas mounted on panel
31.5 x 44 cm (12^3/$_8$ x 17^1/$_4$")

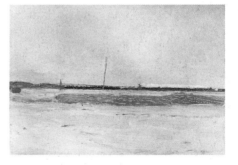

Open Landscape, Train along the Horizon, c.1906–07
Oil on canvas
35.5 x 50 cm (14 x 19^3/$_4$")

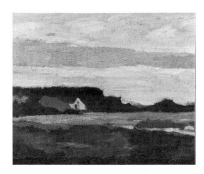

Farm Buildings in White and Red near a Green Field, c.1906–07
Oil on canvas mounted on cardboard
33.5 x 39 cm (13¹/₄ x 15³/₈")

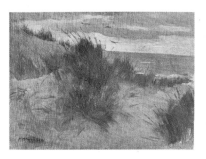

Dune and Sea with Streaked Sky, c.1906–07
Oil on canvas
31 x 41 cm (12¹/₄ x 16¹/₈")

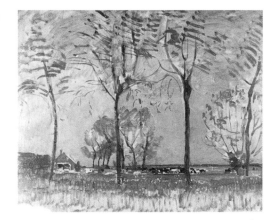

Farm Setting, Four Tall Trees in the Foreground I, c.1907
Oil on cardboard
64 x 74.5 cm (25¹/₈ x 29¹/₄")

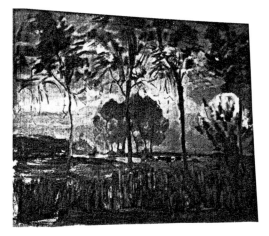

Farm Setting, Four Tall Trees in the Foreground II, c.1907
Oil on cardboard
62 x 73.5 cm (24³/₈ x 28⁷/₈")

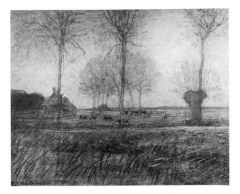

Farm Setting, Three Tall Trees in the Foreground, c.1907
Pastel and crayon over charcoal on paper
44 x 56 cm (17³/₈ x 22")

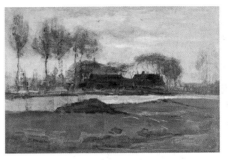

Summer Night: Preliminary Study in Oil, 1906–07
Oil on canvas
31 x 43.1 cm (12¹/₄ x 17")

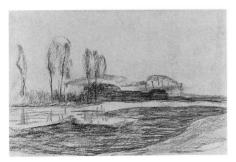

Compositional Study for Zomernacht, 1906–07
Charcoal on paper
34 x 49.5 cm (13³/₈ x 19¹/₂")

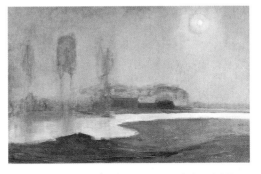

Zomernacht (Summer Night), 1907
Oil on canvas
71 x 110.5 cm (28 x 43¹/₂")

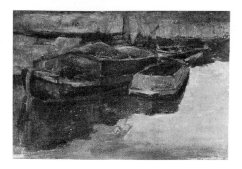

Moored Tjalk and Other Barges, 1905
Oil on board
c.42 x 60 cm (c.16^1/$_2$ x 23^1/$_2$")

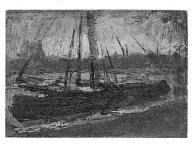

Moored Tjalk in Purple, c.1905
Oil on cardboard
13.5 x 19 cm (5^3/$_8$ x 7^1/$_2$")

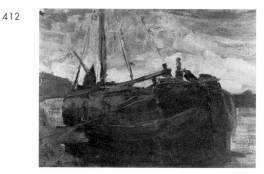

Moored Tjalk, c.1905–06
Oil on canvas mounted on panel; 33 x 43 cm
(13 x 16^7/$_8$")

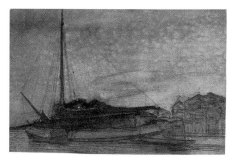

Tjalk Moored near the Omval, 1906–07
Watercolour on paper
31.5 x 46.5 cm (12^3/$_8$ x 18^1/$_4$")

On Ouderkerkerdijk near the Omval,
1906–07
Oil on canvas
42 x 75 cm (16¹/₂ x 29¹/₂")

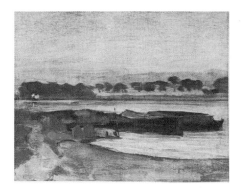

On Ouderkerkerdijk near the Omval
in the Evening II, 1906–07
Oil on canvas
40 x 50 cm (15³/₄ x 19⁵/₈")

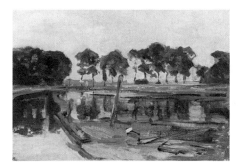

Moorings near the Omval, c.1906–07
Oil on canvas
30.5 x 44.5 cm (12 x 17¹/₂")

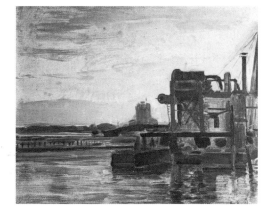

Dredger I, 1907
Oil on cardboard
63.5 x 76 cm (25 x 29⁷/₈")

Dredger II, 1907
Oil on cardboard mounted on panel
63.5 x 75.5 cm (25 x 29³/₄")

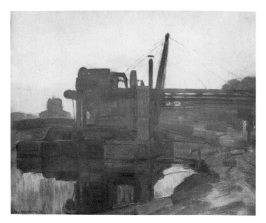

Dredger III, 1907
Oil on cardboard
(remounted on presswork panel)
63.4 x 77.5 cm (25 x 29³/₄")

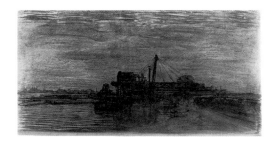

Dredger, Drawing, 1907
Charcoal and crayon on paper
57 x 112 cm (22³/₈ x 44¹/₈")

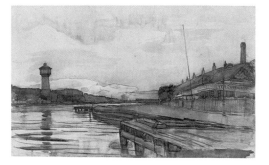

Amstel: Café 't Vissertje I, 1907
Watercolour on paper
paper: 109.8 x 195.6 cm (43¹/₄ x 77")
drawing: 69 x 110 cm (27¹/₈ x 43³/₈")

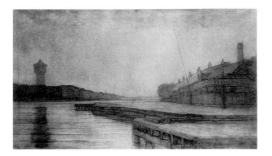

Amstel, Café 't Vissertje II, 1907–09
Watercolour on paper
66 x 115 cm (26 x 45 1/4")

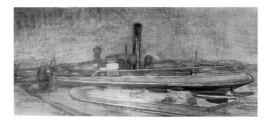

*Steam-Driven Ferry Moored on the
Weesperzijde, c.late 1907–08*
Charcoal and watercolour on paper
80.2 x 173.8 cm (31 5/8 x 68 3/8")

415

416

TWENTE

1906–08

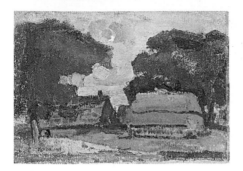

Farmstead under Oak Trees,
Oil Sketch I, 1906–07
Oil on canvas mounted on cardboard
34.5 x 47.5 cm (13$^1/_2$ x 18$^5/_8$")

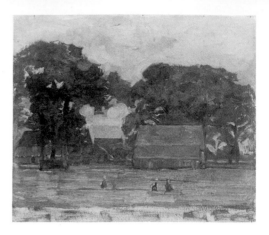

Farmstead under Oak Trees,
Oil Sketch II, 1906–07
Oil on cardboard
64 x 76.5 cm (25$^1/_4$ x 30$^1/_8$")

Farmstead, Drawing, 1906–07
Charcoal plus red Conté crayon highlights
96 x 141.5 cm (37$^3/_4$ x 55$^5/_8$")

Farmstead under Oak Trees,
Oil Sketch III, 1906–07
Oil on cardboard
63.5 x 76.5 cm (25 x 30$^1/_8$")

Farmhouse Façade with Well Boom
at Left, 1906–07
Oil on canvas
35 x 49.5 cm (13³/₄ x 19¹/₂")

Farmstead Façade with Leafless Oak,
1906–07
Oil on cardboard
74.5 x 64 cm (29³/₈ x 25¹/₄")

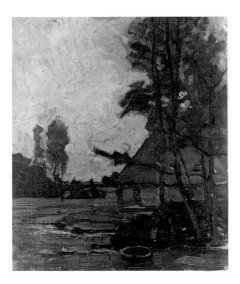

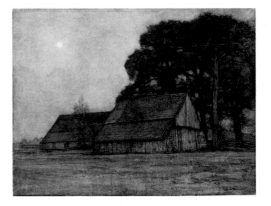

Avond (Evening); Sheepfold and
Farmstead, 1906
Charcoal, crayon and watercolour on puper
74 x 98 cm (29¹/₈ x 38¹/₂")

Farm Building and Well, 1906–07
Oil on cardboard
76.5 x 64 cm (30¹/₈ x 25¹/₄")

Sheepfold with Haystack, Drawing, c.1907
Drawing (crayon?) on paper
Dimensions unknown

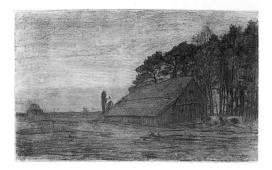

Sheepfold with Haystack, c.1907
Charcoal, crayon, sanguine, gouache on paper
68.5 x 110 cm (27 x 43¹/₄")

420

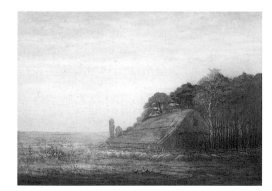

Sheepfold with Flock of Sheep, 1907
Oil on canvas
99 x 141 cm (39 x 55¹/₂")

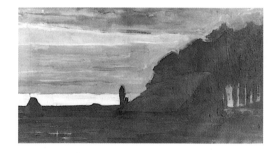

Sheepfold with Haystack at Left, c.1907–early 1908
Oil on canvas
75 x 133.5 cm (29¹/₂ x 52¹/₂")

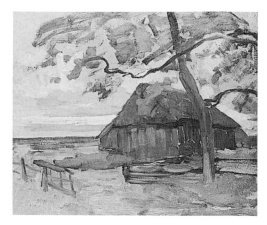

Sheepfold with Tree at Right, c.1907
Oil on cardboard
63 x 75 cm (24³/₄ x 29¹/₂")

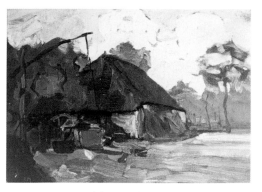

Farm Building with Well in Daylight, c.1907
Oil on canvas
32 x 45 cm (12⁵/₈ x 17³/₄")

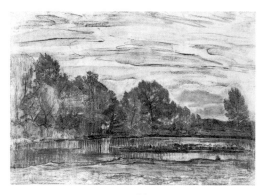

Fen near Saasveld, Drawing, c.1907
Charcoal with traces of chalk and red crayon,
96 x 139.5 cm (37³/₄ x 54³/₄")

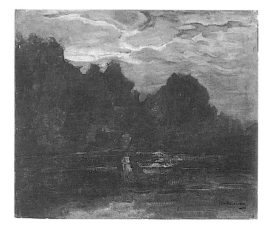

Fen near Saasveld, Oil Sketch, c.1907
Oil on cardboard
63.5 x 76 cm (25 x 29⁷/₈")

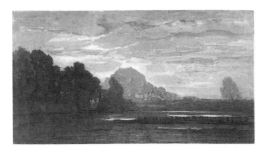

Fen near Saasveld, Large Version,
c.1907
Oil on canvas
102 x 180.5 cm (40¹/₈ x 71")

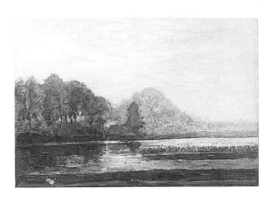

Fen near Saasveld, Small Version,
c.1907
Oil on canvas
52.5 x 73.5 cm (20⁵/₈ x 28⁷/₈")

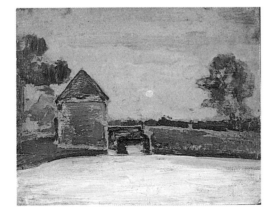

The Old Mill at Oele with Moon,
c.1907–early 1908
Oil on cardboard
59 x 73 cm (23¹/₄ x 28³/₄")

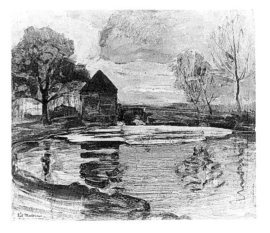

The Old Mill at Oele, c.1907–
early 1908
Oil on board
64 x 73 cm (25¹/₄ x 28³/₄")

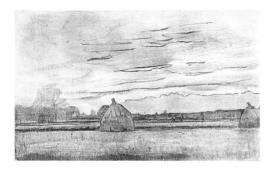

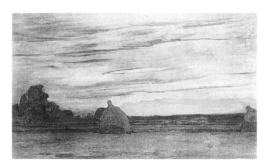

*Fields with Haystacks, Drawing,
c.1907*
Charcoal on buff paper
82.5 x 137 cm (32^{1}/$_{2}$ x 54")

Two Haystacks in a Field I, c.1907
Oil on canvas
85.3 x 148 cm (33^{5}/$_{8}$ x 58^{1}/$_{4}$")

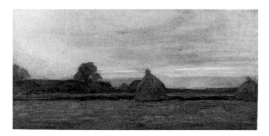

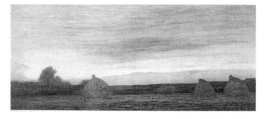

Two Haystacks in a Field II, c.1907
Oil on canvas
55.5 x 117 cm (21^{7}/$_{8}$ x 46^{1}/$_{2}$")

*Avond (Evening); Haystacks in a Field,
1908*
Oil on canvas
82 x 193 cm (32^{3}/$_{4}$ x 74^{3}/$_{4}$")

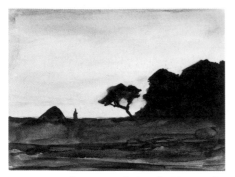

Landscape with Single Haystack, c.1907
Watercolour on paper
22 x 32 cm (8⁵/₈ x 12⁵/₈")

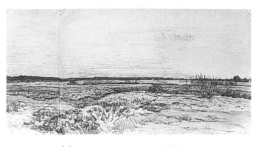

Fields in Twente I, c.1908
Charcoal on two pieces of white paper
39 x 76.5 cm (15¹/₄ x 30¹/₈")

Fields in Twente II, c.1908
Charcoal with white highlights on white paper
39 x 59 cm (15¹/₄ x 23¹/₄")

Fields in Twente III, c.1908
Charcoal with white highlights on white paper
39 x 59 cm (15¹/₄ x 23¹/₄")

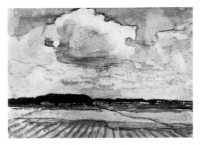

Landscape with Mowed Field I, c.1907
Watercolour on paper
24.5 x 35.5 cm (9³/₄ x 14")

*Landscape with Mowed Field II,
c.1907*
Watercolour on paper
25.3 x 35.5 cm (10 x 14")

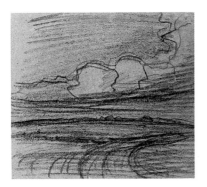

Landscape near Oele, c.1907
Charcoal on paper
29.5 x 32 cm (11⁵/₈ x 12⁵/₈")

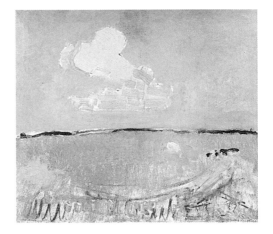

De rode wolk (The Red Cloud), c.1907
Oil on cardboard
64 x 75 cm (25¹/₈ x 29¹/₂")

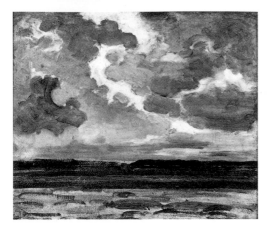

Evening Sky, c.1907
Oil on cardboard
64 x 74 cm (25 1/4 x 29 1/8")

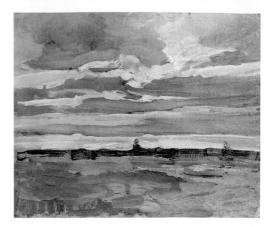

Evening Sky with Luminous Cloud Streaks, c.1907
Oil on cardboard
64 x 76.5 cm (25 1/2 x 30 1/8")

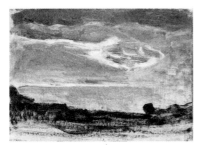

Evening Sky with Luminous Cloud, c.1907
Oil on canvas
36 x 49.5 cm (14 1/8 x 19 1/2")

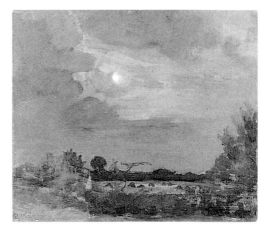

Evening Sky with Moon, c.1907
Oil on cardboard
63 x 74 cm (24 3/4 x 29 1/8")

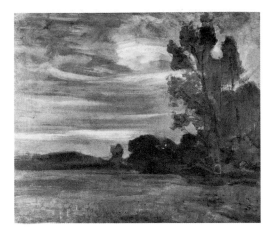

*Field with Tree Silhouette at Right,
1906–07*
Oil on canvas
78 x 91 cm (30³/₄ x 35³/₄")

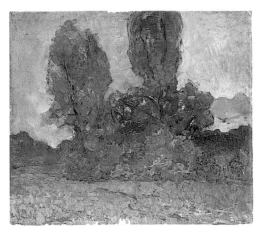

*Field with Two Tree Silhouettes I,
1906–07*
Oil on cardboard
69.5 x 79 cm (27³/₈ x 31¹/₈")

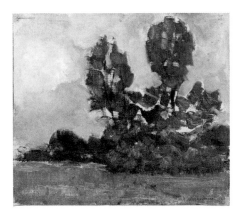

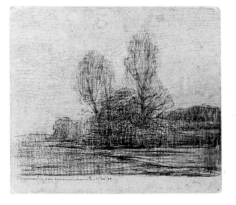

*Field with Two Tree Silhouettes II,
1906–07*
Oil on canvas
43 x 48.5 cm (16⁷/₈ x 19¹/₈")

*Field with Leafless Tree Silhouettes
and Moon, 1906*
Crayon on paper
21 x 24.5 cm (8¹/₄ x 9⁵/₈")

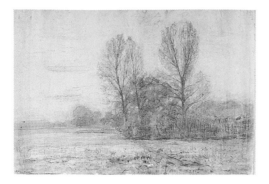

Field with Leafless Tree Silhouettes,
1906–07
Charcoal on paper
95 x 152 cm (37³/₈ x 59⁷/₈")

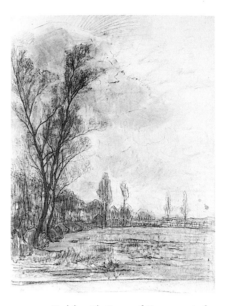

Field with Row of Trees at Left,
Drawing, c.1907
Charcoal with touches of red and black crayon,
103 x 76 cm (40¹/₂ x 29⁷/₈")

428

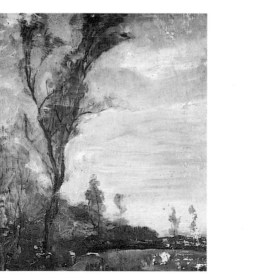

Field with Gate and Trees at Right,
Drawing, c.1907
Charcoal on buff paper
73 x 95.5 cm (28³/₄ x 37⁵/₈")

Field with Row of Trees at Left, c.1907
Oil on paper laid down on board
76.5 x 64 cm (30¹/₈ x 25¹/₄")

*Field with Gate and Trees at Right,
c.1907*
Oil on cardboard laid down on board
64 x 74 cm (25$^1/_4$ x 29$^1/_8$")

*Field with Young Trees in the
Foreground, Drawing, c.1907*
Charcoal on [buff?] paper
68 x 96 cm (26$^3/_4$ x 37$^3/_4$")

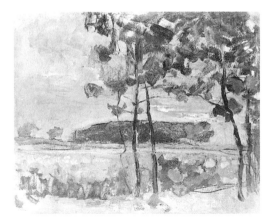

*Field with Young Trees in the
Foreground, c.1907*
Oil on paper laid on board
65.5 x 79.5 cm (25$^3/_4$ x 31$^1/_4$")

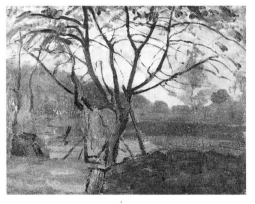

Silhouette of a Spreading Tree, c.1907
Oil on cardboard
63 x 78 cm (24$^3/_4$ x 30$^3/_4$")

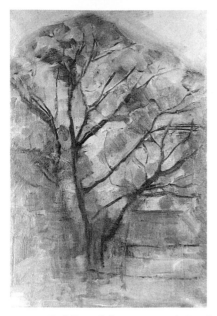

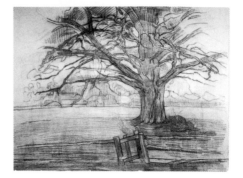

Field with Summer Oak Tree,
c.late 1907–early 1908
Charcoal on paper
34 x 49.5 cm (13³/₈ x 19¹/₂")

Tall Tree Silhouettes with Bright
Colours, c.1907–early 1908
Oil on canvas
108 x 72.5 cm (42¹/₂ x 28¹/₂")

430

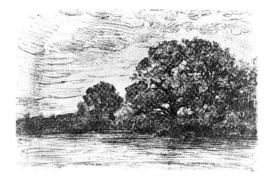

Field with Oak Trees at Dusk,
Sketch, late 1906
Crayon on paper
21 x 24.3 cm (8¹/₄ x 9⁵/₈")

Field with Oak Trees at Dusk, Drawing,
1907–early 1908
Charcoal with traces of chalk and red crayon
on paper
88 x 136.5 cm (34³/₄ x 53¹/₅")

*Field with Oak Trees at Dusk,
1907–early 1908*
Oil on canvas
93 x 145 cm (36$^1/_2$ x 57")

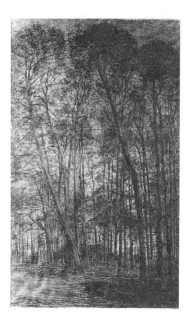

Pine Woods near Oele, c.1906
Crayon on paper
111 x 67 cm (43$^5/_8$ x 26$^3/_8$")

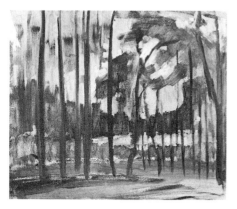

*Woods near Oele, Oil Sketch,
c.1907–early 1908*
Oil on cardboard
63 x 72 cm (24$^3/_8$ x 28$^3/_8$")

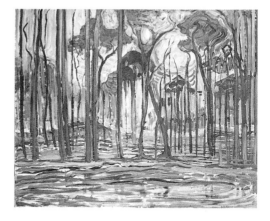

*Bosch (Woods); Woods near Oele,
1908*
Oil on canvas
128 x 158 cm (50$^3/_8$ x 62$^1/_8$")

432

AMSTERDAM

1908–11

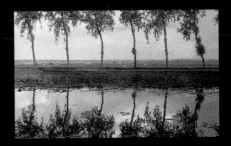

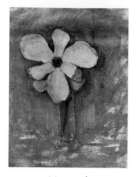

Magnolia, 1908
Oil on canvas mounted on cardboard
39 x 32 cm (15 3/8 x 12 5/8")

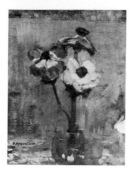

Anemones in a Vase, c.1908–09
Oil on canvas
29 x 22 cm (11 3/8 x 8 1/2")

434

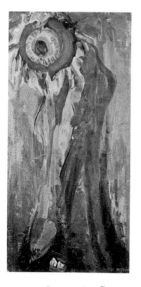

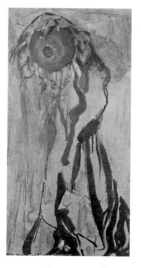

Dying Sunflower I, 1908
Oil on cardboard
63 x 31 (24 3/4 x 12 1/8")

Dying Sunflower II, 1908
Oil on cardboard
65 x 34 cm (25 5/8 x 13 3/8")

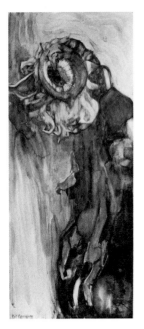

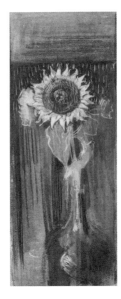

Dying Sunflower, Watercolour, 1908
Watercolour on paper
95.2 x 36.8 cm (37^1/$_2$ x 14^1/$_4$")

Upright Sunflower, 1908
Watercolour, charcoal and pastel on cardboard
94.2 x 38.5 cm (37 x 15^1/$_8$")

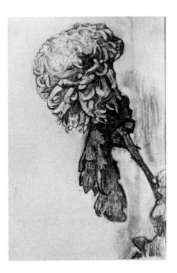

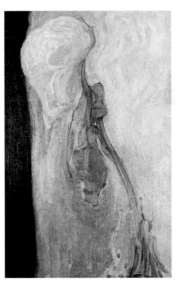

Dying Chrysanthemum, Drawing, 1908
Charcoal on paper
40 x 30 cm (15^3/$_4$ x 11^3/$_4$")

Bloem (Flower): Dying Chrysanthemum,
1908
Oil on canvas
84.5 x 54 cm (33^1/$_4$ x 21^1/$_4$")

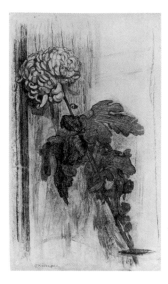

*Drawing for Chrysanthemum with
Red Curtain, 1908*
Charcoal with stumping on paper
78.5 x 46 cm (30$^7/_8$ x 18$^1/_8$")

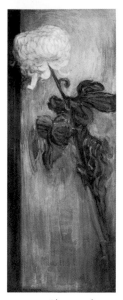

Chrysanthemum with Red Curtain, 1908
Gouache on paper
94 x 37 cm (37 x 14$^1/_2$")

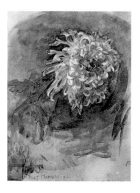

*Watercolour of Chrysanthemum
Leaning Right, c.1908*
Watercolour on paper
29.5 x 22 cm (11$^5/_8$ x 8$^5/_8$")

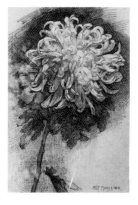

*Chrysanthemum Blossom Leaning Right,
1908–09*
Pencil and crayon on paper
35.5 x 24 cm (14 x 9$^3/_8$")

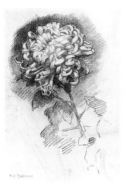

Chrysanthemum Blossom Leaning Left,
1908–09
Charcoal crayon on paper
36.2 x 24.5 cm (14 1/4 x 9 5/8")

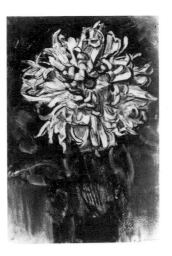

Chrysanthemum Blossom Viewed
Frontally, Drawing, c.1908
Charcoal crayon with stumping on paper
49.5 x 26 cm (19 1/2 x 10 1/4")

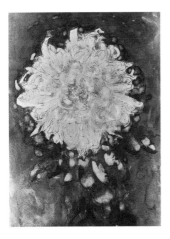

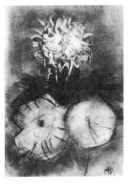

Three Flower Blossoms, One a
Chrysanthemum, c.1909
Charcoal on paper
35.5 x 24 cm (14 x 9 1/2")

Chrysanthemum Blossom Viewed
Frontally, Watercolour, c.1908–09
Ink and watercolour on paper
43 x 31 cm (16 7/8 x 12 1/4")

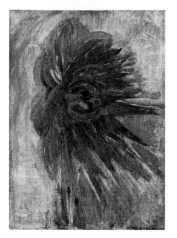

Red Chrysanthemum on Blue Background, c.1909–10
Oil on canvas
40.5 x 30 cm (16 x 11³/₄")

Foxtail Lily: Study I, c.1909
Crayon, charcoal with stumping on paper
31 x 44.5 cm (12¹/₄ x 17¹/₂")

438

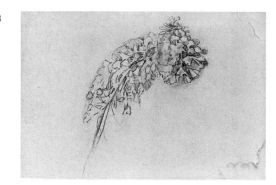

Foxtail Lily: Study II, c.1909
Charcoal on paper
46 x 69 cm (17¹/₂ x 12¹/₄")

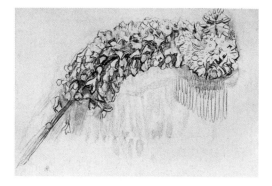

Foxtail Lily: Study III, c.1909
Charcoal with stumping on paper
46 x 69 cm (18¹/₈ x 27¹/₈")

Foxtail Lily: Study IV, c.1909
Charcoal with stumping on paper
46.5 x 69.5 cm (18³/₈ x 27³/₈")

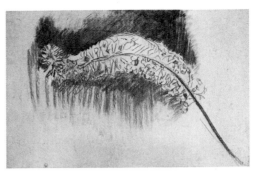

Foxtail Lily: Study V, c.1909
Charcoal on cardboard
57 x 87.5 cm (22¹/₂ x 34¹/₂")

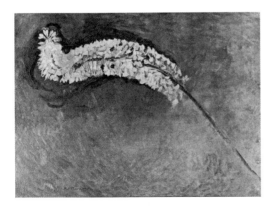

Foxtail Lily, c.1909
Oil on cardboard
75 x 100.5 cm (29¹/₂ x 39¹/₂")

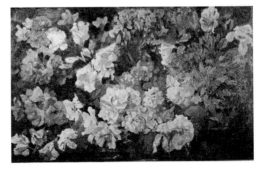

*Flower Arrangement with
Rhododendrons and Irises, c.1909*
Oil on canvas mounted on cardboard
43 x 68 cm (17 x 26³/₄")

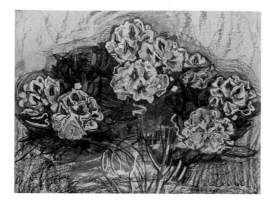

Rhododendrons, 1909–10
Charcoal and pastel on paper
73 x 97.5 cm (28 3/4 x 38 3/8")

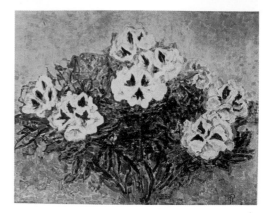

Rhododendrons, 1909–early 1910
Oil on canvas
dimensions unknown

440

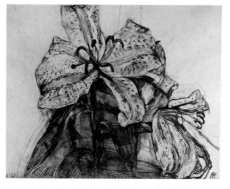

*Lelie (Lily): Gold-banded Lily,
late 1909*
Charcoal, wash and crayon on paper
35 x 44 cm (13 3/4 x 17 3/8")

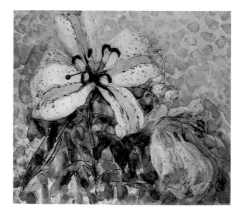

*Lelie (Lily): Gold-Banded Lily,
1909–early 1910*
Ink and watercolour on paper
39 x 44 cm (15 3/8 x 17 3/8")

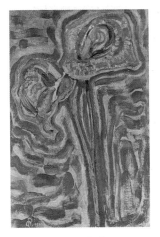

Aäronskelken (Arum Lilies),
1909–early 1910
Oil on canvas
50 x 33.5 cm (19⁵/₈ x 13¹/₈")

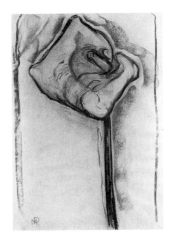

Study for Arum Lily, c.1909
Charcoal on paper
44 x 31 cm (17¹/₄ x 12¹/₈")

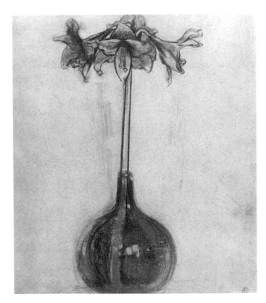

Amaryllis in Round Bottle, 1909–10
Charcoal on paper
c.80 x 75 cm (31¹/₂ x 29¹/₂")

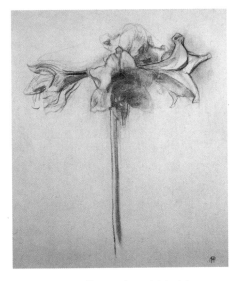

Amaryllis Study, 1909–10
Charcoal on paper
74.3 x 61.5 cm (29 x 24")

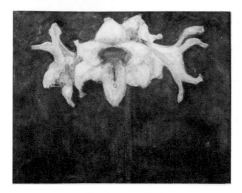

Amarilles (Amaryllis), 1910
Watercolour on paper
39 x 49 cm (15³/₈ x 19⁵/₁₆")

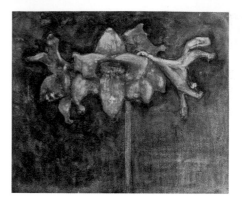

Amaryllis II, 1910
Watercolour on cardboard (?)
39.3 x 47.3 cm (15¹/₂ x 18⁵/₈")

442

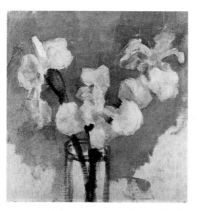

*White Irises against a Light Blue
Background I, c.1909–10*
Oil on canvas
34 x 33 cm (13¹/₂ x 13")

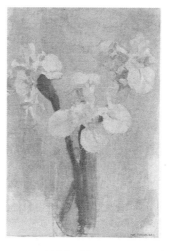

*White Irises against a Light Blue
Background II, c.1909–10*
Oil on canvas
45 x 31 cm (17³/₄ x 12¹/₄")

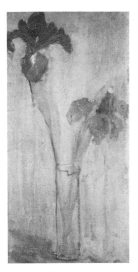

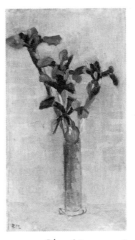

Purple Irises against a Yellow
Background, c.1909–10
Oil on canvas
56 x 28 cm (22 x 11")

Blue Irises against an Orange
Background, c.1909–10
Oil on canvas
58.4 x 32 cm (22³/₄ x 12¹/₂")

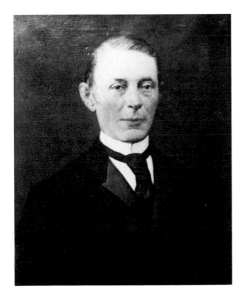

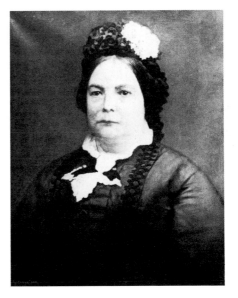

S.J.C. van Aalst, c.1910
Oil on canvas
68 x 54 cm (26³/₄ x 21¹/₄")

H.H. van Aalst-Haagedoorn, c.1910
Oil on canvas
68 x 54 cm (26³/₄ x 21¹/₄")

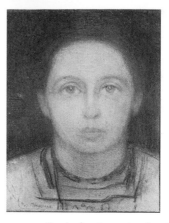

Arda Boogers-Ruhwandl, 1908–10
Oil on canvas
58.5 x 47.5 cm (23 x 19")

*Study for Portrait of a Girl in Red,
1908–09*
Charcoal on grey cardboard
40 x 31 cm (15³/₄ x 12¹/₄")

444

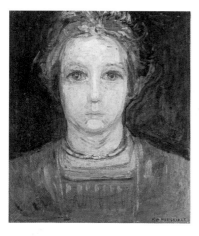

Portrait of a Girl in Red, c.1908–09
Oil on canvas mounted on panel
49 x 41.5 cm (19¹/₄ x 16³/₈")

*Self portrait, Face and Background,
1908–09*
Charcoal, crayon on paper
79.5 x 53 cm (31¹/₄ x 20⁷/₈")

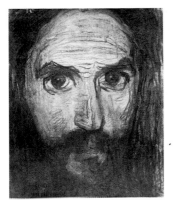

Self portrait, Isolated Face, 1908–09
Charcoal on brown paper
30 x 24.5 cm (11³/₄ x 9⁵/₈")

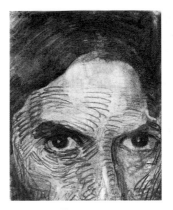

Self portrait, Eyes, 1908–09
Charcoal and crayon on paper
30 x 25.5 cm (11³/₄ x 10")

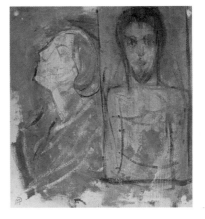

*Images of Torsos (Female in Profile,
Male Viewed Frontally), c.1908–09*
Oil on canvas
34 x 31.5 cm (13³/₈ x 12³/₈")

Two Female Figures, c.1908–09
Crayon on cardboard
54.5 x 73.6 cm (21¹/₂ x 29")

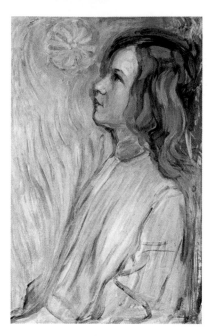

Devotie (Devotion), 1908
Oil on canvas
94 x 61 cm (37 x 24")

Standing Female Nude, c.1908
Pencil on paper
45 x 21.5 cm (17³/₄ x 8¹/₂")

446

Printemps (Spring), c.1908
Chalk on cardboard
69.5 x 46 cm (27³/₈ x 18¹/₈")

Female Nude: Bust Portrait, c.1909–11
Mixed media drawing
33.7 x 40.6 cm (13¹/₄ x 40.6")

Nude Study for Evolution, 1911
Crayon and charcoal on paper
86 x 42 cm (33⁷/₈ x 16¹/₂")

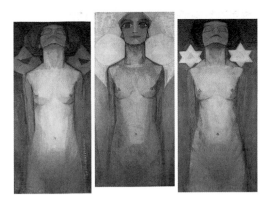

Evolutie (Evolution), c.1911
Oil on canvas
middle panel 183 x 87.5 cm (72 x 34¹/₂")
side panels 178 x 85 cm (70 x 33¹/₂")

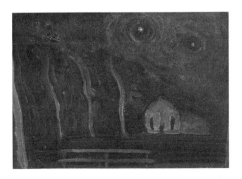

Night Landscape I, c.1908
Oil on canvas
35.6 x 50.2 cm (14 x 19³/₄")

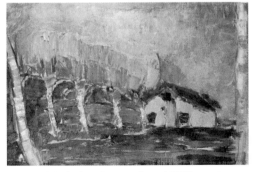

Night Landscape II, c.1908
Oil on canvas
64 x 93 cm (25¹/₈ x 35⁵/₈")

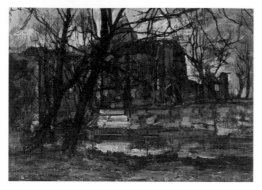

*Castle Ruins: Brederode I,
c.late 1909–early 1910*
Oil on cardboard
50 x 67 cm (19⁵/₈ x 26³/₈″)

*Lentezon (Spring Sun): Castle Ruins:
Brederode, c.late 1909–early 1910*
Oil on canvas
62.2 x 72.3 cm (24¹/₂ x 28¹/₂″)

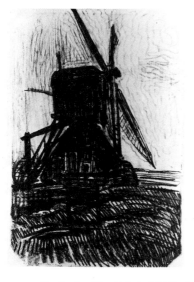

Study for The Winkel Mill, 1907–08
Black and red charcoal on paper
59.7 x 39.8 cm (23¹/₂ x 15⁵/₈″)

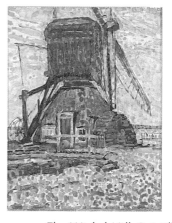

*The Winkel Mill, Pointillist Version,
1908*
Oil on canvas
43.8 x 34.4 cm (17¹/₄ x 13¹/₂″)

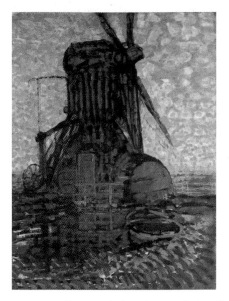

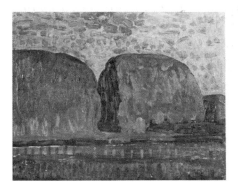

Haystacks I, 1908
Oil (on cardboard?)
c. 30.5 x 43.2 cm (12 x 17")

Mill in Sunlight: The Winkel Mill, 1908
Oil on canvas
114 x 87 cm (44⁷/₈ x 30¹/₄")

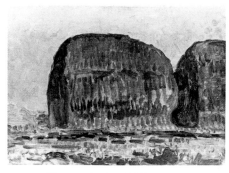

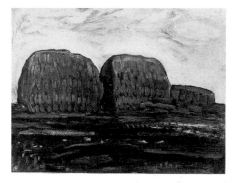

Haystacks II, 1908
Oil on canvas mounted on cardboard
34.5 x 43.2 cm (12 x 17")

Haystacks III, 1908
Oil on canvas
34.2 x 44 cm (13¹/₂ x 17¹/₄")

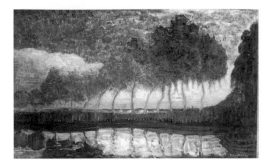

Row of Eleven Poplars in Red, Yellow,
Blue and Green, 1908
Oil on canvas
69 x 112 cm (27^1/$_8$ x 44^1/$_8$")

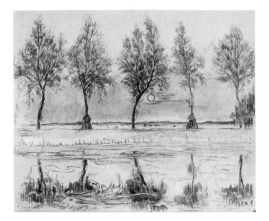

Study for Five Trees along the Gein
with Moon, 1907–08
Charcoal and stumping on paper
63 x 75 cm (24^3/$_4$ x 29^1/$_2$")

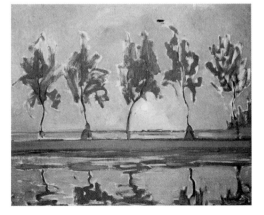

Five Tree Silhouettes along the Gein
with Moon, 1907–08
Oil on canvas
79 x 92.5 cm (31^1/$_8$ x 36^3/$_8$")

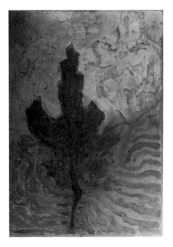

Single Tree Silhouette, c. 1908
Oil on canvas
50 x 35.5 cm (19^3/$_4$ x 14")

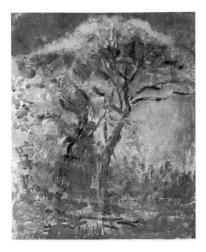

Two Trees with Orange Foliage against Blue Sky, c.1908
Oil on canvas
43 x 35.5 cm (16⁷/₈ x 13⁷/₈")

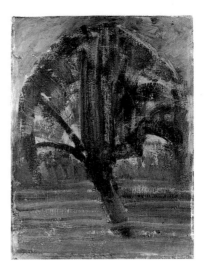

Blue Willow Tree I, c.1908
Oil on canvas
40 x 30 cm (15³/₄ x 11³/₄")

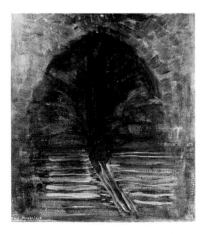

Blue Willow Tree II, c.1908
Oil on canvas mounted on cardboard
37 x 33 cm (14⁵/₈ x 13")

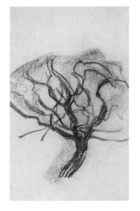

Sketch of an Apple Tree
Black chalk on paper
22.2 x 14 cm (8³/₄ x 5¹/₂")

451

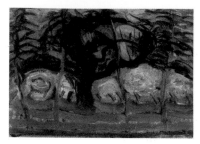

Apple Tree in Blue with Wavy Lines I,
c.1908
Oil on paper mounted on canvas
27.2 x 38.4 cm (10³/₄ x 15¹/₈")

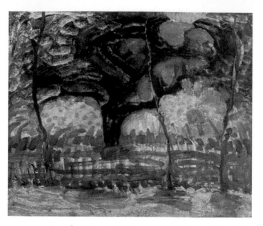

Apple Tree in Blue with Wavy Lines II,
c.1908
Oil on canvas
63.5 x 71.7 cm (25 x 28¹/₄")

452

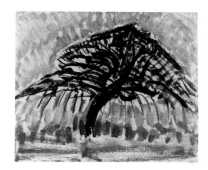

Oil Sketch for Blue Apple Tree Series,
c.1908
Oil on cardboard
31 x 37.5 cm (12¹/₄ x 14¹/₂")

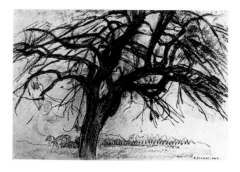

Preliminary Study for Evening:
The Red Tree, 1908
Black crayon and charcoal on paper
31 x 44 cm (12¹/₄ x 17¹/₄")

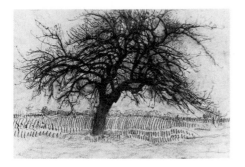

Final Study for Evening: The Red Tree, 1908
Charcoal and stumping on paper
32 x 49 cm (12⅝ x 19¼")

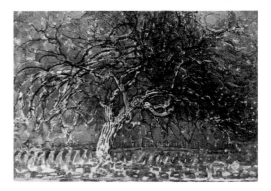

Avond (Evening): The Red Tree, 1908–10
Oil on canvas
70 x 99 cm (27½ x 39")

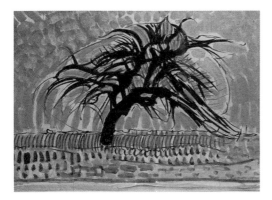

Apple Tree in Blue: Tempera, 1908–09
Tempera on cardboard
75.5 x 99.5 cm (29¾ x 39⅛")

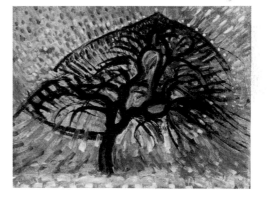

Apple Tree, Pointillist Version, 1908–09
Oil on composition board
56.8 x 75 cm (22⅜ x 29½")

454

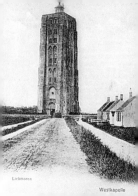

Lichttoren

Westkapelle

Head of Zeeland Farmer, 1909
Pencil on paper
36.2 x 24.5 cm (14$^1/_4$ x 9$^5/_8$")

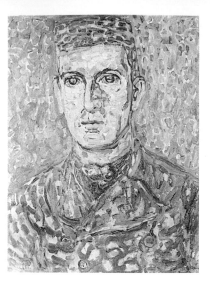

Zeeuws(ch)e boer (Zeeland Farmer),
1909–early 1910
Oil on canvas
69 x 53 cm (27$^1/_8$ x 20$^7/_8$")

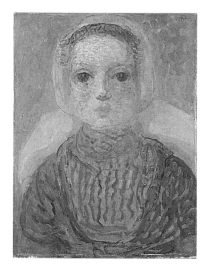

Zeeuws(ch) Meisje (Zeeland Girl),
1909–early 1910
Oil on canvas
63 x 48 cm (24$^3/_4$ x 19")

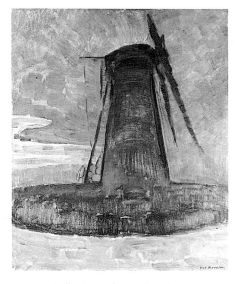

Mill at Domburg, 1909
Oil on cardboard
76.5 x 63.5 cm (31$^1/_8$ x 25")

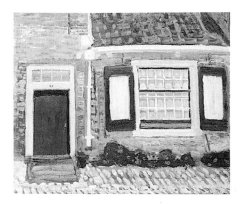

House Façade with Green Trimmed Shutters, 1909
Oil on cardboard
63 x 73 cm (24³/₄ x 28³/₄")

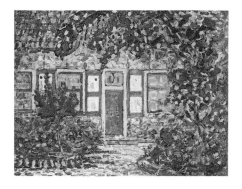

Huisje bij zon (Little House in Sunlight), 1909–early 1910
Oil on canvas
52.5 x 68 cm (20⁵/₈ x 26³/₄")

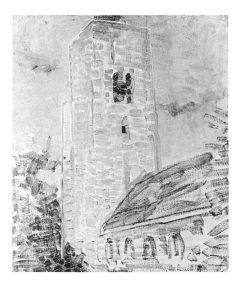

Church at Oostkapelle, Nave and Tower, 1909
Oil on canvas
76 x 65.5 cm (29⁷/₈ x 25³/₄")

Church at Domburg with Tree, 1909
Oil on cardboard
36 x 36 cm (14¹/₈ x 14¹/₈")

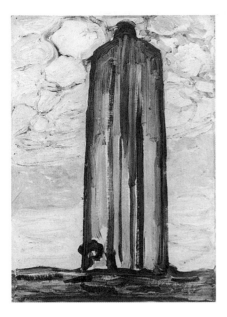

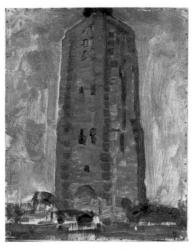

Lighthouse at Westkapelle in Brown, 1909
Oil on canvas
45 x 35.5 cm (17³/₄ x 14")

Lighthouse at Westkapelle with Clouds, 1908–09
Oil on canvas
71 x 52 cm (28 x 20¹/₂")

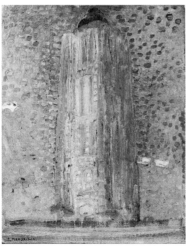

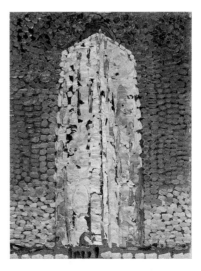

Lighthouse at Westkapelle in Pink, 1909
Oil on cardboard
39 x 29.5 cm (15³/₈ x 11⁵/₈")

Zomermorgen? (Summer Morning): Lighthouse at Westkapelle in Orange, 1909–early 1910
Oil on cardboard
39 x 29 (15³/₈ x 11³/₈")

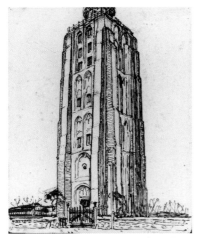

Lighthouse at Westkapelle,
Drawing, 1909
Ink, chalk and gouache on paper
30 x 24.5 cm (11³/₄ x 9⁵/₈")

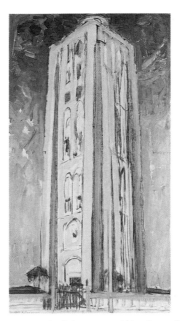

Lighthouse at Westkapelle in Orange,
Pink, Purple and Blue, c.1910
Oil on canvas
135 x 75 cm (53¹/₈ x 29¹/₂")

Church at Zoutelande, Three-quarter
View, 1909
Oil on canvas
69 x 62 cm (27¹/₈ x 24³/₈")

Zon, kerk in Zeeland (Sun, Church in
Zeeland); Zoutelande Church Façade,
1909–early 1910
Oil on canvas
90.7 x 62.2 cm (35³/₄ x 24¹/₂")

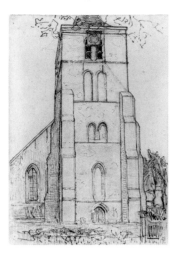

Church Tower at Domburg, Drawing,
late 1910–early 1911
India ink over an underdrawing of pencil and
crayon on paper
41.5 x 28 cm (16³/₈ x 11")

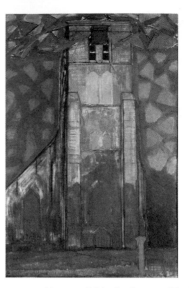

Zeeuws(ch)e kerktoren (Zeeland Church
Tower); Church Tower at Domburg, 1911
Oil on canvas
114 x 75 cm (44⁷/₈ x 29¹/₂")

Sea after Sunset, 1909
Oil on cardboard
62.5 x 74.5 cm (24⁵/₈ x 29¹/₄")

Molen (Mill); The Red Mill, 1911
Oil on canvas
150 x 86 cm (59 x 29¹/₄")

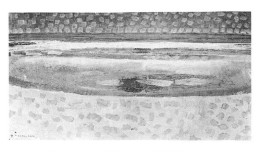

Sea toward Sunset, 1909
Oil on cardboard
41 x 76 cm (16^1/$_8$ x 29^7/$_8$")

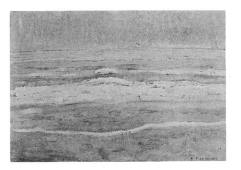

Seascape, 1909
Oil on cardboard
34.5 x 50.5 cm (13^1/$_2$ x 19^7/$_8$")

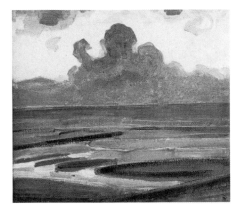

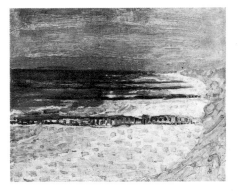

By the Sea, 1909
Oil on cardboard
40 x 45.5 cm (15^3/$_4$ x 18")

Beach with Five Piers at Domburg, 1909
Oil on canvas mounted on cardboard
36 x 44.8 cm (14^1/$_8$ x 17^5/$_8$")

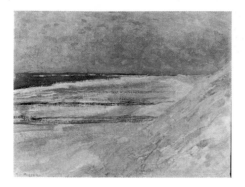

*Beach with Three or Four Piers
at Domburg, 1909*
Oil on canvas
33.5 x 43 cm (13 1/8 x 17")

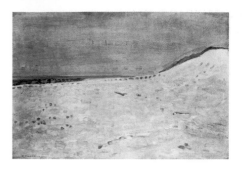

Beach with One Pier at Domburg, 1909
Oil on canvas [mounted on cardboard?]
46 x 67 cm (18 1/8 x 26 3/8")

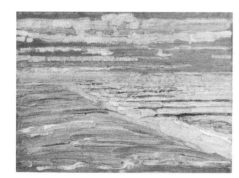

*View from the Dunes with Beach
and Piers, Domburg, 1909*
Oil on cardboard
28.5 x 38.5 cm (11 1/4 x 15 3/16")

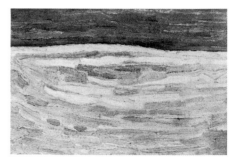

Dune Sketch in Bright Stripes, 1909
Oil on cardboard
30 x 40 cm (11 3/4 x 15 3/4")

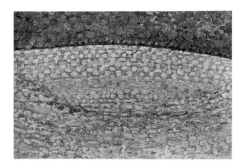

Pointillist Dune Study, Crest at Centre, 1909
Oil on cardboard
29.5 x 39 cm (11⁵/₈ x 15³/₈")

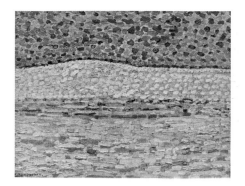

Pointillist Dune Study, Crest at Left, 1909
Oil on cardboard
28 x 38.1 cm (11 x 15")

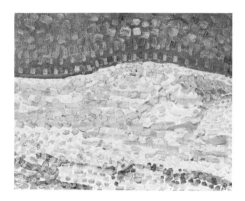

Pointillist Dune Study, Crest at Right, 1909
Oil on canvas
37.5 x 46.5 cm (14³/₄ x 18¹/₄")

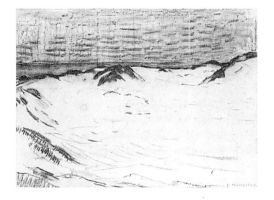

Drawing for Pointillist Study with Dunes and Sea, 1909
Charcoal on paper
46 x 63 cm (18¹/₈ x 24¹³/₁₆")

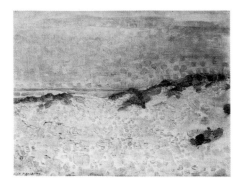

Pointillist Study with Dunes and Sea,
1909
Oil on canvas
33 x 43 cm (13 x 16⁷/₈")

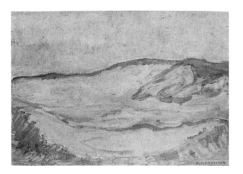

Dune Sketch in Orange, Pink and Blue,
1909
Oil on cardboard
33 x 46 cm (13 x 18¹/₈")

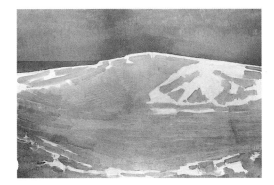

Zomer, duin in Zeeland
(Summer, Dune in Zeeland), 1910
Oil on canvas
134 x 195 cm (52³/₄ x 76³/₄")

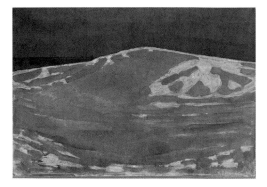

Duinen bij Domburg
(Dunes near Domburg), c.1910
Oil on canvas
65.5 x 96 cm (25³/₄ x 37³/₄")

Duinen bij Domburg
(Dunes near Domburg), 1910–11
Charcoal on paper
45.7 x 68.5 cm (17^{15}/$_{16}$ x 26^{15}/$_{16}$")

465

466

CUBISM

1911–14

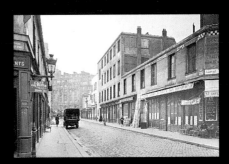

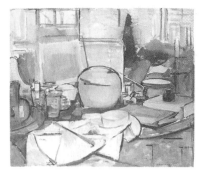

Duinlandschap (Dune Landscape),
(July–September) 1911
Oil on canvas
141 x 239 cm (55¹/₂ x 94¹/₄")

Still Life with Gingerpot 1, 1911
Oil on canvas
65.5 x 75 cm (25³/₄ x 29¹/₂")

468

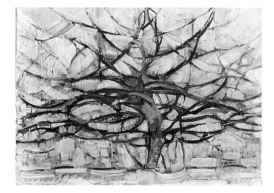

Tree: Study for The Grey Tree, 1911
Black crayon on paper
58.4/57.7 x 86.5/86.2 cm
(23/22³/₄ x 34¹/₈/34")

The Grey Tree, 1911
Oil on canvas
79.7 x 109.1 cm (31¹/₂ x 42⁷/₈")

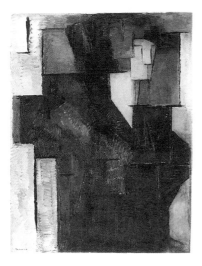

Portrait of a Lady, 1912
Oil on canvas
115 x 88 cm (45^1/$_4$ x 34^5/$_8$″)

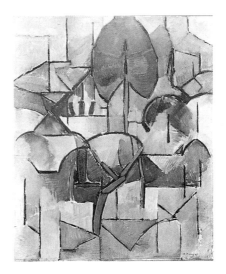

Landscape with Trees, 1912
Oil on canvas
120 x 100 cm (47^1/$_4$ x 39^3/$_8$″)

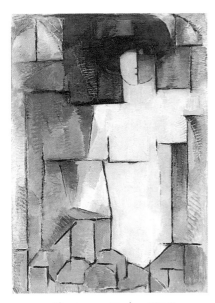

The Large Nude, 1912
Oil on canvas
140 x 98 cm (55^1/$_8$ x 38^5/$_8$″)

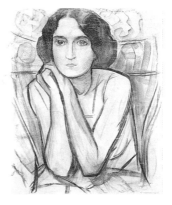

*Portrait of a Woman Leaning on
Her Elbows: Study for Composition
No.XI, 1912*
Charcoal on paper
74.8 x 63 cm (29^1/$_2$ x 24^3/$_4$″)

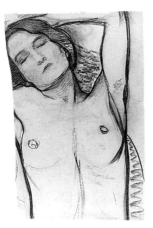

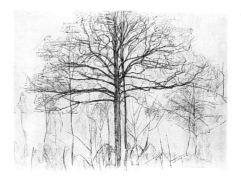

Reclining Nude, 1912
Charcoal on paper
71.7/73 x 49.2/44.1 cm
(28^1/$_4$/28^3/$_4$ x 19^3/$_8$/17^3/$_8$")

Study of Trees 1: Study for Tableau
No.2 / Composition No.VII, 1912
Black crayon on paper
68.1/66 x 89.1/ 88.5 cm
(26^{13}/$_{16}$/26 x 35^1/$_8$/34^7/$_8$")

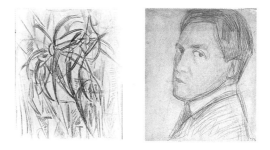

Eucalyptus: Study for Eucalyptus
(unfinished), 1912
verso: Study for self portrait, 1912
Charcoal on cardboard
46.9 x 39.5 cm (18^1/$_2$ x 15^1/$_2$")

Forest: Study for The Trees, 1912
Black crayon on paper
74.8/73.1 x 63.2/60.9 cm
(29^1/$_2$/28^{13}/$_{16}$ x 24^7/$_8$/24")

Eucalyptus (unfinished), 1912
Sketch in oil on canvas
51 x 39.5 cm (20^1/$_8$ x 15^1/$_2$")

Nude, 1912
Charcoal on paper on cardboard
92.3 x 158.2 cm (36^3/$_8$ x 62^3/$_8$")

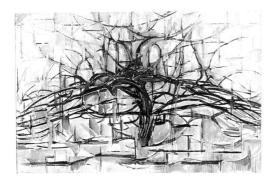

Tree, 1912 (?)
Oil on canvas
75 x 111.5 cm (29^1/$_2$ x 43^7/$_8$")

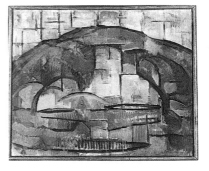

Paysage (Landscape), 1912
Oil on canvas
63 x 78 cm (24^3/$_4$ x 30^3/$_4$")

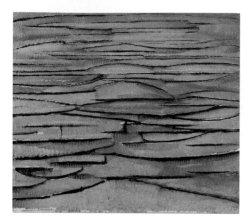

The Sea, 1912
Oil on canvas
82.5 x 92 cm (32^1/$_2$ x 36^1/$_4$")

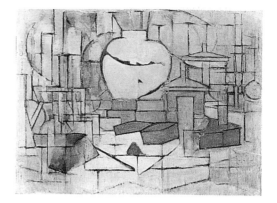

Still Life with Gingerpot 2, 1912
Oil on canvas
91.5 x 120 cm (36 x 47^1/$_4$")

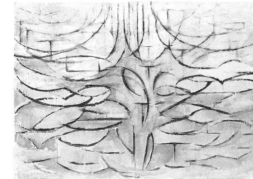

Bloeiende appelboom (Flowering Apple Tree), 1912
Oil on canvas
78.5 x 107.5 cm (31 x 42^3/$_8$")

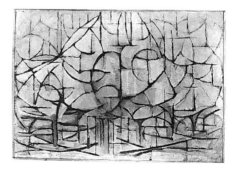

Bloeiende bomen (Flowering Trees), 1912
Oil on canvas
60 x 85 cm (23^5/$_8$ x 33^1/$_2$")

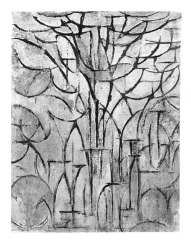

The Trees, 1912
Oil on canvas
94 x 69.8 cm (37 x 27$^1/_2$")

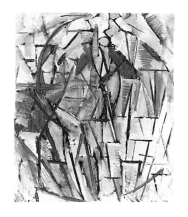

Eucalyptus, 1912
Oil on canvas
60.5 x 51 cm (23$^7/_8$ x 20$^1/_8$")

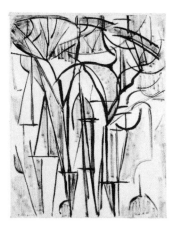

Composition Trees 1 (unfinished),
1912
Oil on canvas
81 x 62 cm (31$^7/_8$ x 24$^3/_8$")

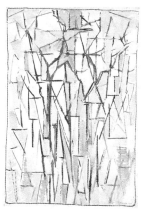

Composition Trees 2, 1912–13
Oil on canvas
98 x 65 cm (38$^5/_8$ x 25$^5/_8$")

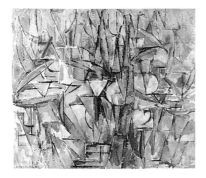

Composition No.X, 1912–13
Oil on canvas
65.5 x 75.7 cm (25³/₄ x 29³/₄")

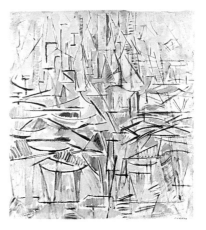

*Composition No.XVI/ Compositie I,
1912–13*
Oil on canvas
85.8 x 75 cm (33³/₄ x 29¹/₂")

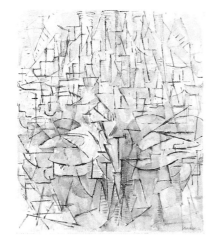

*Tableau No.4 / Composition No.VIII/
Compositie 3, 1913*
Oil on canvas
95 x 80 cm (37³/₈ x 31¹/₂")

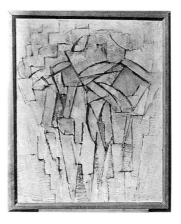

*Composition No.XIII / Compositie 2,
1913*
Oil on canvas
79.5 x 63.5 cm (31¹/₄ x 25")

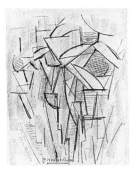

Study after Composition No.XIII/
Compositie 2
Conté crayon and charcoal on paper
31.1/30.8 x 24.3 cm (12 1/8 x 9 9/16")

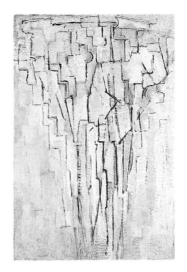

The Tree A, 1913
Oil on canvas
100.2 x 67.2 cm (39 1/2 x 26 1/2")

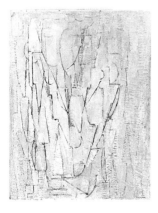

Composition No.XI, 1913
Oil on canvas
76 x 57.5 cm (30 x 22 3/4")

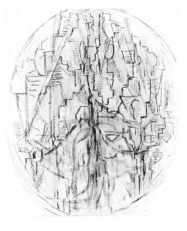

Composition in Oval:
Study for Tableau No.3, 1913
Stumped charcoal on paper
84.7/84 x 70.5/69.5 cm
(33 3/8/33 1/8 x 27 3/4/27 3/8")

475

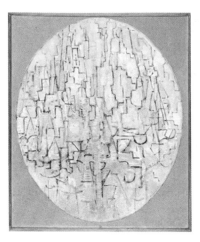

Tableau No.3: Composition in Oval,
1913
Oil on canvas
94 x 78 cm (37 x 30³/₄")

*Study of Trees 2: Study for Tableau
No.2 / Composition No.VII, 1913*
Charcoal on paper
66/65.7 x 84/82 cm
(26/25⁷/₈ x 33¹/₈/32³/₈")

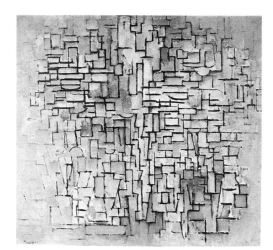

*Tableau No.2 / composition No.VII,
1913*
Oil on canvas
104.4 x 113.6 cm (41¹/₈ x 44³/₄")

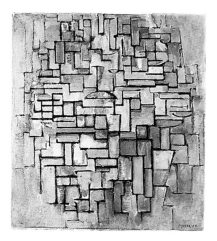

*Gemälde No.II / Composition
No.IX / Compositie 5, 1913*
Oil on canvas
85.7 x 75.5 cm (33³/₄ x 29³/₄")

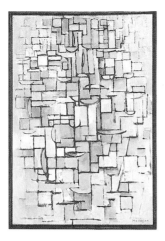

Tableau No.1, 1913
Oil on canvas
96 x 64 cm (37³/₄ x 25¹/₄")

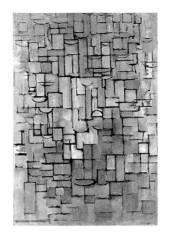

*Gemälde No.I / Composition No.XIV,
1913*
Oil on canvas
94 x 65 cm (37 x 25¹/₈")

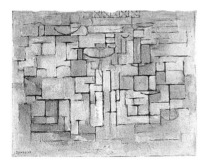

*Gemälde No.II / Composition No.XV /
Compositie 4, 1913*
Oil on canvas
61.5 x 76.5 (24¹/₄ x 30¹/₈")

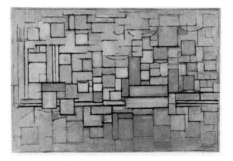

*Gemälde No.I / Composition No.XII,
1913*
Oil on canvas
64 x 94 cm (25¹/₄ x 37")

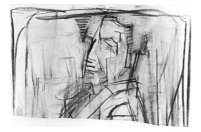

Self Portrait, 1913
Washed charcoal on paper
44.1/49.2 x 73/71.7 cm
(17³/₈/19³/₈ x 28³/₄/28¹/₄")

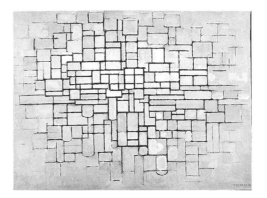

Composition No.II, 1913
Oil on canvas
88 x 115 cm (34³/₄ x 45¹/₄")

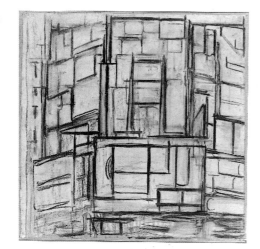

Façade (Buildings), 1914
Charcoal on paper
102.6 x 103.4 cm (40³/₈ x 40¹/₂ [40⁵/₈]")

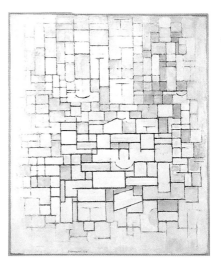

*Tableau No.I / Composition No.I /
Compositie 7, 1914*
Oil on canvas
120.6 x 101.3 cm (47¹/₂ x 40³/₈")

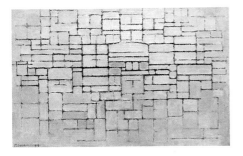

Tableau No.2 / Composition No.V, 1914
Oil on canvas
54.8 x 85.3 cm (21⁵/₈ x 33⁵/₈")

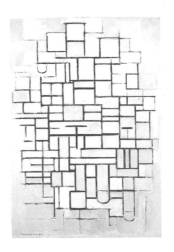

Composition No.IV/ Compositie 6, 1914
Oil on canvas
88 x 61 cm (34⁵/₈ x 24")

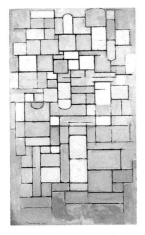

Composition No.III/ Compositie 8, 1914
Oil on canvas
94.4 x 55.5 cm (37¹/₈ x 21⁷/₈")

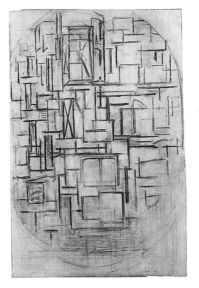

Scaffold: Study for Tableau III, 1914
Charcoal on paper
152.5 x 100 cm (60 x 39³/₈")

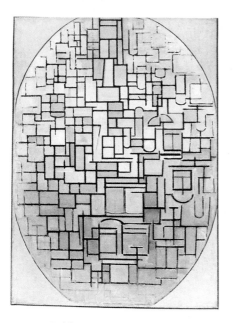

Tableau III: Composition in Oval,
1914
Oil on canvas
140 x 101 cm (55^1/$_8$ x 39^3/$_8$")

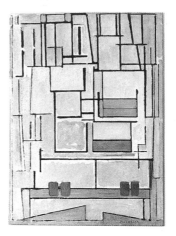

Composition No.VI/ Compositie 9,
1914
Oil on canvas
95.2 x 67.6 cm (37^1/$_2$ x 26^5/$_8$")

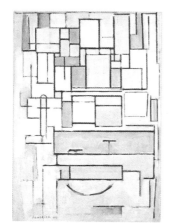

Composition with Colour Planes:
Façade, 1914
Oil on canvas
91.5 x 65 cm (36 x 25^5/$_8$")

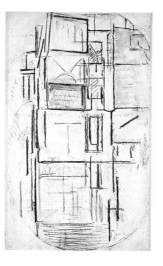

Side Façade: Study for Composition
in Oval with Colour Planes 1, 1914
Charcoal on paper
102.2 x 61 cm (40^1/$_4$ x 24")

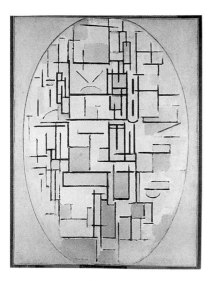

*Composition in Oval with Colour
Planes 1, 1914*
Oil on canvas
107.6 x 78.8 cm (42³/₈ x 31″)

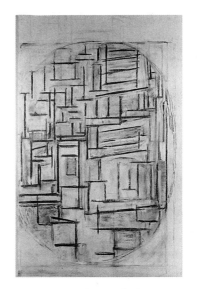

*Façade: Study for Composition in Oval
with Colour Planes 2, 1914*
Charcoal on paper
134.5 x 85 cm (53 x 33¹/₂″)

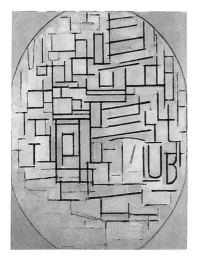

*Colour Study with Pink, Blue, Yellow
and White (1914)*
Oil on cardboard
29.2 x 27.9 cm (11¹/₂ x 11″)

*Composition in Oval with Colour
Planes 2, 1914*
Oil on canvas
113 x 84.5 cm (44¹/₂ x 33¹/₄″)

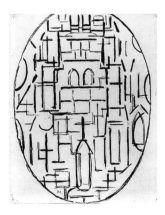

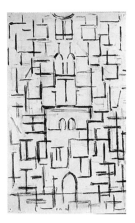

Church Façade 1: Church at Domburg,
1914
Pencil, charcoal and ink on paper
63 x 50.3 cm (24³/₄ x 19⁷/₈")

Church Façade 2, 1914
Charcoal and ink on paper
62.2 x 37.5 cm (24¹/₂ x 14³/₄")

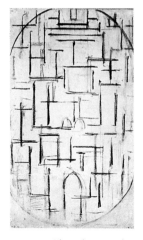

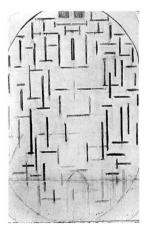

Church Façade 3, 1914
Charcoal on paper
78.7 x 45.7 cm (31 x 18")

Church Façade 4, 1914
Charcoal on paper on cardboard
76.8 x 49.5 cm (30¹/₄ x 19¹/₂")

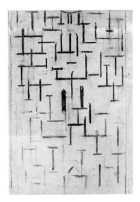

Church Façade 5, 1914
Charcoal on paper
71.4 x 48.4 cm (28 $1/8$ x 19")

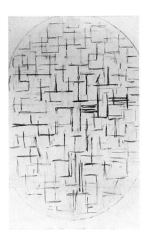

Tree, 1914
Charcoal on paper
79 x 49.8 cm (31 $1/8$ x 19 $5/8$")

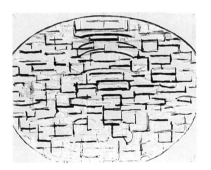

Ocean 1, 1914
Charcoal, ink and gouache on paper
mounted on board
49.5 x 63 cm (19 $1/2$ x 24 $3/4$")

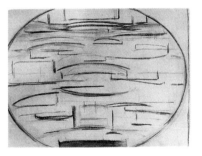

Ocean 2, 1914
Charcoal on paper
58.7 x 76.5 cm (23 $1/8$ x 30 $1/8$")

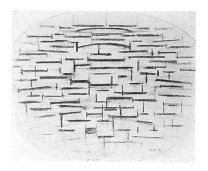

Ocean 3, 1914
Charcoal on paper, mounted on cardboard
50.5 x 63 cm (19^7/$_8$ x 24^3/$_4$")

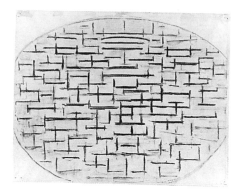

Ocean 4, 1914
Charcoal on paper
50.4 x 62.6 cm (19^7/$_8$ x 24^5/$_8$")

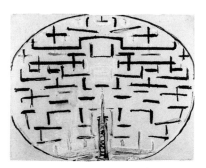

Pier and Ocean 1, 1914
Ink and gouache on paper
50.2 x 62.9 cm (19^3/$_4$ x 24^3/$_4$")

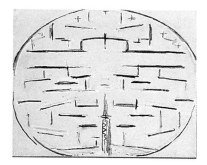

Pier and Ocean 2, 1914
Charcoal, ink and gouache on paper
50 x 62.6 cm (19^5/$_8$ x 24^5/$_8$")

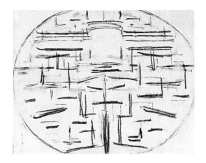

Pier and Ocean 3, 1914
Charcoal on paper
50.5 x 63 cm (19⁷/₈ x 24³/₄")

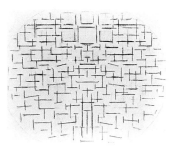

Pier and Ocean 4, 1914
Charcoal on paper
50.2 x 62.8 cm (19³/₄ x 24¹³/₁₆")

485

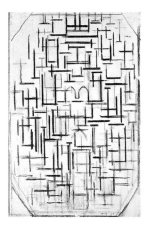

Church Façade 6, 1915
Charcoal on paper
99 x 63.4 cm (39 x 25")

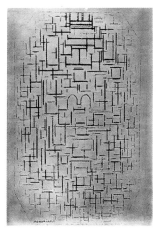

Church Façade 7, 1915
Charcoal on paper
dimensions unknown

Cubism *1911–14*

486

LAREN/BLARICUM

1915–19

Fragment Church Façade:
Composition in Oval, 1915
Charcoal on paper
50.7 x 40 cm (20 x 15³/₄")

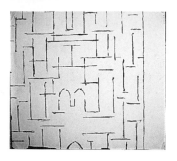

Fragment Church Façade, 1915 /
Ink and gouache on paper
35 x 37 cm (13³/₄ x 14¹/₂")

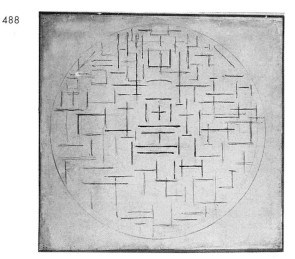

Composition in Circle (Church Façade?),
1915
Charcoal on paper
108 x 113 cm (42¹/₂ x 44¹/₂")

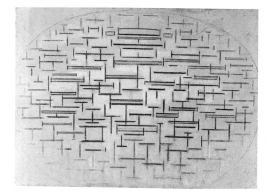

Ocean 5, 1915
Charcoal and gouache on paper
87.6 x 120.3 cm (34¹/₂ x 47³/₈")

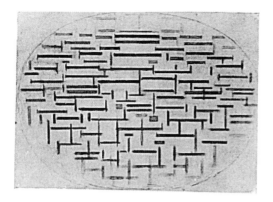

Ocean 6, 1915
Charcoal on paper
dimensions unknown

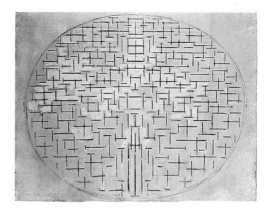

*Pier and Ocean 5: Zee en sterrenlucht
(Sea and Starry Sky), 1915*
Charcoal, ink(?) and gouache on paper
87.9 x 111.7 cm (34⁵/₈ x 44")

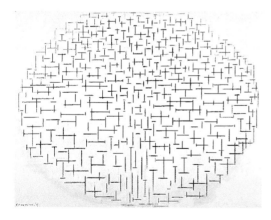

*Compositie 10 in zwart wit
(Composition 10 in Black and White),
1915*
Oil on canvas
85 x 108 cm (33¹/₂ x 42¹/₂")

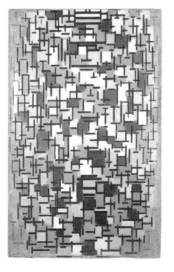

Compositie (Composition), 1916
Oil on canvas
119 x 75.1 cm (46⁷/₈ x 29⁵/₈")

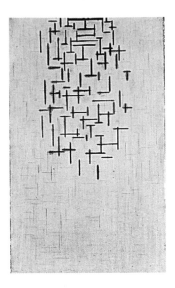

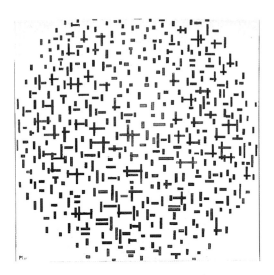

Composition (unfinished), 1916
Pencil, oil on canvas
124.5 x 75 cm (49 x 29¹/₂")

Composition in Line. 1916/
Compositie in lijn. 1917, 1916/1917
Oil on canvas
108 x 108 cm (42¹/₂ x 42¹/₂")

490

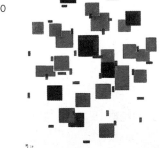

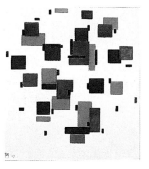

Compositie in kleur A
(Composition in Colour A), 1917
Oil on canvas
50.3 x 45.3 cm (19⁷/₈ x 17⁷/₈")

Compositie in kleur B
(Composition in Colour B), 1917
Oil on canvas
50/50.5 x 45 cm (19³/₄ / 19⁷/₈ x 17³/₄")

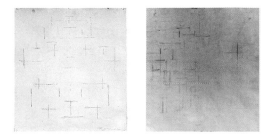

*Study for a Composition in Colour (?),
1916–17 / verso: Plus and Minus Sketch*
Charcoal on paper
50.1 x 44.7 cm (19³/₄ x 17⁵/₈")

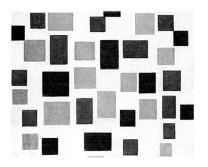

*Composition with Colour Planes 1,
1917*
Gouache on paper
48 x 60 cm (18⁷/₈ x 23⁵/₈")

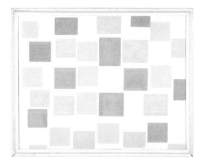

*Composition with Colour Planes 2,
1917*
Oil on canvas
48 x 61.5 cm (18⁷/₈ x 24¹/₄")

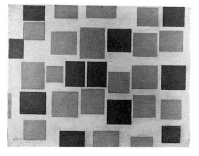

*Compositie No.3, with Colour Planes 3,
1917*
Oil on canvas
48 x 61 cm (18⁷/₈ x 24")

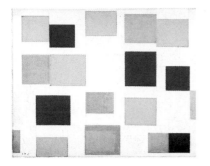

*Composition with Colour Planes 4,
1917*
Oil on canvas
48 x 61 cm (18^7/$_8$ x 24")

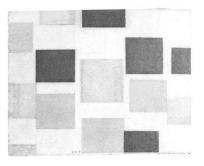

*Composition No.5, with Colour Planes 5,
1917*
Oil on canvas
49 x 61.2 cm (19^1/$_4$ x 24^1/$_8$")

492

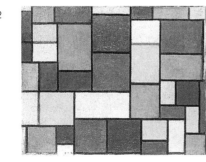

*Composition with Colour Planes
and Grey Lines 1, 1918*
Oil on canvas
49 x 60.5 cm (19^1/$_4$ x 23^7/$_8$")

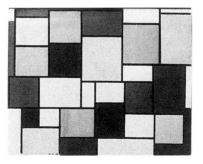

*Composition with Colour Planes
and Grey Lines 2, 1918*
Oil on canvas
49 x 61 cm (19^1/$_4$ x 24")

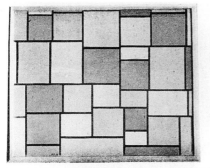

*Composition with Colour Planes
and Grey Lines 3, 1918*
Oil on canvas
67 x 81.5 cm (26³/₈ x 32¹/₈")

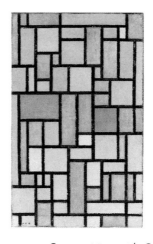

Composition with Grid 1, 1918
Oil on canvas
80.2 x 49.9 cm (31⁵/₈ x 19⁵/₈")

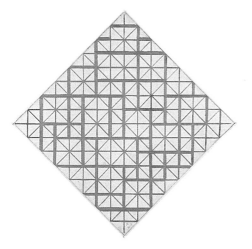

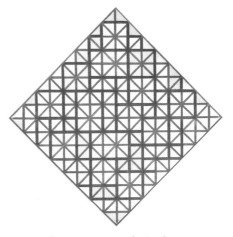

*Composition with Grid 3:
Lozenge Composition, 1918*
Oil on canvas
Diagonal: 121 cm (47⁵/₈")
Sides: 84.5 x 84.5 cm (33¹/₄ x 33¹/₄")

*Composition with Grid 4:
Lozenge Composition, 1919*
Oil on canvas
Diagonal: 85/84.5 cm (33¹/₂ / 33¹/₄")
Sides: 60 x 60 cm (23⁵/₈ x 23⁵/₈")

494

PARIS

1919–38

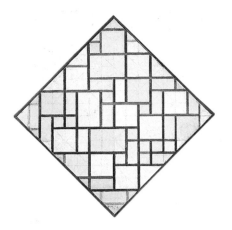

Composition with Grid 5: Lozenge Composition with Colours, 1919
Oil on canvas
Diagonal: 84.5 cm (33$^1/_4$")
Sides: 60 x 60 cm (23$^5/_8$ x 23$^5/_8$")

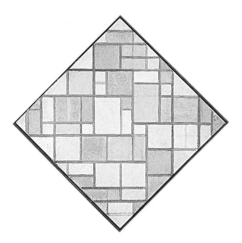

Composition with Grid 6: Lozenge Composition with Colours, 1919
Oil on canvas
Diagonal: 68.5/69 cm (27/27$^1/_8$")
Sides: 49 x 49 cm (19$^1/_4$ x 19$^1/_4$")

Composition with Grid 7, 1919
Oil on canvas
48.5 x 48.5 cm (19$^1/_8$ x 19$^1/_8$")

Composition with Grid 8: Checkerboard Composition with Dark Colours, 1919
Oil on canvas
84 x 102 cm (33$^1/_8$ x 40$^1/_8$")

Composition with Grid 9:
Checkerboard Composition with
Light Colours, 1919
Oil on canvas
86 x 106 cm (33^7/$_8$ x 41^3/$_4$")

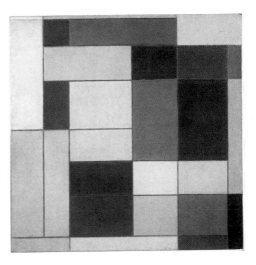

No. VI / Composition No. II, 1920
Oil on canvas
100.5 x 101 cm (39^1/$_4$ x 39^1/$_2$")

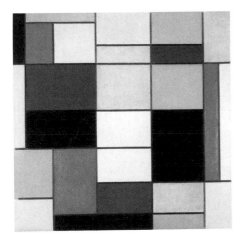

Composition A, 1920
Oil on canvas
90 x 91 cm (35^1/$_2$ x 35^7/$_8$")

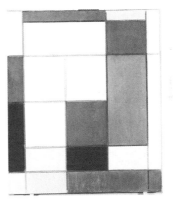

Composition B, 1920
Oil on canvas
67 x 57.5 cm (26^3/$_8$ x 22^5/$_8$")

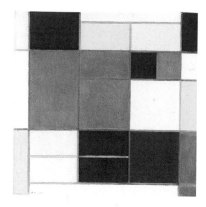

Composition C, 1920
Oil on canvas
60.3 x 61 cm (23³/₄ x 24")

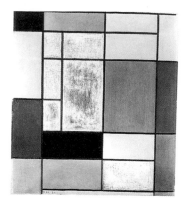

Composition I, 1920
Oil on canvas
75 x 65 cm (29¹/₂ x 25⁵/₈")

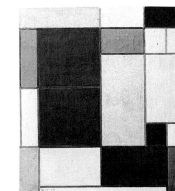

Composition II, 1920
Oil on canvas
63 x 56 cm (24³/₄ x 22")

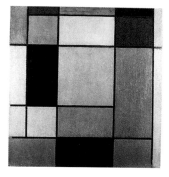

Composition III/Komposition No.XIII,
1920
Oil on canvas
53 x 51 cm (20⁷/₈ x 20¹/₈")

Study for Tableau I. 1921, 1920 (?)
Charcoal on paper
95.8 x 61.6 cm (37³/₄ x 24¹/₄")

Unfinished Composition, 1920 (?)
Oil on canvas
c.67.7 x c.57.5 cm (c.26⁵/₈ x c.22⁵/₈")

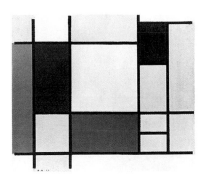

*Composition with Yellow, Red,
Black, Blue and Grey, 1920*
Oil on canvas
51.5 x 61 cm (20¹/₄ x 24")

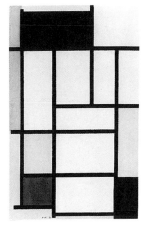

*Composition with Red, Black,
Yellow, Blue and Grey, 1921*
Oil on canvas
80 x 50 cm (31¹/₂ x 19⁵/₈")

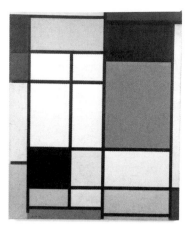

Composition with Yellow, Blue, Black, Red and Grey, 1921
Oil on canvas
88.5 x 72.5 cm (34³/₄ x 28¹/₂")

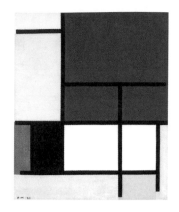

Composition with Large Blue Plane, Red, Black, Yellow and Grey, 1921
Oil on canvas
60.5 x 50 cm (23³/₄ x 19⁵/₈")

Composition with Large Yellow Plane, 1921
Oil on canvas
dimensions unknown

Composition with Large Red Plane, 1921
Oil on canvas
dimensions unknown

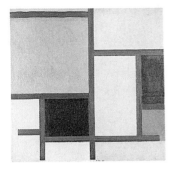

*Composition with Large Red Plane,
Black, Blue, Yellow and Grey,
1921*
Oil on canvas
48 x 48 cm (18⁷/₈ x 18⁷/₈")

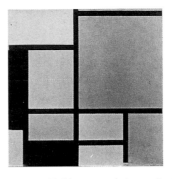

*Tableau, with Large Red Plane, Blue,
Black, Light Green and Greyish Blue,
1921*
Oil on canvas
49.5 x 49.5 cm (19¹/₂ x 19¹/₂")

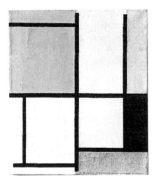

*Tableau 3, with Orange-Red, Yellow,
Black, Blue and Grey, 1921*
Oil on canvas
49.5 x 41.5 cm (19¹/₂ x 16³/₈")

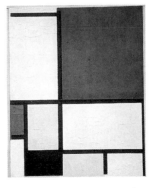

*Composition with Large Red Plane,
Blue, Grey, Black and Yellow, 1921*
Oil on canvas
50 x 40 cm (19³/₄ x 15³/₄")

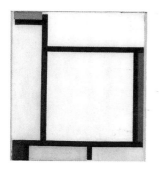

*Composition with Red, Blue,
Black, Yellow and Grey, 1921*
Oil on canvas
39.5 x 35 cm (15¹/₂ x 13³/₄")

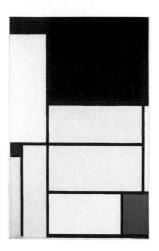

*Tableau I, with Black, Red, Yellow,
Blue and Light Blue, 1921*
Oil on canvas
96.5 x 60.5 cm (38 x 23³/₄")

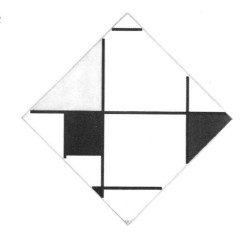

*Lozenge Composition with Yellow,
Black, Blue, Red and Grey, 1921*
Oil on canvas
Diagonal: 84.5 cm (33¹/₄")
Sides: 60.1 x 60.1 cm (23⁵/₈ x 23⁵/₈")

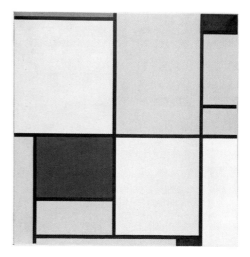

*Tableau I, with Red, Black, Blue
and Yellow, 1921*
Oil on canvas
103 x 100 cm (40¹/₂ x 39³/₈")

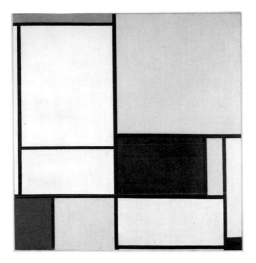

Tableau II, with Red, Black, Yellow, Blue and Light Blue, 1921
Oil on canvas
101 x 99 cm (39³/₄ x 39")

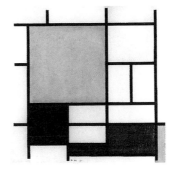

Composition with Large Red Plane, Yellow, Black, Grey and Blue, 1921
Oil on canvas
59.5 x 59.5 cm (23³/₈ x 23³/₈")

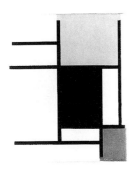

Composition with Red, Yellow, Black, Blue and Grey, 1921
Oil on canvas
48 x 38 cm (18⁷/₈ x 15")

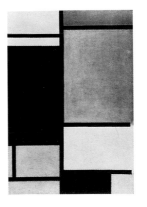

Composition with Red, Blue, Black, Yellow and Grey, 1921
Oil on canvas
76 x 52,4 cm (29⁷/₈ x 20⁵/₈")

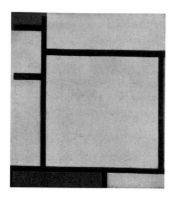

*Composition with Blue, Yellow,
Red and Grey, 1922*
Oil on canvas
38 x 34.8 cm (15 x 13³/₄")

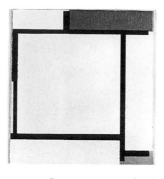

*Composition with Blue, Black,
Yellow and Red, 1922*
Oil on canvas
39 x 34.7 cm (15³/₈ x 13⁵/₈")

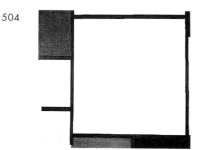

*Composition with Blue, Black,
Yellow and Red, 1922*
Gouache on paper
41 x 49 cm (16¹/₈ x 19¹/₄")

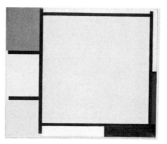

*Composition with Red, Blue,
Yellow, Black and Grey, 1922*
Oil on canvas
41.9 x 48.6 cm (16¹/₂ x 19¹/₈")

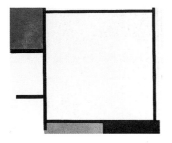

Composition with Blue, Yellow,
Red, Black and Grey, 1922
Oil on canvas
42 x 50 cm (16^1/$_2$ x 19^3/$_4$")

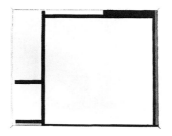

Composition with Yellow, Black,
Blue, Red and Grey, 1922
Oil on canvas
40 x 50 cm (15^3/$_4$ x 19^5/$_8$")

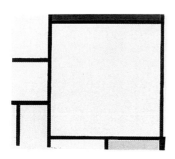

Composition with Blue, Yellow,
Red and Black, 1922
Oil on canvas
42 x 48.5 cm (16^1/$_2$ x 19^1/$_8$")

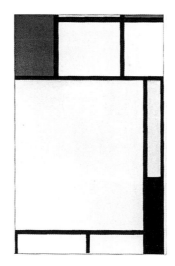

Composition with Blue, Red,
Yellow and Black, 1922
Oil on canvas
79 x 49.5 cm (31^1/$_8$ x 19^1/$_2$")

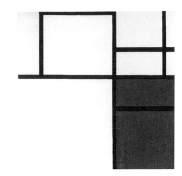

*Composition with Yellow, Blue
and Blue-White, 1922*
Oil on canvas
55.3 x 53.3 cm (21³/₄ x 21")

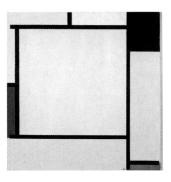

*Composition with Large Red Plane,
Bluish-grey, Yellow, Black and Blue,
1922*
Oil on canvas
54 x 53.4 cm (21¹/₄ x 21")

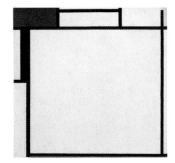

*Composition with Blue, Yellow,
Black and Red, 1922*
Oil on canvas
53 x 54 cm (20⁷/₈ x 21¹/₄")

*Tableau 2, with Yellow, Black,
Blue, Red and Grey, 1922*
Oil on canvas
55.6 x 53.4 cm (21⁷/₈ x 21¹/₈")

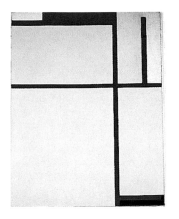

Composition with Red, Black, Yellow, Blue and Grey, 1922
Oil on canvas
50.1 x 39 cm (19³/₄ x 15³/₄")

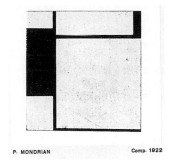

P. MONDRIAN Comp. 1922

Composition 1922, 1922
Oil on canvas
Dimensions unknown

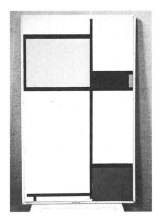

*Komposition mit Gelb, Zinnober,
Schwarz, Blau und verschiedenen
grauen und weissen Tönen.
(Composition with Yellow, Cinnabar,
Black, Blue and Various Grey and
White Tones), 1923*
Oil on canvas
83.7 x 50.2 cm (33 x 19³/₄")

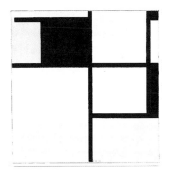

*Tableau, with Yellow, Black,
Blue, Red and Grey, 1923*
Oil on canvas
54 x 53.5 cm (21¹/₄ x 21")

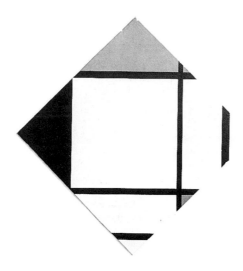

Lozenge Composition with Red,
Black, Blue and Yellow, 1925
Oil on canvas
Diagonal: 109 cm (42^7/$_8$")
Sides: 77 x 77 cm (30^3/$_8$ x 30^3/$_8$")

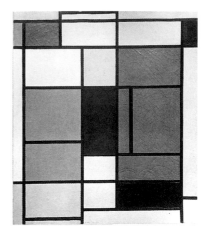

Composition. 1920 (?)/
Tableau No.I. 1921–5, with Red,
Blue, Yellow, Black and Grey, 1920
(?)/1925
Oil on canvas
75.3 x 65 cm (29^5/$_8$ x 25^5/$_8$")

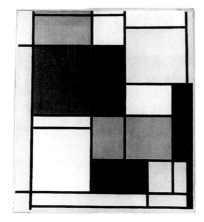

Composition. 1921/
Tableau No.II. 1921–5, with Red,
Blue, Black, Yellow and Grey,
1921/1925
Oil on canvas
75 x 65 cm (29^5/$_8$ x 25^5/$_8$")

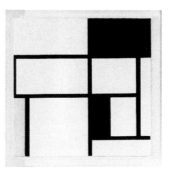

Composition. 1922/
Tableau No.III. 1922–5, with Red,
Black, Yellow, Blue and Grey,
1922/1925
Oil on canvas
49.2 x 49.2 cm (19^3/$_8$ x 19^3/$_8$")

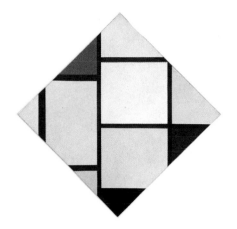

Lozenge Composition. 1924 / Tableau No.IV. losangique pyramidal. 1925, with Red, Blue, Yellow and Black, 1924/1925
Oil on canvas
Diagonals: 142.8 x 142.5 cm (56¼ x 56⅛")
Sides: 100.5 x 100.5 cm (39½ x 39½")

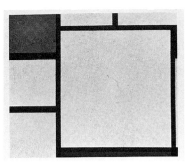

Composition. 1922 / Tableau No.V. 1922–5, with Red, Black, Grey and Blue, 1922/1925
Oil on canvas
55 x 65 cm (21⅝ x 25⅝")

Tableau No.VI, with Red, Yellow and Blue, 1925
Oil on canvas
44 x 54 cm (17³/₈ x 21¼")
[Painting unknown]

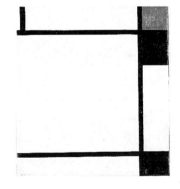

Tableau No.VII, with Blue, Yellow, Black and Red, 1925
Oil on canvas
48.5 x 43.5 cm (19⅛ x 17⅛")

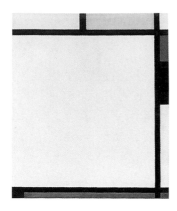

Tableau No. VIII, with Yellow, Red, Black and Blue, 1925
Oil on canvas
49 x 41.5 cm (19^1/$_4$ x 16^3/$_8$")

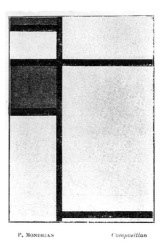

P. MONDRIAN Composition

Tableau No. IX, with Blue, Red and Yellow, 1925
Oil on canvas
63 x 43 cm (24^3/$_4$ x 16^7/$_8$")

510

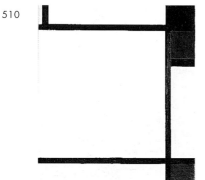

Tableau No. X, with Yellow, Black, Red and Blue, 1925
Oil on canvas
49 x 42.5 cm (19^1/$_4$ x 16^3/$_4$")

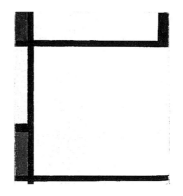

Tableau No. XI, with Red, Black, Blue and Yellow, 1925
Oil on canvas
38.5 x 34.5 cm (15^1/$_8$ x 13^5/$_8$")

Tableau No.XII, with Red, Yellow and Blue, 1925
Medium, support and dimensions unknown
[Painting unknown]

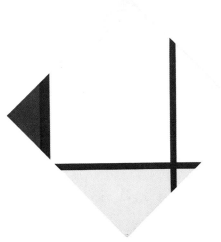

Tableau No.I: Lozenge with Three Lines and Blue, Grey and Yellow, 1925
Oil on canvas
Diagonal: 112 cm (44¹/₈")
Sides: 80 x 80 cm (31¹/₂ x 31¹/₂")

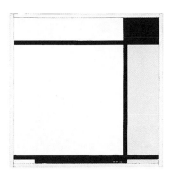

Tableau No.II, with Black and Grey, 1925
Oil on canvas
50 x 50 cm (19⁶/₈ x 19⁶/₈")

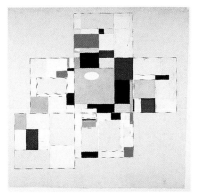

Designs for the Library-Study of Ida Bienert, the so-called 'Salon de Madame B..., à Dresden,' 1926
Exploded Box Plan, 1926
Pencil and gouache on paper
75 x 75 cm (29¹/₂ x 29¹/₂")

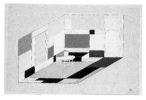

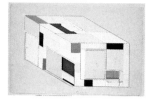

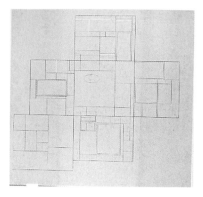

Axonometric View with Floor, Bed and Table,
1926
Pencil and gouache on paper
37.3 x 56.5 cm (14⁵/₈ x 22¹/₄")

Axonometric View with Ceiling, Bookcase
and Cabinet, 1926
Pencil and gouache on paper
37.6 x 56 cm (14³/₄ x 22")

Colour Scheme for the Decoration
of the Library-Study of Ida Bienert,
Dresden, 1926
Ink and pencil with gouache corrections on
paper
76.5 x 75.9 cm (30¹/₈ x 29⁷/₈")

512

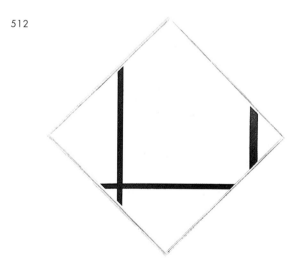

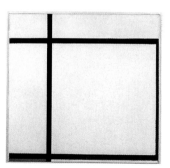

Komposition II, with Red, 1926
Oil on canvas
50.8 x 50.8 cm (20 x 20")

Komposition I: Lozenge with
Three Lines, 1926
Oil on canvas
Diagonal: 112 (44¹/₈")
Sides: 80 x 80 cm (31¹/₂ x 31¹/₂")

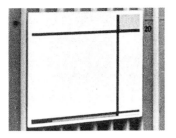

Komposition III, 1926
Oil on canvas
50 x 50 cm (19⁵/₈ x 19⁵/₈")

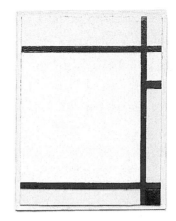

Komposition IV, with Red, 1926
Oil on canvas
40 x 30 cm (15³/₄ x 11³/₄")

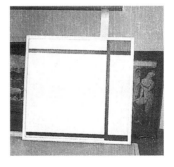

*Schilderij No.2, 'mit Blau, Gelb,
Schwarz und verschiedenen hellgrauen
und weissen Tönen,' ('with Blue,
Yellow, Black and Various Light Grey
and White Tones') 1926*
Oil on canvas
50.1 x 51.2 cm (19³/₄ x 20¹/₈")

*Schilderij No.1: Lozenge with
Two Lines and Blue, 1926*
Oil on canvas
Diagonals: 84.9 x 85 cm (33³/₈ x 33¹/₂")
Sides: 60 x 60.1 cm (23⁵/₈ x 23⁵/₈")

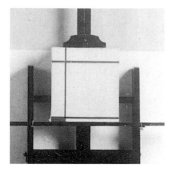

Composition, 1926 (?)
Medium, support and dimensions unknown

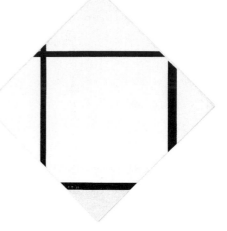

Tableau I: Lozenge with Four Lines and Grey, 1926
Oil on canvas
Diagonals: 113.7 x 111.8 cm (44^3/$_4$ x 44")
Sides: 80 x 80.4 cm (31^5/$_8$ x 31^3/$_4$")

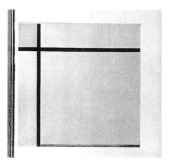

Tableau II, 1926
Oil on canvas
50.1 x 50.1 cm (19^3/$_4$ x 19^3/$_4$")

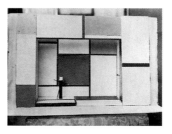

Stage Set Model for Michel Seuphor's 'L'Éphémère est éternel,' 1926
Gouache on cardboard box with three movable backdrop elements
35 x 40 cm (13^3/$_4$ x 15^3/$_4$")

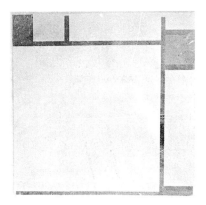

Composition, 1926 (or 1927)
Medium, support and dimensions unknown

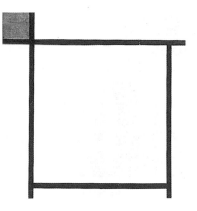

Composition, 1926 (or 1927)
Medium, support and dimensions unknown

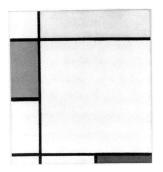

*Composition with Yellow, Red and Blue,
1927*
Oil on canvas
38 x 34.5 cm (15 x 13⅝")

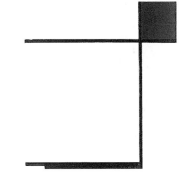

*Composition with Blue, Black and Grey,
1927*
Oil on canvas
38.2 x 35 cm (15¹/₁₆ x 13³/₄")

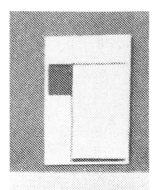

Composition, 1927
Medium, support and dimensions unknown

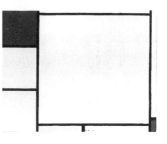

Composition with Blue, Yellow and Red, 1927
Oil on canvas
39.8 x 50.3 cm (15⁶/₈ x 19⁷/₈")

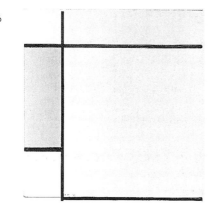

Composition, 1927
Medium, support and dimensions unknown

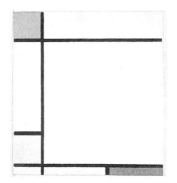

Composition with Red, Yellow and Blue, 1927
Oil on canvas
38 x 35 cm (15 x 13³/₄")

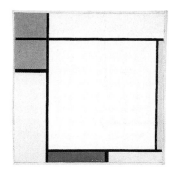

*Composition with Red, Yellow
and Blue, 1927*
Oil on canvas
51.1 x 51.1 cm (20¹/₈ x 20¹/₈")

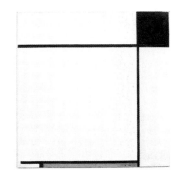

*Composition with Black, Red and Grey,
1927*
Oil on canvas
56 x 56 cm (22 x 22")

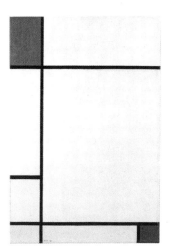

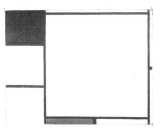

*Composition with Red, Yellow and Blue,
1927*
Oil on canvas
40 x 52 cm (15³/₄ x 20¹/₂")

*Composition: No.III, with Red,
Yellow and Blue, 1927*
Oil on canvas
61 x 40 cm (24 x 15³/₄")

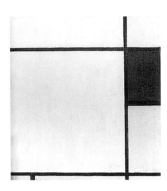

Compositie No.I/Composition: V, with Blue and Yellow, 1927
Oil on canvas
38 x 35 cm (15 x 13³/₄")

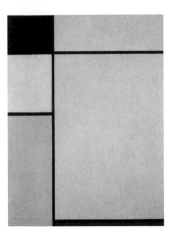

Composition: No.I, with Black, Yellow and Blue, 1927
Oil on canvas
73.5 x 54 cm (28⁷/₈ x 21¹/₄")

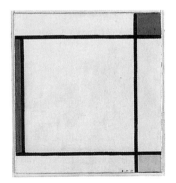

Composition: No.III, with Red, Blue and Yellow, 1927
Oil on canvas
38 x 35.5 cm (15 x 14")

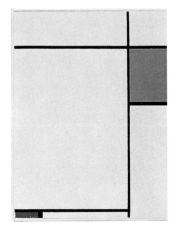

Composition with Red, Blue and Grey, 1927
Oil on canvas
66 x 50 cm (26 x 19³/₄")

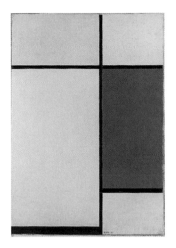

Composition: No.II, with Yellow, Red and Blue, 1927
Oil on canvas
50.2 x 35.2 cm (19³/₄ x 13⁷/₈")

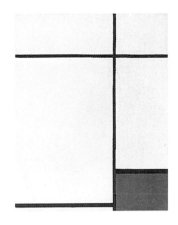

Composition with Yellow and Blue, 1927
Oil on canvas
50 x 39.5 cm (19⁵/₈ x 15¹/₂")

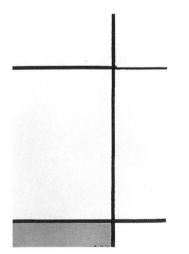

Composition with Yellow and Red, 1927
Oil on canvas
52 x 35 cm (20¹/₂ x 13³/₄")

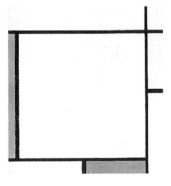

Composition with Yellow, Red and Blue, 1927
Oil on canvas
37.8 x 34.9 cm (14⁷/₈ x 13³/₄")

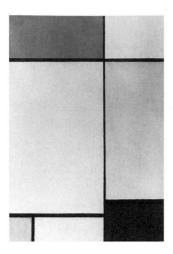

*Composition with Red, Yellow and Blue,
1927 (?)*
Oil on canvas
75 x 52 cm (29^1/$_2$ x 20^1/$_2$")

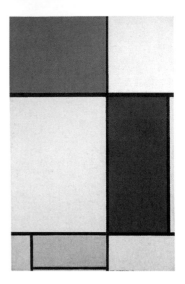

*Large Composition with Red, Blue
and Yellow, 1928*
Oil on canvas board on canvas
123 x 80 cm (48^1/$_2$ x 31^1/$_2$")

520

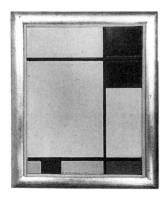

*Farbige Aufteilung (Distribution of
Colours), 1928*
Oil on canvas
41.2 x 32.9 cm (16^1/$_4$ x 13")

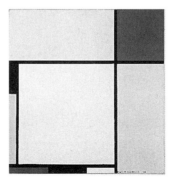

*Composition with Red, Black, Blue,
Yellow and Grey, 1928*
Oil on canvas
52.1 x 49.9 cm (20^1/$_2$ x 19^5/$_8$")

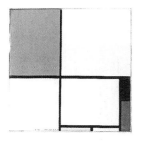

*Composition with Red, Black, Blue
and Yellow, 1928*
Oil on canvas
45 x 45 cm (17³/₄ x 17³/₄")

*Tableau-Poème, with Text by
Michel Seuphor, 1928*
Pencil, pen, ink and gouache on cardboard
65 x 50 cm (25¹/₂ x 19⁵/₈")

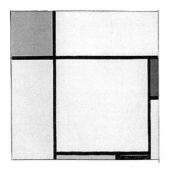

*Composition, with Red, Blue,
Yellow and Black, 1929*
Oil on canvas
45.1 x 45.3 cm (17³/₄ x 17⁷/₈")

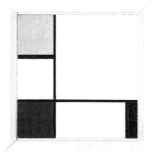

*Composition, with Yellow, Blue,
Black and Light Blue, 1929*
Oil on canvas
50.5 x 50.5 cm (19⁷/₈ x 19⁷/₈")

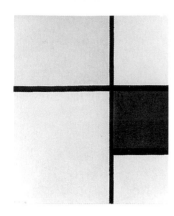

*Composition No.I, with Yellow
and Blue, 1929*
Oil on canvas
40.1 x 32.1 cm (15^{13}/$_{16}$ x 12^5/$_8$")

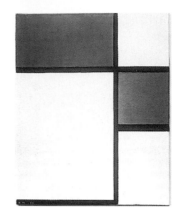

*Composition No.II, with Red and Blue,
1929*
Oil on canvas
40.3 x 32.1 cm (15^7/$_8$ x 12^5/$_8$")

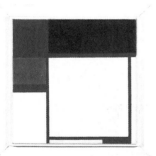

*Composition No.III/ Fox-Trot B, with
Black, Red, Blue and Yellow, 1929*
Oil on canvas
45.4 x 45.4 cm (17^7/$_8$ x 17^7/$_8$")

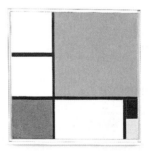

*Composition II, with Red, Blue, Black
and Yellow, 1929*
Oil on canvas
45 x 45 cm (17^3/$_4$ x 17^3/$_4$")

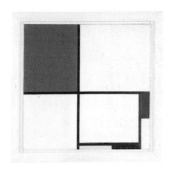

Composition No.III, with Red,
Blue, Yellow and Black, 1929
Oil on canvas
50 x 50.5 cm (19⁵/₈ x 19⁷/₈")

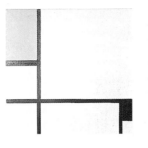

Composition No.I, with Red
and Black, 1929
Oil on canvas
52 x 52 cm (20¹/₂ x 20¹/₂")

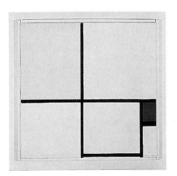

Composition No.II, with Yellow
and Blue, 1929
Oil on canvas
52 x 52 cm (20¹/₂ x 20¹/₂")

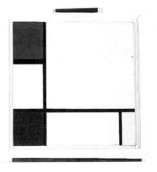

Composition No.IV, with Red,
Blue and Yellow, 1929
Oil on canvas
52 x 51.5 cm (20¹/₂ x 20⁵/₁₆")

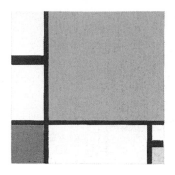

*Composition with Red, Blue
and Yellow, 1930*
Oil on canvas
46 x 46 cm (18^1/$_8$ x 18^1/$_8$")

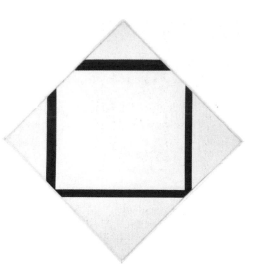

*Composition No.I: Lozenge with
Four Lines, 1930*
Oil on canvas
Diagonal: 107 cm (42^1/$_8$")
Sides: 75.2 x 75.2 cm (29^5/$_8$ x 29^5/$_8$")

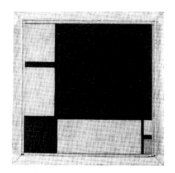

*Composition No.II/ Composition I/
Composition en rouge, bleu et jaune,
1930*
Oil on canvas
51 x 51 cm (20^1/$_8$ x 20^1/$_8$")

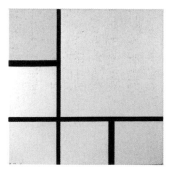

*Composition No.I, with Yellow
and Light Grey, 1930*
Oil on canvas
50.5 x 50.5 cm (19^7/$_8$ x 19^7/$_8$")

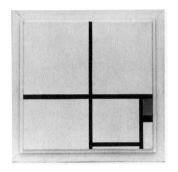

Composition with Yellow, 1930
Oil on canvas
46 x 46.5 cm (18^1/$_8$ x 18^1/$_4$")

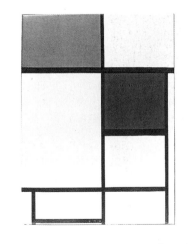

*Composition II, with Red, Blue
and Yellow, 1930*
Oil on canvas
72.6 x 54 cm (28^5/$_8$ x 21^1/$_4$")

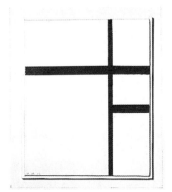

*Composition en blanc et noir I/
Composition No.II, with Black Lines,
1930*
Oil on canvas
40.9 x 33.3 cm (16^1/$_8$ x 13^1/$_8$")

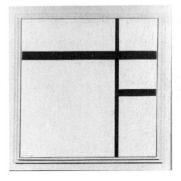

*Composition en blanc et noir II,
with Black Lines, (Composition in Black
and White, II with Black Lines) 1930*
Oil on canvas
50.5 x 50.5 cm (19^7/$_8$ x 19^7/$_8$")

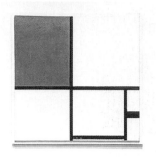

*Composition No.II, with Blue
and Yellow, 1930*
Oil on canvas
50.5 x 50.5 cm (19⁷/₈ x 19⁷/₈")

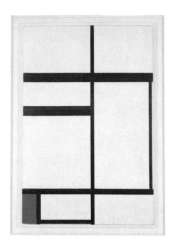

Composition No.I, with Red, 1931
Oil on canvas
82.5 x 54.7 cm (32¹/₂ x 21⁵/₈")

526

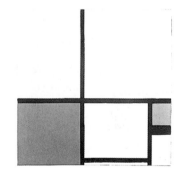

*Composition en Couleurs /
Composition No.I, with Red and Blue,
1931*
Oil on canvas
50.5 x 50.5 cm (19⁷/₈ x 19⁷/₈")

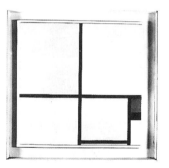

*Composition No.II, with Yellow
and Blue, 1931*
Oil on canvas
52 x 52 cm (20¹/₂ x 20¹/₂")

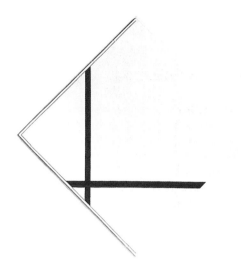

*Lozenge Composition with Two Lines,
1931*
Oil on canvas
Diagonals: 112 x 112 cm (44$^1/_8$ x 44$^1/_8$")
Sides: 80 x 80 cm (31$^1/_2$ x 31$^1/_2$")

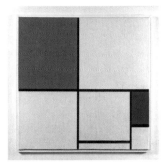

Composition A, with Red and Blue, 1932
Oil on canvas
55 x 55 cm (21$^5/_8$ x 21$^5/_8$")

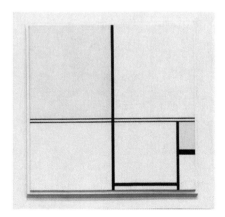

*Composition B, with Double Line
and Yellow and Grey, 1932*
Oil on canvas
50 x 50 cm (19$^5/_8$ x 19$^5/_8$")

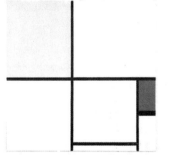

*Composition C, with Grey and Red,
1932*
Oil on canvas
50.2 x 50.4 cm (19$^3/_4$ x 19$^7/_8$")

527

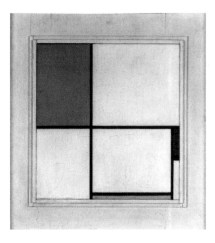

Composition D, with Red, Blue
and Yellow, 1932
Oil on canvas
42 x 38.5 cm (16$^1/_2$ x 15$^1/_8$")

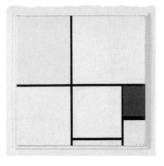

Composition with Yellow and Blue,
1932
Oil on canvas
55.5 x 55.3 cm (21$^7/_8$ x 21$^3/_4$")

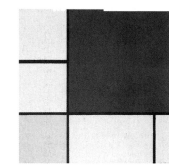

Composition with Blue and Yellow,
1932
Oil on canvas
45.4 x 45.4 cm (17$^7/_8$ x 17$^7/_8$")

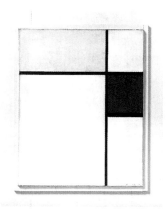

Composition with Yellow and Blue,
1932
Oil on canvas
41.3 x 33 cm (16$^1/_4$ x 13")

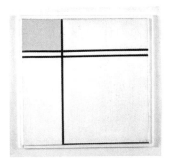

*Composition with Double Line
and Yellow, 1932*
Oil on canvas
45.2 x 45.2 cm (17³/₄ x 17³/₄")

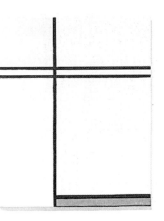

*Composition with Double Line
and Yellow and Blue, 1933*
Oil on canvas
41 x 33.5 cm (16¹/₈ x 13¹/₄")

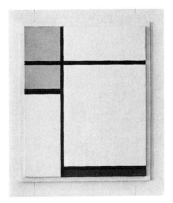

*Composition with Red and Blue,
1933*
Oil on canvas
41.2 x 33.3 cm (16¹/₄ x 13¹/₈")

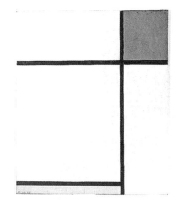

*Composition with Blue and Yellow,
1933*
Oil on canvas
41.5 x 33 cm (16³/₈ x 13")

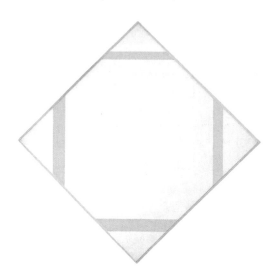

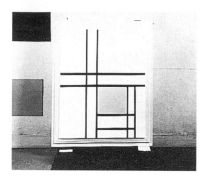

Composition with Double Lines
and Yellow, 1934
Oil on canvas
dimensions unknown

Lozenge Composition with Four
Yellow Lines, 1933
Oil on canvas
Diagonal: 112.9 cm (44^1/$_4$")
Sides: 80.2 x 79.9 cm (30^5/$_8$ x 30^1/$_2$")

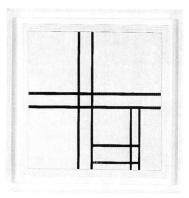

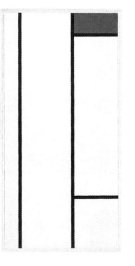

Composition in Black and White,
with Double Lines, 1934
Oil on canvas
59.4 x 60.3 cm (23^3/$_8$ x 23^3/$_4$")

Composition No.I / Composition. C.
1934 / Composition (blanc et bleu).
1936, 1934 / 1936
Oil on canvas
121.3 x 59 cm (47^7/$_8$ x 23^1/$_4$")

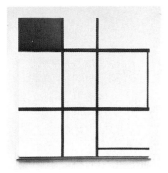

*Composition No.II. 1934 /
Composition (blanc et rouge). 1936,
1934/1936*
Oil on canvas
59 x 56.5 cm (23¹/₄ x 22¹/₄")

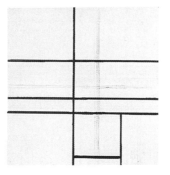

*Composition with Double Line
(unfinished), 1934*
Charcoal and oil on canvas
57 x 55 cm (22¹/₂ x 21⁵/₈")

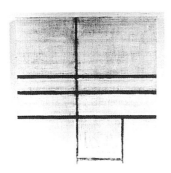

*Composition with Double Line
(unfinished), 1934*
Oil on canvas
c.55 x c.55 cm (c.21⁵/₈ x c.21⁵/₈")

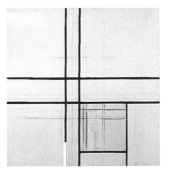

*Composition with Double Lines
and Yellow (unfinished), 1934*
Oil on canvas
55.5 x 54.5 cm (21⁷/₈ x 21¹/₂")

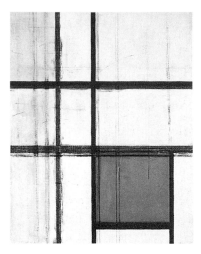

Composition with Red (unfinished), 1934
Charcoal and oil on canvas
80.9 x 63 cm (31$^7/_8$ x 25$^1/_8$")

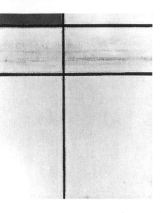

Composition with Double Line and
Blue (unfinished), 1934
Oil on canvas
60 x 50 cm (23$^5/_8$ x 19$^3/_4$")

532

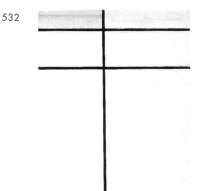

Composition with Double Line
and Yellow (unfinished), 1934
Oil on canvas
61 x 50 cm (24 x 19$^3/_4$")

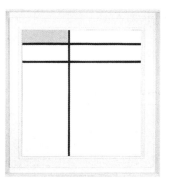

Composition A, with Double Line
and Yellow, 1935
Oil on canvas
59 x 56 cm (23$^1/_4$ x 22$^1/_8$")

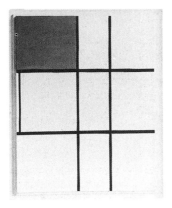

Composition B/(No.II), with Red, 1935
Oil on canvas
80 x 63.2 cm (31$^1/_2$ x 24$^7/_8$")

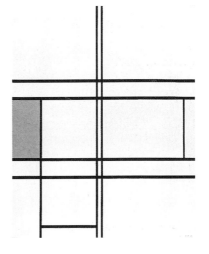

Composition (No.I) gris-rouge,
(Composition (No.I) with Grey and Red)
1935
Oil on canvas
56.9 x 55 cm (22$^3/_8$ x 21$^5/_8$")

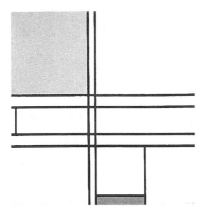

Composition (No.II) bleu-jaune, 1935
(Composition (No.II) with Blue and
Yellow)
Oil on canvas
72.3 x 69.2 cm (28$^1/_2$ x 27$^1/_4$")

Composition, 1934 / Composition
(No.IV) blanc-bleu, 1935, 1934/1935
Oil on canvas
99 x 70.3 cm (39 x 31$^5/_8$")

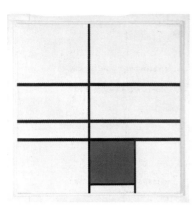

*Composition with Double Line
and Blue, 1935*
Oil on canvas
71.1 x 68.9 cm (28 x 27 1/8")

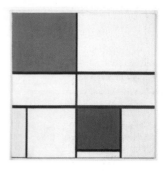

*Composition C (No.III), with Red,
Yellow and Blue, 1935*
Oil on canvas
56.2 x 55.1 cm (22 1/8 x 21 3/4")

534

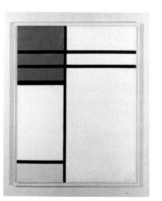

*Composition (A) en rouge et blanc,
(Composition (A) with Red and White)
1936*
Oil on canvas
43.2 x 33 cm (17 x 13")

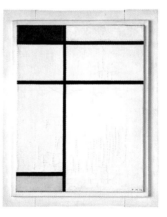

*Composition (B) en bleu, jaune
et blanc, (Composition (B) with Blue,
Yellow and White) 1936*
Oil on canvas
43.5 x 33.5 cm (17 1/8 x 13 1/4")

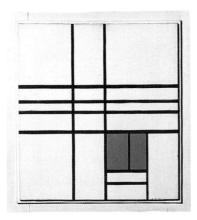

Composition with Yellow, 1936
Oil on canvas
74 x 66 cm (29^1/$_8$ x 26")

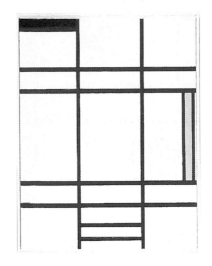

*Composition – blanc, rouge et jaune: A,
(Composition – White, Red and
Yellow: A) 1936*
Oil on canvas
80 x 62.2 cm (31^1/$_2$ x 24^1/$_2$")

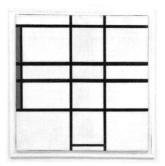

*Composition – blanc et rouge: B,
(Composition – White and Red: B)
1936*
Oil on canvas
51.5 x 50.5 cm (20^1/$_4$ x 19^7/$_8$")

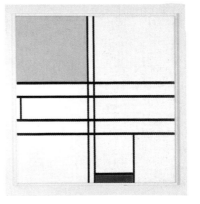

*Composition in White, Blue and Yellow:
C, 1936*
Oil on canvas
70,5 x 68,5 cm (27^3/$_4$ x 27")

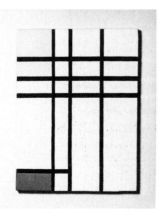

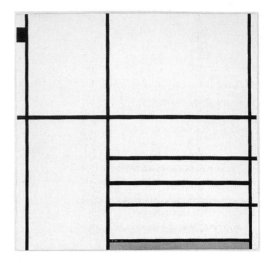

Composition en blanc, rouge et bleu,
(Composition with White, Red and Blue)
1936
Oil on canvas
98.5 x 80.3 cm (38³/₄ x 31⁵/₈")

Composition en blanc, noir et rouge,
(Composition with White, Black and
Red) 1936
Oil on canvas
102 x 104 cm (40¹/₈ x 41")

536

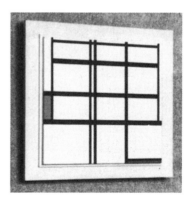

Composition en bleu et jaune,
(Composition with Blue and Yellow)
1937
Oil on canvas
44 x 32 cm (17³/₈ x 13")

Composition en jaune, bleu et blanc: I,
(Composition with Yellow, Blue and
White: I) 1937
Oil on canvas
57.1 x 55.2 cm (22¹/₂ x 21³/₄")

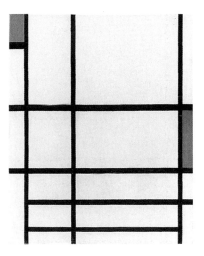

*Composition en rouge, bleu et blanc: II,
(Composition with Red, Blue and White:
II) 1937*
Oil on canvas
75 x 60.5 cm (29^1/$_2$ x 23^7/$_8$")

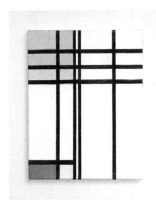

*No.I: Opposition de lignes, de rouge
et Jaune, (Contrasting Lines, Red and
Yellow) 1937*
Oil on canvas
43.5 x 33.5 cm (17^1/$_8$ x 13^1/$_4$")

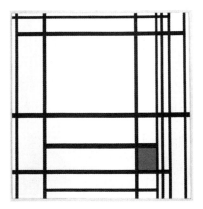

*Composition de lignes et couleur: III,
(Composition of Lines and Colour: III)
1937*
Oil on canvas
80 x 77 cm (31^1/$_2$ x 30^3/$_8$")

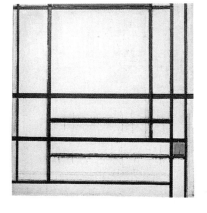

*Composition of Lines with Red
(unfinished), 1937*
Charcoal and oil on canvas
73 x 68.5 cm (28^3/$_4$ x 27")

538

LONDON 1938–40

NEW YORK 1940–44

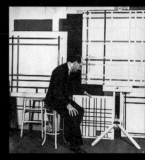

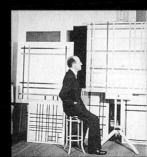

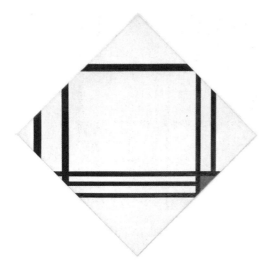

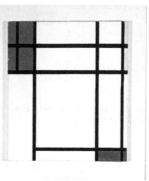

Composition No.2.
1938 / Composition of Red, Blue,
Yellow and White: No.III, 1939
Oil on canvas
44.6 x 38.2 cm (17⁹/₁₆ x 15¹/₁₆")

Lozenge Composition with Eight Lines
and Red / Picture No.III, 1938
Oil on canvas
Diagonal: 140 cm (55¹/₄")
Sides: 100 x 100 cm (39³/₈ x 39³/₈")

540

Composition (unfinished), 1938
or 1939
Charcoal on canvas
70 x 72 cm (27⁵/₈ x 28³/₈ ")

Composition (unfinished), 1938
Charcoal on canvas
115 x 115 cm (45³/₈ x 45³/₈")

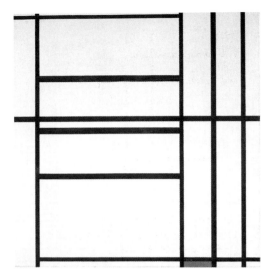

Composition No.1, with Grey and Red,
1938 / Composition with Red, 1939
Oil on canvas
105.2 x 102.3 cm (41$^7/_{16}$ x 40$^5/_{16}$")

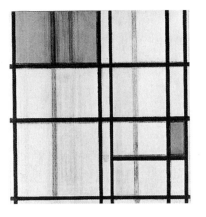

Composition with Red, Blue and Yellow
(unfinished), 1940
Charcoal and oil on canvas
73 x 70 cm (28$^3/_4$ x 27$^5/_8$")

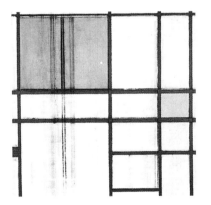

Composition with Red, Blue and Yellow
(unfinished), 1940
Oil on canvas
70.8 x 70.8 cm (27$^{15}/_{16}$ x 27$^{15}/_{16}$")

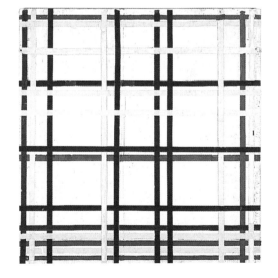

New York City 1 (unfinished), 1941
Oil and painted paper strips on canvas
119 x 115 cm (46$^7/_8$ x 45$^1/_4$")

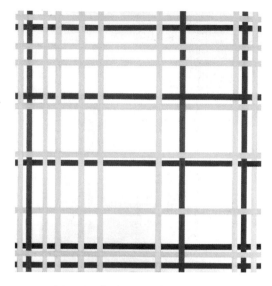

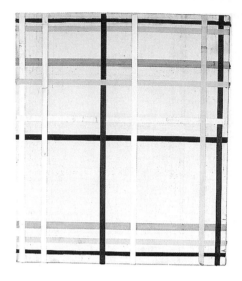

New York City, 1942
Oil on canvas
119.3 x 114.2 cm (47 x 45")

New York City 2 (unfinished), 1941
Charcoal and painted paper strips on canvas
115.7 x 99 cm (45⁹/₁₆ x 39")

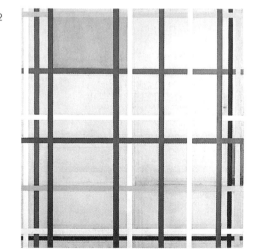

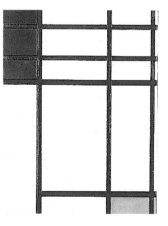

(Composition with Yellow and Blue
[unfinished], 1938?)/New York City 3
(unfinished), 1941 (1938?)/1941/1977
Pencil, charcoal and oil on canvas
116.8 x 110.5 cm (46 x 43¹/₂")

Composition of Red, Blue and White
[No.II], 1939 / Composition with
Red and Blue, 1941, 1939/1941
Oil on canvas
43.5 x 33 cm (17¹/₈ x 13")

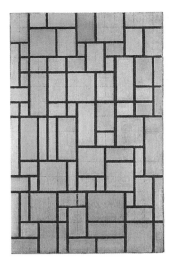

Composition with Grid 3 (unfinished?).
1918 / Composition No.15. 1915,
1918/1942
Charcoal and oil on canvas
97.5 x 61.5 cm (38³/₈ x 24¹/₄")

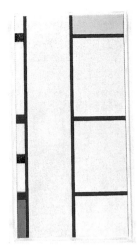

Composition (no.III) blanc-jaune.
1935 / Composition with Red, Yellow
and Blue, 1935–42, 1935/1942
Oil on canvas
101 x 51 cm (39³/₄ x 20¹/₈")/
107.9 x 58.4 cm (42¹/₂ x 23")

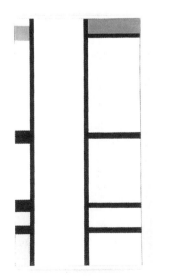

Composition A (No.I), with Red,
1935 / Composition with Blue, Red
and Yellow, 1935–42, 1935/1942
Oil on canvas

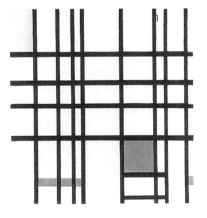

Composition (with Red ?) (unfinished ?),
1937 / Composition with Yellow, Blue
and Red, 1939–42, 1937/1942
Oil on canvas
72.5 x 69 cm (28⁵/₈ x 27¹/₄")

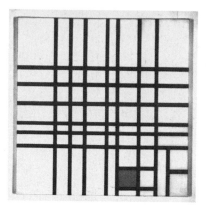

Composition with Blue (unfinished),
1937 / Composition No.12. 1936–42,
with Blue, 1937/1942
Oil on canvas
62 x 60.5 cm (24$^1/_2$ x 23$^7/_8$")

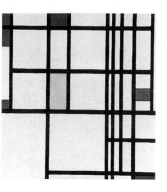

II: [...] blanc et rouge, 1937 /
Composition with Red, Blue and Yellow,
1937–42, 1937/1942
Oil on canvas
60.3 x 55.2 cm (23$^3/_4$ x 21$^3/_4$")

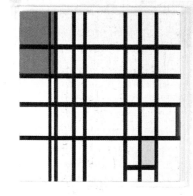

Rythme de lignes droites (et couleur?).
1937 / Composition with Blue, Red
and Yellow, 1935–42, 1937/1942
Oil on canvas
72.2 x 69.5 cm (28$^7/_{16}$ x 27$^3/_8$")

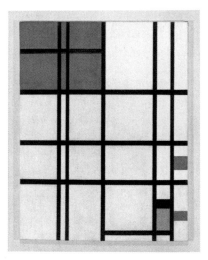

Composition (with Red and Blue?)
(unfinished). 1937 / Composition No.7,
1937–42, with Red and Blue, 1937/1942
Oil on canvas
80.5 x 62.2 cm (31$^3/_4$ x 24$^1/_2$")

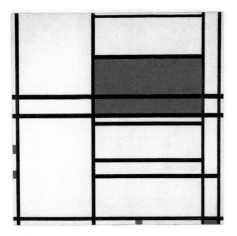

Composition of Red and White: No.I,
1938 / Composition No.4, 1938–42,
with Red and Blue, 1938/1942
Oil on canvas
100.3 x 99.1 (39¹/₂ x 39")

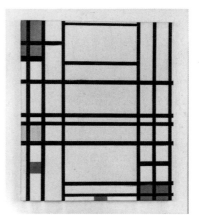

Composition (unfinished), 1938 /
Composition No.5, 1939–42, with
Blue, Yellow and Red, 1938/1942
Oil on canvas
75 x 65 cm (29⁵/₈ x 25⁵/₈")

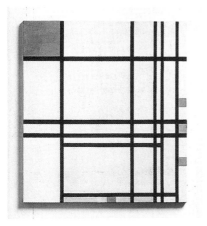

Composition (unfinished), 1939(?)/
Composition No.8, 1939–42, with
Red, Blue and Yellow, 1939(?)/1942
Oil on canvas
75.2 x 68.1 cm (29⁵/₈ x 26⁷/₈")

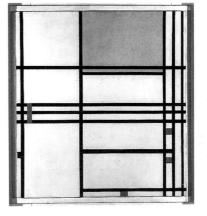

Composition (with yellow?) (unfinished),
1938 / Composition No.9, 1939–42,
with Yellow and Red, 1938/1942
Oil on canvas
79.7 x 74 cm (31³/₈ x 29¹/₄")

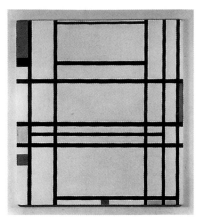

*Composition (unfinished), 1938 /
Composition No.10, 1939–42, with
Blue, Yellow and Red, 1938/1942*
Oil on canvas
79.5 x 73 cm (31³/₈ x 28³/₈″)

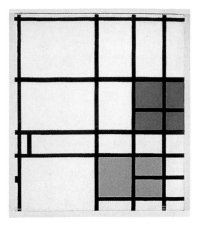

*Composition, 1940 / Composition
No.11, 1940–2 – London, with Blue,
Red and Yellow, 1940/1942*
Oil on canvas
82.5 x 71.1 cm (32¹/₂ x 28″)

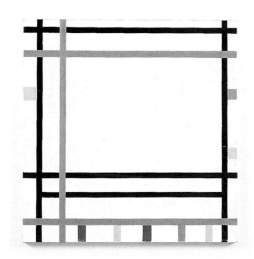

*New York, 1941 / Boogie Woogie,
1941–2, 1941/1942*
Oil on canvas
95.2 x 92 cm (37¹/₂ x 36¹/₄″)

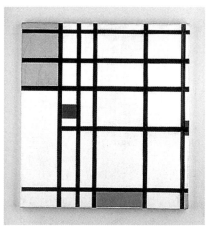

*No.III: Opposition de lignes de blanc
et jaune, 1937 / Picture II, 1936–43,
with Yellow, Red and Blue, 1937/1943*
Oil on canvas
60 x 55 cm (23⁵/₈ x 21³/₄″)

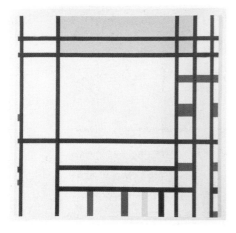

Composition, 1938 / Place de la Concorde, 1938–43, 1938/1943
Oil on canvas
94 x 94.4 cm (37 x 37³/₁₆″)

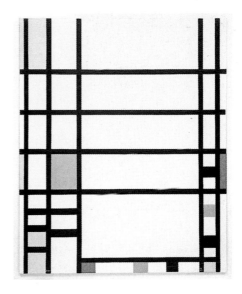

Compositie, 1939 / Trafalgar Square, 1939–43, 1939/1943
Oil on canvas
145.2 x 120 cm (57¹/₄ x 47¹/₄″)

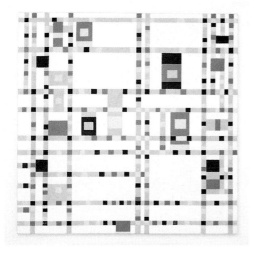

Broadway Boogie Woogie, 1942–3
Oil on canvas
127 x 127 cm (50 x 50″)

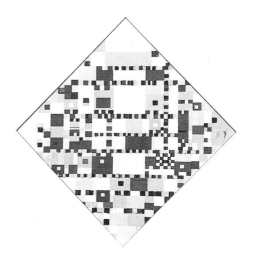

Victory Boogie Woogie (unfinished), 1942–4/1944
Oil and paper on canvas
Diagonal: 178.4 cm (70¹/₄″)
Sides: 126 x 126 cm (49⁵/₈ x 49⁵/₈″)

Sketchbook 1925, Sheet B:
Three Lozenge Compositions
Charcoal on paper
23.5 x 29.8 cm (9¹/₄ x 11³/₄″)

Sketchbook 1925, Sheet D:
Three Rectangle Compositions
Charcoal on paper
23 x 29.8 cm (9 x 11³/₄″)

548

Sketchbook 1925, Sheet F:
Two Square Compositions
Charcoal on paper
23 x 29.8 cm (9 x 11³/₄″)

Sketchbook 1925, Sheet H:
Dresden Notes
Charcoal on paper
29.8 x 23 cm (11³/₄ x 9″)

Sketch of Four Lozenge Compositions,
1925 (?)
Pencil on paper
27.3 x 14 cm (10³/₄ x 5¹/₂")

Study for a Composition, 1935–6 (?)
Charcoal on blue-lined paper
26.7 x 20.9 cm (10¹/₂ x 8¹/₄")

Study for a Lozenge Composition,
c.1938 (?)
Pencil on paper
Diagonals: 29.7 x 29.4 cm (11³/₄ x 11⁵/₈")
Sides: 21.6 x 21.6 cm (8¹/₂ x 8¹/₂")

Study for a Composition, 1938–40 (?)
Charcoal on paper
90 x 89 cm (35¹/₂ x 35")

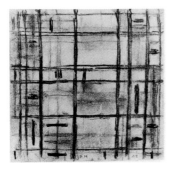

Study I for Broadway Boogie Woogie,
1942
Charcoal on paper
23.1 x 23.2 cm (9 1/8 x 9 1/8")

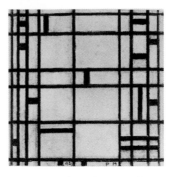

Study II for Broadway Boogie Woogie,
1942
Charcoal on paper
22.9 x 23.2 cm (9 x 9 1/8")

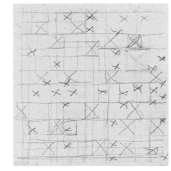

Sketch for Broadway Boogie Woogie (?)
I, 1942–3 (?)
Pencil on blue lined paper
21.5 x 20 cm (8 1/2 x 7 7/8")

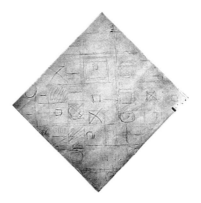

Sketch for Victory Boogie Woogie,
1943 (?)
Pencil on paper
Diagonal: 48.9 cm (19 1/4")
Sides: 37.8 x 36 cm (14 7/8 x 14 1/8")

Sketchbook I, Domburg,
c. October 1914
Cardboard and paper
11.4 x 15.8 cm (4^1/$_2$ x 6^1/$_4$")
1 Horizontal Pier

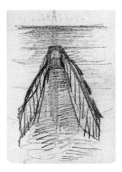

2 Pier and Ocean

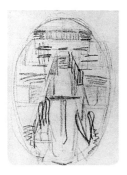

3 Pier and Ocean

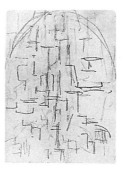

4 Tree

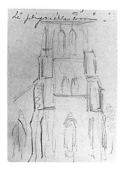

5 Church at Domburg

Sketchbook II, Paris 1914
Paper 17.2 x 11 cm (6³/₄ x 4⁵/₁₆")
(page size: 17.2 x 10.5 cm (6³/₄ x 3¹⁵/₁₆")
1 Demolished Building

2 Demolished Building

3 Paris Roofs

Demolished Building / verso: fragment of written text, 1914
Pencil on paper
17.1 x 10 cm (6³/₄ x 31⁵/₁₆")

Tree, Summer 1912
Pencil on paper
10.2 x 17.2 cm (4 x 6³/₈")

Dunes, Piers and Sea, Summer 1912
Pencil on paper
10.5 x 17.2 cm (4¹/₈ x 6³/₄")

Piers and Sea, Summer 1912
Pencil on paper
10.5 x 17.2 cm (4¹/₈ x 6³/₄")

Rose
Pencil on paper
17 x 10.2 cm ($6^3/_8$ x 4")

Scaffolding 1, early 1914
Pencil on paper
17.2 x 10.5 cm ($6^3/_4$ x $4^1/_8$")

554

Paris Church Façade, 1914
Pencil on paper
10.3 x 17.2 cm ($4^1/_8$ x $6^3/_8$")

Paris Church Façade, 1914
Pencil on paper
10.5 x 17.2 cm ($4^1/_8$ x $6^3/_4$")

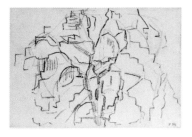

Tree, early 1913
Pencil on paper
12.4 x 17.8 cm (4⁷/₈ x 7")
Oblong sketchbook leaf, torn off at the spine,
with sharp corners

Tree, early 1913
Pencil on paper
12.4 x 17.5 cm (4⁷/₈ x 6⁵/₈")
Oblong sketchbook leaf, torn off at the spine,
with sharp corners

Trees, 1912 (?)
Pencil on paper
11 x 17 cm (4⁵/₁₆ x 6³/₄")
Upright sketchbook leaf, torn off at the spine,
with round corners

Scaffolding 2, Paris 1914
Pencil on paper
23.6 x 15.4 cm (9¹/₄ x 6¹/₈")
Oblong sketchbook leaf, torn off at the spine,
with round corners

Paris Church Façade, 1914
Pencil on paper
15.4 x 23.6 cm (6^1/$_8$ x 9^5/$_{16}$")

Paris Courtyard Façades, Rue du Départ,
1913–14
Pencil on paper
23.6 x 15.4 cm (9^1/$_4$ x 6^1/$_8$")

Paris Courtyard Façades, 1913–14
Black chalk on paper
25.3 x 33.8 cm (10 x 13^3/$_8$")
Oblong sketchbook leaf, torn off at the spine,
with round corners

Record Rack, 1927 or later
Painted wood
78.8 x 30.5 x 27.8 cm (30³/₄ x 13³/₄ x 11")

Stool, 1943
Painted wood
61 x 35.6 x 30.5 cm (24 x 14 x 12")

Desk, 1943
Painted wood
81.3 x 71.1 x 61 cm (32 x 28 x 24")

Work Table, 1943
Painted wood
81.3 x 61 x 55.9 cm (32 x 24 x 22")

Farm near Duivendrecht, c.1916
Oil on canvas
84.5 x 106 cm (33¹/₄ x 41³/₄")

Farm near Duivendrecht, in the
Evening, c.1916
Charcoal on paper
58.7 x 76.5 cm (23¹/₈ x 30¹/₈")

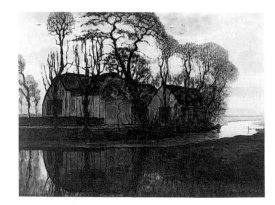

Farm near Duivendrecht in the Evening,
c.1916
Oil on canvas
76.2 x 106.6 cm (30 x 41³/₄")

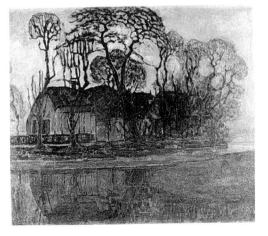

Farm near Duivendrecht in the Evening,
c.1916
Oil on canvas
85 x 100 cm (33¹/₂ x 39¹/₂")

Farm near Duivendrecht, c.1916
Black chalk and pencil on paper
33 x 41 cm (13 x 16^1/$_8$")

Farm near Duivendrecht, c.1916
Black chalk on paper
33 x 41.5 cm (13 x 16^5/$_{16}$")

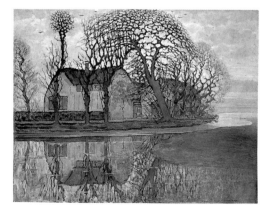

Farm near Duivendrecht, c.1916
Oil on canvas
85.5 x 108.5 cm (33^5/$_8$ x 42^3/$_4$")

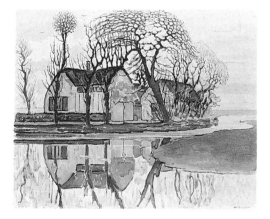

Farm near Duivendrecht, c.1916
Oil on canvas
86.5 x 108.5 cm (34 x 42^3/$_4$")

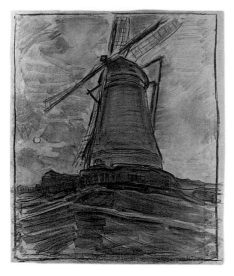

Windmill, c.1917
Charcoal on paper
105 x 90 cm (45^1/$_4$ x 35^3/$_8$")

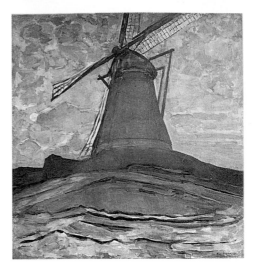

Windmill, c.1917
Oil on canvas
100 x 94.5 cm (39^3/$_8$ x 37^1/$_8$")

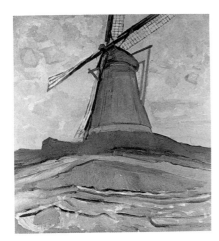

Landscape at Montmorency, 1930
Oil on canvas
45.8 x 55.2 cm (18 x 21^3/$_4$")

Windmill, c.1917
Oil on canvas
99.5 x 94.6 cm (39^3/$_8$ x 37^1/$_4$")

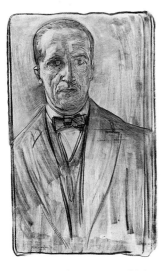

Self Portrait, 1916
Charcoal on paper
121 x 63 cm (47⁵/₈ x 24³/₄")

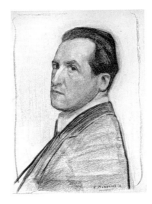

Self Portrait, 1912
Charcoal on paper
65 x 45 cm (25⁵/₈ x 17³/₄")

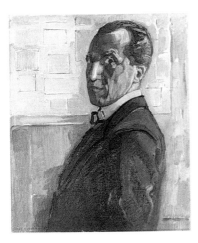

Self Portrait, 1918
Oil on canvas
88 x 71 cm (34⁵/₈ x 28")

*Self Portrait, after reproduction, 1942
(?)*
Charcoal on paper (torn-off oblong sketchbook
sheet with round corners)
28.2 x 23.2 cm (11¹/₈ x 9¹/₈")

Self Portrait, after a reproduction,
1942
Charcoal, ink and gouache on paper
63.5 x 48.2 cm (25 x 19")

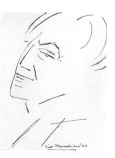

Self Portrait, 1942
Ink on paper
29.8 x 22.8 cm (11³/₄ x 9")

562

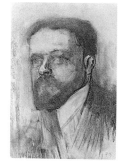

Portrait of M. Ritsema van Eck
(1870–1948), 1912 (?)
Ink and charcoal on paper
53 x 46 cm (20⁷/₈ x 18¹/₈")

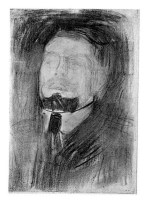

Portrait of M. Ritsema van Eck
(1870–1948), 1912 (?)
Charcoal on paper
70 x 49 cm (28⁹/₁₆ x 20¹/₁₆")

Study for Portrait of Friedel M. Cabos-de Fries (1893–1988), 1924(?)
Black Conté crayon and charcoal on paper
62.9 x 38.4 cm (24³/₄ x 15¹/₈")

Portrait of Friedel M. Cabos-de Fries (1893–1988), 1924
Oil on canvas
57 x 45 cm (22¹/₂ x 17³/₄")

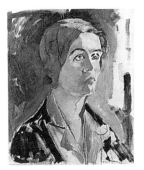

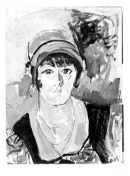

Portrait of a Woman
Oil on canvas
55 x 46 cm (21⁵/₈ x 18¹/₈")

Portrait of a Woman in Yellow Hat
Oil on canvas
56 x 43 cm (22 x 17⁷/₈")

Amaryllis
Pencil and watercolour on paper
47.4 x 32 cm (18$^1/_2$ x 12$^1/_2$")

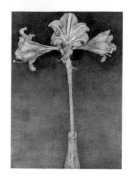

Red Amaryllis with Blue Background
Watercolour on paper
47 x 33.3 cm (18$^3/_8$ x 13")

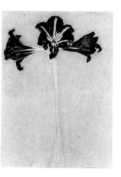

Red Amaryllis with Blue Background
Watercolour on paper
47.3 x 34.2 cm (18$^1/_2$ x 13$^1/_2$")

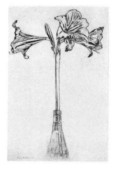

Amaryllis
Pencil and watercolour on paper
49 x 31 cm (19$^1/_4$ x 12$^1/_4$")

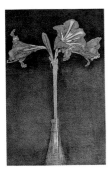

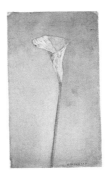

Red Amaryllis with Blue Background
Watercolour on paper
49.2 x 31.5 cm (15³/₈ x 17⁵/₁₆")

Arum Lily
Gouache and ink on paper
42 x 25 cm (16⁵/₈ x 9⁷/₈")

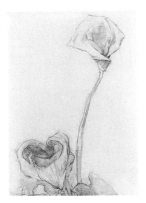

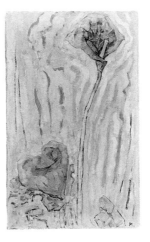

Two Arum Lilies
Charcoal on paper
68 x 50 cm (26³/₄ x 19³/₄")

Two Arum Lilies, c.1917
Oil on canvas
80 x 50 cm (31¹/₂ x 19³/₄")

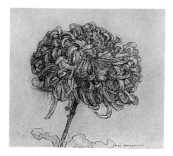

Chrysanthemum
Charcoal on paper
25.5 x 28.7 cm (10 x 11^1/$_4$")

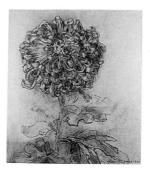

Chrysanthemum
Crayon on paper
40 x 37 cm (15^3/$_4$ x 14^5/$_8$")

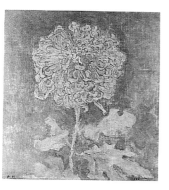

Chrysanthemum
Oil on canvas
41.7 x 38.3 cm (16^3/$_8$ x 15^1/$_8$")

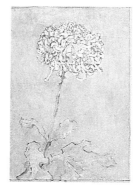

Chrysanthemum
Oil on canvas
50.2 x 34.9 cm (19^3/$_4$ x 13^3/$_4$")

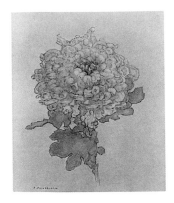

Chrysanthemum
Watercolour on paper
28 x 24 cm (11 x 9$^1/_2$")

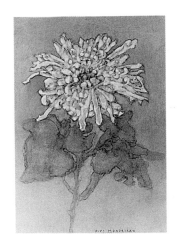

Chrysanthemum
Watercolour on paper
27 x 22.5 cm (10 x 8")

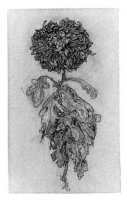

Chrysanthemum
Black and brown Conté crayon and charcoal
on paper
62.9 x 38.4 cm (24$^3/_4$ x 15$^1/_8$")

Chrysanthemum
Oil on canvas
68 x 42.7 cm (26$^3/_4$ x 16$^3/_4$")

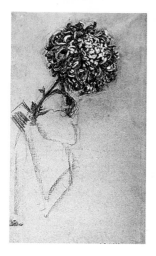

Chrysanthemum
Charcoal, chalk and gouache on paper
60.7 x 36.1 cm (23⁷/₈ x 14¹/₄")

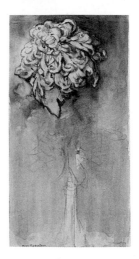

Chrysanthemum in a Bottle
Watercolour on paper
64 x 33 cm (25 x 13")

568

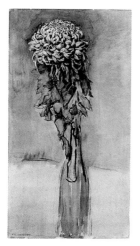

Chrysanthemum in a Bottle
Watercolour on paper
72.5 x 38.5 cm (28⁵/₈ x 15¹/₄")

Chrysanthemum
Charcoal and chalk on cardboard
72 x 47 cm (28³/₈ x 18¹/₂")

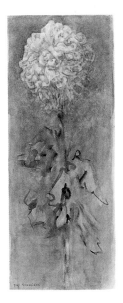

Chrysanthemum
Watercolour and gouache on paper
69 x 26.5 cm (27^1/$_4$ x 10^1/$_2$")

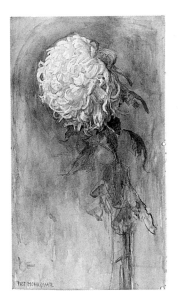

Chrysanthemum in a Bottle
Watercolour and black chalk
dimensions unknown

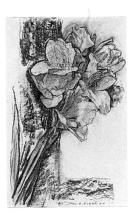

Gladiolus
Charcoal on paper
31 x 21 cm (12^1/$_4$ x 8^1/$_4$")

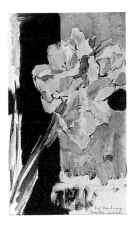

Gladiolus
Oil on canvas
35 x 21 cm (13^3/$_4$ x 8^1/$_4$")

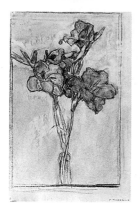

Gladioli in a Bottle
Charcoal on paper
38.7 x 26.3 cm (15¹/₄ x 10¹/₄")

Gladioli (in a Bottle?)
Oil on canvas
39.2 x 20.3 cm (11¹/₂ x 8")

Stalk with Two Japanese Lilies
Watercolor on paper
33.3 x 35.9 cm (13 x 14")

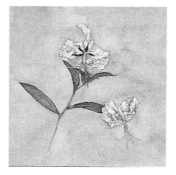

Stalk with Two Japanese Lilies
Watercolour on paper
30 x 30.5 cm (11⁷/₈ x 12")

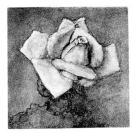

Rose
Watercolour on paper
dimensions unknown

Design for the Decoration of a Plate
Oil on ceramic; diameter 20 cm (7⁷/₈")

571

PHOTOGRAPHIC CREDITS

Centraal Museum, Utrecht
Collection Centre Canadien d'Architecture/Canadian
 Centre for Architecture, Montreal
Christie's, Amsterdam
Christie's, Tokyo
Christie's, London
Christie's, New York
Cincinnati Art Museum, Cincinnati, bequest of Mary
 E. Johnston
Civica Galleria d'Arte Moderna, Milan
James H. and Lillian B. Clark Foundation, Dallas, Texas
The Cleveland Museum of Art, Cleveland, Ohio
Martien Coppens, Eindhoven
Fondation Le Corbusier, Paris

Dallas Museum of Art, Dallas, Texas
D. James Dee, New York
The Denver Art Museum, Denver, Colourado
Deutsche Bank, Frankfurt am Main
Van Doesburg-van Moorsel Archives, RKD, The Hague
Gebr. Douwes Fine Art, Amsterdam

Ethnike Pinakotheke kai Mouseion Alexandrou
 Soutzou, Athens

Gladys Fabre, Paris
Gimpel Fils, London
Fine Arts Communications, Inc., New York
Fogg Art Museum, Harvard University, Cambridge,
 Massachusetts
Corien Folmer, Amsterdam
Fujii Gallery, Tokyo

La Galleria Nazionale, Rome
Mr and Mrs Carl H. Gans, New York
Gemeentearchief, Amsterdam
Gemeentelijke Archiefdienst, Rotterdam
Glerum c.s., The Hague
Graphische Sammlung, Staatsgalerie, Stuttgart
Collection Groninger Museum, Groningen,
 photo John Stoel, Haren
Collection Groninger Museum, Groningen,
 photo Piet Boonstra
Solomon R. Guggenheim Foundation, New York
Joseph M.B. Guttmann Galleries, Los Angeles

Collection Haags Gemeentemuseum, The Hague

Frans Hals Museum, Haarlem
Stichting Hannema-de Stuers, Heino
G. Harrenstein, Bussum
Helga Photo Studio, New York
Hirshhorn Museum and Sculpture Garden, Smithsonian
 Institution, Washington, The Joseph
 H. Hirshhorn Bequest, 1981,
 photo Lee Stalsworth
Historische Kring, Blaricum
Stichting Historische Verz. v/h Huis Oranje-Nassau,
 The Hague
Archiv Hannah Höch, Berlinische Gallerie, Berlin
Emanuel Hoffmann Foundation on permanent loan to the
 Kunstmuseum, Basel, photo Oeffentliche Kunst-
 sammlung, Basel, Martin Bühler
Willem Hoogendijk, Utrecht

Institut Néerlandais, Paris

Annely Juda Fine Art, London

Gallery Kaganovich, Paris
Kaiser Wilhelm Museum, Krefeld
André Kertész/Mission de Patrimoine Photographique,
 Paris
The Kimbel Art Museum, Fort Worth
Koninklijke Bibliotheek, The Hague
Marion Koogler MacNay Art Museum, San Antonio
Kreeger Museum, Washington, D.C.
Kröller-Müller Museum, Otterlo
Kunsthandel Borzo, 's-Hertogenbosch
Kunsthandel M.L. de Boer, Amsterdam
Kunsthandel Monet, Amsterdam
Kunsthaus, Zürich, © The Estate of Fritz Glarner
Kunstmuseum, Bern
Kunstmuseum, Winterthur
Kunstsammlung Nordrhein-Westfalen, Düsseldorf
Mrs Phyllis Lambert, Montreal
Mr and Mrs Alex Lewyt, Sands Point, NY
Los Angeles County Museum of Art, Los Angeles

Mackenzie Art Gallery, Regina, Saskatchewan
Marlborough Fine Art, London
Galleria Martini & Ronchetti, Genoa
Stephen Mazoh & Co, Inc., New York
McCrory Corporation, New York
Klaus Meertens, McKinsey & Co, Amsterdam

The Menil Collection, Houston
The Metropolitan Museum of Art, New York
Ministère de la culture – France, photo André Kertész
The Minneapolis Institute of Arts, Minneapolis
Mizne-Blumental Collection, Tel Aviv Museum of Art,
 Tel Aviv
The Lisette Model Foundation, Inc., New York
Modern Art Museum of Fort Worth
D. Morris Gallery, Birmingham, Michigan
Munson-Williams-Proctor Institute, Museum of Art,
 Utica, N.Y.
Musée d'Orsay, Paris
Musée de Grenoble
Musée Départemental du Prieuré, Saint Germain-en-Laye
Musée National d'Art Moderne, Centre Georges
 Pompidou, Paris
Museum Boymans-van Beuningen, Rotterdam
The Museum of Contemporary Art, Los Angeles
The Museum of Fine Arts, Houston; gift of Mr and Mrs
 Pierre Schlumberger
Museum Folkwang, Essen
Museum Van Gijn, Dordrecht
The Museum of Modern Art, New York
Museum Moderner Kunst, Vienna

574 National Gallery of Art, Washington, D.C.
National Gallery of Canada, Ottawa
National Museum of Modern Art, Kyoto
National Museum, Stockholm
Nederlands Architectuurinstituut, Rotterdam
Nederlands Openluchtmuseum, Arnhem
John Neff, Chicago
O.E. Nelson, New York
Arnold Newman, New York

Noordbrabants Museum, 's-Hertogenbosch
The Norton Simon Foundation, Pasadena, California

Öffentliche Kunstsammlung Basel, Kunstmuseum,
 photo Öffentliche Kunstsammlung Basel,
 Martin Bühler
Jaap d'Oliveira/©Nederlands Fotoarchief, Rotterdam
Cas Oorthuys/©Nederlands Fotoarchief, Rotterdam
Oudheidkundige Collectie 'De Graafschap' / Staring
 Instituut, Doetinchem

The Pace Gallery, New York

Pace Wildenstein, New York
Paleis Het Loo, Nationaal Museum, Apeldoorn
Merilyn Pearl Gallery, New York
Philadelphia Museum of Art, Philadelphia
Philadelphia Museum of Art: Louise and Walter
 Arensberg Collection
Philadelphia Museum of Art: The A.E. Gallatin
 Collection.
The Philips Collection, Washington, D.C.
Photothèque des musées de la ville de Paris
The Pierpont Morgan Library, New York 1985.23
Frans Postma, Delft

Raccolta d'Arte del Commune di Milano
Rijksbureau voor Kunsthistorische Documentatie,
 The Hague
Rijksdienst Beeldende Kunst, The Hague
Rijksdienst Monumentenzorg, Zeist
Rijksmuseum, Amsterdam
The Judith Rothschild Foundation, New York

San Francisco Museum of Modern Art, San Francisco
Antiquariaat Schumacher, Amsterdam
Scottish National Gallery of Modern Art, Edinburgh
Sidney Janis Family collections, NYC
Sidney Janis Gallery, New York
Smith College Museum of Art, Northampton,
 Massachussets. Gift of Mrs John W. O'Boyle
 (Nancy Millar '52)
The Smithsonian's Museum of Modern and
 Contemporary Art
Sotheby's, Amsterdam
Sotheby's, New York
Sprengel Museum, Hanover
Staatliche Museen zu Berlin, Preußischer Kulturbesitz
 Nationalgalerie
State Tretiakov Gallery, Moscow
Statens Konstmuseet, Stockholm
Stedelijk Museum, Amsterdam
Allan Stone Galleries, New York
Jacques Straessle, Le Mont, Switzerland
Studio 2000 Art Gallery, Amsterdam

Tate Gallery, London
Mr and Mrs Eugene Victor Thaw, New York
Fundación Colección Thyssen-Bornemisza, Madrid
The Toledo Museum of Art

Thomas Amman Fine Art, Zurich

Valley House Gallery Inc., Dallas, Texas
Van Voorst van Beest Gallery, The Hague
The Jane Vorhees Zimmerli Art Museum, Rutgers
 University, The State University of New Jersey

Waddington Galleries, London
Wadsworth Atheneum, Hartford. The Ella Gallup
 Sumner and Marty Catlin Sumner Collection
 Fund
Rolf and Margit Weinberg, Zurich
Wilhelm-Hack-Museum, Ludwigshafen
Williams Bros., Vancouver

Yale University Art Gallery, New Haven
Yale University Art Gallery, New Haven, gift of Bruce
 B. Dayton, B.A. 1940
Yale University Art Gallery, New Haven, gift of the
 artist for the collection Société Anonyme

Zeeuws Museum, Middelburg